Indiscreet Fantasies

Campos Ibéricos
Bucknell Studies in Iberian Literatures and Cultures

General Editors:
Isabel Cuñado, Bucknell University
Jason McCloskey, Bucknell University

Campos Ibéricos is a series of monographs and edited volumes that focuses on the literary and cultural traditions of Spain in all of its rich historical, social, and linguistic diversity. The series provides a space for interdisciplinary and theoretical scholarship exploring the intersections between literature, culture, the arts, and media from medieval to contemporary Iberia. Studies on all authors, texts, and cultural phenomena are welcome and works on understudied writers and genres are specially sought.

Titles in the Series

Andrés Lema-Hincapié and Conxita Domènech, eds., *Indiscreet Fantasies: Iberian Queer Cinema*
Katie J. Vater, *Between Market and Myth: The Spanish Artist Novel in the Post-Transition, 1992–2014*

Indiscreet Fantasies

•••••••••••••••••••••••••••

Iberian Queer Cinema

EDITED BY ANDRÉS LEMA-HINCAPIÉ AND
CONXITA DOMÈNECH

UNIVERSITY
PRESS

Lewisburg, Pennsylvania

Library of Congress Cataloging-in-Publication Data

Names: Lema-Hincapié, Andrés, editor. | Domènech, Conxita, editor.
Title: Indiscreet fantasies: Iberian queer cinema / edited by Andrés Lema-Hincapié
 and Conxita Domènech.
Description: Lewisburg: Bucknell University Press, 2020. | Series: Campos ibéricos |
 Includes bibliographical references and index.
Identifiers: LCCN 2020004917 | ISBN 9781684482467 (paperback) | ISBN 9781684482474
 (hardcover) | ISBN 9781684482481 (epub) | ISBN 9781684482498 (mobi) |
 ISBN 9781684482504 (pdf)
Subjects: LCSH: Homosexuality in motion pictures. | Gays in motion pictures. |
 Motion pictures—Spain—History—20th century. | Motion pictures—Spain—History—
 21st century. | Motion pictures—Portugal—History—20th century. | Motion pictures—
 Spain—History—21st century.
Classification: LCC PN1995.9.H55 I53 2020 | DDC 791.43/653—dc23
LC record available at https://lccn.loc.gov/2020004917

A British Cataloging-in-Publication record for this book is available from the British Library.

♾ The paper used in this publication meets the requirements of the American National
Standard for Information Sciences—Permanence of Paper for Printed Library Materials,
ANSI Z39.48-1992.

www.bucknelluniversitypress.org

Distributed worldwide by Rutgers University Press

Manufactured in the United States of America

To Jesús María Montoya Yepes,
Dolors Ortolà, and Victòria Muns.
They already know why.

Contents

Part III Queering Iberian Politics

Part IV Queer Catalonia: Destroying Essential Representations

Part V Burning Counterpoints with Religiosity

Indiscreet Fantasies

Introduction

•

ANDRÉS LEMA-HINCAPIÉ
AND CONXITA DOMÈNECH

In the past twenty-five years, the study of film has increasingly become a curricular staple in literature and cultural studies departments of U.S. and foreign colleges and universities. Many universities have responded to the image's ever more central place in contemporary culture by instituting programs in visual studies. In our own field of Iberian literatures and cultures, the analysis of visual medi products is now a central aspect of the discipline, with film the privileged medium for these analyses. Works such as Virginia Higginbotham's *Spanish Film under Franco* (1987), Barry Jordan and Rikki Morgan-Tamosunas's *Contemporary Spanish Cinema* (1998), Rob Stone's *Spanish Cinema* (2001), Bernard P. E. Bentley's *A Companion to Spanish Cinema* (2008), Jo Labanyi and Tatjana Pavlović's *A Companion to Spanish Cinema* (2012), and Sally Faulkner's *A History of Spanish Film: Cinema and Society 1910–2010* (2013) attest to a growing academic field in English-speaking contexts.

Methodologically, *Indiscreet Fantasies: Iberian Queer Cinema* follows a format similar to that of *Burning Darkness: A Half Century of Spanish Cinema* (2008), edited by Joan Ramon Resina and Andrés Lema-Hincapié, and also of *Despite All Adversities: Spanish-American Queer Cinema*, edited by Andrés Lema-Hincapié and Debra A. Castillo (2015). In both of these earlier works, each chapter, written by a renowned academic in the field of Hispanic studies, analyzes an important film from a historical, thematic, or cinematographic point of view. The analyses are based on a wide range of critical theories, some contemporary and some centuries old. *Burning Darkness* and *Despite All*

Adversities contain fifteen and sixteen critical chapters, respectively, and this number is intentional: because a typical university semester lasts sixteen weeks, these two critical anthologies perfectly suit the teaching calendar of university instructors of Peninsular cinema or Latin American queer cinema. While *Indiscreet Fantasies* is informed by the same spirit as the two previously mentioned titles, it represents a different interpretive approach and teaching philosophy. It is not organized thematically, nor does it favor theoretical analysis. It does not present a panoramic cross section of Spanish and Portuguese cinema, or a comprehensive study of one particular director's cinematography.

Nevertheless, publishers and scholars have clearly shown a preference for books, whether single-author or contributed, studying the cinema of renowned Spanish filmmakers. For instance, extensive bibliographies of titles in English are devoted to Pedro Almodóvar, Luis Buñuel, and Carlos Saura.[1] Consider Juan Rey Fuentes's *All about Almodóvar's Men* (2017); Paul Julian Smith's *Desire Unlimited: The Cinema of Pedro Almodóvar* (2014); Marvin D'Lugo and Kathleen M. Vernon's *A Companion to Pedro Almodóvar* (2013); Gwynne Edwards's *A Companion to Luis Buñuel* (2010); Brad Epps and Despina Kakoudaki's *All about Almodóvar: A Passion for Cinema* (2009); Isabel Santaolalla and Peter William Evans's *Luis Buñuel: New Readings* (2008); Linda M. Willem's *Carlos Saura: Interviews* (2003); Peter William Evans's *The Films of Luis Buñuel: Subjectivity and Desire* (1995); and Marvin D'Lugo's *The Films of Carlos Saura* (1991). Our book complements Chris Perriam's *Spanish Queer Cinema* (2013), which does not consider Portuguese cinema. For English-speaking readers, our book is the first of its kind. It goes beyond already established names in the film industry and pays deep attention not only to films in Spanish but also to films from other cultural/linguistic traditions in the Iberian Peninsula: Portuguese, Catalan, Galician, and Basque. Each of the volume's fifteen collaborators has written a stimulating original essay on a thought-provoking film by a distinct filmmaker.

The academic institutionalization of the fields of women's studies, gender studies, and, more recently, queer and LGBTQ studies has important ramifications for the *way* we teach. Moreover, social and academic movements in the Iberian Peninsula show their impacts on the film industry throughout the world. Filmmakers who address queer topics with intelligence and sensitivity have become more prominent since the mid-1990s, paralleling national trends beyond Western Europe, toward legal recognition of sexual and gender diversity and greater social acceptance. Adding strength to this general and growing interest in cinematic histories are the international recognition and serious critical attention that Iberian films have achieved beyond their commercial success. Indeed, the éclat of prestigious cinema awards for films by Luis Buñuel, Pedro Almodóvar, Ventura Pons, Pablo Berger, Cesc Gay, and Marta Balletbò-Coll is only one index of a tradition of high-quality filmmaking. Besides films

by these directors, our book also includes cutting-edge interpretations of appealing films by auteurs such as Ignacio Vilar, João Pedro Rodrigues, and Roberto Castón, among many others.

Importantly for our purposes, the best known of these films combine commercial success with a social edge. The following sentence that Deborah Shaw wrote in 2007 could easily apply to our current selection of Iberian queer films: "The strength of the most successful films from Latin America, in contrast to many (but not all) of their Hollywood counterparts, is that high-quality entertainment is produced without the loss of a socially committed agenda."[2] The films studied in our contributed volume clearly fight for a queer agenda. Second, we also agree with Chris Perriam, whose words from his book published in 2013 can also characterize the ways we approach queer cinema in this volume as "LGBTQ cinema with a particular weight on the Q: a weight placed there in order to start moving away from the gravitational pull of the still oddly predominant would-be mainstream, alternative-life representation of young, urban, nonimmigrant white, healthy men who have sex with men and are supposed to represent a buzzing New Spain."[3] In the films referenced in this volume, viewers will find lesbian sexuality in various stages of life (*Sévigné [Júlia Berkowitz], Entre tinieblas*), gay male teens (*Krámpack*), diverse ethnicities (*O ornitólogo*), and two rural gay men—one middle-aged, the other young and indigenous Peruvian Quechua—(*Ander*), to name but a few examples.

Indiscreet Fantasies strongly participates in that "moving away" promoted by the cinema scholarship of Perriam and other film critics. In this way, the films discussed in this volume have been chosen not for their box office success, for the publicity that a specific director has received, for the mere fact that all the films belong to the history of Spanish/Portuguese cinema, or for the budget spent on a given film's production. The editors had the following selection criteria in mind: (1) the depth of critical inquiry posed by each film, (2) the richness of the plot, and (3) the existential implications that the "Q" of queer cinema presupposes for any curious spectator. These selective criteria fill a crucial need by inspiring three intellectual abilities on the part of the student and reader: theoretical interpretation, narrative and aesthetic complexity, and ethical and political awareness. Nevertheless, despite the interest and quality of that body of work, until a few years ago there was little that English-speaking students and scholars could use to document their interest in Iberian queer film. Only recently has there been a small but steady trickle of specialized scholarly papers on the subject. While these articles are important, there is not yet any book that meets the need we are addressing here. English-language film students and professors can avail themselves of complementary texts such as Richard Dyer's *Gays and Film* (1977) and *The Culture of Queers* (2002); Vito Russo's *The Celluloid Closet: Homosexuality in the Movies* (1987); Susana M. Villalba's *Grandes películas del cine gay* (1996) [*Great Movies of Gay Cinema*];

Jenni Olson's *The Ultimate Guide to Lesbian and Gay Film and Video* (1996); Boze Hadleigh's *The Lavender Screen: The Gay and Lesbian Films* (2001); Michele Aaron's *New Queer Cinema* (2004); Steven Paul Davis's *Out at the Movies: A History of Gay Cinema* (2008); and Darwin Porter and Danforth Prince's *Fifty Years of Queer Cinema: Five Hundred of the Best GLBTQ Films Ever Made* (2010). Unfortunately, these relevant studies pay only scant attention to queer film in the Iberian Peninsula. The few examples they address are generally limited to films in Spanish and, usually, by Pedro Almodóvar. There are admirable and erudite encyclopedic studies for Spanish cinema, such as Bernard P. E. Bentley's *Companion to Spanish Cinema* (2008). We also need to remember Perriam's *Spanish Queer Cinema* (2013), an immense little book devoted to Spanish audiovisual works (films, videos, and television), actors, and directors of vital relevance. On queer cinema in Portugal, *Cinema e cultura queer* (2014), edited by António Fernando Cascais and João Ferreira, is an essential resource.

On the one hand, *Indiscreet Fantasies* complements in a thematic way—but not in an encyclopedic approach—these three works. On the other hand, it responds to the pedagogical necessity of advanced courses where, in increasing numbers, the cinema world attracts the interest of students, academics, or simply lovers of good foreign cinema. In particular, *Indiscreet Fantasies*—with a clear wink of complicity reminiscent of Buñuel's *Le charme discret de la bourgeoisie* (1972)—accompanies our task of film interpretation for university courses through thematic contributed volumes or books that connect Iberian literature and cinema. The adjective and noun "queer" points to a complex human reality and unstable semantics, while expressing hope and fear. We want to believe that in a central way, "queer" signifies the operating embodiment of physical desires, the practice of nurturing, the exercise of tenderness, and the colorful inner landscape of a multitude of individuals going against a heteronormative logic. Against those desires, practices, exercises, thoughts, feelings, fantasies, and dreams, a significant part of humanity has responded with the greatest of fears. Out of those fears, diverse forms of violence have been justified. That which is different—queer—is among us, and only by tolerating it, accepting it, appreciating it, and embracing it can we have a better understanding of humanity. "Queer" is a word that cries out, with hope, for an open understanding of human sexuality crisscrossed by new and uncertain paths. These paths repudiate all the methods that seek to violate human sexuality through historical myopia, religious sinfulness, legal criminalization, or, in short, absolute certainties à la Descartes. In favor of uncertainty and openness, the word "queer" is a defense of those meanings never completely determined, explained, or even fully understood. Or, in the words of Affad, the disturbing and enigmatic Egyptian created by Lawrence Durrell: "What is too finely

explained becomes inoperative, dead, incapable of realization."[4] "Queer" opens up new possibilities for human fulfillment.

We have not yet found a better way to articulate the fear of difference than these sentences by Special Agent Dana Scully, in episode "Teliko" of *The X-Files*, from October 18, 1998. In her field journal, entry number 74, Scully writes: "But what science may never be able to explain is our ineffable fear of the alien among us, a fear which often drives us not to search for understanding, but to deceive, inveigle, and obfuscate, to obscure the truth not only from others, but from ourselves."[5] The simplicity of the essays presented here is intentional. This book avoids the unnecessary complexity that baffles while promoting neither dialogue nor debate. We echo Eduardo Galeano, in his essential work *Open Veins of Latin America: Five Centuries of the Pillage of a Continent*: "Hermetic language isn't the invariable and inevitable price of profundity. In some cases, it can simply conceal incapacity for communication raised to the level of intellectual virtue. I suspect that boredom can thus often serve to sanctify the established order, confirming that knowledge is a privilege of the elite."[6]

This book is possible because in Basque, Catalan, Galician, Portuguese, and Castilian Spanish, there is an important body of films that show cinematic and narrative brilliance. This quality and variety in the ways the films portray different *queer* aspects of human life deserves the attention of a greater audience— whether or not that audience interprets the films intellectually. *Indiscreet Fantasies* bridges Iberian cinema of great aesthetic and technical value with the commercial or independent production and distribution networks that have usually turned their backs on *queer* cinema. This book opens the door to other realms of expression for, and in acknowledgment of, individuals with a *queer* orientation. Our volume collaborates in the creation of *queerer* societies; that is, it helps make real societies where individuals may "liberate . . . current pleasures, in favor of some more freewheeling, polymorphous sexuality."[7] Within such societies, what is *queer* will not be simply a "category of thought," but also a "category of erotic response."[8] The essays in *Indiscreet Fantasies* promote tolerance, authenticity without repression, and interest in what is "queer," leading to the construction of a *reasoned dissidence* very much still needed in the Iberian Peninsula. The isolation in which millions of people live in loneliness with their queer desires is not predestined. In Noam Chomsky's words, "Organization has its effects. It means that you discover that you're not alone. Others have the same thoughts that you do. You can reinforce your thoughts and learn more about what you think and believe."[9]

This volume has a certain utopian vision. That utopia is what could be called "the erotic North" of this book inside or outside the Iberian Peninsula. We long for our book to promote a freer eroticism within Iberian contexts and beyond. What would that utopia consist of? A glimmer of response to the question

comes in a comment by Matthieu Galey, stemming from a series of interviews with the Belgian writer Marguerite Yourcenar (1903–1987). Galey wrote of Yourcenar, "The author of *Alexis* and *Memoirs of Hadrian*—always, in the name of what is universal—does not see why there should be a difference between homosexual love and love."[10] Eventually, and, we hope, sooner rather than later, *queer* love will just be *love*. It is not naive to think that an academic book may affect customs and modes of thought in its potential readers, even though those readers will not be an overwhelming number. Just as critical thought continues contributing toward opening fields of recognition, of tolerance, and of genuine interest in what was previously viewed as abnormal, sick, or even monstrous, *Indiscreet Fantasies* actually promotes the critical effects of social justice as much for queer love as for those who live that type of love. It is official now: queer love has arrived as an integral aspect of the Iberian aesthetic sphere. The acknowledgment of this arrival, in all its complexity, will facilitate a shift in our readers' ethical, political, and religious awareness in connection with Peninsular cultures.

In Iberian cultures with a Catholic tradition and, often, feudal political systems, the growing alphabet of sexual diversity is not the norm.[11] Queer voices and sentiments persist as bothersome noises and expressive silences. In contexts where the films studied here are born, those noises and silences persist under conditions of repression by social and political forces, the judiciary and the mass media, education systems, and religious practices of heteronormativity. Nevertheless, through cracks and fissures that are more visible every day, some murmurs can be heard. *Indiscreet Fantasies* promotes new nonheteronormative social coordinates, making it possible to hear many more queer murmurs, noises, and even outright screams.

Scholars such as Judith Butler and Michel Foucault help teach us how queer cinema in Spanish America reshapes a vision of human sexuality frequently understood as limited, partial, or incomplete. And they show us how queer cinema attacks both the biological and the cultural essentialisms of gender. Butler, for instance, asks in "Gendering the Body: Beauvoir's Philosophical Contribution," "But what if this substantial sex does not exist, and our experience of gender, pleasure and desire is nothing other than the set of acts, broadly constructed, that constitute an identity rather than reflect one?"[12] At the same time, queer cinema projects the closeness and radical acceptance of that sexuality as a performative practice. Foucault, for instance, uncovers the sordid interests that are cruelly carried out from the heterosexual "microphysics of power." Such sordid interest would consist, as he puts it, of "essentially unequal and dissymmetrical micro-power systems that constitute the disciplines."[13] Queer events and identities embody a rebellion against all the most diverse disciplines trying to enslave human bodies.

Those sordid interests come in many forms, although, fortunately, many of the films in our anthology have been successful in their financing. They have not been as fortunate, however, in their distribution. This is the case both within and outside the countries of film production. That a film can be produced *does not yet guarantee that it exists*. The reasons for the misfortune in distribution go beyond the obstacles studied by Michael Chanan in his essay "The Economic Condition of Cinema in Latin America." Chanan spoke of national cinema and the limited support it received from governments and local spectators. This critic also denounces Hollywood's symbolic and financial imperialism that, on the one hand, controls distributors and cinema halls, and, on the other, provides a model for the filmic taste of Spain's majority audience. A high percentage of the potential audience cannot afford to go to the movies, meaning that only a small fraction of viewers sees films in theaters. Queer cinema from Spain is likewise faced with censorship both explicit and tacit. Among the "censoring" factors are the limited time of exhibition in each film's country of origin, the lack of interest from video-streaming platforms such as Netflix in including Iberian queer films in their inventory, religious and moralizing criticism, the fact that some films can be found only in a VHS format, and the film's slim chance of making it to film festivals around the world. Also, when they have the good fortune to be broadcast on television channels private or public, local or foreign, they are not free from the stigma of a schedule that paradoxically turns them into *invisible movies*. "Queer" movies are shown during a "queer" time slot, that is, between midnight and 5:00 A.M., when most potential spectators are sleeping.

We must acknowledge a contrast, as well as a similarity, between the queer cinema of Spanish America and that of the Iberian Peninsula. First of all, Spanish-American films with LGBTQ or queer content still have a long road ahead of them. Queer cinema of Spanish America has been crushed by an excessive seriousness. It still lacks humor except in crude parody. It is still ruled by an affective mood that is predominantly skeptical and fatalistic. In using intelligent humor, unexpected biases, and complex paradoxes, a film risks falling into the snares of fickleness, disrespect, and superficiality. Nevertheless, facing that risk requires a mature world for what is queer. By contrast, in the Iberian world, some films have confronted that risk and overcome the challenge. Subtle humor and even merciless self-parody pervade films produced in Spain. Among those films not studied in this book, we can think of Nacho G. Velilla's *Fuera de carta* (2008) [*Chef's Special*]; Ramón Salazar's *20 centímetros* (2005) [*20 Centimeters*]; Manuel Gómez Pereira's *Reinas* (2005) [*Queens*]; Daniela Féjerman and Isabel París's *A mi madre le gustan las mujeres* (2002) [*My Mother Likes Women*]; Yolanda García and Juan Luis Iborra's *Km. o* (2000); Pedro Almódovar's *Todo sobre mi madre* (1999) [*All about My Mother*]; and *Amor de*

hombre (1997) [*Man's Love*], also by Yolanda García Serrano and Juan Luis Iborra.[14] Both the casual spectator and the academic scholar can giggle through these productions without forgoing critical thought or compassion.

Independent cinema of lesbian content is still scarce, both on the Iberian Peninsula and in Spanish America. For this reason, in *Indiscreet Fantasies*, only three of the fifteen films discussed deal expressly with a lesbian theme. These are *La residencia* (1969) [*The House That Screamed*], *Sévigné (Júlia Berkowitz)*, and *Entre tinieblas* (1983) [*Dark Habits*]. Why this scarcity? We advance the following response, with the help of Lawrence Durrell: in relation to lesbianism, a false and simplistic position, tirelessly repeated, still stands. It is a harmless lesbianism for the homogenizing heteronormativity, as a character in *Quinx: Or, the Ripper's Tale* expresses. Audrey Blanford, a writer who is the alter ego of Durrell himself, notes: "Nobody bothers about women kissing and hugging each other, a little conventional 'mothering' is quite in order, or trotting off to the powder room together while the husbands solemnly suck their pipes and talk about holy orders!"[15] For lesbian and, more broadly, feminine sexuality, eroticism defies imposed conventions. And feminine fantasies go far beyond the powder room. Men and women following heteronormativity blithely assign that "decent" room a fleeting and banal nature when it may, in fact, imply much more.

The films studied in this volume update, or try to update, what David Norman Rodowick characterizes as "counter-cinema." Some of these films are very à la Hollywood; others allow the spectator to identify fundamentally on an emotional level with the characters and with the film's diegetic content. Almost all of them persist in "masking the means of production."[16] In this respect, even the more traditional films in our selection reject Hollywood norms.

Following the same format as used in *Burning Darkness: A Half Century of Spanish Cinema*, we present the fifteen films of this book, connecting them thematically and identifying some of the relevant aspects studied by each contributor. The chapter authors will help the reader/spectator think about the human and social implications of the various individual portraits of the characters in the films. Here are summaries of each contribution. Each scholar chose, or was assigned, a specific, important film as the focus of study. The analyses are rich and thoughtful, united by the thematic focus of the volume and by the decision to pay attention to a single film per chapter (rather than, for example, a filmmaker's body of work or a topical point of entry).[17] Based on our experience with survey courses on Iberian films and Spanish and Spanish-American queer cinema, we have identified films that would be essential for any course on this subject. Selected for their existential questions, technical originality, and political and social and psychological relevance to Iberian cultures, these works are both representative of notable creative directors and particularly apt for examining critical queer issues. Additionally, we believe that

Indiscreet Fantasies is a work that contributes much to the university curricular structures of Canada, the United States, and the United Kingdom that offer specialization in cinema studies within their bachelor's, master's, and PhD programs. For these programs that either directly or tangentially study Iberian films, our text would serve as a supplementary or even a primary course resource, since its essays can be read individually as well as collectively.

Our book is divided into five parts, which gives an internal and thematic unity to the whole volume. Each part revolves around a specific topic. Part I, "Into the Realm of Sexual Provocations," includes essays that analyze how tensions between sexual provocations and queerness are cinematically portrayed in Narciso Ibáñez Serrador's *La residencia* (1969) and Pablo Berger's *Torremolinos 73* (2003). *La residencia* has outsold many of the Spanish horror and fantasy films that now claim critical attention, yet it still suffers from critical neglect—the apparent legacy of critics' obsession with the New Spanish Cinema of the 1960s. Drawing on different conceptualizations of queer Gothic, Ann Davies discusses the film *La residencia*'s queer regime, with the boarding school at the center of the action as a site where both lesbian and heterosexual desire are queered in a Gothic as well as a sexual sense. Davies also argues that *La residencia* would automatically queer any point of view, offering a destabilization of heteronormativity that is politically as potent as the canonical realism of the 1960s. Its neglect today remains surprising, but the dismissal, at the time, of a film that refuses any "safe" critical position is only to be expected.

For Meredith Lyn Jeffers, *Torremolinos 73* warrants a place within the ever-growing corpus of queer cinema, thanks in large part to its enjoyable and critical take on Spain's late Francoist period (1960–1975) and on subsequent revisions of that era. More specifically, *Torremolinos 73* contests notions of normality in an ingeniously ironic fashion. *Torremolinos 73* would subvert Spain's desire to project a normalized cultural image to an international audience in the final decade of the dictatorship. Moreover, the film would succeed in demonstrating how the new, normative Spanish image was derivative, delayed, and won at a cost, engendering an illegitimate legacy and product that must be revisited and resisted.

Part II deals with questions of intimacy, household, and queer matters, particularly in the following films: Eusebio Pastrana's *Spinnin': 6000 millones de personas diferentes* (2007) [*Spinnin'*]; Cesc Gay's *Krámpack* (2000) [*Nico and Dani*]; and Salvador García Ruiz's *Castillos de cartón* (2009) [*3some*]. This part is titled "Queer Intimacy: Within the Household." Nina L. Molinaro proposes to examine the place and purpose of female figures and femininity in Eusebio Pastrana's film centered on biological reproduction, affective communities, and inclusive families. *Spinnin'* narrates the story of two gay men in a committed and pleasurable partnership, who decide to become fathers and coparents. Within that narrative, however, the writer-director and his creative

team incorporate and question the contributions and complications of a heterogeneous range of female characters. These include mothers, daughters, sisters, wives, women lovers, friends, acquaintances, and even strangers. Ana Corbalán's chapter draws attention to an array of cinematic queer practices that are created with the aim of decentering heteronormativity and embracing tolerance and acceptance in the viewer. By focusing on the construction of teen sexuality, *Krámpack* addresses new portrayals of same-sex desire among adolescents that other cinematic productions have ignored. Corbalán wants to demonstrate that this movie has a clear political agenda, one that would aim to naturalize queer desire twofold: by avoiding explicit sexual scenes that could cause discomfort in its "straight" spectatorship and by showing queer sexuality as a regular practice that is totally accepted and integrated into the narrative. Jennifer Brady analyzes the temporality of the relationship between three university students of fine arts in *Castillos de cartón*, a filmic version of Almudena Grandes's 2004 novel of the same title. Tensions of erotic desire, repeated between the two male characters throughout the film, reveal that even though the two male bodies do not touch each other, their relationship within the threesome challenges heterosexuality. Moreover, the three characters' interactions are fleeting, as represented by the nondurable cardboard material of the so-called castle in the film's title. While the threesome challenges monogamy, the creation of art mimics the construction of the polyamorous relationship of those three characters. In this way, the relationship these characters experience subverts the limiting and antiquated heteronormative and monogamous notions and, at the same time, offers a bridge toward the redefinition of sexualities.

The films in part III are Eloy de la Iglesia's *El diputado* (1978) [*Confessions of a Congressman*]; Jaime de Armiñán's *Mi querida señorita* (1971) [*My Dearest Señorita*]; Ignacio Vilar's *A esmorga* (2014); and Roberto Castón's *Ander* (2009). This part, titled "Queering Iberian Politics," orbits around the ways that certain Iberian films mainly disrupt—or queer—inertial political thoughts. These four films, respectively, deconstruct four socially accepted and intimately believed norms: (1) the long-standing formula that inertially equates heterosexuality with public spaces—still very strong, even with the return of democracy to Spain—and another echo of Francoism; (2) the political notion that "the habit makes the monk" in terms of a rigid discipline of the human body that psychically inoculates against specific sexual desires—such as the now despised and thoroughly debunked sexual conversion therapy (see Joel Edgerton's 2018 film *Boy Erased*); (3) the need to marginalize LGBTQ individuals in order to minimize the perceived dangers that they present to societies that, as a whole, aspire to be "moral"; and, finally, (4) the biased perception that the abominations suffered by homosexuals are independent of the gender-based discrimination experienced by women. In the climate of cultural ebullience and lifting

of censorship characteristic of the immediate post-Franco era, *El diputado* was one of the first Spanish films to engage in a fervent defense of homosexuality. The film details the conflicts and contradictions of the main character, a closeted homosexual and Marxist-Leninist politician. His aspirations of political leadership in the central government under the nascent Spanish democracy are cut short by the threat of a scandalous outing orchestrated by far-right militants. These figures are determined to sabotage his political career and, by extension, the traditional left's political agenda during the Transition. Questioning assertions that the film's political critique fails, Lena Tahmassian studies the complexity of the (proto)queer politics of *El diputado*. Examined through the lens of the current challenges to Spain's political conditions, *El diputado* would arguably gain renewed relevance today while serving as an important document of both early homosexual visibility and Spain's Transition to democracy. Conxita Domènech's essay on *Mi querida señorita* helps us understand how Armiñán's work managed to escape Franco's censorship. One of her hypotheses is based on this fundamental evidence: in *Mi querida señorita*, the priest, the doctor, the banker, and the maid do not express any astonishment at the transformation of Adela into Juan. Darío Sánchez González speaks to the potential of Vilar's film *A esmorga* for developing an assemblage of audiences attuned to nationalist Galician politics, and advocates for LGBTQ issues. His analysis first takes into account the original text that *A esmorga* is based on. The second section of his chapter studies the plot changes that tighten the connections between *A esmorga*'s treatment of queer practices, and its memory of Francoist repression. A third section analyzes visual tropes in Vilar's film, after which Sánchez González examines the evolution of the characters toward their inevitable demise. Finally, he considers the role that *A esmorga*'s queer practices could have in solidifying a link between social danger and marginalization during the Franco regime. For Ibon Izurieta, *Ander* (2009) is a film visually, thematically, and, in its totality, unmistakably Basque. In *Ander*, the performative construction of Basqueness is coupled with the performative representation of masculinity and homosexuality. The übermacho personality, Izurieta argues, is constructed by the oversexualization of tyrannical and despotic acts that exploit and denigrate a woman in particular, but also all women generally, in the multiple abusive references.

In "Queer Catalonia: Destroying Essential Representations," part IV of our volume, scholars interpret, respectively, Ventura Pons's *Amic/Amat* (1998) [*Beloved/Friend*] and *Forasters* (2008) [*Strangers*]; Marta Balletbò-Coll's *Sévigné (Júlia Berkowitz)* (2004); and Agustí Villaronga's *Pa negre* (2010) [*Black Bread*]. Joan Ramon Resina's essay analyzes the theme of social decadence and renewal in two films by Ventura Pons. In both, the Catalan director confronts the difficulty of cultural transmission in the absence of the appropriate organic conditions. In *Amic/Amat*, biological adversity posits the need to seduce an ad

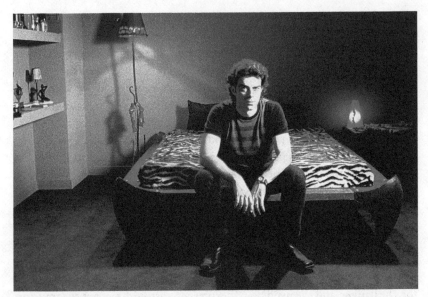

FIG. I.1 David Selvas. *Amic/Amat* (1999) by Ventura Pons. Courtesy of Ventura Pons.

hoc heir, a young "barbarian" capable of replenishing a dying culture's vitality. In *Forasters*, this problem, considered from the viewpoint of a society ruled by Epicurean values in the previous film, is examined in terms of hybridization and dialectical synthesis between immigration and autochthony. History ceases to be a linear movement toward liberation and moves in cycles. From inside these cycles, identity emerges as an effect of the repetition of destinies that, on occasion, become conscious of their doubling and transcend the tragedy of individuality. María Teresa Vera-Rojas focuses on the importance of intertextuality and autoreferentiality in Marta Balletbò-Coll's cinema. This essay studies the filmic devices used to depict both lesbian subjectivity and sexual tension. Vera-Rojas understands such tension as the obstacles that that subjectivity faces while trying to realize its erotic desires. She pays special attention to Balletbò-Coll's third film, *Sévigné (Júlia Berkowitz)*, and to its intertextual relation with the letters written by Mme de Sévigné to her daughter. By foregrounding the intertextuality between Mme de Sévigné and Júlia, Balletbò-Coll seeks to question the subject of the mother-daughter bond as a trope for lesbian desire. This allows for a different depiction of lesbian desire, which intentionally tries to find new languages and means in order to represent its unknowability. For William Viestenz, *Pa negre* shows the Francoist regime's gendered and nationalist rendering of the Spanish political body, which operates according to a paradigm of immunity. His analysis references major revisions and expansions to Michel Foucault's notion of biopolitics by thinkers including Giorgio Agamben, Achille Mbembe, and Roberto Esposito. Also, Viestenz argues that containing

the pathological involves not only physical separation but also the mythologization of the victims of collective violence. The film gestures toward the contemporary effects of what critics have called "queer necropolitics." Moreover, *Pa negre* makes it possible to critique a proposal such as the 2006 Gender Identity Act, passed before the film's release and revised by the Spanish government a decade later.

Reacting against the statism that dominates the fields of politics and gender, the four Catalan directors who are studied here insist on a fluid identity for their nation. In *Amic/Amat* there exists a dynamic of discovering one's own identity. That dynamic arises from a triangle between generations (that of Ramon Llull, the medievalist professor, and the professor's promising student). This same triangle re-enacts a spiritual inheritance within different historical contexts. *Forasters* not only reveals the tension inherent in the relationship between natives and the foreigners (Andalusian and Moroccan) seeking their hospitality but also shows that foreigners in Catalonia are prepared, however reluctantly, to inhabit the culture that receives them in its vital historical spaces. For example, Pons preferentially locates the film's plot in a building in Barcelona at the end of the nineteenth century. According to Resina, in *Forasters*, "Societal renovation is alluded to with the periodic insertion of characters who represent archaic peoples from the viewpoint of the old, exhausted culture." And on the essentialisms of gender, Vera-Rojas asserts that *Sevigné (Júlia Berkowitz)* serves the central objective of "problematizing the meaning of lesbian visibility as well as the cultural images and stereotypes that have normalized and naturalized lesbian sexuality, especially in the Spanish cultural context." The last film of part IV, *Pa negre*, demonstrates the terrible inertia rooted in the political essentialism employed by the conquerors (Falangists). According to Viestenz, the inertia that encompasses the politics of the winners over the losers (supporters of the Second Republic) applies even to dead bodies and is utilized in the claims of culpability against those who caused the deaths of those bodies. Moreover, the four films reject the idea of fixed representations of the genders and of the political conditions in Catalonia. Pons, Balletbò-Coll, and Villaronga force the Spanish language to forgo cultural privilege by displacing its monopoly over a certain type of existential sensibility. Along with Catalan, French, and English, Castilian Spanish shares the public and private spaces.

Part V, "Burning Counterpoints with Religiosity," addresses complex tensions regarding queerness and Catholicism in the Iberian Peninsula. *O ornitólogo* (2016) [*The Ornithologist*], by João Pedro Rodrigues; *A raíz do coração* (2000) [*The Heart's Root*], by Paulo Rocha; and *Entre tinieblas* (1983) [*Dark Habits*], by Pedro Almodóvar, give scholars the opportunity to expose underground clashes between the religious and the queer. According to Kelly Moore, *O ornitólogo* can be read as an elegy to an AIDS victim, through the lenses of a queer hagiography. In a series of surreal encounters with mythological echoes,

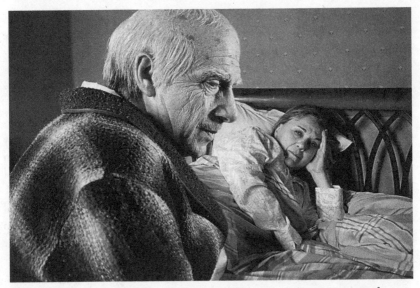

FIG. I.2 Joan Pera and Anna Lizaran. *Forasters* (2008) by Ventura Pons. Courtesy of Ventura Pons.

the camera lets the audience perceive the ornithologist's transformation into various characters. To visualize fragmentation and the main character's subsequent reassembly, Rodrigues harnesses the grammar of cinema—the syncopic and paratactic process of film editing—to theorize the filmic cuts as instances of eroticized violence, a rupture that constitutes a mystical union. Spectators are thus invited to ponder the film's play with visual ruptures in the protagonist's identity. Moore explores the film's own metaphors of filmmaking and their affirmation of the sacred effects of montage. Through a critical engagement with Georges Bataille's *Erotism: Death and Sensuality* and Walter Benjamin's notion of the dialectical image, she offers close readings of landscape and montage to argue that the film is not a representation of a mystical transformation. Rather, Rodrigues would posit the film itself, its very creation, as a vehicle for the director's own transcendence. In *A raíz do coração* (2000), Portuguese filmmaker Paulo Rocha returns to the city of Lisbon thirty-seven years after *Os verdes anos* (1963) [*The Green Years*], his seminal work on the social struggles of the working class in the capital during Salazar's dictatorship. In *A raíz do coração*, Rocha makes Lisbon the central character of a "dramatic fantasy" with musical moments, an urban fable set in a very near future. The "enclosed city" of *Os verdes anos* gives place to a modern Lisbon, an open city facing the future yet still proud of its traditions and monumental historic spaces. Rocha reflects on Portuguese politics by using the clash between two antagonistic groups—a colorful group of drag queens versus an oppressive militia patrolling the streets of Lisbon—during the political campaign of a far-right

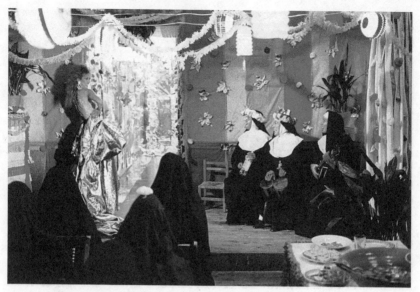

FIG. I.3 Cristina Sánchez Pascual, Chus Lampreave, Carmen Maura, and Marisa Paredes. *Entre tinieblas* (1983) by Pedro Almodóvar. Courtesy of El Deseo, S.A.

candidate (Catão) running for mayor of the city. At the same time, the traditional *Festas de Santo António* inundate the city. But Catão also harbors a secret desire for a young transgender woman named Sílvia. Rui Trindade Oliveira's essay looks at how Rocha explores the city of Lisbon and how he situates his characters, queer and nonqueer, in a city that is in constant change. Andrés Lema-Hincapié argues that in the 1983 film *Entre tinieblas*, Pedro Almodóvar's antireligious stance does not take on the form of bitter insult, scathing criticism, or destructive desires against Catholicism. Consequently, religion would not necessarily deform the human spirit. In *Entre tinieblas*, there is criticism, but instead of promoting monastic lesbianism through a film of "nunsploitation," or repudiating Catholic articles of faith, Almodóvar would favor going deeper and praising some virtues of Catholic Christianity—through indirect and unexpected pathways. Unlike in earlier and later films, in *Entre tinieblas* Almodóvar would be less an apostate heretic than a heretic longing for religious reforms.

The movies analyzed here do not aim at "pacifying" viewers. Rather, they make viewers uncomfortable and critically call on them to remember that there are other people *out there* who desire in a different way. Hence, many human desires have been overshadowed by very subtle mechanisms of the macro- and microphysics of power. On the Iberian Peninsula, queer cinema compels the spectator to acknowledge the illusion of that overshadowing, while speaking out publicly to assert that the illusion is humanly unfair—not only because it

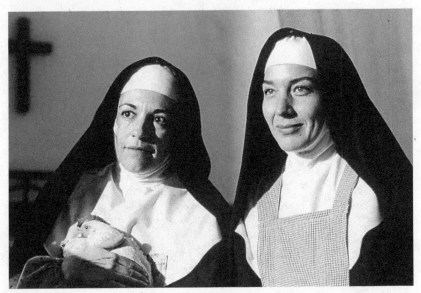

FIG. I.4 Carmen Maura and Marisa Paredes. *Entre tinieblas* (1983) by Pedro Almodóvar. Courtesy of El Deseo, S.A.

destroys individual lives but also because it existentially impoverishes public spaces in general.

Now comes a final and necessary caveat. It is inevitable that, as is the fate of any anthology, the selection of some titles implies that we have not considered others. This situation is already unambiguously expressed by the word "anthology": it is a matter of choosing while separating (λόγος) a limited number of flowers (ἄνθη). Like any anthology, this one has its weaknesses. And we acknowledge this, limiting ourselves to the words of Jorge Luis Borges about compiling anthologies. In the preface to his *Antología poética argentina* (1941), Borges wrote these resolute words about every anthologist's enterprise: "There isn't a book as vulnerable as an anthology of contemporary local works. The tormented anthologist vainly insists on simulating erudition that borders on omniscience, that is, an impartiality untouched by the temptations of custom, passion, boredom, a shrewdness foreshadowing the Final Judgment."[18]

And yet . . . Despite that inevitable fate of all anthologies, thank you, the reader, in advance for your interest in *Indiscreet Fantasies: Iberian Queer Cinema*.

Notes

1 It is quite possible that even compared with Almodóvar, Luis Buñuel is still the most studied Spanish filmmaker. For this reason, we have not included in this

volume a scholarly essay devoted to a specific film by Buñuel. The interested reader can consult *Queering Buñuel: Sexual Dissidence and Psychoanalysis in His Mexican and Spanish Cinema* (New York: Tauris Academic Studies, 2008) by Julián Daniel Gutiérrez-Albilla, as well as specialized articles and critical reviews, including Carlos Jerez-Farrán's "Una lectura 'perversa' del *Ensayo de un crimen: La vida criminal de Archibaldo de la Cruz* de Luis Buñuel" (*Chasqui* 43, no. 2 [2014]: 179–191) and Robert Stam's "Hitchcock and Buñuel: Desire and the Law" (*Studies in the Literary Imagination* 16, n. 1 [1983]: 7–27).

2 Debra Shaw, ed., *Contemporary Latin American Cinema: Breaking into the Global Market* (Lanham, MD: Rowman and Littlefield, 2007), 5.

3 Chris Perriam, *Spanish Queer Cinema* (Edinburgh: Edinburgh University Press, 2013), 7.

4 Lawrence Durrell, *Quinx: Or, the Ripper's Tale*, vol. 5 (London: Faber and Faber, 1985), 14.

5 Jim Charleston, dir., *X-Files*: "Teliko," Season 4, Episode 3, October 18, 1996.

6 Eduardo Galeano, *Open Veins of Latin America: Five Centuries of the Pillage of a Continent*, trans. Cedric Belfrage (New York: Monthly Review Press, 1997), 226.

7 David M. Halperin, *One Hundred Years of Homosexuality and Other Essays* (New York: Routledge, 1990), 52.

8 Halperin, 53.

9 Noam Chomsky, *Media Control: The Spectacular Achievements of Propaganda* (New York: Seven Stories, 2002), 40.

10 Marguerite Yourcenar, *Con los ojos abiertos: Entrevistas con Matthieu Galey*, trans. Elena Berni (Buenos Aires: Emecé, 1982), 15.

11 For example, at Oregon State University, "LGBTQQIA" stands for "Lesbian Gay Bisexual Transgender Queer Questioning Intersex and Allies but also includes Same Gender Loving, Two Spirit, Asexual, Pansexual, and Poly-Amorous" (Oregon State University, Office of LGBT Outreach and Services, https://dce .oregonstate.edu/pc/resources/frequently-asked-questions/lgbtqqia-resources).

12 Judith Butler, "Gendering the Body: Beauvoir's Philosophical Contribution," in *Women, Knowledge, and Reality: Explorations in Feminist Philosophy*, ed. Ann Garry and Marilyn Pearsall (Boston: Unwin Hyman, 1989), 259.

13 Michel Foucault, *Surveiller et punir: Naissance de la prison* (Paris: Gallimard, 1975), 223.

14 In dating the films referred to in this book, we follow the dates provided by the Internet Movie Database (IMDb). We believe, however, that the date of a film should be taken from the final credits in the film. Moreover, when the IMDb provides an English translation for a film title, we include that title in brackets and italics. If the IMDb does not offer an English translation of a film title, we do not include that title in English.

15 Durrell, *Quinx*, 31.

16 David Norman Rodowick, *The Crisis of Political Modernism: Criticism and Ideology in Contemporary Film Theory* (Urbana: University of Illinois Press, 1988), 53.

17 The exception is Joan Ramon Resina's essay, which contrasts two films by Catalan director Ventura Pons.

18 Jorge Luis Borges, Adolfo Bioy Casare, and Silvina Ocampo, eds., *Antología poética argentina* (Buenos Aires: Sudamericana, 1941), 7.

Part I

**Into the Realm
of Sexual Provocations**

• •

1

The Queer Gothic Regime of Narciso Ibáñez Serrador's *La residencia* (1969)

• • • • • • • • • • • • • • • • • • • •

ANN DAVIES

Gothic texts have a long and strong association with queer. As William Hughes and Andrew Smith observe: "Gothic has, in a sense, always been queer. The genre, until comparatively recently, has been characteristically perceived in criticism as being poised astride the uneasy cultural boundary that separates the acceptable and familiar from the troubling and different." They go on to note that "Gothic historically appears to lack the commitment to absolute definitions of identity and substance that arguably characterise . . . mainstream literatures."[1] Paulina Palmer, for her part, claims that "the spectre and phantom, key signifiers of the uncanny, carry connotations of 'excess' since their appearance exceeds the material, and this is another concept that connects the uncanny with 'queer.'"[2] Harry Benshoff, writing on queer as a theoretical concept in horror, argues: "Queer can be a narrative moment, or a performance or a stance which negates the oppressive binarisms of the dominant hegemony . . . both within culture at large, and within texts of horror and fantasy. It is somewhat analogous to the moment of hesitation that demarcates Todorov's Fantastic, or Freud's theorization of the Uncanny: queerness disrupts narrative equilibrium

and sets in motion a questioning of the status quo, and in many cases within fantastic literature, the nature of reality itself."[3]

Now, *all* narrative deals with the disruption of the status quo that Benshoff posits, and this disruption, whether it be through difficulties over boundaries and demarcation, the denial of binaries, or the possibilities of excess, may result in queerness in the sense of "simply" rendering strange, but it does not automatically entail queer in its more specific connection to sexual preferences, identities, and behaviors. Yet it is this second sense that the critics just mentioned are primarily employing in their definitions of queer Gothic and horror, even as the term "queer" itself proves too slippery to be finally pinned down in this way. Drawing us closer to the specific reasons that horror and Gothic possess such a strong association with queer, Dale Townshend observes that the Gothic—perhaps more than most genres, we might say—offers an explicit challenge to notions of patriarchy on which the status quo appears to rest, by showing patriarchy as corrupt to its core, offering a very particular frisson of fear and pleasure at the disturbance of such a cultural bedrock: "There exists at the limit of law and the paternal metaphor in Gothic writing the phantasm of queer perversion that resists the prohibitive, heteronormalising gestures of the paternal metaphor even as it is defined in relation to them."[4] On the other hand, there may not be a need to dig too deep in order to understand a strong association between queer and the Gothic, given that both have been and to some extent still are treated as entities running contrary to good taste and civilized values. As Hughes and Smith acknowledge, "To condemn Gothic for its perceived 'bad taste' is, in essence, to condemn it for acknowledging those very alternatives to monolithic orthodoxy. The endurance of 'taste' will always be compromised by the presence of 'bad taste.' To be queer in Gothic terms is, in a sense, to know both."[5]

Gothic has long had a taint imposed on it arising from its appeal to so-called baser thrills and pleasures, those of sex and violence laced with an ironically comfortable fear, in that a reader or viewer always has the option to retreat to an apparently safer world. Its worrying link to popular culture is made still worse by the "low" emotions it presumes to invoke. It becomes both popular and clandestine in consequence, and its operation at the margins of good taste and good art clearly resonates with the queer identities, behaviors, and preferences that themselves were forced to remain veiled for so long.

A queer Gothic reading of Narciso "Chicho" Ibáñez Serrador's *La residencia* (1969) [*The House That Screamed*] draws on all the conceptualizations of queer Gothic just outlined. *La residencia* is a Gothic horror film that did remarkably well when it was released in late Francoist Spain and which has done well since. The database of the Spanish government's Ministerio de Cultura reveals that the film has had nearly 3 million viewers since its release. Only two Spanish horror/fantasy films have outsold it, Alejandro Amenábar's *The Others*

Table 1.1

Viewing figures for selected horror and fantasy films

Title	Number of Viewers
The Others	6,233,389
El orfanato [*The Orphanage*]	4,419,880
La residencia	2,924,805
El laberinto del fauno [*Pan's Labyrinth*]	1,681,027
[REC]	1,426,688
El día de la bestia [*The Day of the Beast*]	1,416,712
Tesis [*Thesis*]	854,735
El espinazo del diablo [*The Devil's Backbone*]	705,290

SOURCE: Víctor Matellano, *Spanish Horror* (Madrid: Ayuntamiento de Talamanca de Jarama, 2009), 110–111.

(2001) and J. A. Bayona's *El orfanato* (2007) [*The Orphanage*]. It is notable, indeed, how many horror and fantasy films, now canonized and/or the object of sustained critical attention, have gained fewer viewers than *La residencia* (selected figures are presented in table 1.1).

That *La residencia* has attracted nearly double the number of viewers as Guillermo del Toro's *El laberinto del fauno* (2006) [*Pan's Labyrinth*] is particularly noteworthy given that the latter became very much an event film from an internationally known director, as well as the subject of much critical attention from both film critics and academics. The neglect of *La residencia* is, however, hardly surprising, though Ibáñez Serrador's cult status in Spain then and now, as mastermind and quirky presenter of the popular TV series *Historias para no dormir*, suggests that it is not the result of a director's low profile. The general lack of critical interest in such a successful film, however, merely echoes the critical disdain for the film within Spain as outlined by Antonio Lázaro-Reboll,[6] one of the few scholars to pay *La residencia* any detailed critical attention. Most critics of the time did not find horror artistic enough to warrant critical respect, seeing it as by and large a formulaic vehicle in bad taste, in which Ibáñez Serrador shows no aptitude for the auteurism, the personal vision of the world, that was a crucial attribute for film critics at the time the film was released. For more recent critics who specialize in the horror genre, the place of *La residencia* in the history of Spanish horror is now assured. For Carlos Aguilar, this film and *La noche de Walpurgis* (León Klimovsky, 1971) [*The Werewolf versus the Vampire Woman*] form the two key successes that impelled a new surge in horror filmmaking in the last days of the Francisco Franco dictatorship,[7] and *La residencia* duly features in histories of Spanish horror. More general histories of Spanish cinema do not, however, recognize this. The classic volume on Spanish cinema history by Román Gubern et al. does

not mention the film or its director, nor does Vicente J. Benet's recent histori-
cal overview. José María Caparrós Lera namechecks the film in his statistical
appendixes but does not treat it as part of his main history. Anglophone equiv-
alents such as Alberto Mira, Núria Triana-Toribio, or Marsha Kinder do not
mention the film or director either, even though the latter's emphasis on vio-
lence, sexual repression, and subversion could well have found room for such a
film. The reasons for exclusion are not hard to find in the awkward chronologi-
cal placing of the film at the tail end of the Franco era, when subversion of
cultural ideologies emphasized realism and seem far removed from horror for-
mulas; the high valuation given to such filmmakers as Amenábar and Bayona
was never a possibility at the time of *La residencia*'s release, despite Ibáñez Ser-
rador's use of what were high-quality production values in that era.

Nonetheless, subversive *La residencia* is, in many ways, despite its critical
neglect, and much of this derives from the fact that it deals with motifs and
concepts of lesbianism and queerness. Alejandro Melero, in his survey of gay
and lesbian representation in Francoist film, notes a significant convergence
between the explicit (for the time) representation of the lesbian on the Span-
ish screen and the surge in popular horror filmmaking of which *La residencia*
formed a crucial part: "The discreet presence of the lesbian in cinema prior to
the 70s parallels horror's lack of popularity as a film genre and confirms the
extreme link between lesbianism and horror. To put it another way: in cinema,
lesbians ceased to be an exception when, at the end of the 60s, horror ceased to
be exceptional as well."[8]

We can observe from this that *La residencia* forms an integral part of alter-
native cinema histories but not of mainstream ones. As Hughes and Smith com-
mented earlier in regard to queer Gothic, *La residencia* is condemned as in
bad taste precisely because it demonstrates the possibility of alternative cinema
histories that nonetheless do not chime with the good-taste canon derived from
the political auteurism lauded by the Spanish critics of the time and to some
extent enshrined in mainstream histories since.

The plot of *La residencia* is based around a boarding school for young ladies
with a shady or tainted background, presided over by Madame Fourneau (Lilli
Palmer): the girls' school is, as Benshoff notes, a familiar motif of lesbianism,[9]
which would allow for easy assumptions of the formulaic on the part of skep-
tical critics. Into this school arrives the ingenue Teresa (Cristina Galbó), accom-
panied by a middle-aged man who declares himself to be a friend of her
mother, a cabaret singer. He is probably her father but may perhaps be
her mother's new lover, eager to be rid of the encumbrance of the daughter.
From the very beginning, Teresa observes strange sounds and movements that
suggest something mysterious and sinister is going on in the house. Madame
Fourneau affects not to notice anything wrong but later accuses her own son Luis
(John Moulder Brown) of roaming too freely around the school and risking

contamination through encounters with the dubious young women under her charge: she wants him to save himself for a woman just like herself, his mother. She appears to be too late on that score: Luis has already arranged an assignation with another student, Isabel (Maribel Martín), whose throat is cut by an off-screen assailant as she waits for Luis to arrive. Meanwhile, Teresa is settling into a school where the atmosphere is charged with undercurrents of rebellion, cruelty, and clandestine sexuality. The insubordinate Catalina (Pauline Challenor) suffers repeated punishment yet continues to rebel; the young women draw lots to have sexual assignations with the woodman; and Luis spies on the women in the showers. Most disturbing to Teresa, however, is the unwanted attention she receives from Irene (Mary Maude), Madame Fourneau's student lieutenant, in the form of lascivious looks and sexually tinged torment. Teresa decides to flee the house, but she in her turn is murdered. Irene realizes that something has happened to Teresa and confronts Madame Fourneau with the fact of Teresa's disappearance: their partnership is breached as a result of the ensuing quarrel. Later, Madame Fourneau goes looking for Irene, only to find her body slumped in the attic. She then discovers that Luis has been killing the missing girls and cutting them up in the attic to form the perfect woman his mother wanted. The film ends as Luis shuts his horrified mother in the attic along with his corpse bride.

The lesbian overtones of the film were recognized at the time of its release, and arguably were even celebrated by the publicity campaign, partly through design and partly through happy coincidence. Lázaro-Reboll analyzes the publicity in the *Heraldo de Aragón*.[10] The film poster for *La residencia* depicts the back view of a naked woman surrounded by menacing female silhouettes, "well conveying the idea of enclosure and claustrophobia" that coincides with the Gothic but also the lesbian horror possibilities embedded in the motif of the boarding school. Next to that is an ad for Jess Franco's *99 Mujeres* that deals with women in prison, a possibly serendipitous juxtaposition. As Lázaro-Reboll observes: "The sexual suggestiveness conveyed in the advertisements—the spectacle of the female body and, more specifically, the display of female sexuality— must in turn be related to the commercial exploitation of female sexuality (sexploitation) that followed the relaxation of censorship during the late 1960s. . . . The hints of lesbianism at play within *La residencia*'s poster, and in the advertising of Franco's *99 mujeres*, are just two examples of advertising campaigns which resort to the same representational codes."[11]

The use of such representational codes also suggests that Francoist audiences had ready access to the meaning of such codes despite the hitherto prevailing climate of sexual repression, or at the very least that it caught up rapidly once censorship was relaxed. What actual and varying pleasures audiences might have drawn from such codes are likely beyond discovery now, though they would have appealed both to gay audiences and to heterosexual audiences who

liked the titillation of girl-on-girl action. However, Ibáñez Serrador's previous success with the TV series *Historias para no dormir* (1966–1968) would also have been a factor, attracting audiences to *La residencia*, his first feature film. Elsewhere, Lázaro-Reboll argues that "the director's work legitimated a popular taste in horror which was formative for generations of Spanish television audiences,"[12] and which might also have complicated reception in terms of sexual preference: it seems that, after all, a certain style of auteurism would pertain even in late-Francoist horror. Ibáñez Serrador's reputation did not embrace the queer specifically, but, as Lázaro-Reboll also observes,[13] audiences were familiar with his reputation as an innovator. Ibáñez Serrador himself noted of the film: "I know that, because they think my TV programs are a bit out of the ordinary, many would expect to find in *La residencia* new forms, a lack of conformity, breaking the old moulds.... I'm sorry to disappoint them: there's nothing like that in my film. My idea was that, for the length of its three thousand or so meters, the audience would forget there was a director behind the camera. I wanted to narrate the theme in the proper, even classic, style, in the pejorative sense that is used nowadays to talk about classic style in film."[14]

The claim that the film has a "classic" style that contrasts with his earlier TV success ironically becomes a refusal to conform to his avowed lack of conformity. Yet audiences would in any case have been aware of Ibáñez Serrador's declaration of classicism: as his interviewer Torres observes, this information was included on the handout that accompanied the release of the film. From the outset, then, Ibáñez Serrador "queers" the reception of his film in a mise en abyme in which there is no sure critical ground. Good and bad taste become indistinguishable and, as Benshoff observed, a moment of hesitation and unbalance occurs in which audiences cannot be quite sure where to place the film, even if the critics thought they knew.

It is possible to read the boarding school and/or the house that contains it in terms of Francoist history, as Lázaro-Reboll briefly suggests.[15] Madame Fourneau is an oppressive authority figure who sanctions violence, who countenances sexual corruption so long as her authority is not endangered, and who runs an enclosed society in which dangerous moral influences are not permitted to intrude. Such an enclosed, oppressed, and frustrated community readily brings to mind the stifling right-wing, Catholic morality that Franco aimed to impose. By 1969, however, Franco was an old man increasingly out of touch with the ways in which Spanish society was catching up with capitalist European countries and thus sliding further and further out of his grasp, just as Madame Fourneau is increasingly seen to have lost control of the school she governs. Bernard Bentley proposes such a reading, describing the film as "a very successful blend of Jack the Ripper and Frankenstein, from which a parallel can be established between the house and a closeted Spanish society about to explode if safety valves were not allowed."[16]

However, we should be wary of too reductive a reading, as *La residencia*'s own queer regime strongly indicates. Reading the Franco regime itself as queer through the symbolism of the lesbian violence of Madame Fourneau and the cruelty of Irene might prove satisfying for any heterosexual men who despised the regime, allowing them to indulge in the voyeurism of lesbian sexuality while simultaneously viewing Franco's regime as symbolically emasculated. Yet the potential subversion, at least, has by and large not been lauded, even though the auteurist project valued by the original film critics revolved to a great extent around New Spanish Cinema and its oppositional quality. From a right-wing, Francoist perspective, sexual titillation can still be indulged in while using the presence of lesbianism as a mechanism for displacement of Madame Fourneau's final failure away from oppressive political regimes onto corrupt sexual practices. Neither of these hypothetical viewing positions, moreover, takes account of the varied viewing positions that might be taken up by women and/or anyone identifying as LGBTQ: nor do they necessarily exclude pleasure, not only in the lesbianism or the film's queer regime more widely, but also the possibility of pleasure in the sadism it offers. In addition, Nicholas G. Schlegel suggests that the fact that Luis is the murderer also complicates matters: "The film operates under the principle that rebellion against entrenched authority can lead to punishment and death, clearly a fear that all Spaniards knew; however, in what was a politically diffusing and clever move, the film's climax reveals that Madame Fourneau's son, Luis, is the killer. Present is the suggestion that a controlling, overprotective mother and the repressive environment of her school have severely warped Luis, but it is far enough removed to attenuate any political connections or commentary, at least at that time."[17]

Of course, it is possible to argue that the taint of perverse sexuality, embodied by *La residencia*'s queer regime, has come to infect all manifestations of sexuality in a way that parallels the decadent influence of Francoism that permeated all corners of Spanish society, including those hostile to Franco. However, the slippages of sexuality that I will discuss in more detail later ensure that neat parallels with Francoism cannot easily be made.

The link to Francoism is further destabilized by the fuzziness of placing that the film implies. Although it was actually filmed in Spain, the action is ostensibly set in France, a common move to displace any association of Spain with the vulgarities of horror. The cast was international: Cristina Galbó and Maribel Martín were Spanish, but Lilli Palmer was German, John Moulder Brown and Pauline Challoner were British, and Cándida Losada, who plays another staff member at the school, was Argentine. The film was the first Spanish film to be shot in English (thus pioneering a trend that would be picked up later by horror and fantasy filmmakers such as Amenábar and Balagueró), and was made with an eye to the international market.[18] Unfortunately it failed to make any impression abroad even as it was highly successful in Spain, but an

English-language version of the film is still available, and YouTube clips are as likely to be in English as Spanish. (The English-language title varies between *The House That Screamed*, *The Finishing School*, and *House of Evil*). The Spanish version of the film is clearly dubbed, but dubbing is also clear in the English version, implying that the film has no natural language of its own.

The use of generic conventions similarly acts to displace this queer household from Spain, and we should remember in this regard the director's insistence on making what he called a "classic" film rather than resort to the quirkiness familiar to viewers of *Historias para no dormir*. The look of the film pointed away from Spain: Sara Torres claims, "The whole film has a deliberately remote, foreign feel, nothing authentically Spanish: you would say that the film was set anywhere in Europe except Spain."[19] José A. Luque Carreras claims *La residencia* as part of a noir tradition rather than a horror or Gothic one, noir itself offering slippage away from fixed locations (an image from the film—Mary Maude with whip raised to punish a victim while Lilli Palmer watches—adorns the cover of Luque Carreras's book). Despite his emphasis on noir, however, Luque Carreras draws on horror and Gothic referents as influences on *La residencia*, referring to "the spooky settings which Hammer created from Poe's stories."[20] Lázaro-Reboll, for his part, stresses the film's high production values (one of the things that annoyed some of the critics, who objected to Spanish money being squandered on a lowbrow project): such values suggested more "respectable," international, horror films.[21] The result was that "the consensus among audiences was that *La residencia* looked nothing like a Spanish film, breaking stylistically and qualitatively with cinematic forms of the period; however, its critical consignment to the category of generic or sub-generic cinema effectively quashed the opportunity of developing a 'new Spanish cinema' with popular appeal."[22]

The house in particular functions as a classic generic haunted house even if, ultimately, no ghosts prove to be present and the monster is revealed to be all too human. Palmer observes that the haunted house is "admirably suited to queer treatment since several classic Gothic texts constructed around it refer either explicitly or covertly to homoerotic themes and involvements." She mentions Shirley Jackson's *Haunting of Hill House* (1959), Henry James's *Turn of the Screw* (1898), and Daphne du Maurier's *Rebecca* (1938) as examples of "the disturbing effect that same-sex desire can have on the hetero-patriarchal household."[23] The latter examples suggest *La residencia* as part of a wider, and particularly Anglophone, tradition of the haunted house that is also invoked by other, Anglophone films. Lázaro-Reboll mentions *The Innocents* (Jack Clayton, 1961, an adaptation of James) and *The Haunting* (Robert Wise, 1963, an adaptation of Jackson) as examples, both of which are also haunted-house narratives.[24] Luque Carreras cites not only *The Innocents* and *Rebecca* (this time the film [Alfred Hitchcock, 1940]) but also *Psycho* (Alfred Hitchcock, 1960),

another haunted-house narrative.[25] The house of *La residencia* might appear to belie Palmer's reference to the hetero-patriarchal household, given its queer regime revolving around lesbian desire, a regime I shall now analyze in more detail. The regime is nominally controlled by Madame Fourneau and Irene, one of the students. However, it oscillates around implicit markers of Palmer's hetero-patriarchy, co-opting some of the latter's points of view even as patriarchy is destabilized in the process.

Madame Fourneau shows signs of both lesbian and heterosexual desire, and is thus perhaps the queerest of all the characters. Her heterosexuality is indicated by the existence of her son, though her relationship with him appears too intense to be healthy: her repeated insistence on his need to wait for the perfect woman, coupled with her kisses, hint at possible incest. It is in itself queer excess, leading to his uncanny movement around the house, and to the uncanny and excessive replica of his mother. The result is Luis's corpse bride made out of body parts, and it is significant that Luis shuts his mother away in the attic with the body at the end of the film. This gesture can be read in many ways, such as the Gothic imprisonment of women, an equation of the mother with the corpse, or the final failure of keeping heterosexuality separate and pure from the queer atmosphere pervading the house. But it could equally be seen as Madame Fourneau's punishment for her own lesbian tendencies, presiding over a regime where lesbianism and queerness is allowed to flourish. Madame Fourneau's gestures toward lesbian sexuality come firstly with her sanction and witnessing of the whipping of Catalina. She looks on with equanimity as Irene's sidekicks rip the clothes from Catalina's back. After halting Irene in her whipping frenzy, she bathes Catalina's wounds with a tenderness surprising for a woman who rules her roost with the hand of a martinet.

Schlegel observes a particularly queer parallel between Madame Fourneau and her son, as Luis spies on the women in the showers: "He not only gains pleasure from looking, but also compounds his desire intake by observing his mother *also* taking pleasure in looking." Schlegel goes on to note that Madame Fourneau appreciates not only her students but also their scars, the result of Irene's whippings.[26] The parallel clearly points to Madame Fourneau's assumption of a male gaze, and also to Hughes and Smith's refusal of absolute definitions of identity that typifies the queer nature of Gothic itself. This parallel is pushed further in the sequence where, having summoned Irene to her office after their rift, Madame Fourneau pursues her up to the attic. The sequence is preceded by the headmistress's frequent glances of regret and longing toward Irene after the quarrel. Madame Fourneau's pursuit of Irene appears to arise from a lesbian desire in its most predatory form that nonetheless echoes the similar predatory Gothic chase of the powerful man after the frightened and innocent woman (and there is no doubt of Irene's fear in this sequence). Yet this chase also positions Madame Fourneau as a form of Gothic heroine

seeking to uncover the secrets of patriarchal corruption, a concept that I elaborate in more detail later. This triple positioning ironically serves to leave Madame Fourneau in no fixed position, in another refusal of absolute definitions of identity.

Irene, Madame Fourneau's lieutenant, is herself in a liminal situation, given authority over the other students but nonetheless a student herself. Irene's lesbian desire is marked out as cruel and lascivious, in particular as regards the enthusiasm with which she whips the rebellious Catalina: Madame Fourneau has to yell at her to stop. The knowing sadism is developed more fully in her relationship with Teresa. Her lascivious gaze at Teresa while eating an apple or later while brushing her hair combines with her cruelty in forcing Teresa to act out her mother's role as a cabaret singer. It is this act of cruelty that impels Teresa to run away from the house and, as it happens, to her death. As Madame Fourneau's sidekick and spy, Irene serves as an object of displacement for Madame Fourneau's own queer tendencies; together the two women appear to have established a regime of queer oppression in which both use their authority to indulge their queer desires. However, Ibáñez Serrador sets up such a structure only to subvert it through collusion with a secretive heterosexuality. It is notable that Irene uses her own authority to undermine Madame Fourneau's, since it is Irene who masterminds the lottery whereby the girls spend time with the woodman: there is deep irony in such a queer character allowing heterosexual indulgence. Far from simply substituting a lesbian regime for a patriarchal one, Irene, like Madame Fourneau herself, ensures a de facto regime of polymorphous perversity, in that all subversive forms of sexual preference and activity are allowed, facilitated, and repressed. As George Haggerty observes: "Terror is almost always sexual terror, and fear, and flight, and incarceration, and escape are almost always colored by the exoticism of transgressive sexual aggression ... gothic fiction is not about homo- or heterodesire as much as it is about the fact of desire itself. And throughout these works this desire is expressed as the exercise of ... power. But that power is itself charged with a sexual force—a sexuality—that determines the action and gives it shape. By the same token, powerlessness has a similar valence and performs a similar function."[27]

Thus the house of *La residencia* encompasses a highly desiring community in a highly charged sexual atmosphere; but, as Haggerty says, the fact of desiring, rather than the form of the desire, is what drives events within the house. The terror and imprisonment of the school, but also the efforts to escape or resist it, all possess a transgressive sexuality. Irene comes to represent all these positions while being the character most strongly and explicitly marked as sexually transgressive (even with the sanction of Madame Fourneau).

But it is also noteworthy that Irene, deprived of her queer playmate/victim after Teresa's death, starts to investigate what is going on in the house, in the tradition of the Gothic heroine. Ibáñez Serrador originally positions Teresa

herself as the Gothic heroine, innocent and unprotected, who is curious about what exactly is happening in the house in which she is imprisoned and decides to investigate. As I argue elsewhere,[28] Teresa knows from the moment she sets foot in the school that some menacing secret lurks within the house, and she seeks to uncover it. However, any Gothic expectations we might have that Teresa can follow through her investigation are thwarted by her murder half-way through the film. This jolt to expectations is reinforced as Irene takes over the investigation (which will lead in turn to her own death). Irene's assumption of the role of Gothic heroine is in one sense highly ironic, as she is far from innocent or unprotected. Yet, her new role marks out the limits of her complicity with Madame Fourneau; indeed, she argues with her about the disappearance of some of the students, suggesting her refusal to accept how Madame Fourneau is running their regime. In addition, Irene also appears to take up a distorted form of the young hero seeking to rescue the Gothic hero-ine, the distortion arising from the fact that such heroes are traditionally pure and noble. Irene's own tortured and torturing desire is what drives her to find out what happened to Teresa: Ibáñez Serrador himself argued that Irene is dom-inated by Teresa, who becomes her favorite.[29] This comment points to the pos-sibility that Irene's obsession with Teresa is not as straightforward in terms of sexual power as might be presumed from her apparent torment of her victim: the fascination that Teresa inspires is what impels Irene to find out more, and what leads her to her death. This multiple positioning ironically serves to make her more sympathetic, quite an achievement given her actions hitherto. Far from being a straightforward representation of how lesbianism perverts a board-ing school, then, Irene stands astride a cultural, or a sexual, boundary that, as Hughes and Smith argued, is characteristic of the Gothic. She does more than this: she stands astride a confluence of differing sexual desires in which the fact of desire, rather than that of sexual preference, is key.

However, what is also perhaps queer, in all senses of the word, is the fact that *La residencia* does not allow heterosexuality to function as a supposedly healthy alternative. Granted, the young women may well perceive heterosexual sex as an escape route, even if only briefly, from the oppression of the regime operat-ing within the house. This is suggested by the series of sexual encounters in the barn with the woodman: the film makes it clear that all the girls potentially have the opportunity to escape the tedium of rote lessons and silent sewing, in preference for heterosexual pleasure. The prolonged sewing scene, crosscut with the cavortings of one of the young women with the young man, stresses the potential for release in a remarkably overstated way. The crosscutting makes it appear as if all the other girls are listening in silent intent to the ecstatic cries of their classmate, and the sequence culminates in the heavily coded penetra-tive moment when one of the students pricks her finger on a needle. Ironically, heterosexuality appears in this instance to be the subversive option.

All this pales beside the monstrous heterosexuality of Luis, who entices young women to run away with him, only to murder them and use them as body parts in the creation of his perfect woman. His imitation of Frankenstein offers another intertextual reference that points away from Spain. Luis's violent and sinister tendencies are demonstrated from virtually the beginning of the film, as it is soon apparent that he is responsible for the mysterious noises and the creeping hands on windows that so startle Teresa on her first arrival, since his mother scolds him for wandering round the house and spying on her girls. A little later, Luis traps and crushes an insect in the book he is reading. His spying on the students as they shower, thus, comes as no surprise. Torres, in fact, suggests to Ibáñez Serrador that this is a weakness of the film, in that the murderer becomes obvious from the scene in the showers. Ibáñez Serrador argues in response that he meant this to happen so that the audience would doubt, because it would seem too obvious.[30]

However, the shower scene and the possible link to Luis as the murderer provide other readings that serve to queer the film. Benshoff notes that queerness as subtext might well pander to heterosexist norms and voyeuristic pleasures (as I have noted earlier) but that simultaneously it allows for other readings, including queer ones of identification.[31] But Benshoff sees such identification primarily in the figure of the monster, and this causes problems in *La residencia*, since on the one hand the arguable monster figure of Luis is certainly queer in Benshoff's earlier terms but also heterosexual, and, on the other hand, monstrosity is a mantle adopted and then taken off by different characters in turn, as exemplified by Irene's metamorphosis from dominatrix to investigator. If the one principal heterosexual character is the murderer and the monster, this brings a heterosexually based patriarchy into doubt, and particularly one based on the male gaze, as the shower scene demonstrates. Indirectly the mantle of monstrosity is pointed back at a voyeuristic heterosexual audience, who implicitly share in Luis's point of view and thus run the risk of the taint of heterosexual violence. The dangers of audience identification with a male gaze are underscored still further by the fact that Madame Fourneau also shares this gaze, as we saw earlier. No wonder, then, if audiences were to feel more than a little uncomfortable in sharing this gaze, and are keen to displace such a thought in precisely the way that Ibáñez Serrador suggests, by assuming that Luis is too obvious a murderer. They might take further reassurance from the idea that any text by Ibáñez Serrador is bound to have an unexpected twist. Yet the unexpected twist is precisely the fact that there is not one, and the association of violence with the male gaze is unavoidable.

The option remains to blame the overbearing and perverse mother for being the primary cause of Luis's monstrosity: after all, Luis's avowed object is to create the perfect woman, just like his mother. Yet perhaps Luis's final gesture—shutting his mother away with his corpse bride—is not so much punishment

for her as a distorted form of queer pairing, particularly given that the bride is made up of the parts of students whom Madame Fourneau will have looked at with desire. Luis is offering his mother the woman that *she* rather than he wanted, the perfect woman, unlike the female students who surround them with their own sexual taints. There is, of course, further irony that the perfect bride is still made up out of these tainted women. But the taint brings us back to the hidden patriarchy that remains implicit in the very existence of the school: it is, after all, a house created by the needs of patriarchy to deal with the consequences of patriarchal behavior. The house is a residence for young women with unspecified dubious backgrounds, which appear to include sexual impropriety of a heterosexual kind, as indicated by Teresa. The presence of her mother's lover at the very beginning of the film becomes more significant than we might initially realize, the house becoming a site for the displacement of patriarchy's heterosexual excesses. These are Palmer's excesses of the uncanny, in which the uncanny becomes heterosexuality itself. And when Townshend argues for queer resistance to patriarchy, this pertains to the film in some degree, whereby queer attempts to co-opt control. But in fact—in another move of uncanny excess—patriarchy is responsible for creating its own queer regime. *La residencia* therefore holds no secure foothold anywhere for the viewer. In this it is queerest of all. As Benshoff claimed for queer in horror, this film negates the binaries of heterosexuality by rendering all oppressive binarisms as queer moments of hesitation. Against Benshoff, however, we can add that the oppression remains even as we are given no secure point of view: regardless of where we try to find a foothold, *La residencia* provides no suggestion of a way out, as Madame Fourneau's queer regime simply gives way to an even more punishing regime in which a queered heterosexuality presides over imprisoned, distorted, and dead women in a final queer union. If, as Hughes and Smith argued at the beginning of this chapter, Gothic has historically lacked a commitment to absolute definitions of identity and is thus queer, then *La residencia* participates in this history too. It is not and probably never will be clear quite why *La residencia* continues to rank above so many critical successes in terms of the box office, but its very success demonstrates that queer Gothic also lurks behind and destabilizes the canons of Spanish film history.

Notes

1 William Hughes, and Andrew Smith, "Introduction: Queering the Gothic," in *Queering the Gothic*, ed. William Hughes and Andrew Smith (Manchester: Manchester University Press, 2009), 1.

2 Paulina Palmer, *The Queer Uncanny: New Perspectives on the Gothic* (Cardiff: University of Wales Press, 2012), 7.

3 Harry M. Benshoff, *Monsters in the Closet: Homosexuality and the Horror Film* (Manchester: Manchester University Press, 1997), 4–5.

4 Dale Townshend, "'Love in a Convent': Or, Gothic and the Perverse Father of Queer Enjoyment," in *Queering the Gothic*, ed. William Hughes and Andrew Smith (Manchester: Manchester University Press, 2009), 29.
5 Hughes and Smith, "Introduction," 2.
6 Antonio Lázaro-Reboll, "Screening 'Chicho': The Horror Ventures of Narciso Ibáñez Serrador," in *Spanish Popular Cinema*, ed. Antonio Lázaro-Reboll and Andrew Willis (Manchester: Manchester University Press, 2004), 152–168.
7 Carlos Aguilar, "Fantasía española: Negra sangre caliente," in *Cine fantástico y de terror español 1900–1983*, ed. Carlos Aguilar (Donostia: Donostia Kultura, 1999), 23.
8 All translations are mine, unless otherwise indicated.
9 Benshoff, *Monsters in the Closet*, 194.
10 Lázaro-Reboll, "Screening 'Chicho,'" 159.
11 Lázaro-Reboll, 159.
12 Antonio Lázaro-Reboll, *Spanish Horror Film* (Edinburgh: Edinburgh University Press, 2012), 97.
13 Lázaro-Reboll, 111.
14 Sara Torres, "Entrevista," in *Cine fantástico y de terror español 1900–1983*, ed. Carlos Aguilar (Donostia: Donostia Kultura), 246.
15 Lázaro-Reboll, *Spanish Horror Film*, 112.
16 Bernard P. E. Bentley, *A Companion to Spanish Cinema* (Woodbridge, UK: Tamesis, 2008), 175.
17 Nicholas G. Schlegel, *Sex, Sadism, Spain, and Cinema: The Spanish Horror Film* (Lanham, MD: Rowman and Littlefield, 2015), 93.
18 Lázaro-Reboll, "Screening 'Chicho,'" 158.
19 Torres, "Entrevista," 248.
20 José A. Luque Carreras, *El cine negro español* (Madrid: T&B Editores, 2015), 54.
21 Lázaro-Reboll, "Screening 'Chicho,'" 160.
22 Lázaro-Reboll, 165.
23 Palmer, *The Queer Uncanny*, 108.
24 Lázaro-Reboll, "Screening 'Chicho,'" 160.
25 Luque Carreras, *El cine negro español*, 367.
26 Schlegel, *Sex, Sadism, Spain, and Cinema*, 96.
27 George E. Haggerty, *Queer Gothic* (Champaign: University of Illinois Press, 2006), 2.
28 Ann Davies, "Spanish Gothic Cinema: The Hidden Continuities of a Hidden Genre," in *Global Genres, Local Films: The Transnational Dimension of Spanish Cinema*, ed. Elena Oliete-Aldea, Beatriz Oria, and Juan A. Tarancón (London: Bloomsbury, 2016), 122.
29 Torres, "Entrevista," 250.
30 Torres, 250.
31 Benshoff, *Monsters in the Closet*, 15.

2

A Queer Path to "Normal"

●●●●●●●●●●●●●●●●●●●●●

Pablo Berger's
Torremolinos 73 (2003)

MEREDITH LYN JEFFERS

Torremolinos 73 might come as a surprise in an anthology dedicated to Iberian queer cinema. The film tells the story of Alfredo (Javier Cámara) and Carmen (Candela Peña), a newlywed couple struggling to make ends meet in the early 1970s in Francoist Spain. Carmen and Alfredo have the modest goal of leading what most would consider to be a "normal" life, and they evince desires common to the middle class of the time. That is to say, they are caught up in the new cult of consumerism that characterized Spain's *desarrollismo* period: they wish to afford certain household luxuries, vacation in Spain's newly internationalized resort towns, and eventually have a family. The pair epitomizes the traditional, conservative, Catholic, heteronormative roles and customs both dictated by the regime and later criticized and subverted following Spain's Transition to democracy. Or at least they appear to do so in the first fifteen minutes of the film.

 Torremolinos 73 is the debut feature film of Basque writer and director Pablo Berger.[1] It received four nominations at the prestigious Eighteenth Goya Awards, including Best New Director (Pablo Berger), Best Original Screenplay (Pablo Berger), Best Actor (Javier Cámara), and Best Supporting Actor (Juan Diego). However, *Torremolinos 73* was outshone by Icíar Bollaín's domestic

violence drama *Te doy mis ojos* (2003) [*Take My Eyes*] that same year and failed to win in any category.[2] Furthermore, although *Torremolinos 73* won top prizes at respectable international venues, it was not as commercially successful as other films released around the same time.[3] Nor can it be considered Berger's most popular work, having been widely eclipsed by his subsequent silent film *Blancanieves* (2012), a black-and-white re-creation of the homonymous fairy tale by the Brothers Grimm.[4]

Torremolinos 73 has also not won much in the way of scholarly attention. Belén Vidal's "Memories of Underdevelopment: *Torremolinos 73*, Cinephilia, and Filiation at the Margins of Europe" offers a notable reading of the film through the lens of cinephilia, tracing "alternative histories that run parallel to and circumvent national borders and official discourses."[5] Paul Julian Smith also offered a significant and favorable review following the film's release, at the time hopefully (and accurately) anticipating Berger's second full-feature project.[6] Beyond this, there are limited academic journals or anthologies that mention Berger's *opera prima*, and then only in cursory detail.[7] For their part, more mainstream film critics offer mixed reviews of *Torremolinos 73*. Some, such as Luis Arredondo, see promise—"a great start to Pablo Berger's career"—though even the title of Arredondo's article, "*Torremolinos 73*: Un afortunado collage," is not entirely auspicious.[8] Others, such as Hilario J. Rodríguez, are scathing in their remarks: "It is enough, however, just to focus on the tensions proposed in the film to realize that there is nothing along the lines of intelligence or imagination."[9] And no one has, to date, examined the film through the lens of queer theory.

Why, then, include it among a collection of scholarly essays examining some of the most prominent LGBTQ works ever produced in the Iberian Peninsula? *Torremolinos 73* warrants further attention, and a place within the ever-growing corpus of queer cinema, in large part due to its enjoyable and critical take on Spain's late Francoist period (1960–1975) and on subsequent re/visions of that era. More specifically, *Torremolinos 73* contests notions of normalness in ingeniously ironic fashion. On a plot level, the illusory normal life so desired by Carmen and Alfredo is attained by wholly abnormal means: they must write, direct, and costar in homemade pornographic films they shoot themselves on an 8mm camera and then sell to a Scandinavian distributor—all under the thinly veiled guise of creating Spanish installments for an international encyclopedia on reproductive customs. Similarly, Alfredo's newfound inspiration to become a cinematographic *auteur de force* is only realized by plagiarizing the works of Ingmar Bergman, compromising his directorial vision, and allowing his wife to become impregnated by her Danish costar Magnus (Mads Mikkelsen) in the climactic scene of Alfredo's first and only full-feature film. On a broader, more allegorical scale, *Torremolinos 73* subverts Spain's desire to project a normalized cultural image to an international audience in the final

decade of the dictatorship. Undoubtedly, Spain's increased aperture to the exterior was a superficial attempt to appear modernized and mainstream, thus rendering it anything but authentic. Understood this way, *Torremolinos 73* succeeds in demonstrating how the new, normative Spanish image was ultimately derivative, delayed, and engendered an illegitimate legacy. This essay will thus begin by outlining the basic connection between *Torremolinos 73* and the precepts of queer theory, and then offer a close reading of how the film revisits and resists the "normal" image promulgated by the regime.

Queer Theory and *Torremolinos 73*

In his critical volume *Spanish Queer Cinema* (2013), Chris Perriam notes that the term "queer," much like the field of queer theory or the genre of queer cinema, points at a "deliberately unfixed" signified.[10] The oft-repeated axiom encompasses the evolution of how the word "queer" has been used socially, politically, and even academically. Michele Aaron reminds us in *New Queer Cinema* that queer was originally a "derogatory term levelled at the non-hetero-seeming," and was later re-appropriated in the late 1980s and 1990s by its victims "as a defiant means of empowerment."[11] Since queer was used to designate a wide range of non-hetero-seeming individuals, who did not appear to conform to the normative gender and sexual identities and practices of the time, queer's most basic function became that of an "umbrella term or catch-all for uniting various forms of non-straight sexual identity."[12]

However, at the risk of oversimplifying a complex concept, queer has come to mean much more than this, both in the United States and abroad. Richard Dyer rightly explains throughout *The Culture of Queers* that the contemporary formulation of queer functions in sharp contrast to its past. To be queer now signals a certain fluidity, to be "untethered from 'conventional' codes of behavior."[13] Furthermore, queer has assumed a more active and inspiring connotation. David Halperin proposes that queer is "*whatever* is at odds with the normal, the legitimate, the dominant. . . . [It] demarcates not a positivity but a positionality vis-à-vis the normative."[14] Queer is more than a presence or absence of certain codes and characteristics; it is a stance that very much concerns them.

As a working definition, then, queer is positioned counter to the normative and normalizing, geared toward marginalized practices and sexualities beyond the designations of LGBT. Taking this a step further, Leandro Palencia proposes that queer operates in—and/or makes—a flexible space for the deployment of thoughts, images, and actions that counter the heterosexual, straight, and mainstream "norms."[15] Rather than serve as a passive label, queer harnesses agency: to contest, subvert, and resist hetero- and homosexual normality. Michael Warner perhaps puts it best throughout *Fear of a Queer Planet*: queer has the power to challenge *normalness*, not just heterosexuality.[16] This means

the subversive potential of queer may now transform the once "vague and unde-finable" label of queer very much in the direction of challenging the "normal" and normative knowledges and identities that once labeled it as queer.[17]

This aspect of subversive potential, of challenging what is believed to be normal and normative, permeates *Torremolinos 73* and plants it firmly in the genre of Iberian queer cinema.[18] The film makes visible, and puts into new contexts, thoughts, images, and actions, a variety of nonnormative customs and practices, sexual and otherwise.

The "Normal" 1970s

Torremolinos 73 opens with Alfredo, an encyclopedia salesman, trudging alone along an empty street on a strikingly gray afternoon. He is balding, middle-aged, and in far from peak condition. As he approaches the new housing complex where he is meant to sell his product, Alfredo passes a sunny billboard advertising the neighborhood, "My Paradise," a name that ironically contrasts with the utter sense of desolation inspired by the somber environment. Further adding to the irony, Alfredo's efforts in Mi Paraíso seem to exemplify his daily, hellish routine. For starters, the elevator does not work, forcing him to lug enormous volumes of *La historia ilustrada de la Guerra Civil Española* (The Illustrated History of the Spanish Civil War) up countless flights of stairs, along with a gold-plated bust of Franco, "escala 1:10" (scale 1:10). No one is pleased to see him, he must repeat his sales pitch over and over, and even a young boy slams the door in his face before he can catch his breath. The sequence concludes with Alfredo exiting the edifice—tired, sweaty, not having made a sale—as a clap of thunder presents a deluge that will further dampen his long walk home.

Upon his arrival, we view Alfredo through a close-angle shot of a peephole. This perspective pertains to the interior of the apartment owned by his neighbor and landlady, Doña Isabel, who immediately confronts him about multiple months of late rent. Weakly assuring her all debts will be paid, Alfredo finally enters his apartment, where his loving wife, Carmen, prepares a *tortilla española* and warmly greets him with a kiss. The two briefly watch television, criticizing an ad for Alfredo's own publishing company that offers sale-by-installment volumes of *The History of Film*. Their jibes betray the truth the audience has already come to perceive: Alfredo and Carmen are struggling financially, and his career is about to be supplanted by new modes and products of sale. Adding to their financial dilemma, Carmen wants a child, and Alfredo is fearful of the cost.

The exposition thus succeeds in presenting Alfredo and Carmen as an average middle-class couple in early 1970s Spain. They have regular jobs as a salesman and a beautician; they live in a basic apartment, eating typical Castilian meals and wearing plain, mainstream clothes; and they are surrounded by items

characteristic of the time, such as the black-and-white television and period kitsch displayed on the walls. The couple is heterosexual and Catholic and displays conservative family goals and values—all in keeping with the codes dictated by the Francoist regime of the time. In short, Alfredo and Carmen are boringly normal.

Using them as protagonists, however, calls attention to the new image of Spain projected to the international community during the late Francoist period of 1960–1975. The regime's efforts to market a welcoming, safe visage to a global audience gradually improved Spain's international recognition and acceptance, as well as its domestic economy. However, the creation of this renovated national image ultimately promoted and perpetuated the performance of a new "normal." Following Vidal, underlying the facade of Spain's "controlled exposure" abroad was tension with the official culture of traditional values that still permeated society.[19] This was, in reality, a time of superficial modernization within limited freedoms, during which the middle class, in particular, aspired to partake in the new wave of *desarrollismo*: "[an] ideology of rapid and uneven economic development" that came to characterize the regime's domestic policy of the time.[20]

Visual evidence of *desarrollismo* abounds in *Torremolinos 73*. However, rather than inspire any sense of nostalgia for the period, the seemingly endless examples call attention to the far-reaching effects of what was ultimately the regime's latest wave of normalization. The gray apartment buildings of Mi Paraíso reflect the hasty, redundant housing blocks erected across Spain in the 1970s, which produced a standardized (or standardizing) look to much of the construction from the period. Similarly, the densely populated department stores and the nationally produced affordable vehicles—such as the one flaunted by Alfredo's colleague Juan Luis (Fernando Tejero)—point at an era of consumerism in which many individuals desired the same objects as a means of identifying with the latest trends. In essence, the mission to market Spain to a global community failed on a local scale: it had the adverse effect of selling a fake, mass-produced ideal to Spaniards, one that many, such as Alfredo and Carmen, could not afford.

Compounding the illusory image of a newly normal Spain is a sense of stagnation. In one way, this is demonstrated through the first scene in the Montoya Publishing offices where Alfredo works. The midrange and close-up shots emphasize the gray, bland cubicles, while the muted, monotonous typing of paperwork reveals the tedium of a dead-end job. Even Alfredo's elderly coworker appears in frame in the middle of a coughing fit that might well be his last. By the time Alfredo reaches his boss, Don Carlos (Juan Diego), the whole operation is condemned: sales are down to 1 percent, and only four salesmen, including Alfredo, remain after some fifteen years. Don Carlos concludes, unsurprisingly, "As such, door-to-door encyclopedia salesmen are going to

disappear" (00:08:53). He goes on to mimic the technocratic plan of the time, deciding that his company must "renovate or die," all with an eye toward an international collaboration that will hopefully pull them out of their economic slump and propel them forward into the path of progress (00:09:13).

In a similar way, the torpid atmosphere permeates Carmen's interactions and observations at work at the Paris Beauty Parlor. As she waxes a well-to-do client, a cameo role deftly played by Carmen Machi, she listens to the latter express her surprise over the "soft-core French porn" she inadvertently found herself watching. The film in question is, in fact, Bernardo Bertolucci's famous drama *Last Tango in Paris* (1972). Though the client admits she does not speak French, she describes a scene in which Marlon Brando penetrates the young female protagonist with a stick of butter. The client exclaims she had thought *Last Tango in Paris* would be a musical and concludes by criticizing French liberal attitudes toward sex and cinema: "What an immoral film! That does not happen in Spain!" (00:10:30). The client's outlook aligns with the conventional values underlining Spanish society at the time. Her unfamiliarity with the language and with a landmark work of cinema may well indicate personal ignorance, but it plays at the larger issue of Spain being out of touch with the rest of the Western world following decades of isolation. Similarly, her unwillingness to appreciate a different, nontraditional, nonnormative representation of sexuality, even on-screen, betrays an undercurrent of conservatism during the *desarrollismo* phase. The characters, both primary and secondary, all want to buy into the movement—even the xenophobic client goes to the ironically named Paris Beauty Parlor (00:10:40) to complain of *Last Tango in Paris*—yet they are held back by the behaviors and beliefs they have regularized over time.

Contesting Misconceptions

The paradox of *Torremolinos 73* is that the only way for Alfredo and Carmen to enter the new cult of consumerism and afford the heteronormative family unit they desire is to depart from the standard customs and beliefs they have practiced throughout their lives. That is to say, in order to overcome their financial difficulties, climb the social ladder, and successfully project the new image of middle-class Spain, the couple must subvert the normality they hold so dear. This conundrum is presented to Alfredo, his colleagues, and their wives by Don Carlos. He invites them on a weekend company retreat and explains that he has been approached by the Copenhagen Sexology Institute to collaborate on a new endeavor: "the audiovisual encyclopedia of reproduction around the world." Don Carlos plays an introductory video, in which one "Dr. Johansen," wearing an unconvincing lab coat and glasses, explains that their mission is to document reproductive practices from around the world (00:13:10). The series has produced record sales, and so Don Carlos has agreed that his company will

make the most of this chance to *renovarse* and participate in a study "for the progress of science" (00:14:15). To do so, his employees will be paid 50,000 pesetas per movie, plus a bonus, for writing, directing, and costarring in home-made videos of Spanish sexual practices. Should they refuse, and get on the bus to go home, they will be fired.

The immediate response from the employees is one of confusion. One man seeks clarification, declaring, "In other words what you want is for us to make films of when we make love to our wives in our homes" (00:15:10). To this, Don Carlos simply replies: "Scientifically speaking, yes" (00:15:20). It is clear from the collective reactions and expressions of the Montoya Publishing employees that they find the proposition both insulting and disgraceful: their first instinct is to reject the idea because it goes against the mainstream belief that sex is love-making between a man and wife, done in the privacy of one's home and largely for reproductive results. Alfredo is outraged and tells Carmen, "Don't even think about it, OK? My wife is not going to show her bits. Not for science or the pope" (00:18:10). His words reinforce the performed sanctity and privacy of a Catholic heterosexual marriage. She, on the other hand, sees how the ends (earning money, getting pregnant, and starting a family) might justify the means (doing so on film). When she reminds Alfredo that he would have to sell 154 encyclopedias to earn what they would be paid for one film, while an ad for Nestun baby food plays on the hotel television, he finally consents.

Though the presentation of the pitch is amusing, the scene reiterates the fact that the company has made a choice for its employees without their consent and then leveraged their participation by threatening their economic well-being. Framed as a cutting-edge opportunity to support progress and scientific research, and to promote the inclusion of Spain in an international series and marketplace, the opportunity is an obvious facade. In one way, censorship under Franco prohibited much less than a full-blown 8mm sex film: what would seem a standard film poster to the average U.S. citizen was often edited to appear less sensual and risqué in Spain. By forcing his employees to participate, Don Carlos is forcing them into a crime against the state. In another way, the company's proposal parallels the regime's rhetoric to renovate Spain's image and revitalize the economy, marketing Spain as a warm, welcoming neighbor to the south without addressing its decades of dictatorship. Carmen and Alfredo will get paid, just as Spain was to benefit fiscally, but only for making and selling porn—a clear critique of the public's passive participation in moving forward without looking back.

This paradox is pregnant with symbolism and satire: the employees, once ency-clopedia salesmen armed with Franco's bust and a historical rendering of the war, are to become sex workers supporting an industry that the dictatorship censored until Franco's death in 1975. The timing is particularly significant because the film is set just a few years before the new democratic government

abolished censorship and created a new classification office that began allowing commercial soft-core porn (in 1977). By 1982, the Ministry of Culture, fearing pornographic and horrific images were likely to wound the sensitivity of the average spectator, passed new regulations confining the new boom of these S films to X-rated venues and home video markets. But in the early 1970s, the time of *Torremolinos 73*, Spanish attitudes toward sex were much more personal and private. Carmen and Alfredo attempt to justify their newfound *protagonismo* in the porn business by focusing on the fact that they will finally have financial stability, which will, in turn, allow them to secure a future for the family they hope to grow. Put another way, they cling to their conservative values while agreeing to contest them at their very core.

The subsequent montage of the Spanish couple learning how to make a pornographic film is perhaps the best sequence of subversive contrasts in the film. In one room, Alfredo works with Erik, a Scandinavian director who claims to have been Ingmar Bergman's assistant, and who sports a megaphone with the famous director's name in large print. Erik teaches Alfredo and Juan Luis about lighting and angles, and he times them as they assemble various pieces of camera equipment. In parallel, interspersed scenes, Carmen works with Frida, Erik's wife (and often costar). The two women could not be more dissimilar. Frida has platinum blond hair, bold earrings, and a provocative bodysuit. She confidently shows Carmen how to move before the camera and tells Carmen in broken Spanish that "most important for female [*sic*] is not to dress for man but to take off clothes for man . . . slow and hot" (00:19:50). In comedic fashion, Carmen clutches her purse and begins to take off her many layers of clothes, carefully folding each item atop a dresser as she offers Frida a weak, apologetic smile. Carmen is unmistakably nervous, makes almost no eye contact, kisses the cross around her neck, and goes so far as to remove each earring, slowly and awkwardly, to buy more time—all while Frida encouragingly yells, "Everything! Everything!" (00:21:50).

The sequence signals just how behind the times the Spanish individuals are. Daniel Kowalsky explains that "elsewhere in Europe and the United States, the era of mainstream sexploitation had come and gone," but in Spain conservative values reigned supreme.[21] Likewise, Vidal notes that the humor of the sequence "springs from the clash of brash stereotypes recycled from the *landismo* era," with both costume and performance highlighting the difference between the two couples.[22] Erik and Frida are portrayed as "the bohemian and sexually liberated Scandinavians," experts in the field; they stand in stark contrast to Alfredo and Carmen, "the inhibited and sexually naïve Spaniards," who are technological and erotic amateurs.[23] Vidal likewise notes that the "bohemian and sexually liberated" perception of Scandinavians was informed by the pioneering decriminalization of pornography in Denmark and Sweden in the late 1960s. Such popular stereotypes of Scandinavians then reached Spain

through the increased flow of tourists visiting Spain from northern Europe: "On the one hand, Frida's lesson in striptease playfully alludes to the 'Swedish bombshell' cliché, which became an erotic myth amply exploited, first in the *landismo* sex comedies, and more explicitly in the subsequent raunchy *destape* (sex comedies with nudity) and soft-core porn films, many of which were set in Torremolinos and similar resort towns.... On the other hand, Erik is both coded as a professional of low-budget pornography and presented as a 'former assistant to Ingmar Bergman,' whom he continuously quotes while instructing Alfredo and Juan Luis on the shooting of sex scenes."[24]

The scenes of Alfredo, Juan, and Carmen learning to use the camera and perform a striptease thus frame the Spaniards as amateurs compared with their "expert" Scandinavian counterparts. What remains most amusing is that they wish to become experts at all.

Alfredo and Carmen attempt to normalize their abnormal situation by inserting Spanish stereotypes and situations into their installments. As if the company really did want portrayals of Spanish customs, they choose to center their first film around the theme of a traditional Spanish wedding night. The audience views the footage through Alfredo's camera, as Carmen begins to undress while wearing a long veil that conceals most of her body. Both Alfredo and Carmen have improved since their lessons: she is less halting in her movements, and he begins to experiment with different angles and close-ups of her face. Following an awkward review of the footage with his boss, Alfredo gets paid for the first installment and receives permission to make more films. This green light leads into a montage of their many leitmotifs, set to the song "Carmen" performed by Trebol. For example, Carmen dressed as a soccer player; Carmen dressed as a nurse; Carmen doing laundry; Carmen showering; and Carmen receiving Alfredo, a clumsy delivery man—all to the chorus of "Carmen, Carmen, Carmen" (00:35:09). Doña Isabel spies some of their installments from the hallway and hears some of their work through the walls; she is similarly surprised by their ability to pay advances on their rent, to refurbish their apartment, and to dress in furs and fashion-forward clothing.

At the end of the sequence, Carmen and Alfredo's subversion of Spanish sexuality yields both positive and negative results: they are better off financially, but Carmen is still not pregnant and Alfredo finds himself "bored" with making the same basic film time and again. They also come to learn that their abandonment of conventional codes of conduct has had the inadvertent and adverse effect of launching Carmen's career as a sex symbol in Scandinavia. A Danish foreigner stalks her through the baby section of a department store and approaches her to request she sign an autograph in a porn magazine, one that has still shots of her naked body and shows her real name used in the titles of the films they have sold. Understood this way, Carmen has become the literal and figurative face of Spanish sex abroad. Her shame and Alfredo's irritation

are evident. However, their respective desires to leave a legacy—she through a child and he through a film—push them into a new phase of defying their traditional, and monogamous, values.

Climax and Consequences

These heightened stakes begin when Alfredo must produce a sperm sample to assess his fertility. Escorted by a nun—wearing a full habit and a large crucifix around her neck—Alfredo enters a room covered in pictures and posters of pin-up models. All are women, and all are clothed, in keeping with the heterosexual norms and censorship practices of the time. He lovingly removes a head-shot of Carmen from his wallet and holds it up to different bodies to remain faithful to his wife. As he mounts Carmen's head and bust (covered by a turtleneck) on the bikini-clad body of a tan woman on a beach in Torremolinos, Alfredo finally becomes excited—though it is unclear whether he is aroused by the demure black-and-white image of his wife or the setting of the new tourist-driven beach resort and the idea it inspires. He leaves the medical office with a professional epiphany: he will write and direct a full-feature film starring Carmen as a wealthy widower who goes to Torremolinos to grieve and instead meets a mysterious, ominous man.

The results from the clinic reveal that Alfredo is sterile, thus explaining their failure to conceive despite their increased sexual activity over the last few months. Carmen communicates her depression to Alfredo by accusatorily raising the volume of Mocedades's "Eres tú" on their new television, which they symbolically break during the ensuing fight. Carmen's reaction to the news is understandable and in keeping with her dreams of a full family unit. She learns that adoption is even more costly than expected: they must have an annual income more than 500,000 pesetas and "a decent and unblemished morality" (00:55:22). Assuming those primary requirements are met, each prospective parent must then undergo an in-depth investigation conducted by the juvenile court system, which can take between four and five years to determine suitability. If cost and time are more practical concerns, Carmen most strongly reacts to the mention of morality. As if realizing for the first time that her seditious role in the 8mm films might impact her conservative, heteronormative goals, Carmen must find another way to make a family.

Meanwhile, Alfredo's sexual infertility contrasts with his successful production of a new script for his film. Unable to become a biological father, he conceives of and gives life to his filmic vision, one that Don Carlos agrees to produce during a hypermasculine hunting trip, the likes of which were fashionable to the Franco regime. As with the shorter film installments, the full-feature film is to be coproduced with the Scandinavian "institute" due to economic and distribution necessity. This sort of opportunistic coproduction arrangement was

behind many of the S films flooding the Spanish market in the early 1970s. However, including both the Scandinavians and the Spaniards in the production of Alfredo's first major work, also titled *Torremolinos 73*, presents a transcultural negotiation of normal.

This first occurs when everyone arrives at Torremolinos and meets for the first time. It is February, the beach town is completely deserted, and even the cab driver cannot comprehend why they would come there in the freezing cold weather. The Scandinavian crew is surrounded by drinks and cigarettes, and Erik has returned as a translator because none of the others understand or speak basic Spanish. Magnus (Mads Mikkelsen), one of the Nordic men, is obsessed with Carmen, and offends Alfredo's directorial command by going to greet her in the lobby of the hotel. Furthermore, all the crew members assume that Juan Luis is gay. His insistence to the contrary—that he is "normal" and heterosexual— is thwarted by the fact that he recently "fell off a horse" making a bestiality film to sell to the same Scandinavian population (01:00:40). The interactions between Juan Luis and the crew are the only overtly homosexual references made throughout the duration of *Torremolinos 73*. However, this thread of queer implications does not materialize beyond simple name-calling and one scene of skinny-dipping in the cold seawater. The cultural contrast is understated: the Scandinavians are far more open than the Spaniards are to practices that are not heteronormative.

Bypassing the opportunity to explore this homoerotic scene of Juan Luis's nonnormative sexual practices, *Torremolinos 73* maintains its singular approach to queer by compounding the plight of Alfredo and Carmen. It quickly becomes clear that Alfredo's big break is a heavily plagiarized reworking of a Bergman masterpiece, *Det sjunde inseglet* (1957) [*The Seventh Seal*]. As Vidal notes, this transcultural reworking of Bergman's art cinema and relocation to the landscape of Spanish *landismo* sex comedies produces an endearingly trashy cliché.[25] Alfredo's ambitious vision is not truly his own, and it is not good. To demonstrate this, the audience hears bits of the dialogue and views footage from Alfredo's shoot, which is shown solely in black and white. For example, we see Carmen, shivering from the cold as she swims up to Magnus, who tells her to listen to the silence, "the kiss of death" (1:03:55). We also watch Carmen and Magnus clumsily march down the beach as the crew stumbles backward filming, and Alfredo offers little in the way of meaningful direction: "There is a desire . . . that you desire" (01:06:45). Scenes from *The Seventh Seal* are also parodically refashioned: for example, the famous chess game with Death is played out on a paddleboat christened *La Paella* as Carmen and Magnus pull frighteningly far away from shore (01:06:15).

Furthering the divide between Carmen and Alfredo's normalized desires and abnormal predicament, Don Carlos and Erik have decided that the film should conclude in a sex scene between Carmen and Magnus. Alfredo is

furious, and Don Carlos calmly sets him straight: "What did I tell you? That you were going to direct *Torremolinos 73*. Well, you're doing it. We are filming in black and white as you wanted. But look, Alfredo. Don't be naive. You think that if we don't pep up the film a bit, that if we don't add a bit of sex, and extend it for an international market, that I'm going to be able to get my money back? . . . Carmen is the star. She's become a star in certain circles in the Scandinavian countries. Did you know that?" (01:09:50).

This is the truth lost only on Alfredo: there is a huge international market for sex films, and doing the scene is the only way to make a profit. No one believed in Alfredo's vision beyond it working as an erotic adaptation of a readily recognizable film. And, perhaps most important, Carmen has become a star. The transnational coproduction was approved and financed because of her hypersexualized image and success, not because of Alfredo.

Significantly, the decision to film the sex scene is made by Carmen, who informs Alfredo she has already agreed to the changes in the script. She reminds him of their goals, which she understands may be realized in an unconventional way, "That . . . that you want to finish your film, and I want to have a child" (01:16:05). After a brief silence, Alfredo disappointedly declares, "You can't have children, Carmen," to which she replies, "Yes, I can" (01:16:25). Alfredo's remark, that Carmen cannot have children, discloses his belief that he, Carmen's husband, is her only means of impregnation. For Alfredo, his infertility means she cannot conceive, because he cannot comprehend the possibility that his wife could circumvent their monogamous relationship. Carmen, on the other hand, contests such cultural beliefs and practices, showing that she is willing to break with tradition if it means she will achieve her dream of having "the perfect" family unit. Furthermore, she understands that her act of conception will serve as the climactic scene of Alfredo's own creation. Their goals have become one and the same, whether Alfredo likes it or not.

While filming the last scene of the film, Alfredo dejectedly says, "Action!"— as if begrudgingly granting a sort of patriarchal consent to his wife's unconventional finale (01:20:16). It is reasonable to assume the scene represents Carmen's first time with anyone other than Alfredo, and it is perhaps for this reason that she tries to maintain eye contact with him. She assumes a dominant position, ignores Magnus's belabored efforts to deliver the dialogue, and holds him down on the bed as they copulate. In response, Alfredo resumes his post behind the camera, zooming in on Carmen's determined face. Although they are committing one of many such acts included throughout the film, this sequence represents a cardinal sin, as well as a completely subversive move against the traditional Catholic, conservative values espoused by the government at the time. The gaze maintained between them, which culminates

in the figurative "money shot," displays resolve and complicity: they are defiant of the norm; they are queer.

The epilogue takes place approximately two years and nine months after filming the end of Alfredo's *Torremolinos 73*. This is implied by the two candles on the birthday cake for Marisol, the very blonde biological daughter of Carmen and Magnus. Carmen has lightened her hair, as well, likely to sell the ruse of Alfredo's paternity. He now works as a wedding videographer, an amusing reference back to their first S film. They appear content considering everything they have been through. For the first time in the film, the set (their apartment) is luminous, with light radiating off the colorful birthday banners, clothes, and blond locks. The happy home life cuts to black, and the closing titles appear: "*Torremolinos 73* was the only film directed by Alfredo López. It was released, rated 'S' in 1977 with the title *The Adventures and Misadventures of a Very Horny Widow*" (01:24:20). In one way, the fact that this was Alfredo's one and only full-length film could indicate that it was simply terrible, and that he was not given a second opportunity. In another way, it suggests that Carmen became pregnant, and that they left the industry having achieved their goals of financial and familial bliss. Similarly, the cultural data on viewership may be interpreted in multiple ways: perhaps Spain had not yet fully immersed itself into the *destape* era of permissiveness, and/or perhaps the longer film was extremely successful in Scandinavia because that population had already enjoyed the couple's shorter works in the time leading up to its release.

The film thus ends with pros and cons. Alfredo and Carmen are finally happy and have obtained a traditional, nuclear family structure with heterosexual parents. However, it is indeterminate whether their happiness stems from their new "normal" life or from having experienced a moment of cultural liberation in the final scene of Alfredo's film. The real audience, much like the greater part of the fictional Scandinavian audience, knows that this guise of normalcy was obtained by wholly queer means. Furthermore, Marisol is not a genetically "pure" Spaniard but rather a hybrid, obtained by nonnormative means, all of which was filmed on a camera in front of a Scandinavian crew and sold to an undisclosed number of foreigners. Simply put, in *Torremolinos 73* the scientific and religious imperative to reproduce—to conceive a Spanish child and perpetuate the monogamous Spanish family—was both corrupted and sold as a full-feature pornographic film abroad. Furthermore, Scandinavia did not want to see Spanish reproductive customs, but rather wanted to enjoy the illusion of a typical Spanish woman playing the role of porn star.

Torremolinos 73 thus succeeds in subverting the desire to project a normal/normalized cultural image. It shows how that very image was delayed, derivative, and won at a cost, engendering an illegitimate identity that must be

revisited. In doing so, *Torremolinos 73* resists the complicated censorship practices of late Francoist Spain, as well as the way in which the country insisted on projecting a safe and normal image abroad at a time when it was anything but. *Torremolinos 73* thus presents a queer path to normal and an opportunity for Spain to "queer" its stance on the late Francoist past.

Notes

All translations are mine, unless otherwise indicated.

1 His only previous work was *Mamá* (1988), a short film produced by Joaquín Trincado with artistic direction by Álex de la Iglesia. The prizes awarded to *Mamá* allowed Berger to obtain a grant from the Basque government to pursue a master's degree in film at New York University. Upon completing his doctorate in film, Berger was a professor of directing in the filmmaking department of the New York Film Academy until he began filming *Torremolinos 73*.

2 The film, along with Berger, its protagonists, and its director of photography Kiko de la Rica, fared better at slightly smaller festivals, totaling fifteen overall wins. These venues included the Málaga Film Festival, the Toulouse Cinespaña Spanish Film Festival, the Miami Film Festival, the Palm Springs International Film Festival, the Onda Awards, the Spanish Actors Union Awards, and the Sant Jordi Awards, among others. At these festivals, *Torremolinos 73* won for Best Director, Best Actress, Best Actor, Best Cinematography, Best Screenplay, and Best Debut, as well as grand jury prizes for best new visions, among others. For a complete list, consult IMDb.

3 An online search through the Lumiere database on admissions of films released in the European Union reveals that *Torremolinos 73* sold a total of only 448,619 tickets. This is significantly less than for other major films released in the same period: León de Aranoa's *Los lunes al sol* (2002) [*Mondays in the Sur*] sold 2,417,785 tickets, and Almodóvar's *Hable con ella* (2002) [*Talk to Her*] (featuring both Cámara and Peña) sold 6,763,398. Likewise, *Torremolinos 73*'s Goya rival for 2004, *Te doy mis ojos*, had three times as many admissions as *Torremolinos 73*.

4 *Blancanieves* swept the Twenty-Seventh Goya Awards show, receiving an unprecedented eighteen nominations, of which it won ten. It was nominated for countless international prizes and went on to win an additional twenty-four awards. See IMDb for a complete list.

5 Belén Vidal, "Memories of Underdevelopment: *Torremolinos 73*, Cinephilia, and Filiation at the Margins of Europe," in *Cinema at the Periphery*, ed. Dina Iordanova, David Martin-Jones, and Belén Vidal (Detroit: Wayne State University Press, 2010), 212.

6 See Paul Julian Smith, "*Torremolinos 73*," *Sight and Sound*, July 2005, http://old .bfi.org.uk/sightandsound/review/2400.

7 See Burkhard Pohl, "'Hemos cambiado tanto': El tardofranquismo en el cine español," trans. Alistair Ross, in *Cine, nación y nacionalidades en España*, ed. Nancy Berthier, Jean-Claude Seguin, Fernando Lara, and Alistair Ross (Madrid: Casa de Velásquez, 2007), 217–231.

8 See Luis Arredondo Luis, "*Torremolinos 73*: Un afortunado collage," *Butaca Ancha*, January 20, 2014, http://butacaancha.com/torremolinos-73-un-afortunado-collage.

9 Hilario J. Rodríguez, "Made in Spain: *Torremolinos 73*," *Ikusgaiak: Cuadernos de Cinematografía* 7 (2005): 188. The film appears to have fared better critically in France. See, for example, the following review summary: Octavi Martí, "La crítica francesa aclama *Torremolinos 73*, de Pablo Berger," *El País*, June 24, 2005, http://elpais.com/diario/2005/06/24/cine/1119564016_850215.html.

10 Chris Perriam, *Spanish Queer Cinema* (Edinburgh: Edinburgh University Press, 2013), 11.

11 Michele Aaron, "Introduction," in *New Queer Cinema: A Critical Reader*, ed. Michele Aaron (New Brunswick, NJ: Rutgers University Press, 2004), 5.

12 Aaron, 5.

13 Richard Dyer, *The Culture of Queers* (New York: Routledge, 2002), 4.

14 David M. Halperin, *Saint Foucault: Towards a Gay Hagiography* (Oxford: Oxford University Press, 1995), 62 (emphasis in original).

15 Leandro Palencia, *El cine queer en 33 películas* (Madrid: Popular, 2011), 16.

16 Michael Warner, "Introduction," in *Fear of a Queer Planet: Queer Politics and Social Theory*, ed. Michael Warner (Minneapolis: University of Minnesota Press, 1994), vii–xxxi (emphasis added).

17 Nikki Sullivan, *A Critical Introduction to Queer Theory* (New York: New York University Press, 2003), 43–44.

18 The discussion of whether the Anglicism "queer" functions appropriately in Spanish cultural contexts—and particularly cinematic contexts—is deftly tackled by a number of scholars. See, for example, David Córdoba, Javier Sáez, and Paco Vidarte, eds., *Teoría Queer: Políticas bolleras, maricas, trans, mestizas* (Madrid: Editorial Egales, 2005); Oscar Guasch and Olga Viñuales, "Introducción: Sociedad, sexualidad y teoría social: la sexualidad en perspectiva sociológica," in *Sexualidades: Diversidad y control social*, ed. Oscar Guasch and Olga Viñuales (Barcelona: Edicions Bellaterra, 2003), 9–18; Alfredo Martínez-Expósito, *Los escribas furiosas: Configuraciones homoeróticas en la narrativa española* (New Orleans: University Press of the South, 1998); Gema Pérez-Sánchez, *Queer Transitions in Contemporary Spanish Culture* (Albany, NY: SUNY Press, 2007); Chris Perriam, *Spanish Queer Cinema* (Edinburgh: Edinburgh University Press, 2013); Gracia Trujillo Barbadillo, "Desde los márgenes: Prácticas y representaciones de los grupos *queer* en el Estado Español," in *El eje del mal es heterosexual: Figuraciones, movimientos y practices feministas queer*, ed. Grupo de Trabajo Queer (Madrid: Editorial Traficantes de Sueños, 2005), 29–44; and Nancy Vosburg and Jacky Collins, eds., *Lesbian Realities/Lesbian Fictions in Contemporary Spain* (Lewisburg, PA: Bucknell University Press, 2011).

19 Vidal, "Memories of Underdevelopment," 215.

20 Vidal, 214.

21 Daniel Kowalsky, "Rated S: Soft-Core Pornography and the Spanish Transition to Democracy, 1977–1982," in *Spanish Popular Cinema*, ed. Antonio Lázaro-Reboll and Andrew Willis (Manchester: Manchester University Press, 2004), 193.

22 Vidal, "Memories of Underdevelopment," 218.

23 Vidal, 218.

24 Vidal, 218.

25 Vidal, 223.

Part II

Queer Intimacy
• •
Within the Household

3

Turning Around Altogether

● ● ● ● ● ● ● ● ● ● ● ● ● ● ● ● ● ● ● ●

Gyrodynamics, Family
Fantasies, and *Spinnin'*
(2007) by Eusebio Pastrana

NINA L. MOLINARO

The crowdsourced online *Urban Dictionary* currently lists seven definitions for "spinning": "playing records," "group exercise . . . (usually women)," unhealthy fixation on "a relatively insignificant thought or event," bafflement, the art and sport of causing a "spinnie" to look for a "spinner," "lighting a joint," and wavy hair.[1] Additionally, the same site defines "spinnin" (no apostrophe) as the natural happiness that results from the action of turning around in a circle.[2] In a related context, the same physical movement refers, in mechanical terms, to "gyrodynamics," or the rotational dynamics of an object in flight. And more conventionally, spinning has long been associated with the activity of making yarn, producing any kind of filament-based thread, and "fabricating in a manner suggestive of spinning thread, as in spinning a tale."[3] When Spanish director Eusebio "Use" Pastrana assigned to his first full-length feature film the title *Spinnin'* (2007), he invited his audiences to seek the center of gravity in some combination of the aforementioned associations, while adding to the list yet another entry, articulated by one of the protagonists in the latter part of the film. Speaking directly to the filming camera, the character of Gárate

matter-of-factly declares, "The only thing that we six thousand million people in this world do at the same time is to spin with the planet."[4]

Although the English-language word "spinning" has entered the popular Spanish lexicon in reference to aerobic group exercise (although not necessarily by women), it is unlikely that Pastrana had indoor cycling, exercise, or possibly even women in mind when he wrote, directed, and produced *Spinnin'*. The film's title, with its marked elision of the final *g*, simultaneously emphasizes onomatopoeic resonance, suggests a casual and regional American idiom, and introduces the pivotal image of a twirling motion around an axis. All of this is threaded through the literal and figurative "gyrodynamics" of spinning as the movement is reiterated, expanded, and transformed throughout the film, from the initial sight (and sound) of a whirling coin to the last jubilant dance number. In this essay, I argue that the film also prioritizes one particular ideological "axis" and incorporates another ideological "torque" within the motion and the meaning of spinning.

As Ralph D. Lorenz reminds us, in the realm of gyrodynamics, "The spin of objects has analogies with the motion of bodies through space—Newton's laws apply."[5] In complementary fashion, then, people, objects, and even the filming camera itself in *Spinnin'* twist and turn their way through a dizzying array of narrative threads, social themes, and visual aesthetics. To return briefly to the fifth definition from the *Urban Dictionary*, it could also be argued that within Pastrana's filmic universe, material and metaphoric "spinners" and "spinnies" constantly rotate toward one another, looking for (and finding) solidarity, celebration, and the family ties that bind, salvage, and heal. As the film's refrain, reiterated no fewer than six times, reminds us: "Love has sharp edges, the wounds keep you alive." I might suggest, however, that neither love nor wounds, nor the combination of the two, provides the primary magnet for the events and the message of *Spinnin'*.

For the mechanically minded, the movement of spinning depends on the presence of an axis, and "just as the (translational) momentum of an object will remain constant with time unless an external force is applied, so the angular momentum remains constant unless there is an external torque."[6] The challenges, joys, and uncompromising defense of gay fatherhood surely constitute one of the prominent ideological axes in and of *Spinnin'*. To that end, Pastrana's film and Miguel Albaladejo's *Cachorro* (2004) [*Bear Cub*] have been elegantly analyzed by Jorge Pérez as triumphant exercises in expanding the range and possibilities of paternity among and between gay men. More particularly, Pérez maintains that the two contemporary Spanish films demonstrate the ways in which gay male fatherhood "transforms the conventional understandings and cinematic treatments of parenthood and masculinity" such that homosexual fathers can, without selling out to homonormativity, be desiring subjects and objects.[7] In his far-reaching book *Spanish Queer Cinema* (2013), Chris

Perriam, for his part, connects the "ethical texture" of *Spinnin'* to "queer social concerns" and to "a series of critiques of naturalised and naturalising received ideas";[8] among these concerns and ideas, both the nuclear (heterosexual) family and homonormativity are unequivocally revised in the course of Pastrana's film. Pérez and Perriam also underscore the optimistic tone, the political commitment, and the heterogeneous visual style of the project, and they both highlight, albeit in different ways, the axis of "queer politics" as it infuses the treatment of gay male fatherhood.[9]

My intention in the present analysis is neither to diminish the radical import of the film's rejection of homonormativity nor to rewrite Pastrana's exuberant message of hope and camaraderie to and for alternatively envisioned families and kinship structures.[10] At the same time, in a text so obviously devoted to men and boys, to what end does Pastrana employ women and girls? What is the place and purpose of female figures and femininity in a film about biological reproduction, affective communities, and inclusive families? To return to the classifications of "spinning," how might men and boys respond to the role of "spinnies" vis-à-vis the female and feminine "spinners"? *Spinnin'* is, after all, not only a film about two gay men in a committed and, as Pérez rightly reminds us, pleasurable partnership who decide to become fathers and co-parents, although that is undeniably its dominant theme. Along the way, the writer-director and his creative team also incorporate and interrogate the contributions and complications of a heterogeneous range of female characters. These include mothers, daughters, sisters, wives and partners, women lovers, friends, acquaintances, and even strangers.

To revisit the mechanics of spinning, I might submit that women and girls in fact constitute a formidable "external torque" that disrupts the so-called angular momentum of the chief axis of and in *Spinnin'*.[11] One of the evident premises of the film rests on the sociocultural dynamics surrounding biological reproduction, and another derives from the promotion of cohesion and filiation between and among divergent social groups. In both premises, women and girls are fundamental and productive, even as they supplement and subrogate the men and boys around whom the action seemingly revolves. In other words, it is my contention that women and girls alter, in ways both fanciful and fantastic, the "spin" of Pastrana's paean to gay male desire and paternity.

Viewers of the film will immediately grasp that strict linearity and chronology are far from the predominant features of *Spinnin'*, although a cause-and-effect logic paradoxically orients the progression of the plot(s). The whimsical formal proposition, articulated in the first few minutes of the opening scenes, consists of one man's desire to bring to life the 101 different parental kisses of which he has dreamed. At its core, however, the film follows the odyssey of a committed gay couple, Gárate (Alejandro Tous) and Omar (Olav Fernández), as they make their way toward their chosen destination of fatherhood. Gárate,

on one hand, initially resists the idea and the reality of parenthood, but he gradually overcomes his ambivalence and his own conflicted family history. Omar, on the other hand, never wavers in his drive to become a father, and, it is quietly intimated, he will do whatever it takes to achieve his goal. The two men embark on their singular and shared quest in fits and starts, encountering along the way an expanding array of fellow travelers, some of whom reveal a biography and others of whom register only as motifs and metaphors.

All of the narrative threads of Pastrana's film unspool from one or both of the principal (male) protagonists. The first filaments spin off from Omar; in his aspiration to biologically father a child, he unsuccessfully attempts to impregnate his lesbian friend Luna (Carolina Touceda) and his heterosexual friend Asia (Guadalupe Lancho). Both acts have emotional and practical consequences, but neither delivers the desired outcome. In the second thread, when Luna and her common-law wife, Jana (Arantxa Valdivia), subsequently decide to conceive their own child via artificial insemination, they ask Omar to donate his sperm. Gárate playfully sneaks into the donor clinic, and the two men agree to obfuscate any potential paternity by mixing their sperm, although no child is conceived from their efforts. Successful biological reproduction is, nonetheless, very much in evidence in other couples, but the gay men seem to be incapable of (or, alternatively, uninterested in) insemination, to the extent that it is hinted that Omar and/or Gárate may in fact be sterile.

The third strand twists out from Gárate; cast throughout the film as a compassionate observer, he has noticed a young woman, Kela (Zoraida Kroley), who accosts strange men in the street with the question "Do you want to be my partner? I need a common-law partner." After failing to convince any male passerby to help her, she confesses to Gárate that she is HIV-positive and alone, having aided her beloved Quique, a drug addict with AIDS, to end his life. In the second half of the film, Gárate, Omar, and Kela spin off into an unconventional family unit, legalized in a wedding ceremony between Gárate and Kela. The two men assume responsibility for Kela and for her unborn (and possibly HIV-positive) child, arranging for and accompanying her to medical appointments and seamlessly integrating her into their domestic and social lives. After she gives birth to a healthy son, the still-grieving Kela commits suicide and leaves the baby in the care of his doting fathers. The infant magically ages into the young Fernando, who, at the end of the film, raptly watches his mother's filmed testament. Afterward he and Gárate wander outside for some father-son bonding time, and the internal film narrative collapses into the freewheeling exhibition of a spinning crowd, followed by a series of quick-cut scenes of kissing pairs leading (again) to the accumulation the 101 kisses originally envisioned and a miscellaneous sequence of spinning people.

Other narrative lines also emerge as the film advances: Gárate's pregnant sister Luz (Laura Gómez) and her husband, José (Daniel Castro), hope that

their newborn child will be the 6 billionth citizen on the planet; Gárate's widowed father, Zamora (Mario Martín), laments the loss of his first wife and begins an amorous relationship with a woman named Teresa; Omar's client and friend Sara (Charo Soria) fights, and ultimately loses, a legal battle to gain custody of her deceased wife's daughter Adriana (Alejandra P. Pastrana); Omar and Gárate's friend García (Agustín Ruiz) films scenes for his pseudodocumentary project on gay culture and the AIDS crisis, in honor of his HIV-positive ex-partner Ramón; a kiosk owner named Hector (César Sanz) comes to terms with his wife's pregnancy, possibly by her lover Carlos; two policemen (Íñigo Espert and Iker Ortiz de Zárate) engage in a push-and-pull seduction; and an unspeaking couple (María Brea and Beto Carvajal) reel through several cycles of physical attraction and rejection.[12] In addition, two fairy godfather figures, one with a tutu (Guillermo de la Madrid) and the other without (Angel Paisán), hover on the edges of several plots; the perennial second-place Spanish soccer team, Atlético de Madrid, wins the Spanish Cup;[13] and members of the film's crew, together with Useless and Skaiwalker (Eduardo Velasco and Rubén Escámez), episodically bridge the vacillating divide between fiction and reality by introducing written tallies of the number of kisses that have transpired. And last but not least, *Spinnin'* unfurls "spontaneous" dance scenes, a rap sequence, a sing-along, at least one dancing ghost, and a comical cross-dressing reinterpretation of Botticelli's iconic painting *The Birth of Venus*. All of the aforementioned threads are sewn together into the wildly nonconformist film that is *Spinnin'*.

Pérez and Perriam have lucidly theorized the resonances and subtleties of queer nonconventionality in and through the film, particularly as regards gay fatherhood. Along the way, Pérez observes that "the most influential branch of queer studies has assumed that queerness indisputably lies in the deliberate destabilizations of social and cultural norms regarding gender and sexuality,"[14] whereas Perriam echoes Nikki Sullivan's discussion of queerness as "a sort of vague and indefinable set of practices and (political) positions that has the potential to challenge normative knowledges and identities."[15] Any elaboration of queerness must be indebted, in part or in the main, to Eve Kosofsky Sedgwick's brilliant and transformative work on queer identities, and her early formulations continue to inform contemporary discussions of the topic. Among the many designations of the term that she elaborates in *Tendencies* (1993) is the following: queer can refer to "the open mesh of possibilities, gaps, overlaps, dissonances and resonances, lapses and excesses of meaning when the constituent elements of anyone's gender, of anyone's sexuality aren't made (or *can't be* made) to signify monolithically."[16] For all of these scholars, then, queerness emphasizes resistance, relationality, and extra- and nonnormativity, all of which are abundantly on display in Pastrana's film.

If one can argue, as Pérez has, that the writer-director of *Spinnin'* effectively "queers" the ideological axes of fatherhood in general and gay fatherhood in

particular, how and when do women and girls fit into this "family" picture? From among the innumerable discussions of gender, I might, if only for the purpose of my current analysis, signal R. W. Connell's contribution: *"Gender is the structure of social relations that centres on the reproductive arena, and the set of practices (governed by this structure) that bring reproductive distinctions between bodies into social processes.* To put it informally, gender concerns the way human society deals with human bodies, and the many consequences of that 'dealing' in our personal lives and our collective fate."[17]

Gender, according to Connell, is relational, social, and corporeal. Although "queer" and "gender" can certainly lean toward, and even fully embrace, Sedgwick's "lapses and excesses of meaning," gender registers, at least in the context of the women and girls featured in *Spinnin'*, as differential, dual, and inflected by biology. How do queerness and gender collide and collude around the female characters in a film text that establishes its base at the intersection of gay fatherhood and homoeroticism?

It is telling that the first female presence to interrupt the "happily-ever-after" romance between Gárate and Omar, with which the film commences, is spectacularly absent. After a brief visual sequence of seduction in which the two men slowly rotate around one another while comparing their own lists of likes and dislikes, Gárate discusses with his filmmaker friend García his intention to visit the grave of his deceased mother, Adela, on the occasion of her birthday. It would seem, at least from this initial exchange between men, that in a film about parenthood some mothers belong outside the visual frame. Given all of the visible evidence in a narrative so insistently focused on the impetus for and consequences of biological reproduction, the reality of maternity insistently informs, from the outset, the gyrodynamics of gender, at least for the men who want to create a new family.

Though she remains invisible within the slightly disjunctive present of the narrative, the character of Adela is, at a crucial moment of crisis in the primary father-son relationship, reanimated thanks to Gárate's memory. After his father, Ricardo, stomps off in midconversation, the adult son recalls and relives his family's excitement during the 1974 soccer tournament, as well as his father's distress when Atleti loses the semifinal championship game. Using the visual technique of a washed-out chromatic palette to distinguish the past from the more vivid present, the camera prioritizes the grieving paterfamilias, as his wife and two children gather around him and try ineffectually to console him. During the recovered memory, Gárate's smiling mother sits silently on the couch near her daughter and then steps in to hug her son, in the absence of his father. In a subsequent scene, located immediately after the televised game, the young Gárate lies alone in his room and then steps momentarily to the window in order to look down at his father, seated on the stoop below. Mother and daughter have disappeared entirely from the nuclear family, which has been reduced to

father and son, both of whom will continue to dominate the screen and the story many years after Adela's death.

Gárate and Ricardo will, however, continue to champion their favorite soccer team and to develop deep, though conflicted, ties of affection to one another, and to other men, via the game itself. In the former context, the omnipresent camera-eye of García films several "real" Atleti fans outside the stadium. Curiously, all are men, and the only female presence to intervene in the pseudodocumentary, a young girl, stands mute beside the much larger and more vocal man, presumably her father. In the latter context, Gárate's amateur soccer team is composed entirely of men, gay and straight, and the only public for their haphazard matches would appear to be his father. Ricardo shows up on two separate occasions, but he cannot stay for the first match, and the next time he only seeks an audience with one of the players who also happens to be a priest. We are left to wonder, in a film that stresses the joy of inclusion and the pain of exclusion, where all the women and girls have gone. Even within the privacy of their own homes, soccer fans are men, with the possible problematic exception of Kela, which I will discuss subsequently.

The absent Adela casts an equally long shadow over her widower husband, who can and does still count the number of years, months, days, and minutes that have elapsed since his wife's death. Ricardo periodically resurrects his spouse in the conversations that he sustains with their adult son, but he shares no scenes or dialogue whatsoever with his pregnant daughter or her husband. The male axis spins relatively unimpeded during a discussion that occurs early in the film, during which Ricardo both berates Gárate regarding his "choice" to be gay and exhorts his only son to produce offspring, in part because, he reasons, Adela would have liked to have been a grandmother to her son's children. Apparently, the child to whom the visibly pregnant Luz will give birth does not count in this particular reckoning. The verbal duel between the two men ends abruptly when they argue and Ricardo departs in anger, but not before the oldest father in the film voices his own longing for a grandson to carry on his family's name. Not coincidentally, he receives his wish by the end of the film, when Gárate and Omar "father" a son, whose biological progenitor is out of the picture well before the child's birth and whose mother leaves the family frame shortly thereafter.

The character of Adela, named only by the priest–soccer player, is not the only absent female figure to tilt, from beyond the grave, the choices, actions, and future of her family. Although, thankfully, not all maternal figures expire or are expired in Pastrana's film, another deceased mother leaves behind a traumatized family. In this instance, however, she merits neither a name nor a flashback, perhaps because she has left behind only female family members: a wife, Sara, and their two young daughters. This second mother's absence is actively grieved by various female figures because it provokes the dissolution

of her family. As "the other mother," Sara struggles, unsuccessfully because of the laws in play during 1995 in Spain, to exercise her parental rights vis-à-vis the two daughters that she shared with her companion. In spite of her best efforts (and those of her lawyer, Omar) she loses Adriana to the child's biological father and his accommodating and cheerful wife. Even her heartfelt articulation of loss is erased, later in the film, when two men (a stranger at the cemetery and Gárate) subsequently steal her lines, uttering them to one another in a different context.

Heteronormativity is further promulgated during the departure scene, when the (male) object of Adriana's affection appears with a heart-shaped card and the two adolescents exchange "I love you's." Though the overt message of loyalty and uncomplicated caring is endearing, it might strike the viewer as odd that the children, these children and all successive children, seem poised to emulate the gendered norms of heterosociality, whereby the girls will follow where the boys lead. Once Adriana rides off into her father-centered future, however, her narrative thread and that of her matrilineal family fade from view.

Given the escalating urgency of fatherhood, one sacrificial mother rises above all others thanks to her decisive contribution to Gárate and Omar's dream of paternity. The character of Kela receives more screen time, and surely delivers more lines, than any other maternal figure in *Spinnin'*. Because her fate is inextricably intertwined with her role as the quasi-surrogate mother of Gárate and Omar's son, she evolves and proceeds through time with them; as one example, she enters the narrative only when Gárate and/or Omar "sees" her. Approximately the first half of the film is dedicated to bringing the three aspiring parents together, whereas the second half tracks Kela's pregnancy, childbirth, and eventual suicide. Though she carries with her a sexual and romantic history, as is made painfully apparent in the scene during which she physically supports her dying boyfriend as they cross the street together, once she confirms her pregnancy (thanks to Omar's extra pregnancy kit), it never occurs to her to do anything but prioritize the life and health of her unborn child. Only after she has given birth, co-parented during several months with Omar and Gárate, and received assurance that her son is healthy can Kela prioritize her own grief and eschew her maternal obligations. In subsequently ending her life, she can therefore put an end to her constant anguish and, at the same time, foment the happy ending for the patrilineal family unit at the heart of *Spinnin'*.

In a film so bounded to relationships of all kinds, it is significant that Kela imagines a way to remain forever present in her son's memory, even after her death. Her filmed testament transcends the limits of time and can be watched and rewatched by both the intended intradiegetic viewer (her son) and the limitless extradiegetic viewers. As she speaks directly to the camera, the young woman confidently reiterates some of the many optimistic messages of Pastrana's film by claiming that they constitute her legacies to her heir: "The most

important thing that I have is the strength to combat unjust things and the tenacity to fight for the things that I believe in. . . . I have the assurance that we are all equal and that we are all different. But they should treat us the same so that we can be who we are. I have the certainty that love can overcome anything even though love may have sharp edges and the wounds from those sharp edges keep you alive."

As the mother who has contributed the most to the realization of Gárate and Omar's vision, she may be gone, but, like Gárate's mother, Adela, she will not be forgotten by her (male) child. However, such rememoration takes a distant backseat to the ongoing importance of the father-son dynamic. The last shot of Kela, inserted after her testament and after Gárate and Fernando have agreed to leave the apartment for the park, portrays a Madonna-like image of an unspeaking and slightly smiling mother with her eyes cast downward. This image is quickly subsumed by the multiple endings, all of which are optimistic and full of physical movement.

Spinnin' does not, however, rely exclusively on adult mothers to torque the axis of gay fatherhood. Where there are mothers, there are usually children, and that is undeniably the case in Pastrana's film. Early on, the camera focalizes Gárate's perspective and settles on two young girls at play in the street. As one among many techniques designed to integrate the disparate narrative threads throughout the film, the girls' voices precede, by a few seconds, their image, with the notable effect that spectators hear the sounds of children as we watch Gárate and Omar embrace. The camera then moves seamlessly to the street scene. One of the girls, Adriana, is dressed in a Superman suit, as a possible visual counterpart to the recurring male figure in a tutu who joyfully skips through this scene and others to come. Though she is at the center of a heated custody battle that will eventually tear her away from her surviving mother and her (step)sister, Adriana is positioned from the outset as a maternal figure who is wise beyond her years. She regularly comforts and advises the much older Gárate, who self-identifies as a child and, in several sequences, plays children's games with a man who may be homeless but nonetheless takes Gárate to task for his charity. Adriana also calmly urges Sara to give up her legal conflict, promises to return once she has reached the legal age of eighteen, and comforts her mother before her departure.

In the audience's first extended exposure to her, however, Adriana, like many of the characters in *Spinnin'*, is literally folded in on herself because she has lost her mother; she states despondently to Gárate, "I tried to make the world spin backward but nothing changed. My mother has still died." Female child and male adult both concur that they have loved their mothers "to infinity and beyond," and when Adriana admits to having a second mother, Gárate expresses envy: "What I wouldn't have given to have had two moms." In theory, and at this moment, motherhood looks a lot more viable than fatherhood to Gárate,

but that changes as he and Omar move ever closer to fatherhood. As evidence of this metamorphosis, Adriana asks Gárate for advice on her budding love life, advice that he gives and she implements with great success; she also declares at this same moment, "It would be cool if you were my dad." But adolescent girls with complicated family ties are not interchangeable with infant sons in the film. Once Adriana has made the decision to return to her father, and once she has realized her own dream of receiving the affection and attention of a boy, her work in the narrative is done, and the focus moves to babies and the future.

It bears noting that not all female figures in the film are constrained either by their maternal roles or by their relationship to the developing family unit headed by the two protagonists. Two pivotal examples come to mind. The first spins off from the unnamed woman who repeatedly pursues and is pursued by her male lover. Though hers is the first visual image of a woman to encroach upon the mostly male visuality of *Spinnin'*, she and her male counterpart are always viewed in tandem. Secondly, shortly after, Gárate's initial discussion-confession regarding his mother, the camera films a woman crouched on a public bench with her back turned toward an obvious (male) admirer. The man offers a gift to her, and they enthusiastically embrace. The subsequent six installments, interspersed throughout the film, follow the pair as their passion waxes and wanes, leading to episodes of reciprocal violence followed by emotional reunions.

With the time lapse between the birth of Fernando and his transformation into a young boy comes an equivalent disruption in the couple's biography. In their eighth and final encounter, they are wearing different clothes, and the long, flowing hair of each is pulled into a bun.[18] They sit on opposite ends of, presumably, the same park bench where they first embraced, and as the camera pans out, we see that each person is now juggling a baby carriage. Because they walk in separate directions when they depart, the audience is led to believe that each has begun a family with someone else, but their physical desire for one another remains unabated, as evidenced by their prolonged kisses. They are, visually and thematically, a unit, and their separate familial obligations do not, in the final analysis, impede their ongoing mutual attraction. This unavoidable mutual attraction is echoed in the emerging sexual dynamic between León and Samuel, the two dueling policemen. In the case of the heterosexual couple, however, the way in which their relationship is filmed emphasizes complementarity and inevitability, both of which also imbue Gárate and Omar's experience of paternity.

Perhaps the strongest "drag" on the axis of gay fatherhood derives from the characterization and evolution of the lesbian couple, Luna and Jana.[19] Depicted as harmonious and endlessly supportive of their male and female friends, they are integrated into the various stages of the drive toward paternity, either as participants or as enthusiastic cheerleaders. Like Gárate and Omar, they

eventually distinguish themselves as an independent and potentially functional family unit, but only after they have exhausted other options involving their two male friends. Luna in fact characterizes Omar's failed attempt to impregnate her as "against nature," a logic that might also be applicable to his similar failure with the heterosexual Asia. Once the prospective fathers have integrated Kela and her unborn baby into their orbit, however, the lesbian couple announces to the camera that they too are pregnant, with a daughter whom they have already named Lucía. With the pregnant Luna in front, the two women are framed together in a series of medium shots as united, hopeful, and clear-sighted, and they offer a series of intercalated declarations regarding their paradoxical status, within the film and during the historical moment:

JANA
—I like to fantasize about a world without prejudice but it isn't this world.

LUNA
—It's not true that homosexuals are in fashion.

JANA
—In some environments, gay men are in fashion. But us? We simply do
 not exist.

LUNA
—Perhaps our daughter will live in a better world and these things won't
 be spoken of.

They cement their physical presence, their right to conceive and parent their daughter, and their romantic partnership with a sustained kiss, and then they, like the female figures before them, fade from view.

The public does not get to witness the birth or growth of their daughter because this femicentric family unit disappears from the narrative progression once Kela definitely enters the picture. Though the lesbian couple has temporarily interrupted the "spin" of gay fatherhood, same-sex parenthood is not an equal opportunity venture, and focus must win out. In one of the final scenes, the young Fernando and the daughter who has been born to Héctor, his wife, and her lover appear on screen (and, in another nod to heteronormativity, run off together after Fernando declares that Ana is one of his girlfriends). The visual and narrative absence of Lucía and her mother gives the lie to Luna's stated hope that their daughter will live during better times, although "these things" are still not spoken of in the hypothetical future inhabited by the various nonnormative families.

Before their pregnancy, however, the two women are arranged as complements to the protagonists. In the initial scene, in which the two couples discuss and explore co-parenting, each woman sits by one of the men, Gárate

strokes Luna's hair as she lays her head in his lap, and the four-way conversation is relaxed and affectionate, amid abundant food and drink. When Luna and Jana next appear to announce that they are getting married, Luna declares to Omar, "We'd better hurry up with our thing, right? I'm going to be a married woman." And hurry up they do. Amid a tangle of sheets and extensive backlighting, the temporary couple is playful, affectionate, and honest, with the two bodies explicitly on display. Omar and Luna explore and enjoy each other's bodies, whereas Gárate and Jana engage in a flirtatious game of "what if" before hurriedly cutting it off in favor of watching a movie.

Spinnin' offers up at least five complementary conclusions. In the first, the young Fernando watches the film of his mother as she tenders her final words of advice. Then Gárate enters the frame and suggests that father and son go to the park to play catch. As Omar joins them when they exit the building, the happy family is absorbed into an extensive crowd scene, filmed from various angles, of twirling people. The fourth conclusion follows Gárate's announcement of 101 kisses, which are then quick-cut into a progressive series of images, interspersed with shots of a blackboard on which Useless and Skaiwalker cross off successive numbers as the kisses unfold. In one last commentary on the theme and reality of gay desire, the 101st kiss is bestowed by Useless on Skaiwalker. And the fifth conclusion features a series of outtakes of the crew, the cast, and, presumably, random members from among the extras and the observing crowd, all of whom spin themselves or one another. By the final frames, the spinners have definitely eclipsed the spinnies.

By the end of Pastrana's film, the original whirling coin has come to rest on one side. Sons and daughters have been born, and Spain has progressed toward (but not yet arrived at) 2007, the year of the debut of *Spinnin'*, and toward more legalized rights and options for more people. The 6 billionth world citizen has long since appeared, and we all continue, for better and for worse, to revolve in consonance with the planet. Gárate and Omar's desire for their own family has come to fruition, and any accompanying torque has been abandoned or revolved itself into stasis. The difference, duality, and biology associated with gender in the film, together with the resistance and nonnormativity of queerness, have spun themselves out in favor of extended relationality and family unity. Or wouldn't it be nice to think so.

Notes

1 "Spinnin," *Urban Dictionary*, accessed September 21, 2017, http://www.urban dictionary.com
2 "Spinnin."
3 "Spinning," dictionary.com. *Spinnin'* was released selectively for several LGBTQ film festivals during November and December 2007, although the official release

date in Spain is listed as November 21, 2008. See Chris Perriam and Darren Waldron, *French and Spanish Queer Film: Audiences, Communities, and Cultural Exchange* (Edinburgh: Edinburgh University Press, 2016), for a comprehensive analysis of contemporary LGBTQ film festivals in Spain and France, including some of the festivals where *Spinnin'* first appeared. Pastrana's film received the following awards between 2007 and 2008: Best Feature Film (Fiction Category) and Best Actor (Festival Internacional de Cine Gay Lésbico de Andalucía); Best Full-Length Feature Film (Festival Internacional de Cine LGBT de Barcelona); Audience Awards for Best Film and Best Spanish Work, and Jury Award for Best Actor (Festival Internacional de Cine LGBT de Madrid LesGaiCinemad); Audience Award for Best Film (Festival Internacional de Cine LGBT de Andalucía aLandaLesGai); Audience Favorite (Festival Internacional de Cine LGBT de Bilbao Zinegoak); Honorary Special Mention by Jury (San Diego Latino Film Festival); and Best Feature Film and Best Actor (Festival IDEM de Córdoba).

4　All translations are mine, unless otherwise indicated. In some cases they coincide with the English-language subtitles available in the version of the film that was released for U.S. audiences in 2010, and in other cases they do not.

5　See Lorenz's fascinating and accessible book *Spinning Flight* for a thorough analysis of the mechanics of gyrodynamics in the context of spinning objects. Ralph D. Lorenz, *Spinning Flight: Dynamics of Frisbees, Boomerangs, Samaras, and Skipping Stones* (New York: Springer, 2006), 2.

6　Lorenz, 2.

7　Jorge Pérez, "Who's Your Daddy? Queer Masculinities and Parenthood in Recent Spanish Cinema," in *The Dynamics of Masculinity in Contemporary Spanish Culture*, ed. Lorraine Ryan and Ana Corbalán (New York: Routledge, 2017), 99. Pérez has, to my mind, crafted the definitive argument thus far on the interrelated issues of masculinity, sexuality, and fatherhood in the context of Pastrana's film. I intend my argument as a complement to, and in dialogue with, his essay.

8　Chris Perriam, *Spanish Queer Cinema* (Edinburgh: Edinburgh University Press, 2013), 27. Perriam cites Paco Vidarte's *Ética marica* (2007) in his nod to queer ethics (Perriam, *Spanish Queer Cinema*, 27). I might also mention in this context Colleen Lamos's intelligent exploration of "the divergent ethical aims and practices of these two competing theoretical paradigms for the contemporary study of same-sexuality: on the one hand, *lesbian and gay theory*, and, on the other hand, *queer theory*" (Colleen Lamos, "The Ethics of Queer Theory," in *Critical Ethics: Text, Theory and Responsibility*, ed. Dominic Rainsford and Tim Woods [Basingstoke and New York: Macmillan and St. Martin's, 1999], 142).

9　*Spinnin'* also merits a brief mention by Helio San Miguel as the epitome of "modern, open and cosmopolitan gay urban contemporary society" in Spain. See Helio San Miguel, "The New Ethos of Gay Culture and the Limits of Normalization," in *(Re)viewing Creative, Critical and Commercial Practices in Contemporary Spanish Cinema*, ed. Duncan Wheeler and Fernando Canet (Bristol: Intellect, 2014), 86.

10　See Pérez, "Who's Your Daddy?," 99–102, as well as the accompanying list of references, for a cogent discussion of some of these kinship structures.

11　For the purposes of my analysis, I have adapted Lorenz's summary of gyrodynamics: "Just as the (translational) momentum of an object will remain constant with time unless an external force is applied, so the angular momentum remains constant unless there is an external torque" (Lorenz, *Spinning Flight*, 2).

12 In a 2007 interview, Pastrana characterized the miming couple as "a metaphor in which we live the extremes." "Entrevista a Use Pastrana," June 20, 2007, http://www.alejandro-tous.es/entrevistause.

13 As Perriam and Pérez have noted, the film is intentionally set in September 1995, well before the legalization of same-sex marriage in Spain, in order to highlight the future legal advances for same-sex couples. In addition to documenting the embedded homophobia of the time, and giving cause for celebration regarding the legal rights and social advances achieved by Spain's LGBTQ communities as of 2007, I might also note that, in one of the few nods to mimeticism in the film, 1995 corresponds to the year in which Atlético Madrid actually won the Copa del Rey (King's Cup). All of the principal characters are depicted as ardent fans of "Atleti," and García also interviews and films several, presumably "real-life" fans during the pertinent Atlético Madrid matches.

14 Pérez, "Who's Your Daddy?," 99.

15 Quoted in Perriam, *Spanish Queer Cinema*, 10. I do not rehearse the problematic transference of the term "queer" to Spanish contexts. See Perriam's discussion (*Spanish Queer Cinema*, 10–15) for a summary of the issues and a list of secondary references regarding this debate.

16 Eve Kosofsky Sedgwick, *Tendencies* (Durham, NC: Duke University Press, 1993), 8.

17 R. W. Connell, *Gender* (Cambridge, UK: Polity, 2002), 10 (emphasis in the original).

18 In the previous six scenes, the couple are wearing the same clothes. Both actors have long dark hair, sometimes kept loose and sometimes pulled back throughout the six sequences.

19 Perriam rightly notes that these two women are "conventionally beautiful, long-haired, [and] golden-skinned," and that their physical beauty may in fact coincide with Lucille Cairns's critique of the ways the "homogenizing dream-machine" co-opts the lesbian imagination. Perriam, *Spanish Queer Cinema*, 34.

4

Framing Queer Desire

• •

The Construction of Teenage
Sexuality in *Krámpack*
(2000) by Cesc Gay

ANA CORBALÁN

The Spanish film industry produces a significant number of coming-of-age nar-
ratives featuring visual representations of youth navigating diverse social, cul-
tural, and sexual experiences on the path to adulthood. These movies address
the radical loss of innocence and reflect the search for identity endured by the
child or teenage protagonists. The genre—which can be categorized as *Bil-
dungsfilm*, a term used by Thomas Deveny to refer to films of "growing up"
starring children or adolescents[1]—attempts to establish empathetic connec-
tions with moviegoers. Far from symbolizing the universal childhood experi-
ence, these protagonists represent unique and defined characters who belong
to specific cultures and who discover new friendships, awaken to love, and expe-
rience betrayal—all with the openness unique to adolescence.

Bildungsfilms straddle the line between social conformity and nonconfor-
mity, conveying the complexities that revolve around the process of growing
up. These narratives explore specific social environments in which the main
characters construct and reinforce their senses of identity, friendship, and sex-
uality. The prominence of young characters appeals to a wide variety of view-
ers and focuses on the common anxieties that constitute the most defining

elements of adolescence. In this regard, Timothy Shary argues that youth films "question our evolving identities from youth to adulthood while simultaneously shaping and maintaining those identities."[2]

According to Carolina Rocha and Georgia Seminet, "Children and adolescents are appropriated to mediate issues of identity and difference, history, class and gender, as well as their place in discourses that question the construct of family and nation."[3] By taking on the debate regarding the construction of teen identity, these films problematize the assumption of "the wisdom of adult society."[4] Anne Hardcastle, Roberta Morosini, and Kendall Tarte add that they "portray a typical coming of age for their adolescent protagonists as they move from childhood towards adulthood, embrace their emerging sexuality and a new awareness of themselves and their world."[5] In youth films, the main protagonists are unprepared to face an impending adult world, against which they rebel while simultaneously losing their innocence. As a result of this rite of passage, teen characters serve as the vehicles though which cinema questions and critiques societal norms: "As adolescents are exposed to, and contribute to, changing attitudes toward sexuality, drug use, and child-parent relationships, traditional assumptions underlying cultural values and standards are questioned through their representation on screen."[6]

Regarding the loss of innocence, one of the most noticeable characteristics of the *Bildungsfilm* is that it displays youth sexuality. For this essay, I concentrate on queer youth films, a genre that "understands cinematic sexualities as complex, multiple, overlapping, and historically nuanced, rather than immutably fixed."[7] While mainstream cinematic productions marginalize homosexuality and portray their gay or lesbian characters negatively, queer cinema questions and deconstructs the ways that patriarchal hegemony deems heterosexuality and monogamy as the normal and desirable sexuality.[8] According to Susan Driver, "Existing in between the categories of adult identification, in a state of flux and transition to sexually aware and contested selfhood, queer youth present unique predicaments to the imaging and conceptualization of desiring subjects on the screen."[9] Moreover, these films have a political message, "as they enable ways of seeing and imagining young romance beyond the heteronormative gaze and narrative structures while borrowing and resignifying elements from teen film genres."[10] The representation of queer youth in contemporary cinema acknowledges the traditional invisibility that queer adolescents have experienced on-screen and facilitates the normalization of their sexual desires. This genre is also political because it problematizes heterosexual hegemony in cinematic depictions of youth and opens up spaces for different approaches to sexuality. Along these lines, Shary proposes the necessity to accept and integrate "homosexual teen characters into plots that further normalize queer lifestyles and depict queerness as one of many qualities that youth may encounter on their path to adulthood."[11]

Krámpack: Growing Up and Coming Out

Beyond the imperatives of mainstream cinema, this chapter draws attention to an array of cinematic queer practices that are created with the aim of decentering heteronormativity and embracing tolerance and acceptance in the viewer. By focusing on the construction of teen sexuality, *Krámpack* (2000) [*Nico and Dani*] by Cesc Gay addresses new portrayals of same-sex desire among adolescent figures who have been ignored in other cinematic productions.[12] As I will demonstrate in the following pages, this movie has a clear political agenda that aims to naturalize queer desire twofold: by avoiding explicit sexual scenes that could cause discomfort in its "straight" spectatorship and by showing queer sexuality as a regular practice that is totally accepted and integrated in the narrative. Hence, *Krámpack* openly questions heterosexuality as the standard form of citizenship and adulthood in Spain while normalizing homoeroticism. As Eve Kosofsky Sedgwick observes, a queer identity formation offers an "open mesh of possibilities, gaps, overlaps, dissonances, and resonances, lapses and excesses."[13] Although the film was released five years before the legalization of gay marriage in Spain, at that time, an active fight for the rights and visibility of the LGBTQI community was already taking place. Therefore, this audiovisual production is successful in portraying the coming-out process and creating a transitional space that opens doors to the construction of other identities traditionally disregarded by mainstream cinema.

Krámpack is based on a homonymous play by Catalan Jordi Sánchez. It was a box office success garnering almost 1 million spectators, has been translated into several languages, and has won many prizes at Cannes, Málaga, Chicago, Giffori, and Valencia. The plot unfolds in a relatively straightforward fashion through a linear narrative. Nico (Jordi Vilches) and Dani (Fernando Ramallo) are two teenage friends spending ten days of summer together at Dani's beach house, while his parents are on vacation in a different country. The clear absence of parental figures allows them to more openly explore their sexuality and independence. By lacking all adult supervision (except for a young housemaid and an English tutor), both friends have the freedom to discover their bodies, cavort all night long, drink and take drugs, enjoy their free time, and flirt with two girls—in sum, to do anything they feel like doing. Even though they face the typical adolescent issues of alienation, rebellion, angst, and conflict, these topics seem trivialized in the film. Free and without parental control, the protagonists only want to meet girls and lose their virginity before they turn seventeen. During their days together, they engage in practices of mutual masturbation that allow them to discover their sexuality; however, their friendship is jeopardized when Dani realizes he has homoerotic feelings for Nico, while the latter disregards this desire and pursues a sexual relation with Elena (Marieta Orozco). The need to come to terms with their sexuality is determinant for their relationship.

It follows, then, that the transition from childhood to maturity brings with it an inflection point defined by an existential crossroad (Erikson 16).[14] Toward the end of the story the teens reconcile and Nico takes the train back to the city, bringing to a close the summer of growing up and coming out.

The recurring image of a moving train in the opening and closing scenes of the movie symbolizes movement and change. To begin with, the train displaces Nico from his regular environment, making him prone to new adventures. The opening scene also foreshadows the rest of the narrative when Nico is in a wagon trying to flirt with a young French girl, who is also traveling to the coast. This initial encounter sets the tone of the movie as a light comedy that revolves around teen sexuality. As the train stops and Nico arrives at the beach town, the camera follows this moving protagonist, focusing on how he carelessly crosses the tracks to greet his friend Dani. After a series of transitional events, Nico takes another train back to the city, and in the final scene he stares at another young girl who enters the railcar. Given this circular structure, the return journey is fundamental for understanding the protagonist's coming of age. Although Nico is the same person who rode the train at the beginning of the film, the viewer perceives how he has changed throughout the summer. Accordingly, this train symbolizes the transition in the main characters' lives and the in-betweenness of their adolescence. Santiago Fouz-Hernández considers that the tracks "become a positive symbol of progression, as the boys . . . seem to leave traumas behind and welcome a more flexible model of masculinity."[15] Indeed, the image of the train connects the past and the future. Nico returns home completely transformed after a summer in which he embarked on homosexual and heterosexual experiences, and the discovery of his sexuality helps him accept queerness as part of his path to adulthood.

Further emphasizing the concepts of movement and change are the juxtaposed, rapid cuts that characterize the flow of the plot and set the tone for a film that highlights the rapidity of the growing-up process. All of them start with a fade to black in which a sentence appears, foreshadowing what is going to happen in the following minutes: "Dani: I say what I say. Let's do it."[16] Those cuts are framed by a sentence written on a black screen that functions as an aesthetic strategy to mark the progression of time: "Nico: not so fast that you hurt me." This framing makes the narrative evolve in a linear way and clarifies the storyline to make it more accessible to the viewer. The speed of the film is also enhanced by contemporary upbeat music, which sets the rapid tone of the scenes and adds to the visual and emotional impact of the story. The effect of the music is energizing and marks the fast action that defines Nico and Dani's summer transformation.

Another image that evokes movement is the sea. *Krámpack* is set in a coastal town near Barcelona. The camera often lingers on the panoramic landscapes. Except for a few sexual scenes that take place in Dani's bedroom with soft

illumination, most of the film is shot at exterior locations, with a scenography that enhances the water on the Costa Brava, which could symbolize the freedom that both friends experience in an open space. The scenery contributes to the portrayal of male sexuality through a positive lens, aided by a bright illumination that highlights images of the beach. The coastal town is a particularly apt setting for the exploration of the significant changes in the lives of the protagonists. Correspondingly, Fouz-Hernández suggests that "the summer proves a beneficial, life-changing experience for both boys, and their different sexual tendencies do not seem to get in the way of their friendship."[17] In fact, the summertime—a familiar trope in coming-of-age movies—provides the perfect venue for exploring friendship, love, and sexuality. Both friends are seeking validation as adults, and to achieve this goal they engage in a series of straight and gay sexual practices that help them discover their own identity. It is a summer of exploration and adventure that depicts modern-day Spain through the thoughts and actions of its youth. It is important to reiterate that both Nico and Dani are portrayed positively, which encourages the audience to respond more empathetically to their process of maturity, a process characterized by coming of age and coming out.

The director declared in an interview that *Krámpack* is a film about feelings and emotions between two friends with similar personality traits. He added that this is not an action movie and that it has an open ending.[18] Yet he never considered his film to be a queer production. Perhaps the filmmaker's intentionality explains the ambiguities that revolve around the queer gaze on the screen. Both protagonists become adults once they have learned to accept the uncertainty of their sexual experiences. *Krámpack* is defined by its indeterminacy and in-betweenness, underscoring the need to discuss youth queer representation for a wide audience in a more inclusive way than is traditionally done in gay and lesbian films. Cesc Gay presents a verisimilar narrative of coming out, falling within the parameters of the genre and depicting a positive representation of gay and straight sexuality. By focusing on the emotions, concerns and interests of its two main characters, the script challenges the expectations of normative parameters of heterosexuality in contemporary Spain. In addition, the film positions itself beyond a simple coming-out narrative. The director insists that his movie mostly addresses friendship instead of desire or sexual identity.[19] Although the process of coming out is a constant motif that determines the diegesis of the film, I agree that homoeroticism is not a central element in the cinematography. In fact, *Krámpack* explores queer youth by celebrating and exploiting the discovery of homosexual desire through a sensitive and sympathetic lens that delves into the feelings of its main characters. The camera tracks the changes that characterize Dani, a sixteen-year-old who engages in several masturbation practices with his buddy, Nico. The activity starts out as merely entertaining but evolves into a strong sexual attraction on

the part of Dani toward Nico, jeopardizing their friendship. Dani needs to come to terms with his homosexuality, and he shares with the viewer the difficulty that gay teenagers experience when they struggle to accept their sexual identity. Echoing Susan Driver's assertion, "Queerness is portrayed as an active verb, a doing, a growing, and a maturing into agency."[20]

According to Robin Griffiths, "Explorations of sexuality and cinema in Europe are imbued, possibly more than any other, with an almost unrelenting determination to venture into those unknown and uncharted realms at the edges of celluloid subjectivity, embodiment and desire."[21] *Krámpack* focuses on sexually active youth and offers a complex approach regarding queer identity, since the main characters' sexualities are based on experimentation with homoeroticism. Mostly, the film employs a gay gaze, but it also centers on the process of growing up, drawing on elements of traditional approaches to coming-of-age stories, such as the transition from adolescence to adulthood, the experience of sexual awakening, the development of friendship, and the search for one's identity. Moreover, *Krámpack* relies on identity construction and coming of age as a rite of passage, paying special attention to the transformation of the main characters into adults. By focusing on the protagonists' subjectivity, the film examines the crossroad at which Nico and Dani must decide their sexual orientation, facing conflicting values and anxieties. However, as Elena Boschi notes, "*Krámpack* minimises conflicts because its protagonist never finds himself confronting overt hostility. Dani's parents are not there, every adult character enables his new experiences, and the other teenagers never tease him for his sexuality."[22] Thereby, Dani does not struggle to accept his queer sexuality, since he has the support of his English tutor, who reassures him that having a "special friend" is something normal, and that she used to have a very close female friend in high school, comparable to Dani and Nico's relationship. She even finds them sleeping in the same bed in two scenes and smiles at them with understanding. Likewise, an older writer, Julián (Chisco Amado), who almost doubles Dani's age, invites him to a dinner at his place with other gay men. Dani wants to become a writer and admires Julián, but the situation at Julián's place is awkward, foreshadowing the quasi-sexual encounter that Dani will have with him later on. By portraying queer sexuality through a positive lens, the film defines the main characters by their affective, social, emotional, and sexual relationships, and draws in the mainstream viewer, presenting homosexuality as a normal and acceptable identity.

Notably, the first twenty minutes do not indicate the presence of any queer sexuality in the film. The first sequences center on the traditional heteronormative expectations of two teenagers in the summertime, and the camera follows Nico and Dani's adventures, focusing on how they flirt with two girls by the beach. Both friends have decided they will lose their virginity that summer, and they consistently work toward achieving that goal. According to

Santiago Fouz-Hernández and Alfredo Martínez-Expósito, male teenagers in films "feel pressured to 'perform' their assigned gender role and establish a firm male identity in front of their peers, as well as reaffirm the heterosexuality that is taken for granted by the social majority."[23] That is why Dani buys twelve condoms to get ready for their first one-night stand with the two girls, while they continue bragging about their sexual prowess. In this regard, Fouz-Hernández also mentions that "issues of gender stereotyping are crucial and sensitive in films that deal with 'teenage' representations and 'coming out' narratives, given the kids' age and the symbolic value of adolescence as a key moment in the development of one's gender and sexual identity."[24] Given the film's ambiguity, it is hard to determine if the protagonists' queer performance is temporary or constitutes a determinant factor of their coming out. For example, Nico is a master of performing hegemonic masculinity, as can be observed in several instances: in one of the first scenes he is proud of his big Adam's apple, which is displayed in a close-up shot, and he explains to Dani that "women like this: it is a sign of strength, virility and potency." During the film's earliest sequences, the viewer perceives only a typical adolescent movie about boys and girls flirting and performing adult roles. Despite being only sixteen years old, the boys act as if they are older: they dress up as men when they want to impress the two girls at their private party; they drink—pretending to be familiar with all kinds of adult beverages; they take drugs; and they smoke on a daily basis. With this performance, their bodies serve as explicit references to their growing-up process. Overall, they are liberated teenagers who spend a summer free of parental control or surveillance. Both friends become sexually active while they discover who they are and what they want. In this sense, the movie depicts the sexual awakening and social standing of two adolescents who experience the end of their innocence through sexual initiation.

Framing Queer Desire

As Henry A. Giroux points out, "It has been through the body that youth displayed their own identities through oppositional subcultural styles, transgressive sexuality, and disruptive desires."[25] Exploration of the main characters' bodies defines the narrative of the film. Echoing Giroux's assertion, Dani's and Nico's bodies are a terrain for pleasure and sex. It is in the bedroom scenes where they openly explore the potential of their queer sexuality. The first "krámpack" takes place without any intradiegetic or extradiegetic music, and this lack of soundtrack enables the viewers to pay closer attention to the characters' mutual masturbation. In the first scene that displays how they masturbate together, Dani switches off the light, enhancing the ambience, and the soft lighting displays their bodies in a chiaroscuro that suggests a queer moment of intimacy. During the second krámpack, Dani decides to perform fellatio—again in a

dimly lit room. Nico at first seems shocked, but allows him to continue. Fouz-Hernández and Martínez-Expósito argue that Nico considers these actions to be simple mechanical acts of pleasure, whereas for Dani their sexuality constitutes an intimate affair.[26] Perhaps the main reason for the popularity of this queer film is that youth sexuality is never explicit or graphic, and it always takes place in an intimate setting in the dark. Although not visually explicit, the sexual scenes are filmed with medium-close shots that frame the two friends in the center of the close space of the bedroom, symbolizing the harmony between them.

What begins as an overt construction of a friendship between two boys becomes clearly corporeal, emphasizing the physicality of the desired male body. Remarkably, their camaraderie is reaffirmed by mutual masturbation. These scenes are "sexually charged and draw attention to the homoerotic component that underlies such friendships."[27] As such, queer representation disrupts traditional definitions of heteronormativity. At the beginning of the film, their sexual encounters are isolated acts that take place in the intimacy of the bedroom. Dani's house becomes the ideal safe space where they are free to explore their sexuality without limitations or parental control. Fouz-Hernández points out that "the discovery of sex is a rite of passage that . . . transgresses the limits of the private to become an act of public pleasure."[28] Although mutual masturbation between Nico and Dani constitutes an action that reasserts their bond, as soon as they advance in their sexual experimentation, both feel that their act of social transgression has seriously compromised their friendship. Dani reaches a turning point that leads to his loss of innocence when he discovers that the physical encounters with Nico have evolved into a clear sexual attraction toward his friend. Drawing attention to this specific element of the mise-en-scène, several close-ups show the details of Dani's face while he is framed in the center of the screen, staring and smiling at Nico after their almost complete sexual act. Dani even kisses Nico on the mouth while he is sleeping, and puts his arm around his friend's body. That scene is characterized by the intensity of their eye contact. Therefore, their story is told directly through the lens of the camera, and the viewer becomes involved in the film. The expression on Dani's face allows us to understand how he feels, and his physical presence and emotions become something tangible, enhancing the audience's empathy toward the point of view of these adolescents.

In the next sequences, Dani attempts to embark on a romantic relationship. His homoerotic desire is clearly shown by his words and actions: first he brings breakfast in bed to Nico; then he gives him a T-shirt; and finally he tells his friend that he cannot stop thinking about him, that he only wants to be with him, that he could stay the whole day looking at him, and that he even wants to die at the same time as him: "I like being with you more than with anyone else . . . besides, I don't want you to leave. . . . I would like us to die at the same

time." Once Dani discovers his gay sexuality and his infatuation with Nico, the latter feels uncomfortable with Dani and does not know how to proceed under such pressure. The camera shows this discomfort through Nico's facial expressions right before he rejects Dani and engages in a series of heterosexual acts with Elena. These sexual practices defy the homoerotic threat posed by Dani and serve as a way of disciplining Nico's body in order to better fit within the accepted heterosexual social order.

The presence of Elena and her cousin Berta repeatedly disrupts the homosocial harmony between Dani and Nico. For example, the female characters are never depicted in a positive light: they seem very cold and fake, their personality traits are not adequately traced in the film, and they always interfere with Dani and Nico's plans to go hunting or fishing. At the beginning of the film, the girls seem to add flavor to the summer of adventures. The settings where they meet are mostly in the open, public space of the beach town and at parties, including a private one in Dani's home where a performance of adulthood takes place involving adult clothes, drugs, alcohol, and sexual overtures. Both Dani and Nico flirt with Elena and Berta at first, but eventually Dani tires of spending time with the girls every day, responds with cruelty to Berta's attempts at seduction, and becomes jealous when Nico decides to have sex with Elena. This decision breaks the harmony between the four friends, and Dani responds with an act of jealousy and treachery when he locks Nico in the house to prevent him from meeting Elena and informs her that his friend is gay: "During the night he goes to my room and touches me . . . the other day he forced me to do it!" There is even a second on the screen in which Dani seems as if he is about to push Elena into the middle of the road. Despite Dani's controlling efforts, Nico experiences sex with a woman for the first time, although in the film this act is trivialized because the female character is constructed as superficial—she already has a boyfriend, and she dismisses Nico after sleeping with him. In this sense, girls, as Fouz-Hernández and Martínez-Expósito posit, are used "both as mediators of underlying homoerotic desire and as a means to deny that desire, given the homosexual panic that seems common at that stage of a man's life."[29] It is through the interactions among the four young characters that the film encourages the viewer to accept both straight and queer sexualities.

Their paths separate once Dani realizes he is attracted to men, and Nico shows a clear preference toward women. The second part of the film depicts Dani's self-discovery when he has an affair with Julián, an older writer who is a friend of his father. There is an obvious physical and sexual attraction between them from the first time they meet. Although it seems that Dani is going to lose his virginity with Julián, they exchange only a few kisses before Dani backs away and runs from the writer's house. Finally, Nico and Dani reconcile immediately before Nico's departure. Their bond seems unaltered, despite the resentments their sexual experiments had initially triggered. At the end of

the film, the viewer sees Dani walking toward the open sea, which symbolizes the freedom he has just achieved. Although this denouement seems to offer an optimistic note, its precise significance is unclear, as Dani is framed from the back in a panoramic shot, immersing himself in the moving water, revisiting the concept of a future open to change and movement.

Conclusion: *Krámpack* and Social Change

Krámpack allows viewers to understand the ongoing transformation of traditional cinematic views surrounding queer desire. The film raises unresolved questions about sexual identity while conveying queer adolescent validation. Through a coming-out and a coming-of-age narrative, Cesc Gay represents the lives of two teenagers who are in the process of discovering and accepting their homoerotic desire. In the tradition of *Bildungsfilms*, this queer teen movie also focuses on the rite of passage from adolescence to adulthood, paying special attention to the sexuality involved in this transition. The two friends experience a series of events that will profoundly affect their future as adults. This movie not only depicts queer youth identity but also tackles the normalization and naturalization of homoerotic desire. *Krámpack* is also innovative because it encourages the acceptance of queer sexuality in a way that is accessible to all audiences. Nico and Dani evolve throughout the summer—a time frame that prepares them to accept new experiences and integrate into the adult world. The film also demonstrates that explicit sexual scenes are no longer needed to depict a coming-out process. Instead, a suggestive setting with soft lighting in chiaroscuro and an emphasis on male friendship brings queer sexuality closer to the mainstream viewer. In this sense, *Krámpack* also challenges hegemonic narratives of coming-of-age representations. By exploring what it means for one adolescent to fall in love with another, become sexually active, and search for sexual identity, *Krámpack* offers new perspectives on a positive queer youth filmic discourse that previously has been subtly discouraged.

Finally, positioning the scenography in a coastal town—free from adult supervision and during the summertime—facilitates the transition and life transformation of the protagonists, in which they become open to new experiences and reconfigure their adult identities. The movie, filmed when equal rights for the LGBTQI community were not yet recognized in Spain, represents a step forward in the social acceptance, integration, and normalization of queer youth sexualities. Cesc Gay's *Bildungsfilm* is a significant contribution to the cinematic body of films that displays the changes taking place in Spain at the turn of the twenty-first century. Returning to the title of this chapter, *Krámpack* asserts itself as a successful film that masters the art of framing queer desire while constructing youth sexualities.

Notes

I would like to acknowledge Jenna Reynolds for her excellent assistance in proofreading this chapter.

1 Thomas Deveny, "*Pa Negre (Pan negro)*: Bildungsroman/bildungsfilm de memoria histórica," *La Nueva Literatura Hispánica* 16 (2012): 397.
2 Timothy Shary, "Teen Films: The Cinematic Image of Youth," in *Film Genre Reader III*, ed. Barry Keith Grant (Austin: University of Texas Press, 2003), 492. Considering the indeterminacy that characterizes this period of life and how it is usually represented by the genre of the bildungsroman, Franco Moretti posits that youth "acts as a symbolic concentrate of the uncertainties and tensions of an entire cultural system." Franco Moretti, *The Way of the World: The Bildungsroman in European Culture*, trans. Albert Sbragia (New York: Verso, 2000), 185.
3 Carolina Rocha and Georgia Seminet, "Introduction," in *Representing History, Class, and Gender in Spain and Latin America*, ed. Carolina Rocha and Georgia Seminet (Basingstoke: Palgrave Macmillan, 2012), 2.
4 Rocha and Seminet, 19.
5 Anne Hardcastle, Roberta Morosini, and Kendall Tarte, eds., *Coming of Age on Film: Stories of Transformation in World Cinema* (Newcastle upon Tyne: Cambridge Scholars, 2009), 1.
6 Rocha and Seminet, "Introduction," 5.
7 Harry M. Benshoff and Sean Griffin, *Queer Cinema: The Film Reader* (New York: Routledge, 2004), 2.
8 Harry Benshoff and Sean Griffin claim that "sexuality is a vast and complex terrain that encompasses not just personal orientation and/or behavior, but also the social, cultural, and historical factors that define and create the conditions for such orientations and behaviors." Benshoff and Griffin, *Queer Cinema: The Film Reader*, 1.
9 Susan Driver, "Girls Looking at Girls Looking for Girls: The Visual Pleasures and Social Empowerment of Queer Teen Romance Flicks," in *Youth Culture in Global Cinema*, ed. Timothy Shary and Alexandra Seibel (Austin: University of Texas Press, 2007), 242.
10 Driver, 254.
11 Timothy Shary, *Generation Multiplex: The Image of Youth in Contemporary American Cinema* (Austin: University of Texas Press, 2002), 246.
12 The word "krámpack" refers to the mutual act of masturbation as defined by the main characters of the film. Because it is a neologism, the English translation of the title only mentions both protagonists' names: Nico and Dani. However, it is interesting to point out that the adapted title starts with Nico's name, who is the one who turns out to be heterosexual, leaving Dani in a secondary role, although he is the main character of the film and the one who is struggling to come to terms with his homosexuality. Throughout this essay, I will mostly refer to the Spanish title because I find it more accurate.
13 Eve Kosofsky Sedgwick, *Tendencies* (Durham, NC: Duke University Press, 1993), 8.
14 Erik H. Erikson, *Identity: Youth and Crisis* (New York: W. W. Norton Company, 1968), 16.
15 Santiago Fouz-Hernández, "Boys Will Be Men: Teen Masculinities in Recent Spanish Cinema," in *Youth Culture in Global Cinema*, ed. Timothy Shary and Alexandra Seibel (Austin: University of Texas Press, 2007), 235.

16 All translations are mine, unless otherwise indicated.

17 Fouz-Hernández, "Boys Will Be Men," 224–225.

18 Celestino Deleyto, "Aquellas pequeñas cosas: Una entrevista con Cesc Gay y Tomás Aragay," *Hispanic Research Journal* 9, no. 4 (2008): 355.

19 Deleyto, 367.

20 Driver, "Girls Looking at Girls Looking for Girls," 254.

21 Robin Griffiths, "Introduction: Contesting Borders—Mapping a European Queer Cinema," in *Queer Cinema in Europe*, ed. Robin Griffiths (Bristol: Intellect, 2008), 15.

22 Elena Boschi, "Sexuality and the Nation: Urban Popular Music and Queer Identities in *Krámpack*," *Quaderns* 9 (2014): 93.

23 Santiago Fouz-Hernández and Alfredo Martínez-Expósito, *Live Flesh: The Male Body in Contemporary Spanish Cinema* (London: Tauris, 2008), 38.

24 Santiago Fouz-Hernández, "School Is Out: The British 'Coming Out' Films of the 1990s," in *Queer Cinema in Europe*, ed. Robin Griffiths (Bristol: Intellect, 2008), 146.

25 Henry A. Giroux, "Teenage Sexuality, Body Politics, and the Pedagogy of Display," in *Youth Culture: Identity in a Postmodern World*, ed. Jonathan Epstein (Oxford: Blackwell, 1998), 28.

26 Fouz-Hernández and Martínez-Expósito, *Live Flesh*, 54, 55.

27 Fouz-Hernández and Martínez-Expósito, 61.

28 Fouz-Hernández, "Boys Will Be Men," 232.

29 Fouz-Hernández and Martínez-Expósito, *Live Flesh*, 60–61.

5

Bridging Sexualities

• • • • • • • • • • • • • • • • • • • •

Polyamory, Art, and
Temporary Space in
Castillos de cartón (2009)
by Salvador García Ruiz

JENNIFER BRADY

The three characters in Salvador García Ruiz's *Castillos de cartón* (2009) [*3some*],
a filmic version of Almundena Grandes's 2004 novel of the same name, par-
ticipate in a temporary polyamorous relationship.[1] Mari Jose (played by Adri-
ana Ugarte), Marcos (Nilo Mar), and Jaime (Biel Durán) are university students
who study fine art. The threesome of one woman and two men takes part in
sexual acts together in a private room in the home that Jaime shares with his
roommate. Throughout the film, which is dominated by sex scenes of ménage
à trois, their physical relationship and their production of art dynamically
interweave. The space that they create is temporary and functions as a bridge
between their triangular relationship and societal heteronormativity. Their
"cardboard castle," to which the title refers, attempts to privatize the sexual
interactions of their polyamorous relationship and emphasizes the temporal-
ity of their relationship and productions of art.

The sexual relationship of the three characters in a temporary and private
space aligns with Michel Foucault's concept of heterotopia. In his 1967 speech

"Of Other Spaces: Utopias and Heterotopias," Foucault defines heterotopias as nonhegemonic spaces "linked to slices of time." He proclaimed: "The space in which we live, which draws us out of ourselves, in which the erosion of our lives, our time and our history occurs, the space that claws and gnaws at us, is also, in itself, a heterogeneous space. In other words, we do not live in a kind of void, inside of which we could place individuals and things. . . . [W]e live inside a set of relations that delineates sites which are irreducible to one another and absolutely not superimposable on one another."[2] Foucault's heterotopias offer transitory spaces from which conceptualization of the self may be analyzed. The heterotopia is a liminal space that subtly subverts hegemonic notions of subjectivities. In this sense, the heterotopia might be described as a junction between societal norms and the subversion of such mandates.

In *Castillos de cartón*, the transitory nature of heterotopic space is expressed in the private room where Mari Jose, Marcos, and Jaime have sex. The bridge between society and the individual is expressed first and foremost through performances of sexuality in the film. The physical desire in the polyamorous relationship between the three characters follows and unsettles heterosexual norms of sex. Mari Jose participates in intercourse with both male characters at the same time. Even though Marcos and Jaime do not touch each other during sex with Mari Jose, the participation of the other male character pleases them. The physical interactions of the three "resist and transcend categorization" in "a space that offers refuge from the perceived tyranny of what has come to be termed 'monosexuality.'"[3]

Following Eve Kosofsky Sedgwick's notion in *Epistemology of the Closet* of bisexuality as more than just a space between binaries, I contend that the polyamorous relationship of the three characters may be defined as a bridge between hegemonic norms and queerness. Polyamory, then, does not replicate dyadic identities; rather, it challenges heteronormative notions of subjectivities from its own space, which, in the film, is a fleeting, private room.

The room in Jaime's apartment, a temporary space that the three characters set up, houses their sexual interactions. Lynda Johnston and Robyn Longhurst write, "Homes have traditionally been constructed as private spaces but they are also subject to public rules and regulations."[4] The private space in which the three characters engage in sexual acts is constructed as the cardboard castle, echoing the title of the film. The three characters outfit their metaphoric cardboard castle. Marcos purchases a king-size bed for the space. A medium shot frames all three characters as they organize the room and make their shared bed. The three paint the walls, and Mari Jose brings a plant from her family's home, a traditional space, to the threesome's shared space. Even though Marcos and Mari Jose do not live with Jaime, the young adults idealize home in their metaphoric cardboard castle. They participate, as an imagined family, in

outfitting the space. However, the composition of their relationship subverts traditional notions of family in some instances and reinforces conceptualizations of family in others.

The desire to push the heteronormative boundaries of sex occurs in the temporary space. However, rather than redefine sexuality and agency, the interactions between the three characters may be described as occurring in the gap, or the metaphoric bridge, between heteronormativity and queerness. The polyamorous relationship between the three characters permits two sexual variations of heterosexuality. Either one male character has intercourse with the female character while the other male character watches (and frequently masturbates), or one male character has intercourse with the female character while the other male character kisses her. Their sexual acts traverse heteronormative boundaries with the inclusion of a third member, yet they also reinforce norms, since the two male characters do not engage directly with each other's bodies.

In their triangular relationship, Mari Jose may be defined as the connection between the two male characters. Marcos and Jaime imagine themselves maintaining so-called heterosexual boundaries by never touching each other's body during sex. The female body of Mari Jose, then, functions as a barrier that bolsters the male characters' identities as heterosexual. Donald E. Hall examines the imagined maintenance of heterosexuality in his analysis of pornography where two men penetrate—one anally and one vaginally—one woman. The mediation of the subjectivities of the two male participants is the tissue that separates the woman's vagina and rectum. Hall writes: "It may be thin, but it is a wall that now rigidly determines sexual orientation, separating men from identity-undermining contact with each other and providing the divisionary mechanism through which heterosexuality is constructed and maintained. For the men involved, her 'membrane' *is* heterosexuality; both men's penises only touch the flesh of a woman, even as they revel in sensations that the term 'bisexual' may or may not describe appropriately. The young woman plays only a mediatory role, rendering desire between men nonthreatening and embodying the division between the homosocial and the homosexual."[5] The threesome in the film, following Hall's ideas, highlights Mari Jose as the mediator between the two male characters. Jaime and Marcos control the sex acts through their gaze, and the female character passively submits to their requests. Mari Jose prepares dinner for them, taking on the antiquated role of the domesticated angel. She is the symbolic housewife in the threesome, and even though she has sex with both men and serves as an erotic connection between their homosocial relationship, she ends up returning to heteronormativity. Embedded in this heteronormative performance of polyamory, however, is Mari Jose's constant desire to emerge as something queer, or, in other terms, her continuous desire to challenge heteronormative rules of sex. When their erotic triangle

comes to an end, it is she who sits on the edge of her bed, crying and mourning a relationship that sought to defy norms but that never completely emerged due to the patriarchal constraints of sexual relationships.

The analogy of the space as cardboard, a recyclable material made from corrugated paper, highlights the relationship between the three characters as fleeting and temporary, and as having the potential to collapse at the slightest force or pressure. The private space of Jaime's room permits erotic exploration. The sexual acts of the threesome challenge patriarchal notions of austere and heteronormative sexual acts. In this sense, the cardboard castle offers a space where the threesome may perform sexual acts that do not necessarily align with heteronormative conceptualizations of sex. The cardboard castle is an imaginary, private, and luxurious space where the three characters engage in sexual acts. It is a metaphoric, sensual space where the three characters challenge patriarchal norms of sex, which mandate that sex be between a man and a woman, take place in a private space, and conform to societal standards of reserved decorum. Mari Jose, Marcos, and Jaime challenge the patriarchal, heteronormative convention of so-called sexual correctness with their polyamorous relationship. Rather than participate in mandated decorum, the three characters have sex often, but not in creative and enterprising ways. Their erotic relationship, which may be described as hyperbolic according to patriarchal norms, permits them to explore agency: agency as individual lovers, agency as a threesome, and agency as artists. The space of the private room becomes an imagined, metaphoric castle that is built with cardboard, a material that decomposes easily and quickly, rather than a durable, long-lasting material such as stone.

The simultaneous fulfillment of desire in the triangulated relationship is temporary, as represented by the metaphoric castle made of cardboard. Maria Pramaggiore notes, "Coupling signifies completion, wholeness, and stasis and usually suggests a diachronically stable object choice. Temporality is critical."[6] The fleeting nature of the threesome's relationship offers an amorous model, distinct to Pramaggiore's description of a relationship between one man and one woman as static. It is supposed, according to antiquated notions of heteronormativity, that the one and only so-called acceptable relationship includes two people, one woman and one man. The attainment of this type of relationship is thought of in terms of completion and finality. This is where the triangular relationship between Jaime, Mari Jose, and Marcos challenges the conceptualization of stability of monogamous and heterosexual amorous relationships. Their polyamorous relationship is temporary; it skirts the pressures of heteronormative sexuality, but only temporarily.

The time that Jaime, Mari Jose, and Marcos spend together engaging in sex defies societal norms. In this sense, their triangular relationship may be described in the following metaphor. When they have sex together, Mari Jose, Marcos, and Jaime begin crossing the symbolic bridge between heteronorma-

tivity with the metaphoric objective of successfully entering a queer space, where, perhaps, they would be able to redefine their subjectivities in the "concrete coordinates of queer agency."[7] The bridge is the liminal space between their mainstream interactions in society—Mari Jose with her family, for instance—and what might be deemed subculture. Near the end of *Castillos de cartón*, when Marcos offers to pay for a home where all three can live and continue developing their polyamorous relationship—instead of a cardboard castle, Marcos's proposed space would be a metaphoric stone castle—Jaime and Mari Jose refuse. To continue with the metaphor, Mari Jose and Jaime turn back; instead of crossing the bridge, they return to heteronormativity at the end of the film.

Throughout *Castillos de cartón*, however, the characters attempt to distance themselves from heteronormativity. In one scene in particular, when Mari Jose kisses both Marcos and Jaime as they dance at a club in public, a medium shot focuses on the reactions of the other people at the club who stare, astonished, at the trio. That night, in the confined space of a taxi, Mari Jose calls both Marcos and Jamie her boyfriends. They tell her that they are in love with her, and she confesses her love for them. She temporarily defies heteronormative rules when she defines the threesome by telling Marcos and Jaime, "We are a threesome."[8] This is a fleeting confession, however. When her parents wish to meet her boyfriend, Mari Jose slips back into the heteronormative and monogamous notion of having one boyfriend. Even though Mari Jose invites both male characters to her family's home to have dinner in celebration of her mother's birthday, Jaime performs the role of boyfriend and Marcos takes on the role of friend. Mari Jose plans the visit, telling the two male characters, "I cannot have two boyfriends." At her family's home, Mari Jose's parents watch Jaime sketch, during which time Marcos pushes the limits of so-called socially accepted sexual behavior by inviting Mari Jose into her family's bathroom to have sex with her. There, Marcos is physically able to perform sexual intercourse with Mari Jose. It is as if pushing the heteronormative boundary arouses him. The emergence of the risky erotic situation of having clandestine sex in Mari Jose's parents' home vacillates at the edge of subversion; however, participating in heterosexual sex where he penetrates the female character's body coupled with the competition that he and Jaime constructed around which male character would ultimately control the objectified Mari Jose reveals, once again, a fleeting queerification of sexual norms.

Castillos de cartón alternates scenes between the creation of art and the three characters engaging in sexual acts. The film begins in the university art studio as students sketch in carbon and work on sculptures and screen printing. The focalization of the camera narrows in on Mari Jose in a crowded café as she brings coffee to a friend, makes eye contact with Jaime, and then spots Marcos sketching by himself across the room. Even though the character is played by

the beautiful Ugarte, Mari Jose does not conform to traditional norms of female beauty. Her hair, parted in the middle, is short and messy, and to the right of her mouth is a large, deep scar. Marcos, on the other hand, is portrayed in the film as effeminate. He is strikingly beautiful. His tall, lean body is reminiscent of a fashion model. Even though sexuality is displayed in myriad possibilities and as attempting to go against the heteronormative grain, in the film, performances of masculinity and femininity follow heteronormative epistemology. That is to say, the character with the biologically female body has historically feminine traits, and the two characters with biologically male bodies act according to historically masculine norms.

Often Marcos takes a passive position, and Jaime postures for control of the group. Jaime attempts to rename Mari Jose several times near the beginning of the film. Mari Jose tells Jaime not to call her by the diminutive "Josita." Mari Jose has renamed herself, in fact, by removing the accent from traditionally masculine name "José." The extraction of an accent mark in her name is symbolic, modifying her name from the masculine form, and permits Mari Jose agency of her subjectivity. The removal of the accent mark may be interpreted as a symbolic castration. The removal of the male designator, the accent mark on José in this case, might be the linguistic correlation to a symbolic female castration. This removal of the masculine signifier positions Mari Jose as an object of the male gaze, removing her from the realm of the masculine. Even though her act of naming herself seems to give her subjectivity, the metaphoric female castration solidifies her role in the film as an eroticized object. The two male characters will continue to objectify her throughout the film. In all of the sex scenes, she will take on the role of passive agent and the male characters will alternate orchestrating the erotic performances. Even though the focalization of the film seems to be on Mari Jose, it becomes clear that the focus rests on the power of the male gaze.

The first sex scene begins with Marcos and Mari Jose engaging in kissing on the bed. Jaime peers at them from the hallway, where he is unhappy with his passive position as a voyeur. When Marcos cannot physically engage in intercourse with Mari Jose, Jaime enters the room at the very moment in which Marcos admits disappointment in his perceived failure to supposedly please Mari Jose. Jaime tells Marcos and Mari Jose, "Don't you worry. I will fix this right away." In this first erotic scene with all three characters, Jaime takes off his clothes and kisses Mari Jose while Marcos watches from the edge of the bed. In the long medium shot of the three characters on the bed, Jaime tells Marcos that he is doing him a favor by taking over Marcos's so-called physical, heteromasculine responsibilities by performing intercourse with Mari Jose. Jaime takes on the role of phallic substitute with pride, self-identifying at one point as "a vulture." Traditional male posturing continues when Jaime says that Marcos is a better artist, but that he himself is a better lover. Proving Jaime wrong,

Marcos calls Mari Jose by the name that she prefers, "Jose" without the accent, to which she responds positively by kissing Marcos. The recognition of her preferred name pleases her, and the three engage in intercourse.

After the third sex scene between the threesome, which is implied, Jamie tells the other two about his first sexual experience with a man in which the man performed fellatio on Jaime. He implies that he would like Marcos to engage in fellatio on him, but Marcos responds angrily by telling Jaime that he is not homosexual. Throughout the film, both male characters insist on their heterosexuality and repeatedly deny homosexuality even though they freely participate in a ménage à trois. Marcos and Jaime insinuate conformity with heteronormative notions of sex; however, they both receive pleasure by watching the other have intercourse with Mari Jose. The male characters teeter on the precipice of so-called homosexuality. Even though Marcos denies homosexuality or bisexuality, viewers may question if he has bi- or homosexual tendencies according to homosocial stereotypes: first, when he is unable to maintain an erection in order to have intercourse with Mari Jose, and again and repeatedly in his effeminate appearance. Pramaggiore describes love triangles when she writes: "The rivalry, jealously, and competition that characterize relations between and among certain characters within a triangle generally are construed as involving only similarity and identification, rather than identification *and* desire. Because the triangle offers the possibility for simultaneous desire and identification among its various participants, regardless of the gender of the figures occupying those positions, triangulation often highlights the both/and quality of bisexual desire."[9] Even though Jaime and Marcos do not touch or penetrate each other, the participation of the other in group sex brings them pleasure. They each desire the other, as evident in the scenes where they gain pleasure by watching the other's erotic interaction with Mari Jose. Moreover, the men compete with each other in their attempts to arouse and please Mari Jose.

Jaime's confession of his homosexual interaction on the beach permits Mari Jose to make an admission of her own, which opens up the space for even more competition between the two male characters. Mari Jose tells Marcos and Jaime that she has never experienced sexual climax. She says that she fakes orgasms so that the two men will be happy with her and so it seems like everything went well, admitting that she has been conforming to male desires. Mari Jose's admission motivates both men to obsessively focus on her attaining sexual climax. Jaime and Marcos metaphorically sword fight with their phalluses as both attempt to aid the so-called damsel in distress.

The posturing between the male characters extends to their paintings. In one scene in particular, Jaime announces that he thinks artists should paint what they see whereas Marcos thinks they should paint that which cannot be seen. Jaime's realist approach to art mirrors his viewpoint of sex. Of the three, Jaime is the most egotistical when it comes to erotic interactions. It is clear that

he engages in sexual acts with Mari Jose and Marcos primarily to please himself. Just like the man on the beach who performed fellatio on Jaime, Marcos and Mari Jose are mere objects for Jaime's fulfillment of personal erotic desires. On the other hand, Marcos takes an abstract approach to painting and, at first, performs as a voyeur or passive sexual partner in the threesome. His paintings embed hidden meaning, as exemplified by the series of large paintings in red of three horizontal wavy lines for which he is praised near the end of the film. Red, traditionally a color of passion, reveals the threesome's relationship, but only to himself, Jaime, and Mari Jose, for it is only the three characters who know about their polyamorous relationship. In this sense, Marcos's abstract art is privileged in the film as a more profound mode of signifying desire and longing. The message is fleeting, however, as confirmed later with Jaime and Mari Jose becoming monogamous partners.

The creation of art continues to emphasize the transitive nature of the relationship among the three, as exemplified by Marcos's painting of three wavy horizontal lines. Marcos's three wavy lines are all of equal size. The artist's message in the lines of equal size may be the desire for all three characters to have the same power and agency in their sexual interactions. The three characters, however, do not share the same amount of control in their erotic interactions. In all of the sex scenes, Mari Jose is the passive receiver of male penetration. Both Jaime and Marcos perform vaginal intercourse on Mari Jose. There are no scenes in which she is the agent of sexual acts on the male characters' bodies.

Just as the orchestration of their sexual interactions is directed by the male characters who hold the power of the gaze, the interpretation of art is also controlled by the men. Even though it is repeated throughout the film that Mari Jose is a talented artist, the men are the ones who take on roles as artists in the film. By the end of the film, Marcos becomes a successful artist. He sells his series of red paintings with the three wavy lines for a large, undisclosed sum of money, but one that enables him to live without having to work or sell more art. Jaime takes on the role of art critic in the film when he offers brief analyses of three works by Francisco de Goya, *El sueño de la razón produce monstruos* (1799; The sleep of reason produces monsters), *Saturno devorando a su hijo* (1819–1823; Saturn devouring his son), and *Perro semihundido* (1820–1823; The dog).

El sueño de la razón produce monstruos is the forty-third *Capricho*, one of Goya's recognized laminate plates, which were created during the Spanish Enlightenment in the eighteenth century. Goya's laminate depicts a man, hunched over seemingly in despair or suffering from longing. He dreams of owls, a metaphor for the acquisition of knowledge, yet the owls transform into dark, disfigured bats. The laminate, which has been widely studied, highlights the disillusionment of the Enlightenment. How can one trust reason in a world

that is full of events that challenge logic? The role of the artist may be gleaned as one of many interpretations of Goya's *Capricho* 43. Helmut C. Jacobs writes, "According to the artist's vision. Goya reproduces the artistic production process. Here, it is not the people at the bottom, full of superstition, who invent monsters. Rather, it is the artist himself; it is he who produces the monsters in his dream."[10] The three characters in *Castillos de cartón* orchestrate their physical acts. Goya's dreams in *Capricho* 43 may mark the artist as both the creator and the destroyer of he or /his desire. In the film, the characters succumb to societal pressures, and at the end, with the death of Marcos, it is presumed that Mari Jose and Jaime will return to follow societal norms of expressions of sexuality.

The inclusion of *Saturno devorando a su hijo*, one of the most recognized of Goya's black paintings, is striking in relation to the power struggle between the two male characters in the film. In Goya's masterpiece, a monstrous figure, whose deranged eyes bulge from his head, gnaws the arm of a decapitated, bloodied body. Saturn, having bitten the head off his son's body, is depicted consuming the corpse. The act may point toward the intention to stabilize Saturn's power and prohibit the possibility of his son taking control. One reading of the inclusion of this painting in *Castillos de cartón* might lead viewers to see Jaime as Marcos's symbolic father who metaphorically bites his son's head off to maintain power. The two male characters compete for the erotic fulfillment that they believe the female character, as an object of desire, provides them.

The last of Goya's paintings is the one that receives the most attention in the film. When Jaime gives a lecture to fine art students about the famed painting, Marcos begins drawing comic strips. *Perro semihundido*, one of Goya's black paintings, was originally painted directly on the wall of the artist's home near Madrid. The two uneven sections of the painting—what might be identified as the sky and the sloping ground—are divided by the image of the head of a dog looking up, its body submerged in the sand. Art critic Tom Lubbock offers analyses of the dog's precarious placement in the painting:

> You can see the creature as submerged in the lower area, up to its neck in it, buried in the ground, or swallowed up by something more liquid, like quicksand. It is stuck there, sinking, and is unable to extricate itself. It raises its head, trying to keep itself "above water." . . . Alternatively, you can see the dog as cowering behind a ridge, trying to hide and protect itself. It raises its head in trepidation, looking up at the impending danger from above. . . . And now the depth of the upper area signifies the overwhelming volume of whatever this threat is. Either way, it is a picture about bare survival in the face of hopeless doom. Whether the danger comes from below or from above, the picture tells us there is no escape. There is no way out of the drowning mire. There is no hiding place from the avalanche.[11]

In his lecture on Goya's painting, Jaime asks the students (and, presumably, himself), "Why do we identify with him [the dog]?" Taking Lubbock's description of the dog in the painting as one possible answer to Jaime's rhetorical question, we may be able to surmise that there exists a symbolic connection between the figure of the dog and the triangular relationship in the film. The invisible pressure that threatens the threesome, represented, perhaps, by the image of the dog in the painting, may be viewed as the constraints of heteronormativity. The brief scene in which Jaime discusses Goya's *Perro semihundido* may suggest prefiguration of the impending end to the polyamorous relationship between Marcos, Jaime, and Mari Jose.

In the next scene, the eighth sexual encounter in the film, Jaime watches and masturbates as Mari Jose and Marcos have intercourse. The roles shift in this scene between the two male characters with the transference of the power of the phallus. While penetrating Mari Jose, the passive object of male eroticism, Marcos watches Jaime for a moment. In the silence of desire, viewers wonder if Jaime and Marcos will finally have physical contact, but they do not. Rather, in a jealous rage afterward, Jaime demands that Mari Jose and Marcos do not have sex without him. Male power shifts once again, and, in the tenth sex scene, which is implied in the film, Marcos is completely excluded. As the camera focuses in on the couple after sex, it becomes clear that Jaime and Mari Jose have chosen monogamy. Their cardboard castle is symbolically destroyed. The suicide of Marcos is hinted at in the film, but it is described explicitly in Grandes's novel. The film concludes as Mari Jose mourns not only Marcos's death but also her return to heteronormativity.

The space that the threesome had constructed to house their sexual interactions is destroyed at the end of the film with the finality of Marcos's death and the coupling of Mari Jose and Jaime. Despair replaces desire in the final scene, in which Mari Jose sits in her bedroom in her parents' house, crying alone. The heterotopic space of the threesome's cardboard castle provided a temporary bridge to the exploration of sexuality as something different from the heteronormative conceptualization of sex. In this sense, their cardboard castle was a queer space. Sue Kentlyn writes, "The queer home provides a *safe space* where people can cast off constraints of heteronormativity and do varieties of gender and sexuality which would be sanctioned in other contexts; thus the queer home becomes a *subversive space*."[12] In *Castillos de cartón*, societal norms are challenged in the temporary and fleeting space of a private room.

The boundaries of so-called acceptable erotic acts are pushed, but not subverted permanently, in the film. What is communicated is the sensation of "moving closer" toward spatial and sexual queerification and "falling back" under the pressures of heteronormativity. Queer space is slippery and temporary in the film. Hall wonders, "Have we come full circle? Of course not. Binaries of race, class, age, and sexual orientation continue to dominate our lives."[13]

He admits that the term "'[q]ueer' has the potential" to "destabiliz[e]" socially mandated binaries of sexuality.[14] The concept of queerness, according to Hall, "will show us if movement beyond the 'straight'-jacket (so to speak) of binary orientation is possible, or if the discourses of mutually exclusive, and socially enforced, hetero- and homo-sexuality will continue to dominate lives and imperfectly (though substantially) regulate expressions of desire, as it erases the inconvenient, the messy, the polymorphously perverse."[15]

Hall's musings are apropos to the discussion of *Castillos de cartón* in this chapter. Even though the three characters explore the bridge to what may be defined as a queer space, heteronormative pressures push back. The film is successful in the pursuit of resistance, and it reveals that a bridging of sexualities is possible.

Notes

1 Born in Madrid in 1963, García Ruiz has directed three other movies, which are also adaptations of novels: *Páginas de una historia, Mensaka* (1997, based on the novel by José Angel Mañas) [*Mensaka*]; *El otro barrio* (2000) [*The Other Side*] (based on the novel by Elvira Lindo); and *Las voces de la noche* (2003) [*Voices in the Night*] (based on the novel by Natalia Ginzburg). He wrote the screenplays for *El otro barrio* and *Las voces de la noche*.

2 Michel Foucault, "Of Other Spaces: Utopias and Heterotopias" (1967), trans. Jay Miskowiec, accessed February 13, 2017, http:// web.mit.edu/allanmc/www /foucault1.pdf.

3 Clare Hemmings, *Bisexual Spaces: A Geography of Sexuality and Gender* (New York: Routledge, 2002), 3.

4 Lynda Johnston and Robyn Longhurst, *Space, Place, and Sex: Geographies of Sexualities* (Lanham, MD: Rowman and Littlefield, 2010), 41.

5 Donald E. Hall, "Graphic Sexuality and the Erasure of a Polymorphous Perversity," in *RePresenting Bisexualities: Subjects and Cultures of Fluid Desire*, ed. Donald E. Hall and Maria Pramaggiore (New York: New York University Press, 1996), 111.

6 Maria Pramaggiore, "Straddling the Screen: Bisexual Spectatorship and Contemporary Narrative Film," in *RePresenting Bisexualities: Subjects and Cultures of Fluid Desire*, ed. Donald E. Hall and Maria Pramaggiore (New York: New York University Press, 1996), 277.

7 Andrés Lema-Hincapié and Debra A. Castillo, "Introduction," in *Despite All Adversities: Spanish-American Queer Cinema*, ed. Andrés Lema-Hincapié and Debra A. Castillo (Albany: State University of New York Press, 2015), 7.

8 All translations are mine, unless otherwise indicated.

9 Pramaggiore, "Straddling the Screen," 277.

10 Helmut C. Jacobs, *El sueño de la razón: El Capricho 43 de Goya en el arte visual, la literatura y la música* (Frankfurt: Iberoamericana Vervuert, 2011), 32.

11 Tom Lubbock, "Goya, Francisco de: The Dog (c1820)," *Independent*, July 10, 2008, http://www.independent.co.uk/arts-entertainment/art/great-works/goya-francisco-de-the-dog-c1820-864391.html.

12 Sue Kentlyn, "The Radically Subversive Space of the Queer Home: 'Safety House'
 and 'Neighborhood Watch,'" *Australian Geographer* 39, no. 3 (2008): 327
 (emphasis in original).
13 Hall, "Graphic Sexuality," 118.
14 Hall, 119.
15 Hall, 119.

Part III

Queering Iberian Politics

• •

6

Eloy de la Iglesia's
El diputado (1978)

● ● ● ● ● ● ● ● ● ● ● ● ● ● ● ● ● ● ● ●

On the Margins of
Spanish Democracy

LENA TAHMASSIAN

The polemical content of Eloy de la Iglesia's films, particularly of those tied to
the period of Spain's Transition to democracy, often seems irrelevant today
because the films' aesthetics may appear flat or dated. Rife with contradictions,
his cinema is open to various interpretations, but there is a general consensus
that the films' greatest accomplishment is the defense of marginal subjects that
also managed to attract mass audiences. Films such as *Los placeres ocultos* (1977)
[*Hidden Pleasures*] and *El diputado* (1978) [*Confessions of a Congressman*] in
particular are the most fervent and among the earliest to present homosexuality
openly on Spain's cinema screens. The latter film, specifically, defends not only
the sexual Other but also the class Other over the backdrop of the Transition
and the building of Spain's constitutional consensus. The film posits that both
the homosexual Other and the class Other continue to be oppressed in the era
of democracy and, in effect, takes up the challenge of politicizing sexuality
while simultaneously mirroring the historical moment in which official poli-
tics became depoliticized in Spain. Because of the insistence on the intersec-
tionality of oppression by means of the projection of a somewhat unusual
pessimism about the historical moment, and the ultimate rejection of the ethics

of sacrifice for the heteronormative political consensus, *El diputado* could be considered a radically queer film *avant la lettre*, despite the fact that its aesthetics and mode of representation at times undermine its status as such.

El diputado is considered one of the most important cinematic documents of early gay visibility in Spain.[1] Furthermore, through the main protagonist's sexual encounters, the film also introduces a viewpoint counter to the heteronormative one (while also featuring hetero sex, often gratuitous in Eloy de la Iglesia's films in general). Facilitated by camera angles that are, in some cases, inspired by pornography, the close-ups of male bodies put the viewer in a position of identification with the voyeuristic protagonist. This confrontational technique essentially forces the viewer to assume a position for or against homosexuality.[2] De la Iglesia's treatment of political subjects is equally confrontational and, at times, also equally exploitative. I will discuss the stakes in these representations by addressing the perceived shortcomings of *El diputado* before analyzing the complexities that manage to redeem it as a subversive film.

The film details the conflicts and contradictions of Roberto Orbea (José Sacristán), a closeted homosexual and Marxist-Leninist politician whose aspirations of political protagonism in the central government under the nascent Spanish democracy are cut short by the threat of a scandalous outing orchestrated by far-right militants who are determined to sabotage his political career and, by extension, the political agenda of the traditional left during the Transition. Beginning at the moment immediately prior to Roberto facing his public outing (which never actually takes place within the diegesis), the plot unfolds through an extended flashback that takes place between 1976 and 1977. When Roberto is imprisoned for political activities, his homosexual desire is reactivated by an inmate, Nes (Angel Pardo), who is charged with *peligrosidad social*.[3] Despite Roberto's attempts at "logical" restraint and repression of his urges, Nes introduces him to a string of younger hustlers, and he eventually becomes infatuated with Juanito (José Luis Alonso). Though he is initially interested only in the monetary transaction, the fatherless Juanito begins to confide in Roberto and is adopted into a quasi-family structure with the politician and his wife, Carmen (María Luisa San José). She incorporates herself into the arrangement in order to satisfy her desires while simultaneously attempting to maintain appearances of normality. Under the couple's tutelage and introduction to art museums and Marxist theory, Juanito attends political rallies and begins to come to terms with his own sexuality. Just as the plot reaches a potential resolution, Juanito's prior obligation to the far-right militants who are scheming to drag Roberto into public scandal reaches a boiling point. The fascists grow impatient and interpret Juanito's induction into Roberto's party and the relationship between the two men as acts of insubordination. Their final strategy to ruin Roberto's political career is to murder Juanito, leaving his bloodied body for Roberto to discover in his apartment.

Challenges of Representing the Other

Developed from a disenchanted communist perspective and depicting the obsolescence of a purely materialist worldview in accounting for the entirety of political struggle, the film connects sex and politics as a means of defense of marginal subjects. But does the film make the case that oppression is intersectional? Furthermore, does it, as a cultural product, succeed in challenging this oppression? Perhaps, in its attempt to present sex *as* politics, the film gets caught up in the very dilemma of political cinema, characterized by a need not just to expose injustice and grant it visibility, but also to challenge dominant representational systems and totalizing depictions of reality. While *El diputado* notably challenges the heteronormative view, thereby creating a space for the sexual Other in the popular consciousness, the manner in which Juanito and the male hustlers are used to depict the class Other perhaps undermines the film's potential to fully and intersectionally politicize sexuality.

At times, it seems as though *El diputado* presents Roberto's character as an "exceptionally" sympathetic gay man, or as what Paul Julian Smith refers to as the "good homosexual," played by the respected actor José Sacristán.[4] The good homosexual is levelheaded, patient, and straight-laced—a contrast to previous depictions of homosexual men in Spanish cinema as effeminate *mariquitas*.[5] Roberto is a relatable character, and the message is clear: "Gays are normal people just like us." Thus, through his representation, the film makes an important contribution to the normalization of homosexuality. Yet, it seems that the logic of normativity leads to other forms of exclusion. Roberto is positioned in contrast to other gay characters who are depicted either as delinquent *quinquis*,[6] or as the stereotype Alberto Mira has termed "la loca burguesa."[7] Furthermore, the young hustlers are shown with objectifying camera angles that display their bodies, while Roberto's body is always covered by his suit—an indication of bourgeois respectability. They are excluded from the consumer possibilities available to the middle class and more prosperous working classes and are also denied a political identity. Nes's lack of political commitment is summarized in his reply to Roberto, who asks what motivated Nes to aid and abet the far right and turn his own friend into bait: "You thought it easy to buy me? Well, so did they."

Ensnared by the good-life consumer fantasy from which they have been excluded, the lumpens are presented as having little insight into their social condition, and their material deficit renders them susceptible to manipulation and utilization by the political actors in the film. Juanito is temporarily able to escape his condition, but his character development relies on Roberto rehousing and re-educating him. Once his material needs are met, his character is permitted a political and class consciousness. This formula, while intended to denounce the plight of the class Other, simultaneously fixes it in its place, so

to speak, because it judges that economic precariousness (and lack of "moral" judgment) disqualifies one from political life. In her theory of political performativity, Judith Butler argues against Hannah Arendt's distinction between the social and the political—or the body and the speech act—in which the political domain is distinguished from the one of economic need, signifying that the struggle for necessities cannot also be the fight for freedom.[8] In other words, in the film the poor are not political beings because it is understood that their individual needs and desires supersede their political investment. The film's tragic conclusion culminates not only in Juanito's death but also in the fact that Roberto, as a soon-to-be-public homosexual will also be stripped of his political qualifications and perceived as incapable of public responsibility beyond individual needs.

Nevertheless, while constructing a bourgeois gaze aligned with the image of the "good homosexual," *El diputado* also generates an ironic distance from the protagonist. At times, the film's apparent bad taste functions as a critique of the lack of sexual politics and cultural relevance in general by the orthodox left, and is depicted through ironic Marxist explanatory dialogue and the functional mise-en-scène. If Juanito and Nes are not to be trusted because they lack ideology, then Roberto's credibility as a defender of the working class is also questioned in his bourgeois *progre* (short for "progresista" and alluding to left-wing) tastes, made particularly evident in the scene in which the lovers are in his clandestine apartment. Once used for covert political meetings and the printing of illegal leaflets under the Franco dictatorship, Roberto's spare apartment continues to provide the secrecy needed in his life, but now for his romantic rendezvous. Against the kitschy mise-en-scène of the fervently Marxist-Leninist decor, Juanito asks Roberto if he can put on some music to set the mood. While Juanito prefers radio and flamenco rock (which Roberto considers *hortera*), Roberto prefers the somber and serious register of the protest songs by Raimon, Joan Manuel Serrat, and Manuel Gerena. They settle on Gerena's "Canto a la libertad," repeated extradiegetically throughout the film.

Roberto's musical tastes and decor reiterate the film's own aesthetic in which the primary function of art is as a didactic vehicle for political messages. While the music plays, close-ups of Juanito's and Roberto's faces alternate. As the politician stares into his young lover's eyes, the reverse shot is jarringly interrupted by shock cuts as Roberto's intensely solemn gaze moves between Juanito's laughing face and the portraits of Karl Marx, Vladimir Lenin, Che Guevara, and Santiago Carrillo that adorn the walls and whose collective watchful gaze foreshadows the fact that Roberto's sexual desire and party-political vocation are on a collision course. The difference between Roberto's and Juanito's aesthetic preferences is echoed in the affective mismatch between the two; their behavioral cues for navigating romantic situations seem to be derived from very different sources. To drive home the point of the obsolescence of Roberto's

Marxist-Leninist aesthetics of political commitment and sacrifice, Juanito (who represents pleasure and bodily enjoyment) introduces Roberto to marijuana spliffs (*porros*). The film not only throws the lack of sexual politics of the newly institutional left into relief but also suggests that it is out of touch with its purported historical subject—the (lumpen) proletariat. The Marxist Roberto ironically applies bourgeois universality to Juanito. Nevertheless, the irony of these scenes seems to have been lost on the film's contemporary critics, who tended to interpret them as unintentionally humorous in their bad taste.[9]

The Spectacle of Democracy

Eloy de la Iglesia unapologetically employs melodramatic conventions and "sexploitation" tactics to attract spectators.[10] However, Roberto and Juanito's private drama is set against the backdrop of a realistic fictional account of the political Transition to democracy through which the issue of exclusion of sexual difference is an entry point for the critique of the consolidation of consensus politics in Spain. I am inclined to diverge from the assertion that the film's critique fails because it resorts to a Manichaean dichotomy between the "goodies" (leftists) and the "baddies" (far right),[11] or that it partakes in a militant defense of Marxism or Marxist-Leninism.[12] In my view, the film's position is, in fact, more complex in that the film attempts to capture the moment when consensus is being built and when the objects of critique—(homophobic) left- and right-wing political factions—are in flux and struggling for inclusion and influence in a postdictatorship political climate. While the neofascists are unambiguously painted as the villains, the film is also an indictment of the hegemonic/institutional left, or the left in the process of institutionalization, connecting the exclusion of the sexual Other to the negotiations and pacts characteristic of the consolidation of democracy. Rather than assuming a position in favor of one of the political sides, the film expresses a perspective of disenchantment with the political actors presented. In other words, it is on the side of those who have no side, or what Jacques Rancière calls the "part of those without part," whose grievances are brushed off and cast as a defense of personal interests rather than being of public concern.[13]

The incompatibility of Roberto's sexuality and his political aspirations that are tied to his political party affiliation is made clear on various occasions and is expressed explicitly by Carmen, who tells her husband: "The party and public opinion can turn on you when all of this becomes public knowledge. Tomorrow they are supposed to nominate you as their leader. You know this would be impossible if they find out you are a homosexual. It's not just about your prestige, but the whole party's prestige." Even without the confrontation between Roberto and his party comrades taking place, we know that it would result in Roberto's exclusion from politics and public life. With the moment of

confrontation omitted, what remains ambiguous and open to interpretation is whether this exclusion is primarily a political strategy due to the need of the hegemonic left to gain acceptance and legitimacy from a homophobic public, or if the hegemonic left's reluctance to defend sexual difference is a result of homophobia within its own ranks. To elucidate this aspect of the film, some scholars have referred to Spain's gay rights history, detecting in *El diputado* a historically relevant reference to the hesitation of the Transitional left to include gays and lesbians in its political agendas, who then had to carve out their own political spaces outside of the official options.[14]

This conflict that shapes the dramatic tension in the film reflects what the filmmaker (a gay man himself) likely viewed as a glaring contradiction in Marxist-Leninist thought—that is, that individual freedom and political struggle were apparently considered mutually exclusive. As Robin Podolsky noted in reference to the U.S. milieu, but which could be applied to the divergence between international communism and Western countercultures during this period in general: "One aspect of the middle-class Marxist approach to the working class as an idealized, hence objectified, Other was a diminishing of difference—racial, national, gendered and sexual" in which "lesbian and gay sexuality and relationships—more to do with personal happiness and sexual pleasure than the 'material basis' of procreation—were considered self-indulgent distractions from struggle."[15] This notion that individual pleasures must be sacrificed for the greater political good undoubtedly granted privilege to heterosexual males whose sexual desires coincided with the reproductive needs of the revolution. This point is evident not only through the theme of homophobia in the film but also in the treatment of Roberto's wife, Carmen, who, for example, is instructed in jest by party comrades to fulfill her duty in tending to her husband's "needs" after his release from prison. In contrast, countercultural young people and adults emphasized the pursuit of pleasures and freedoms based on sexual openness and through adherence to alternative lifestyles and nontraditional familial configurations.

The tone of disenchantment in *El diputado* is a commentary on the establishment of a new bipartisan political common sense, illustrated on one hand through the hegemonic left's compromise (which predicts their abandonment of Marxism and historical struggle), as well as through the far right's collusion with the post-Franco state security apparatus. In the opening credits the film claims that the events depicted are fictional, yet the fact that such a disclaimer seems necessary inadvertently presumes that *El diputado* aspires to be mimetic of the real. It does so by anchoring itself in historically resonant references and by inserting authentic newsreel footage of real politicians. Roberto's party, which has just been legalized after forty years of clandestine status under the Franco dictatorship, is a fictitious one, although it is recognizable as an amalgam of the Spanish Communist Party and the Spanish Workers' Party. In

reality, these parties had different fates as the latter became Spain's hegemonic center left and the former morphed into various regional iterations and is today housed within the United Left.

Upon the legalization of the party under the new democracy, the general secretary—Eusebio Moreno Pastrana (a character inspired by Spanish Communist Party leader Santiago Carrillo)—makes a public speech crediting the struggle of the populace in bringing about democracy, but also outlines the limits of this struggle and accepts defeat: "First we championed the democratic rupture [with Francoism], then we accepted the pact, and finally the negotiations between the government and the opposition." We learn that Roberto's party, like the real democratic opposition, must negotiate asymmetrically with the former Francoist elites, accepting the "pacted rupture" that is offered as a means of avoiding a confrontation with the traumatic past of Spain's historical conflict. Moreno Pastrana's speech is also framed first as a close-up at the party headquarters, then is shown as a broadcast on a television screen in a typical Spanish restaurant-bar so as to provide verisimilitude between the fictional Pastrana and the real news footage of Transition politicians displayed in the film.

While insisting on realism through matching the fictitious politicians to the real-life political scene, the film fixates on Spain's new (post)political reality in which political discourse becomes inseparable from media optics. The proliferation of television screens in the film is a functional plot device that links the characters and drives the story forward, but also shows the media as it becomes a central tool in building consensus. After a leftist political gathering is violently targeted by the far-right ringleader Carrés's thugs—with whom the police are apparently complicit—their impunity is condemned by Roberto in Parliament. We are then shown newsreel footage of Felipe González and Adolfo Suárez, deceptively edited as a reverse shot to Roberto standing before a mix of real and fictional politicians as he condemns the destabilizing violence perpetrated by right-wing militants. Roberto's speech is televised, which prompts a reaction from the far-right cadre who voice their concern about controlling public opinion in their favor. While their homophobia (and contempt for democracy) is unambiguous—revealed in Carrés's disdain for Nes and Juanito: "It's that liberal corruption that turned you into what you are"—the scandalizing potential of their plan to force Roberto out of the closet nevertheless relies on the homophobia of the general public. The moment in which Roberto transitions from political clandestinity to media visibility is when his serious problems begin because that is when his opponents' plans begin to take form. They do not engage the opposition on the political issues but from a behind-the-scenes plot to generate a media scandal in order to discredit the left, thereby resolving to employ the "weapon" of media optics to win over public opinion. At another point, a copy of *El Alcázar*,[16] an intransigent pro-Franco newspaper, is inserted

into the film in Carrés's lap as he looks up from reading it to watch the news. If, in our day and age, *El diputado*'s transparent strategy for producing realism seems too explicit or dated, its focus on the mediation of reality should resonate today in the era of increasingly intense mediatization of everyday life, not to mention the manipulation of political realities through social media.

Consequently, *El diputado* generates a damning depiction of the mingling of coercive violence and consent, as they operate together to inform the consolidation of democracy. While the scenes depicting the far-right machinations feel somewhat contrived, they in fact render visible the taboo subject of political violence during the Transition, in this case particularly of the far-right and pro-Franco groups whose actions underpinned the climate of fear that shaped the process. Roberto's references to real events of far-right violence taking place as contemporarily as 1977—such as the assassination of the Atocha lawyers in Madrid and the bombing of the headquarters of the satirical magazine *El Papus* in Barcelona—attaches a sense of urgency to the film's message. While those on the far right were to be cast as fringe extremists by the dominant Transition narrative, the visibility of their violence in the film implicates their influence on mainstream politics and echoes in the state security apparatus.

Notably, however, rather than espousing a clear ideological message prescribing the institutional left's program as a solution to Spain's democratic troubles, *El diputado* demonstrates that, despite the arrival of democracy, the sphere of official politics will continue to produce Others as well as be contaminated by undemocratic elements. The film's radical queerness resides not just in its defense of homosexuality but in its distaste for the political binary, shifting its focus, instead, to the interdependence of systems of domination.

Queer Pessimism

Near the end of the film, when Roberto is summoned to his clandestine apartment to face his political enemies, he delivers a monologue to Carmen, in which he accepts the imminent public scandal and projected ejection from political office. Refusing to accept the consensual premise of history as linear progress, he states: "I was someone who had signed up to shape history, but instead I will have to suffer it." At the same time, he admits the futility of attempting to influence a history that never belonged nor will belong to him: "Let them get into power. Those who don't care about giving in and concealing things in order to get ahead. But not me, I'm sick and tired of giving in and concealing." This powerful yet somewhat ambiguous assertion (who exactly are the "they" he is referring to?) has undoubtedly given way to differing interpretations about the political message of the film. It is significant that Roberto's charge does not single out the right or the left, and that his grievance has to do with both his identity and his politics; he is excluded as a homosexual and feels uneasy about

the political compromise necessary to exist in the world of parliamentary politics. He lets go of the normalization fantasy and accepts the impossibility of hiding his sexuality and of forming part of the new political reality, which he recognizes requires a degree of concealment. Concealed under the surface-level resolution of the Transition pact is not just sexual Otherness but the irreducible difference among various political, national, and cultural identities, as well as the associated irreconcilable understandings of freedom.

After Roberto delivers this monologue and departs to discover his murdered lover, the filmic time catches up to where the story began, with Roberto on his way to being presented as the new leader of his party, with the knowledge that he is also about to be forcibly outed by the imminent scandal. The film closes with Roberto raising his fist to the song of the International in front of his party comrades, the camera framing his solemn face as he holds back tears.

Far from a neat melodramatic resolution, the film ends on a more sordid note than where it began, projecting that there is no happy future for the class or sexual Other. Considering the legislative developments that would decriminalize homosexuality in Spain—including the reversal of the Ley de Peligrosidad y Rehabilitación Social—that were underway at the time of the film's release, it was this pessimism that did not sit particularly well with the contemporaneous critics of the film.[17] While Juanito is sacrificed for the continuation of the status quo determined by the consensus, Roberto is destined for the underground margins. He no longer seeks integration but rather accepts that his visibility will be limited to "that queer who tried to be a politician . . . an irresponsible guy" who will spend his future days not making political speeches but, as he projects, lurking in adult cinemas and underground spaces. Accepting his contradictions and rejecting the concealment necessary to lead a double life, it is implied that he will no longer be qualified for political life in the conventional sense. Nevertheless, facing reality marks a point of agency in no longer seeing the value of sacrifice for a prosperous future that may never exist for him.

Recalling his contribution to queer theory in *No Future: Queer Theory and the Death Drive*, Lee Edelman locates the queer's radical potential precisely in the pessimism toward reproducing the present: "Queerness exposes the obliquity of our relation to what we experience in and as social reality, alerting us to the fantasies structurally necessary in order to sustain it."[18] Roberto, as the "good homosexual," comes apart, giving way to the pessimistic queer who rejects the viability of the social and the consensual fantasy that structures reality and ensures its reproduction. Uninterested in seeking integration and inclusion in the unjust system, he will no longer capitulate to the social order and legitimize the authority of the hetero-patriarchy to sanction inclusion or delineate between self and Other. For Edelman, in order for queerness to fulfill its political potential, it must necessarily represent "the side outside the consensus by which all

politics confirms the absolute value of reproductive futurism. . . . Far from partaking of this narrative movement toward a viable political future, far from perpetuating the fantasy of meaning's eventual realization, the queer comes to figure the bar to every realization of futurity, the resistance, internal to the social, to every social structure or form."[19] *El diputado*'s singularity, then, resides in the questioning of the normalization fantasy characterizing the new democracy and rejection of the assumption that the present will necessarily be an improvement on the past simply by allowing the future to unfold. Thus, while the film undoubtedly presents a fervent defense of homosexual rights, Roberto's predicament also suggests the limits of seeking inclusion within a social order that necessitates exclusion to ensure its own survival. Ryan Prout's opinion on the film's pessimistic continuity focuses on what he views as a dystopian homogenization of party politics through the proliferation of government surveillance and archiving practices (Roberto is monitored first by the Francoist state, then surveilled by Carrés and his minions).[20] Considering the renewed criminalization of public dissent in Spain today through legislation such as the Popular Party's 2015 Citizens Security Law (referred to colloquially as a new "gag law") or the violent repression of Catalonia's exercise of self-determination in 2017, Prout (who was writing with 9/11 in near retrospective view) was not off the mark in acknowledging the film's anticipation of the continuation of undemocratic practices in twenty-first-century Spain. What I suggest, however, is that the film's early, prescient pessimism about Spanish democracy is in fact its peculiar virtue. Freed from the obligation of justifying the present based on a responsibility to, and for, the next generation, the film accepts its queer capacity to "tell the truth," however unpopular.

El diputado and the Future

Ultimately, Eloy de la Iglesia seized a window of opportunity during the frenetic period of Transition cinema, in which he managed to make politics and homosexuality attractive to a mass audience. His cinema contributed to the social acceptance of homosexuality prior to Pedro Almodóvar's mainstreaming of homosexual and transgender subjects. Perhaps the popular of these auteurs could be considered a cultural barometer of their time, when the waning of Eloy de la Iglesia's oeuvre in the middle to late 1980s coincided with the ascension of Almodóvar's new aesthetics. While de la Iglesia centered marginality against the backdrop of a crisis temporalness and questioned the viability of the future, Almodóvar's inclusion of marginal subjects reads more as a celebration of Spain's social progress in the democratic era. De la Iglesia went on to make various successful films, reaching an apex of viewership in *El pico* (1983) [*Overdose*] that coincided in cinemas with Almodóvar's third feature-length *Entre tinieblas* (1983; considered his first "serious" picture) [*Dark Habits*], both

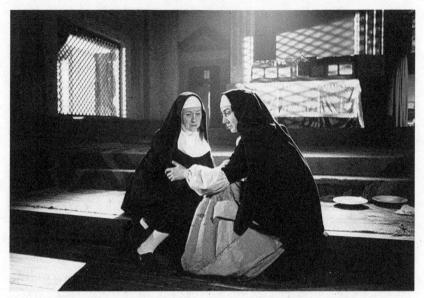

FIG. 6.1 Julieta Serrano and Marisa Paredes. *Entre tinieblas* (1983) by Pedro Almodóvar.
Courtesy of El Deseo, S.A.

films containing homosexual undertones. *El pico* was Spain's highest-grossing
movie of 1983, and Eloy de la Iglesia's biggest blockbuster. He continued mak-
ing films until 1987, followed by a fifteen-year hiatus attributed to the direc-
tor's own struggles with hard drug use, and finally returned to placing
homosexuals in the foreground in *Los novios búlgaros* (2003) [*Bulgarian Lov-
ers*] before his death in 2006.

 El diputado was a commercial success at the time, with close to a million
viewers in Spain. Despite tackling universal themes, however, de la Iglesia's cin-
ema seemed somewhat anchored in Spain's social reality, and the implementa-
tion of utilitarian aesthetics contributed to the fact that it may not have firmly
stood the test of time or have translated to a broad international viewership.
His films do, nevertheless, remain on the radar of cult audiences interested in
either queer cinema or *cine quinqui*; the latter has experienced a revival of inter-
est in recent years, academically as a trove of counternarratives of the Spanish
Transition, and in popular culture in general. By signaling the obsolescence of
the purely materialist metanarrative and also maintaining a pessimistic attitude
about what was becoming the dominant mode, *El diputado* in particular reso-
nates with a preconsensus view of intersectional homosexuality that wanted
to change social relations beyond nonnormative sexual identities. Roberto's
conflict is easily deciphered under the rubric of early leftist gay rights initia-
tives of the time who believed that a transformation of sexual relations would
form part of a larger transformation of society.[21]

In Alberto Mira's view, *El diputado* laid the groundwork for the intersection of class and sexual consciousness in which the homosexual relationships fail because of a repressive system and not because of any inherent fault in the homosexual characters, and yet the example it set would not be replicated anytime soon in Spanish cinema.[22] The intrigue of the dominant postmodern temporalness of 1980s Spain declared that the optimal future had already arrived in the present, absorbing the radical potential of the queer and transforming it into an identity available for consumption in the cultural marketplace. Observing this subsequent depoliticization of homosexuality, Santiago Fouz-Hernández writes, "While Spanish gay movements have been successful in eradicating homophobic Francoist laws, there are now new forms of oppression often disguised as gay-friendly businesses and media which operate alienating modes of control."[23] Insofar as the premise of the liberal, good-life fantasy is accepted and sexuality is reduced to solely an identity issue, its political potential appears to be neutralized. In Lee Edelman's words: "Queerness thus comes to mean *nothing* for both: for the right wing the nothingness always at war with the positivity of civil society; for the left, nothing more than a sexual practice in need of demystification."[24] It would take the emergence of poststructural queer theory in the 1990s and its development into the new millennium—which explored the political potential of nonnormative sexuality and gender fluidity—to fully engender a radical queer critique of *El diputado* and other cultural production of its era.

At the time of its release, and perhaps until the political and economic crisis of the last decade, *El diputado*'s pessimism and explicit political content seemed out of step with the dominant narrative of the Transition to democracy that was characterized by hope and even euphoria surrounding the emerging democratic era. The film's commentary on sexual identity is set against a crisis temporalness that is tied to an unsustainable present. It is this pessimism that may now make it seem timely for current audiences who can recognize its crisis temporalness, which cycles back into the contemporary moment. While the topic and the largely functional aesthetic of the film at times hinder its political possibility, it remains a captivating document of both early homosexual visibility and Spain's Transition to democracy. I have proposed a case for its renewed relevance, particularly in light of current challenges to Spain's constitutional consensus calling, more than ever, for a queer politics of alliance across marginalized groups against an increasingly generalized precariousness. Perhaps the film's prescient skepticism about the Spanish Transition to democracy is most clearly vindicated by the current formidable challenges to Spain's bipartisan constitutional consensus—evinced by the proliferation of social movements as well as parliamentary formations such as Unidas Podemos, the varied coalitions of Catalan and Basque separatist parties, and unfortunately also the surge of the far-right Vox party.

As for the actor who played Roberto Orbea over forty years ago, José Sacristán has been embedded in the Spanish star system for decades and is recognizable as perhaps the most emblematic actor of the Spanish Transition to democracy. More recently, through his performance as the "honorable man" in the highly intertextual Isaki Lacuesta's *Murieron por encima de sus posibilidades* (2014) [*Dying beyond Their Means*], one can detect a resonance with Roberto's character brought up-to-date into the present moment. The elderly honorable man is a debtor in this realist satire, oddball film about the economic crisis; the film's title explicitly undermines the discourse of individual responsibility and self-sacrifice used by Spain's governing officials to normalize austerity. When confronted by his creditor, the honorable man refuses to pay his debts, resolving instead to pay some wisdom forward to the younger generation: "We love saying that we fought to bring you all a democracy . . . but what we've left you is shit. We complain endlessly about the politicians, and then we ask for another round."

Notes

All translations are mine, unless otherwise indicated.

1 See Alberto Mira, *De Sodoma a Chueca: Una historia cultural de la homosexualidad en España en el siglo XX* (Barcelona: Egales, 2007), 502; Alejandro Melero Salvador, *Placeres ocultos: Gays y lesbianas en el cine español de la Transición* (Madrid: Notorious, 2010), 250; and Alberto Berzosa, *Homoherejías fílmicas: Cine homosexual subversivo en España en los años setenta y ochenta* (Madrid: Traficantes de Sueños, 2014), 201.

2 Paul Julian Smith, "Eloy de la Iglesia's Cinema of Transition," in *Modes of Representation in Spanish Cinema*, ed. Jenaro Talens and Santos Zunzunegui (Minneapolis: University of Minnesota Press, 1998), 222.

3 The Ley de Peligrosidad y Rehabilitación Social (Law of Social Danger and Rehabilitation) was written under Francisco Franco in 1970 as a continuation of the Ley de Vagos y Maleantes (Law of Vagrants and Crooks), established during the Second Spanish Republic, and was later modified to target homosexuality and its cultural practices explicitly.

4 Smith, "Eloy de la Iglesia's Cinema of Transition," 234.

5 Smith, 234.

6 The juvenile delinquent figure popularized in 1970s and 1980s Spanish cinema and mass culture.

7 Mira, *De Sodoma a Chueca*, 504.

8 Judith Butler, *Notes toward a Performative Theory of Assembly* (Cambridge, MA: Harvard University Press, 2015), 46–47.

9 Smith, "Eloy de la Iglesia's Cinema of Transition," 233.

10 The combative nature of Eloy de la Iglesia's style has been referred to by Alberto Berzosa as a "Trojan Horse," in which subversive homosexuality is coated in an attractive melodrama packaging, readily accessible for mass consumption. See Berzosa, *Homoherejías fílmicas*, 201.

11 Smith, "Eloy de la Iglesia's Cinema of Transition," 236.

12 Isolina Ballesteros, *Cine (ins)urgente: Textos fílmicos y contextos culturales de la España postfranquista* (Madrid: Editorial Fundamentos, 2001), 98.

13 Jacques Rancière, *Dissensus: On Politics and Aesthetics*, trans. Steve Corcoran (New York: Continuum, 2010), 44.

14 See Melero Salvador, *Placeres ocultos*, 246–250; Berzosa, *Homoherejías fílmicas*, 194–195.

15 Robin Podolsky, "Sacrificing Queers and Other 'Proletarian' Artifacts," *Radical America* 25, no. 1 (1991): 54.

16 The far-right periodical responsible for having galvanized the cell of Franco loyalists who later attempted the February 23, 1981, coup in the Spanish Parliament.

17 Ryan Prout, "*El Diputado / Confessions of a Congressman*," in *The Cinema of Spain and Portugal*, ed. Alberto Mira (New York: Wallflower, 2005), 164.

18 Lee Edelman, *No Future: Queer Theory and the Death Drive* (Durham, NC: Duke University Press, 2007), 7.

19 Edelman, 3–4.

20 Prout, "*El Diputado*," 165.

21 Melero Salvador, *Placeres ocultos*, 242.

22 Mira, *De Sodoma a Chueca*, 512–513.

23 Santiago Fouz-Hernández, "Queer in Spain: Identity without Limits," in *Queer in Europe: Contemporary Case Studies*, ed. Lisa Downing and Robert Gillett (New York: Routledge, 2016), 193.

24 Edelman, *No Future*, 28.

7

A Blatant Failure in Francoist Censorship
•••••••••••••••••••••

Jaime de Armiñán's
Mi querida señorita (1971)

CONXITA DOMÈNECH

Signaling the changes that occurred in both Spanish cinema and Spanish society, a film emerged in the early 1970s that caused confusion among both film critics and the public at large: *Mi querida señorita* (1971) [*My Dearest Señorita*].[1] The film by Jaime de Armiñán (1927–) could possibly be considered the predecessor of the Pedro Almodóvar (1949–) phenomenon: extreme characters, suffering, and provincialism are present in the works of both directors. Almodóvar himself has pointed out, "I would have loved to direct López Vázquez in *Mi querida señorita*."[2] Although José Luis López Vázquez (1922–2009)—the main actor—never worked with Almodóvar, two actresses in the film became the director's future muses: Julieta Serrano (1933–) and Chus Lampreave (1930–2016). Before Almodóvar and democracy in Spain, Armiñán dared to offer the main role of his film to López Vázquez, the Spanish comic actor—or the character of the popularly known *españolada*.[3] The director not only dresses López Vázquez as a woman in *Mi querida señorita* but also achieves a place for the actor and the film in the artistic tradition of the Transition period known as Third Way Cinema.[4] In Third Way Cinema, Spaniards no longer had to identify themselves with the foolish characters of Hispanic comedy. On the

FIG. 7.1 Julieta Serrano. *Entre tinieblas* (1983) by Pedro Almodóvar. Courtesy of
El Deseo, S.A.

contrary, the dignity of the protagonists—vulnerable and perplexed—allowed
spectators to see themselves reflected in the inexorable social changes underway.[5]

Scholars have analyzed *Mi querida señorita* as a product of Francoist repres-
sion; in particular, they have focused on the near absence of—or rather
nonexistent—sex education under the dictatorial regime of Francisco Franco.[6]
Furthermore, the film has been examined as one of the first Spanish queer
films.[7] Finally, critics have noted with disbelief that the film was not censored.[8]
Even the director could not understand why only a single scene—which showed
the bare breast of Feli (Mónica Randall)—was excised. In this essay, I will estab-
lish a hypothesis for how the film of Jaime de Armiñán managed to escape
Franco's censorship. My hypothesis will revolve around this central filmic evi-
dence: in *Mi querida señorita*, the priest, the doctor, the banker, and the maid
are nonplussed by the transformation of Adela into Juan. Before addressing the
characters' lack of astonishment, however, I will briefly summarize the film.

The life of the provincial Adela Castro is upended when the newcomer San-
tiago (Antonio Ferrandis)—the new director of the bank—asks her to marry
him. The respectable forty-three-year-old woman has doubts: she has never had
sex; she shaves her face every day; and she is attracted to her maid Isabelita
(Julieta Serrano). Adela decides to explain her misgivings about the proposal
to her confessor (Enrique Ávila), who advises her to visit a doctor (José Luis
Borau) in Zaragoza. The doctor assures Adela that she is strong and courageous,
but she is not a woman. After a medical intervention, Adela changes her name

to Juan and moves to Madrid. In the big city, Juan settles in a motel, where he encounters financial hardship. He cannot work due to lack of experience, nor can he use his identification card because it states that his name is Adela. Still, he manages to earn a few pesetas by sewing secretly. Next door to the building where Juan picks up dresses to be sewn, his former maid, who has changed her name to Isabel, works as a waitress. Besides going out with Isabel, Juan studies for his baccalaureate. Eventually, he realizes that he must return to his native Galicia to legalize and normalize his situation. Once he returns to Madrid and buys an apartment, his sexual uncertainty continues. These doubts dissipate in the suggestive final scene: Juan and Isabel chat in bed after having their first sexual encounter.

From Fittipaldi to Pirri: Adela's Doubts

The initial misgivings of the screenwriters—Jaime de Armiñán and José Luis Borau—are reflected in Adela's doubts about her sexuality.[9] From the beginning, both screenwriters knew that the film presented a challenge requiring great boldness:[10] "At first, we thought that it was a totally crazy movie."[11] Their audacity could result in complete censorship of the film: "The difficult part was to escape censorship with a subject like that."[12] That issue aside, the screenwriters' greatest concern was the spectator reception of the film. It was important that the audience laugh, but only at the right time: "The problem would have arisen if they laughed when we had not planned it."[13] The challenge and the laughter could arise immediately, in the first scene after the opening credits: a close-up of López Vázquez—one of the best-known actors on the big screen in Spain—dressed as a woman.[14]

From the beginning, Armiñán and Borau thought of López Vázquez for the character of Adela/Juan, but the proposal, and especially the character, initially frightened the actor, who backed off.[15] The actor's fear is perfectly transmitted to the main character. Adela's fear—and, later, Juan's fear—is felt throughout the film. One of the many moments when Adela is frightened takes place when Santiago puts an engagement ring on her finger. He caresses her face affectionately, and Adela flees in terror (0:28:11–0:28:30).[16] Moreover, fear adds to the discomfort of being male and female at the same time. Adela feels uncomfortable with facial hair and sighs in front of the mirror at having to shave again (0:16:18),[17] and López Vázquez felt uncomfortable as a woman: "He had a hard time. It was August, he was wearing a corset and we had to shave him constantly."[18]

The doubts and the discomfort are also reflected in the many mirrors present in the film. The mirrors display a ubiquitous presence: there are two in Adela's room, one in the living room and another in the bathroom, in the foyer and in the motel room, in Feli's room and, finally, in the bathroom of Juan's

apartment.[19] Furthermore, the use of mirrors implies a call of attention to the viewers, reminding them never to forget their presence. In these close-ups, Adela/Juan examines her/his face methodically to make sure everything is in order. In front of the mirror, Adela, first, and Juan, later, checks mustache and beard, allowing a queer contrast between the manicured hands and the facial hair. Adela/Juan carefully studies her/his face, an action that could easily be linked to Jacques Lacan's mirror stage theory. Although I am aware that Lacan bases his theory on observations of a baby, in Adela's case, her lack of knowledge of her own body and her sexual innocence could be related to the fragmented infant body.

On three occasions, Adela/Juan observes herself/himself attentively in the mirror, corresponding to the three logical stages of Lacan's theory.[20] The film begins with an establishing shot: Adela in front of the mirror (0:01:43). At that moment, Adela is struck by her image reflected in the mirror and understands the image as that of an actual being. At that moment for Lacan, the infant also perceives his own image as a real being, whom he wishes to approach and touch. It should be noted that the spectator of *Mi querida señorita* is also a participant in that initial moment: the spectator discovers the protagonist for the first time. In the second instance, Adela is in the bathroom inspecting her facial hair (0:16:18). When she touches the hair on her face, Adela seems to realize that this other specular being, in front of her, is not actually a real being but the reflected image of another who is not she. In other words: there is no identification between the reflecting person and the reflected image. And, in Lacan's views, the child discovers that the other is not a real being, but the mirror image of another. In the third moment, the spectator now discovers Juan's face for the first time: Juan looks at his face in the mirror at the motel (0:36:30). It is an event of negative recognition and positive identification: the image of Juan that he sees as mere reflection is not that of another, but that of himself. Like Lacan's child, Juan has successfully resolved fragmentation—or, rather, the absence of organicity—between certain parts of his own body.

The first image of the film—the close-up of Adela—is preceded by the opening credits and a series of photographs, which are ordered from baby Adela to adult Adela. The sepia photographs show Adela alone or with other people—mostly women, such as her schoolmates. Adela's latest photograph—the close-up of today's Adela—is set in motion as she stands in front of the mirror, in an action that blurs the boundaries between photography, film, and reality. As described by David Neumeyer, "The camera's work at its most basic results in something much like the image in the mirror: the still photograph is a contained frame and therefore interpreted representation of 'what's out there.' Even the simple statement 'a photograph (or a film shot) represents reality.'"[21] According to Roland Barthes, photography does not recall the past: "The effect it has on me is not the restitution of what has been abolished (by time, by

distance), but rather the testimony that what I see has been."[22] The photographs with the opening credits do not recall Adela's past. Rather, they serve to assure the spectator that Adela has been a girl and a woman. The photographs and the mirrors do not translate, nor do they interpret, "and that naturalness allows us to trust them."[23]

These photographs or this reflected image of a woman—of the protagonist—fades away and Adela gradually transforms into a man. First, the change occurs with flowers. Adela gives a carnation to Isabelita (0:02:06). The maid says goodbye to Adela from the balcony with the carnation in her hand (0:02:56)—an image of traditional courtly love—while Isabelita's suitor observes her from a distance, also with flowers in his hands. Subsequently, Isabelita's suitor—a flower delivery man—brings the flowers that Santiago sends to Adela's house (0:07:43). As Sally Faulkner has pointed out, "The close relationship between Señorita and maid is established from the first post-credit sequence by the presentation of a red carnation . . . the audience understands that Adela's gift of flowers to Isabelita represents exactly the same thing as Santiago's floral offering: heterosexual romance."[24] The second change becomes evident when Adela drives her car. Few women in Spain in the 1970s had a driver's license or a car. In addition, Adela drives aggressively, as would be expected of a man.[25] Third, Adela athletically kicks a soccer ball (0:14:46). Her soccer dexterity is such that a photograph of Adela kicking the ball appears in the newspaper (0:14:50), leading Isabelita and her suitor to call Adela "Pirri."

"You Will Be Fulfilled Physically and Spiritually": Progressive Advice

"We are no longer in the Middle Ages . . . not even in the 1940s. . . . It is necessary to put aside prudishness and fear of sin. You can ascend to Heaven the same in a frock coat as in sport pants or, in the case of girls, in a two-piece bikini" (0:12:17–0:12:39), the priest José María proclaims in a speech at the opening of a sports club. The priest's modern declaration prompts both positive reactions in the form of the characters' nods of approval (0:12:41) and negative reactions reflected in statements such as "we are on the wrong track" (0:12:40). For the occasion, the handsome priest leaves his cassock in the church and dresses in shorts. Besides the shorts, the most striking aspect of the priest's personality is his defense of the body, summed up in the Latin phrase *mens sana in corpore sano*. José María advocates, "If we improve our bodies . . . we will be closer to God" (0:12:58). Adela must improve her body to be closer to God. Thus, the Church not only blesses but also recommends that Adela change to Juan.

Adela does not express her opinion on the priest's speech at the sports club. To Santiago's question, "Do you agree with him?" she answers with another question: "And you?" (0:13:13). Agreeing with José María might constitute a threat: the priest belongs to the progressive clergy of the time—or the so-called

new priests—who "openly showed their nonidentification with an ecclesiastical hierarchy that was too cozy with political powers."[26] Adela suppresses her feelings toward the progressive priest, but in the confessional booth she reveals her secrets. Adela's confession begins with "I have never been interested in men" (0:23:50); continues with an explanation of Santiago's marriage proposal, which the priest approves with the response: "You will be fulfilled physically and spiritually" (0:24:15); and ends with "You understand me, right?" (0:24:50). The priest is not scandalized by Adela's confession, nor does he condemn her. On the contrary, he understands her, shows compassion, and, above all, refers her to a doctor in Zaragoza—a former classmate. The priest's acceptance without judgment is the first in a succession of similar reactions.

Although José María's equanimity might seem surprising, it does not depart from the position of the Catholic Church on hermaphroditism or pseudohermaphroditism. The Catholic Church condemns surgical interventions to change sex: "No one has the right, while actually . . . being a member of one sex, to attempt, by surgical or pharmacological alteration, to live as a member of the opposite sex."[27] Nevertheless, in the case of hermaphroditism or pseudohermaphroditism, the Church permits surgical intervention: "Everyone has a right to have the inconsistencies of his sexual anatomy corrected by plastic surgery and pharmacological therapy."[28] Moreover, the Catholic Church recommends that hermaphrodites or pseudohermaphrodites undergo surgical intervention, "to fix himself or herself as clearly as possible in one of the two sexes of humanity."[29] Therefore, Adela not only can have an operation but must do so—according to the Catholic Church—in order to belong to "one of the two sexes of humanity."

Aggrieved by Santiago and Isabelita, Adela decides to make an appointment with the doctor in Zaragoza. After the medical examination, the doctor reacts as the priest did, with total professionalism, and paraphrases the priest's speech given during the inauguration of the sports club: "You cannot have a sick mind without the body being sick as well" (0:33:41). The healthy body (referred to by the priest) is now a sick body (referred to by the doctor). In Adela's sick body, "we have to intervene, of course, . . . but do not be alarmed, it will be very simple" (0:33:20). Adela's surprise at the comment "you are not a woman" (0:34:08) contrasts with the nonchalance with which the doctor pronounces these words. For him, the situation is not alarming and the intervention is simple. The reactions of the priest and the doctor are identical: both offer empathy, understanding, and help—spiritual and medical, respectively. The Catholic Church accepts the surgery: "The action of the surgeon who helps, by his art, those who wish to escape from sexual indetermination imposed on them by nature, is perfectly justified."[30]

I agree with Leticia I. Romo in "assuming that this is a case of hermaphroditism,"[31] or, more specifically, one of the variants of the partial androgen

insensitivity syndrome in which "genetic males are born with what appears to be female genitalia with an enlarged clitoris. These persons are often raised as females, but at puberty an increase of testosterone leads to masculinization. There then ensues a transition from the psychosocial behavior of a prepubertal female to that of an adult male."[32] For her hypothesis, Romo relies on "the simple intervention." I would add that homosexuality was condemned in Franco's Spain—the Law of Endangerment and Social Rehabilitation was approved in 1970 and included "acts of homosexuality."[33] In contrast, a "simple intervention" for the treatment of partial androgen insensitivity syndrome was fully accepted.

The Extinction of Adela: The Birth of Juan and the Rupture with Santiago

While neither the priest nor the doctor shows surprise at Adela's revelation, their words and actions change her life. In the doctor's office, Adela disappears forever and, from then on, López Vázquez will play Juan. The film is symmetrically divided into two parts, or—as Borau noted—it is built on a script of calculated structure.[34] A woman, Adela, guides the first part, and a man, Juan, leads the second part. Each part begins with Adela/Juan observing herself/himself in the mirror. The two parts connect with a train trip and a tunnel that, at the same time, separates them: "The tunnel points, of course, to the emotional darkness of Adela's past and inasmuch as it has a womb-like resonance, to her birth into a new life in the form of Juan."[35] The train and the tunnel are two motifs used repeatedly by Almodóvar, as seen in *Todo sobre mi madre* (1999) [*All about My Mother*].[36] In Armiñán's film as in Almodóvar's, the tunnel offers a luminous image "of an aesthetic birth,"[37] "an umbilical cord,"[38] or a "birth canal."[39] The train and the tunnel also connect two places and two ways of life: Pontevedra and Madrid, or Galician provincialism and Madrid urbanity. The same journey by train, but in the opposite direction—from Madrid to Galicia—will take place in another Almodóvar film: *Julieta* (2016).[40]

It is worth underscoring that this will not be Juan's last voyage. Like Julieta—the protagonist of the eponymous film—Juan travels from Madrid to Galicia, but his journeys are not shown explicitly. Juan goes from the motel in Madrid to the bank and the house in Pontevedra and, then, back to the school in Madrid. His stay in Galicia lasts less than eight minutes in the film, just long enough to legalize his situation and withdraw funds from his bank. Although Juan does not want to talk to anyone in Pontevedra, he needs to interact with Santiago—not with Father José María because Juan does not open the door when the priest shows up at his house. When Juan goes to the bank, he disguises himself as Adela, covering his short hair with a headscarf. Adela/Juan has changed not only her/his physical appearance but also her/his

signature—as the bank employee states: "as you see, the signatures do not match" (1:02:38). Although Juan signs with his still legal name—Adela Castro—the signature does not match the one that the bank has on file. Consequently, Juan needs the approval of the bank's director Santiago in order to withdraw money. Adela's former suitor—like the priest and the doctor—does not show any kind of astonishment at Adela/Juan. Rather, the banker is angry because she seems to have disappeared. Both Santiago and José María were concerned about not knowing Adela's location or fate. As happened with the priest and the doctor, Adela receives help from the banker. After Santiago gives Juan all the money from his account, the banker avers: "You understand that this is not entirely legal" (1:04:49). Juan's stay in Pontevedra concludes with a forensic examination and the burning of the photographs that were exhibited in the opening credits. Thus, Juan is legally a man, and the baby Adela, the young Adela, and the adult Adela are consumed in the flames of the stove.

A Liberated Maid: From Isabelita to Isabel

Isabelita/Isabel is a modern woman in Galicia and Madrid. In Pontevedra, Isabelita is excited when Adela tells her that they will remodel the apartment: "We are going to change the house a little . . . and have a living room, as they call it nowadays" (0:19:41). Isabelita responds cheerfully: "¿Qué me va usted a contar, Señorita?" (0:19:49) (What are you telling me, miss?). Nonetheless, her situation in the provinces is not ideal: Isabelita does not understand Adela's attacks of jealousy. Moreover, the maid's salary is low—1,000 pesetas. Isabelita can only improve her situation by leaving for Madrid. In the capital, she is emancipated: her name is now Isabel, and she dresses in a tight blouse and a red miniskirt. Like Juan, she has changed her name and attire. She also finds a good job as a waitress in a cafeteria. However, she is not attracted to young men: she plays along with the courier in Pontevedra and ignores the young man at the bus station in Madrid. In contrast, when Juan and Isabel meet at the same bus station, her face lights up, and she feels comfortable walking with him in the park. While having Coca-Colas in the park, Juan points out their age difference: "You do not need to waste time with an old man like me" (0:54:44). Isabel rushes to counter: "You are neither old nor are we wasting our time" (0:54:49). Also in the park, Juan behaves just like a man, fighting with two individuals who are making fun of them. The afternoon in the park ends with kisses: first, Isabel passionately kisses Juan under a tree; then, in the entryway of Isabel's house, she says goodbye with a quick kiss on his cheek.

Isabel always takes the initiative and behaves like a sensual woman. According to the Sección Femenina de la Falange (Women's Section): "We cannot expect serious work, deep ideas, fruitful labor, or cozy tenderness from the

sensual woman."[41] In addition, Isabel maintains sexual relations before marriage. As Margarita Almela Boix argues, "During Francoism . . . and in the public mind, the name 'bad women' referred exclusively to those who had sex outside marriage, as opposed to 'normal women' (not 'good women,' because female submission to the dictated morality is assumed)."[42] Isabel, however, is by no means submissive.

One Last Question: "¿Qué me va usted a contar, Señorita?"

Isabelita/Isabel asks rhetorically "¿Qué me va usted a contar, Señorita?" on two occasions: when Adela explains that they will remodel the house—as noted previously—and in bed with Juan at the end of the film (1:19:29). "¿Qué me va usted a contar, Señorita?" becomes the favorite phrase of film critics and journalists who interviewed the director. According to Marvin D'Lugo, this question reveals that "she knows the secret."[43] In turn, Armiñán has never confirmed, "she knows the secret." The director has been elusive. He stated in an interview that "the ending does not mean that she knew everything from the beginning";[44] in another interview, he repeats that "the girl pronounces the phrase instinctively, without realizing it. She did not recognize him before nor does she recognize him now. With this phrase, she simply opens up to a new, strange world."[45] Notably, these two interviews with the director took place during Franco's dictatorship.

From the moment they meet, Isabel closely observes Juan. For example: she looks amazed when he unwraps the sugar cubes in the same idiosyncratic way as Adela did. Isabel also notes how Juan fully enjoys her grandmother's muffins and states, "My poor Lady also liked them a lot" (0:55:12). Furthermore, Isabel becomes tense when Juan gets confused and calls her Isabelita—not Isabel—and she replies, "It's been a long time since anyone has called me that" (0:57:09). Edwards asserts that "¿Qué me va usted a contar, Señorita?" is "a phrase which slips out inadvertently—a kind of Freudian slip."[46] I disagree with Edwards's hypothesis. Isabel does not seem to miss anything and is far from naive. She leaves her work in Pontevedra on her own initiative; goes alone to Madrid; gets a job in the capital; defends herself from men who harass her; does not care what people say; passionately kisses Juan; and has a sexual encounter with him without being married. Could it be that a smart, determined woman who knows Adela well would not have realized?

Isabel simply plays the role of a naive woman. She pretends to masculinize Juan, "What a Don Juan!" (0:52:52), without his noticing: "How do you know my name?" (0:52:54). He is the naive one, in a country where the patriarch—Franco—ascribed naïveté to women. Unlike Juan, Isabel has no misgivings and knows perfectly what she wants: "[Adela] is the only person in the world who has loved me" (0:55:26). Isabel's false innocence turns *Mi querida señorita* into

a love story for the heterosexual public of Francoism—in four more years, Spaniards could stop pretending.[47] Without a doubt, the film is a magnificent love story with an even more magnificent insinuation: "¿Qué me va usted a contar, Señorita?"

Notes

All translations are mine, unless otherwise indicated. I would like to acknowledge Kathleen Hammond for her excellent assistance in proofreading this chapter.

1 See some of the recent reactions to the film in *Filmaffinity*. For example: "I would have paid to see the faces of the people who watched the movie in 1971. . . . Paid to see the faces of the spectators when Antonio Ferrandis lovingly takes the hand of José Luis López Vázquez who is dressed as a woman." See *"Mi querida señorita," Filmaffinity*, accessed November 13, 2017, http://www.filmaffinity.com/es/reviews/1/257805.html.

2 For more information on Almodóvar's admiration for López Vázquez and *Mi querida señorita*, see "Almodóvar hubiera querido dirigir a López Vázquez en *Mi querida señorita*," *La información: Cine*, November 3, 2009, http://www.lainformacion.com/arte-cultura-y-espectaculos/cine/almodovar-hubiera-querido-dirigir-a-lopez-vazquez-en-mi-querida-senorita_0GXGmzhsg0Hwx9RfrIsaY6/.

3 For more information about the *españoladas*, see Núria Triana-Toribio, *Spanish National Cinema* (New York: Routledge, 2003), 62–65.

4 Ana Asión Suñer defines Third Way as "a label invented in the '70s to designate a middle road between popular film and intellectual cinema." Ana Asión Suñer, "La Tercera Vía del cine español: Relecturas del periodo tardofranquista," *Revista de la Asociación Aragonesa de Críticos de Arte* 26 (2014): 1.

5 See Josefina Martínez, "Tal como éramos . . . El cine de la Transición política española," *Historia Social* 54 (2006): 85.

6 According to Ana Hontanilla, the film "even presents the consequences of the sexual repression during Franco's regime." Ana Hontanilla, "Hermafroditismo y anomalía cultural en *Mi querida Señorita*," *Letras Hispanas* 3, no. 1 (2006): 113.

7 For a queer analysis of the film, see Julián Daniel Gutiérrez Albilla, "Reframing *My Dearest Señorita* (1971): Queer Embodiment and Subjectivity through the Poetics of Cinema," *Studies in Spanish and Latin American Cinemas* 12, no. 1 (2015): 27–42.

8 In the blog *Cine progre y subvencionado*, the same question appears: "How could this escape Francoist censorship? Because . . . in such everyday situations—going to a motel, looking for work, going to the capital in search of fortune, taking money out of a bank—they did not suspect the depth of the movie." *"Mi querida señorita* (Jaime de Armiñán, 1971)," *Cine progre y subvencionado*, September 28, 2012, http://cineprogre.blogspot.com/2012/09/mi-querida-senorita-jaime-de-arminan.html.

9 Emerson Fittipaldi (1946–) was a Formula One driver in the 1970s. José Martínez Sánchez (1945–), nicknamed Pirri, was a Real Madrid football player.

10 Marsha Kinder uses the adjective "courageous" to describe the film: "Borau also is the producer and co-writer of other courageous Spanish films. . . . *Mi querida señorita* . . . challenged sexual borders with a sympathetic portrait of a

transsexual." Marsha Kinder, *Blood Cinema: The Reconstruction of National Identity in Spain* (Berkeley: University of California Press, 1993), 348. Likewise, Ronald Schwartz uses the adjective "witty" to describe the film: "an extremely witty film played with high style and directed with careful, exquisite taste." Roland Schwarz, *Spanish Film Directors (1950–1985): 21 Profiles* (Lanham, MD: Scarecrow Press, 1986), 10.

11 Agustín Sánchez Vidal, *Borau* (Zaragoza: Caja de Ahorros de la Inmaculada, 1990), 89. An American version of the film starring Sylvester Stallone would have been even more absurd: "During their time in California, they considered other projects, among them an American version of *Mi querida señorita*. For the main character, Lerner proposed an unknown actor named Sylvester Stallone. The project did not prosper." Román Gubern, "Introduction," in *Un extraño entre nosotros: Las aventuras y utopías de José Luis Borau*, ed. Hilario J. Rodríguez (Madrid: Notorious, 2008), 13.

12 Sánchez Vidal, *Borau*, 89.

13 Sergio Garrido Pizarroso, "No puedo imaginarme *Mi querida señorita* sin López Vázquez," *Aisge*, April 16, 2013, http://www.aisge.es/coloquio-sobre-mi-querida-senorita.

14 José Luis López Vázquez and Alfredo Landa (1933–2013) starred in many "sex comedies. The latter even originated the moniker *landismo*." Belén Vidal, "Memories of Underdevelopment: *Torremolinos 73*, Cinephilia, and Filiation at the Margins of Europe," in *Cinema at the Periphery*, ed. Dina Iordanova, David Martin-Jones, and Belén Vidal (Detroit: Wayne State University Press, 2010), 216. See the film by Pablo Berger (1963–) titled *Torremolinos 73* (2002), which serves as a parody of these sexual comedies. The name of the protagonist is Alfredo (Javier Cámara), as a tribute to Alfredo Landa.

15 Garrido Pizarroso, "No puedo imaginarme."

16 Although the couple—Adela and Santiago—are in an idyllic and romantic setting by the sea, the roar of the birds creates tension. Fear intensifies when Adela runs and a dog follows her.

17 Adela combs her hair in the room and shaves in the bathroom, where she makes sure to lock the door with a latch. Although creams and soaps are displayed in the bathroom, the shaving products are not visible. Adela keeps them hidden, wrapped in a towel.

18 Garrido Pizarroso, "No puedo imaginarme."

19 There are eight mirrors in total. In addition, there is a set of mirrors in Adela's room, where one mirror is reflected in the other. Although it is not a mirror, the image of Juan is also reflected in a shop window in Madrid (1:15:51).

20 Indeed, for Jacques Lacan there existed only one stage of the mirror: "At any rate, . . . this single structure was divided into three logical moments" (Verónica Vega, Pablo de Vedia, and Denise Roitman, "Narcisismo e identificación en la fase del espejo: Una articulación entre Freud y Lacan," Buenos Aires: Universidad de Buenos Aires, accessed November 27, 2017, http://www.psi.uba.ar/academica/carrerasdegrado/psicologia/sitios_catedras/obligatorias/055_adolescencia1/material/archivo/narcisismo_identificacion.pdf). See the theory of the mirror in the paper that Lacan presented on July 17, 1949, in Zurich, and published with the title "The Mirror Stage as Formative of the Function of the I as Revealed in Psychoanalytic Experience."

21 David Neumeyer, "Film Theory and Music Theory: On the Intersection of Two Traditions," in *Music in the Mirror: Reflections on the History of Music Theory and Literature for the 21st Century*, ed. Andreas Giger and Thomas J. Mathiesen (Lincoln: University of Nebraska Press, 2002), 275.

22 Roland Barthes, *La cámara lúcida: Nota sobre la fotografía*, trans. Joaquim Sala-Sanahuja (Barcelona: Paidós, 1990), 145.

23 Umberto Eco, *De los espejos y otros ensayos*, trans. Cárdenas Moyano (Barcelona: Debolsillo, 2012), 18.

24 Sally Faulkner, *A History of Spanish Film: Cinema and Society 1910–2010* (London: Bloomsbury, 2013), 144.

25 Until 1981, a woman needed the permission of her husband to open a bank account, get a driver's license, obtain a passport, or sign a contract of employment. "8 de marzo: Ser mujer en los 50, en los 80 y ahora," accessed December 3, 2017, http://www.eslang.es/politica/8-de-marzo-ser-mujer-en-los-50-en-los-80-y-ahora_20160308-lr.html. In 1990, only 30 percent of Spanish women drove, in contrast to 69 percent of men. "Cada año más mujeres al volante," Dirección General de Tráfico, accessed December 3, 2017, https://revista.dgt.es/es/noticias/nacional/2017/03MARZO/0307-Dia-Mujer.shtml#WiR2JLQ-fUI.

26 Feliciano Blázquez Carmona, *La traición de los clérigos en la España de Franco: Crónica de una intolerancia, 1936–1975* (Madrid: Trotta, 1991), 164.

27 Thomas Joseph O'Donnell, *Medicine and Christian Morality* (Barcelona: Alba, 1998), 230.

28 O'Donnell, 230. In none of the consulted texts—all written by priests and theologians—is surgical intervention in cases of hermaphroditism or pseudohermaphroditism condemned. According to Miguel Angel Fuentes—also a priest and doctor in theology—"in the case of the individuals who present some forms of physical anomalies, through the copresence of anatomical elements of both sexes (hermaphroditism, pseudohermaphroditism), surgical intervention has never aroused moral doubts." Miguel Angel Fuentes, "Elementos generales sobre sexualidad humana," *Catholic.net*, accessed December 9, 2017, http://es.catholic.net/op/articulos/20325/cat/320/es-correcto-el-cambio-de-sexo.html. For more information on hermaphroditism and surgical interventions, see Earl E. Shelp, "Introduction," in *Sexuality and Medicine* (Dordrecht: Reidel, 1987), xxi–xxxii.

29 Eugène Tesson, "Moral Reflections," in *Medical Experimentation on Man*, ed. Dom Peter Flood (Cork: Mercier, 1955), 102.

30 O'Donnell, *Medicine and Christian Morality*, 230.

31 Leticia I. Romo, "Intersexualidad: La irregularidad entrópica del sistema en *Mi querida señorita*, *Cola de lagartija* y *En el nombre del nombre*," *Latin Americanist* 55, no. 1 (2011): 113.

32 Kara Rogers, *The Reproductive System* (Chicago: Britannica, 2011), 126. For more information on the possible variants of this syndrome, see the detailed study "Síndrome de Insensibilidad Androgénica," December 15, 2017, http://www.orpha.net/data/patho/Pro/es/Sindrome-Insensibilidad-Androgenica.pdf.

33 Isolina Ballesteros adds that "discrimination and contempt toward a sexuality considered 'perverted' or 'deviant' . . . still made things very difficult even in the era of the *destape*, a filmic representation of homosexuality that was not inserted in the zone of masquerade, folkloric buffoonery, and histrionics." Isolina Ballesteros, *Cine (ins)urgente: Textos fílmicos y contextos culturales de la España postfranquista* (Madrid: Fundamentos, 2001), 91–92. The "acts of homosexuality"

were eliminated from the Law of Endangerment and Social Rehabilitation in 1978. For more information on this law, see Juan Vicente Aliaga and José Miguel Cortés, *Identidad y diferencia: Sobre la cultura gay en España* (Barcelona: Egales, 1997).

34 José Luis Borau, *Diccionario del cine español* (Madrid: Alianza, 1998), 579.

35 Gwynne Edwards, "Sexual Ambiguity in Jaime Armiñán's *Mi querida señorita* (1972)," *Tesserae* 2 (1996): 48.

36 Julián Daniel Gutiérrez Albilla and Marsha Kinder also connect the two films: "In *All about My Mother*, the tunnel vision is rendered more spectacular, yet equally transformational. My sincere thanks to Marsha Kinder for making me aware of this connection between these two films." Gutiérrez Albilla, "Reframing *My Dearest Señorita*," 34. *Mi querida señorita* recalls another Almodóvar film: *La piel que habito* (2011) [*The Skin I Live In*]. Gutiérrez Albilla links Juan/Adela with Vicente/Vera, and the image of Juan reflected in the shop window with the scene "showing the reflection of Vicente/Vera in the shop window of her/his mother's clothing store almost at the end of *La piel que habito*"(38). Chris Perriam observes, "In Almodóvar's film, resonances of repression in the 1960s and rebellion in the 1970s disturb and inform the repositioned queer image of the present." Chris Perriam, *Spanish Queer Cinema* (Edinburgh: Edinburgh University Press, 2013), 53. There is no doubt that Almodóvar is quite familiar with *Mi querida señorita*, a film that he remembers, first, in his tribute to Chus Lampreave and, later, in José Luis López Vázquez's tribute. See the tributes in "Lee el emotivo homenaje de Pedro Almodóvar a Chus Lampreave," *Noticias de cine*, April 5, 2016, http://www. ecartelera.com/noticias/30116/este-es-homenaje-almodovar-chus-lampreave/), and "Almodóvar hubiera querido," respectively.

37 Jean-Claude Seguin, "El espacio-cuerpo en el cine de Pedro Almodóvar o la modificación," in *Almodóvar: El cine como pasión*, ed. Francisco A. Zurian Hernández and Carmen Vázquez Varela (Toledo: Universidad de Castilla–La Mancha, 2005), 237.

38 Jean-Claude Seguin, *Pedro Almodóvar o la deriva de los cuerpos* (Murcia, Spain: Tres Fronteras, 2009), 242.

39 Marsha Kinder, "Reinventing the Motherland: Almodóvar's Brain-Dead Trilogy," *Film Quarterly* 58 (2004): 17; Susan Martin-Márquez, "Pedro Almodóvar's Maternal Transplants: From *Matador* to *All about My Mother*," *Bulletin of Hispanic Studies* 81 (2004): 504; Ernesto R. Acevedo-Muñoz, "The Body and Spain: Pedro Almodóvar's *All about My Mother*," *Quarterly Review of Film and Video* 21 (2004): 29.

40 For *Julieta*, Almodóvar bought the rights to Alice Munro's book *Runaway* (2004), specifically for the scenes of the train. Daniel Dercksen, "Spanish Writer-Director Pedro Almodóvar Talks about *Julieta*, His Most Severe Film to Date," *Writing Studio*, November 3, 2016, http://writingstudio.co.za/ spanish-writer-director-pedro-almodovar-talks-about-julieta-his-most-severe-film-to-date/.

41 Antonio García Figer, *Medina* (Madrid: Sección Femenina, 1945), 49.

42 Margarita Almela Boix, "Reflexiones sobre los estereotipos de maldad y bondad femeninas: Apuntes sobre la historia de una infamia," in *Malas*, ed. Margarita Almela Boix, María Magdalena García Lorenzo, and Helena Guzmán García (Madrid: Universidad Nacional de Educación a Distancia, 2015), 99.

43 Marvin D'Lugo, *Guide to the Cinema of Spain* (Westport, CT: Greenwood, 1997), 71.

44 José María Carreño and Fernando Méndez-Leite, "Ocupadísimo, Jaime de
 Armiñán: Entre el cine y T.V.E.," *Fotogramas* 55 (1972): 16.
45 José María Carreño, review of *Mi querida señorita, Fotogramas* 54 (1972): 38.
46 Edwards, "Sexual Ambiguity," 52. In *El cine en que vivimos*, the same hypothesis is
 restated "in the final scene with Julieta Serrano and López Vázquez, when she
 admits (accidentally) that she knows her boyfriend's previous identity." *"Mi
 querida señorita," El cine en que vivimos*, accessed December 3, 2017, www
 .elcineenquevivimos.es/index.php?movie=2115.html.
47 I agree with Ronald Schwartz: "It is a fascinating love story" (*Great Spanish Films
 since 1950* [Lanham, MD: Scarecrow Press, 2008], 34).

8

Social Danger and Queer Nationalism in Ignacio Vilar's *A esmorga* (2014)

●●●●●●●●●●●●●●●●●●●●●

DARÍO SÁNCHEZ GONZÁLEZ

When I arrived at the Pontevedra (Galicia) train station in December 2014 for a holiday visit, one of the ads posted on the walls gripped my attention. The poster for *A esmorga* (Ignacio Vilar, 2014) featured a long shot of two men climbing a dirt heap and another man walking on top of it toward a dull, gray horizon; it contrasted starkly with the outdated, innocuous ads I had come to associate with public spaces such as transit stations in Galicia. The poster itself turned out to be slightly old: the film premiere had happened a month earlier. However, when I found it once again in August 2015 at an Ourense train station, I felt the film might have endured despite its bleak imagery—or precisely because of it.

A brief literature survey confirms its success: *A esmorga* received positive reviews by many critics (Bonet Mojica, Holland, Martínez, Weinrichter), had the second-highest revenue per screen in Spain during its weekend premiere,[1] and has been described as a "qualitative jump" within the history of Galician cinema.[2] These accolades do not mean that *A esmorga* was the first film to clearly target an autonomous audience with a significant impact across Spain:[3] its contemporary *Ocho apellidos vascos* (Emilio Martínez-Lázaro, 2014) [*Eight Basque Surnames*] might be the paramount example of such an impact. Nevertheless, *A esmorga* has unique features. First, it was filmed in Galician. Few

121

feature films have succeeded in this minoritized language partly due to distribution issues and to the vagaries of state financing for motion pictures in languages other than Spanish within Spain.[4] Ignacio Vilar is well known for his double commitment to create "films directed, conceptualized and produced in Galician, a cinema for my country and our people" and to foster a "domestic market that can sustain it."[5] Second, *A esmorga* addresses concerns of cultural alienation—implicit in Vilar's politics—from a perspective that could be analyzed as intersectional, following Kimberle Crenshaw's traffic analogy.[6] Yet it also hints at the many limitations of this approach: while the three main characters of this film suffer from the combined effects of economic, geographic, and political marginalization, these are entwined in ways that prevent a final determination of the "cause of injury." Third, at least two of these characters, as we will see later in this chapter, engage in queer practices—an aspect usually glossed over in comments about the film and the novel that inspired it. Therefore, *A esmorga* deserves attention not just as an example of a successful feature film in a minoritized language but also as a multilayered narrative whose treatment of both queer sexualities (in this case, homoerotic affection that does not fit into the gay paradigm)[7] and national imaginaries demands a closer look.

In this chapter, I argue that Vilar's work brings to the present the history of queer practices in Spain and explores their linkage to the many activities that the Franco dictatorship considered a cause of "social danger." I read *A esmorga* as reaching an assemblage of present-day audiences attuned to either sexual identity politics or Galician nationalism, both of which are likely to share a critical view of Spain's Francoist past. The film maps its protagonists' precarious queer desires as a preview of "realms that are yet to come";[8] they are places that did not exist as such during the Franco years in which the film takes place, and that do not exist yet. By definition, these nonexistent places are utopias—and not just queer ones—or their realization requires new legal frames, political alliances, and even new physical landscapes for all, queer and otherwise. In the pages that follow, I will examine the layering of this assemblage by first engaging with the novel that inspired *A esmorga*, focusing on elements that have been transferred directly from the original text to the film. I will also analyze the presentation of queer practices in the latter, as well as the ways in which visual tropes of queerness relate to the film's treatment of Galician landscapes. Finally, I will shed light on how *A esmorga* interpellates allies, while also assessing the impact and validity of this assemblage as a political tool.

A esmorga (1959): A Queer Galician Classic

A esmorga's original text,[9] a novel by Ourense-born writer Eduardo Blanco Amor (1897–1979), is often acknowledged as a key piece of the contemporary

Galician literature canon in several dimensions. Despite its local theme, the book was written and first published in 1959 in Argentina, a country where the author resided most of his life that is sometimes described as Galicia's "fifth province."[10] This geographic displacement is more than a mere glitch on the map. Blanco Amor had established a presence in Buenos Aires by the time the Spanish Second Republic started, and the Civil War gave the author reasons to remain on that side of the Atlantic given his leftist political leanings and his connections. In the summer of 1939, he received a letter from France in which Manuel Azaña, ex-president of the Second Republic, compares the recent events to an "enormous mutilation, like the ones that happened in 1610 or 1492. . . . They have shattered something that will be impossible to fix." All cultural dissidence, including the Galician nationalist milieu in which Blanco Amor spent some of his formative years, had been wiped out in the chaos in which Spain was mired. *A esmorga* could only be published in its full version away from the reach of the Spanish censors. The writer's long exile also contributed to the linguistic aspects of the text: Blanco Amor claims that "in Buenos Aires lived four hundred thousand Galicians from all parts of Galicia, each one with their own way of speaking. . . . I made a general koiné. . . . Hence the language of *A esmorga*."[11] Blanco Amor innovated in other ways: the book was soon hailed as the first Galician modern novel, bridging international tendencies such as realism, naturalism, and existentialism; it received extensive literary criticism and study. Last but not least, it became mandatory reading in Galician schools after the demise of the Franco regime,[12] being prominently featured in the first round of controversial high school revalidation exams of Galician as recently as 2017.[13] Blanco Amor never attested to this (questionable) success. He passed away in November 1979 before the approval of the 1978 Statute of Autonomy for Galicia, a text that he regarded as insufficient, but that still allowed for the eventual implementation of a primary and secondary school curriculum in Galician.[14]

In addition to his advocacy in favor of Galician identity, Blanco Amor also championed the legalization of homosexuality. This demand of lesbian and gay liberationists across the Spanish state would be met to some extent on December 26, 1978,[15] when the *Boletín Oficial del Estado*, Spain's official gazette, published an amendment to the 1970 Ley de Peligrosidad y Rehabilitación Social (LPRS; Law of Social Danger and Rehabilitation), which was an update of the prior Ley de Vagos y Maleantes (Law of Vagrants and Crooks) that was approved in 1933. According to the amended text, "people who perform acts of homosexuality" would no longer be listed, along with fourteen other categories, as "socially dangerous" individuals in need of re-education.[16] Unlike the passion for Galician culture and language that Blanco Amor carried with him—even during his long period in Buenos Aires—his thoughts on homosexuality were

mostly ignored by his biographers until the release of Gonzalo Allegue's land-mark volume *Diante dun xuíz ausente* (In front of an absent judge) in 1993.[17] According to a later interview with the book's author, Blanco Amor's sexual advocacy was not taken into account due to the fact that it could stain his cali-ber as a nationalist icon.[18] On the other hand, a 1985 analysis of *A esmorga* already vindicates the role that homosexuality has in its plot—even within a primarily nationalist reading.[19] It is surprising, however, that this intersection was not addressed earlier given the subtle, but transparent, presence of queer affective practices in the novel. In the words of the protagonist, the narrative voice revealed queer themes "when Milhomes took advantage of the other guy's drunkenness; when Xanciño was sober, he would not consent to it, or at least he would not go as low as to allow those dirty tricks that didn't seem fit for men."[20]

Therefore, Blanco Amor's double advocacy qualifies the original text of *A esmorga* and its adaptations as likely candidates for a thorough study of the intersection between Galician identity and queer practices, with the latter under the umbrella notion of "social danger" as defined by the LPRS. While *A esmorga*'s first film version, *Parranda* (Gonzalo Suárez, 1977) [*Binge*], used a screenplay penned by Blanco Amor himself and brought some queer elements of the original plot to the screen, it did so in a way that was too easily encapsu-lated in the representation of homosexuality as personal tragedy.[21] Moreover, Suárez filmed in Spanish and set the movie not in Galicia but in neighboring Asturias; *Parranda*'s title sequence contains shots of a steel mill, an image that viewers from the 1970s would associate more readily with an Asturian land-scape. These production choices explain the strong push by Vilar to reappro-priate *A esmorga* into Galician culture, aligning more with Blanco Amor's views. At the film premiere, the director went as far as reading a 1978 letter by the writer to Suárez, revealing his disappointment with the adaptation and his intention to work on a new project with Galician actors.[22] Blanco Amor's super-vision also encompassed the performance of *Parranda*'s "queer" character (named "Milhombres" in this film); according to the screenplay notes added by the writer himself, Blanco Amor ordered the actor to "[be] careful with play-ing this character *en marica* [like a queer], a species that is unpleasant in any show. His effeminacy must rely very little on the gestures, short steps, and usual *ratimangos* [*sic*] of the stock character. It must be something more profound, nuanced, and intimate, which will demand great talent from the actor."[23] Mil-hombres's role was pivotal to the narrative of *Parranda*: no less, I would argue, than the choice of language or filming location. There are reasons to think that Suárez did achieve better results in addressing the issue of homosexuality than that of national identity—simply due to the absence of the latter. Thus, any further analysis of *A esmorga*'s queer *and* political content requires focusing on the elements shared by the 1959 novel and the 2014 film.

Not Just on a Bender

On a Bender, the title of the English translation of Blanco Amor's novel, correlates with its literal subject matter; the element that anchors the plot in all versions of *A esmorga* is a drinking binge of dire consequences. Both the original work and the 2014 film locate this event in Ourense ("Auria" for the novelist), one of Galicia's largest cities and one that has a privileged role in the history of Galician literature.[24] The narrative frame is a deposition: the protagonist, Cibrán,[25] stands accused in front of a silent authority figure, identified in the novel by the mark "—." This authorial voice is invisible and inaudible in the film, yet its point of view coincides with the camera during Cibrán's deposition scenes. Cibrán tells his version of the facts that led him to be arrested and taken to the "judge."[26] It all starts one morning, as he walks to a construction job site from Raxada's house on the outskirts of town—Raxada is a retired sex worker with whom Cibrán has a son. On the way, he runs into his friends Bocas and Milhomes, who have been out drinking since the previous night and show no intention of going home (hence the title). It seems, in fact, as if they have no home to go back to, given that Bocas has accidentally murdered someone the day before. Cibrán, who ignores the incident at this point, joins them grudgingly; the trio takes shelter from the rain first in a tavern, then in a *pazo* (old mansion) where Milhomes's cousin runs an *orujo* (grape liqueur) distillery. They accidentally burn the place down, with their host in it. After this, Bocas leads the group to a brothel, where he picks a fight and gets expelled by Nonó, the madam. Later on, they break into a bourgeois mansion where the same character plans to have sex with the owner's wife, a Frenchwoman of famed beauty, who turns out to be a porcelain doll. Every single stop in this route is punctuated by copious alcohol consumption. However, it is Bocas's sexual frustration, as he demands to have sex "with a woman that is not a prostitute," that ultimately leads to the final episode. He visits a local madwoman named Socorrito, who lives in a dump site outside of town, and drags his friends along. When Bocas proceeds to rape Socorrito in her shack, Milhomes bears witness to the scene and stabs his friend to death in a clear bout of jealousy. Right afterward, he plunges into a pond. Cibrán tries to flee the crime scene when he hears two Guardia Civil officers engaged in a manhunt nearby, but he is caught. Both the film and the book have a somewhat open ending: according to the authorial voice that compiles the story in the book (reproduced verbatim before the closing credits in the film), Cibrán either is killed during a harsh questioning or commits suicide.

This superficial synopsis explains Cibrán's, Milhomes's, and Bocas's likely charges of "social danger" on several accounts. Following the LPRS (or the 1954 version of the Ley de Vagos y Maleantes), they could be accused of being "habitual slackers [and] drunkards"; of "performing homosexual acts" in the case of

Milhomes and Bocas; and of carrying "weapons or objects . . . that show beyond doubt their possible use as a tool of aggression" when it comes to Milhomes. And yet, the statement of these facts does not reveal all the reasons that made the novel a veritable protest in its time instead of simply an exposé on Ourense's underworld or a Galician-language version of "tipismo esperpéntico."[27] The film still accounts for these two possible readings; there is ample time devoted to exploring Ourense's taverns and brothels. Additionally, Vilar seems to hark back to Ramón del Valle-Inclán's definition of *esperpento*,[28] in a scene in which the three main characters find a series of distorting mirrors, pause to make gestures in front of them, and laugh at their deformed images. This reference is counterbalanced, among other things, by the closing sequence in which Milhomes's body vanishes immediately in the pond's turbid water and Cibrán's final showdown with the Guardia Civil features a close-up of him against the background of a torrent. These final shots hint at the ways in which *A esmorga* exceeds realist strategies (despite the director's claims to a commitment to them).

The key layer of its filmic elements and of the assemblage built in *A esmorga* is Vilar's cultural politics that build on Blanco Amor's message—they are encompassed in both the filming and exhibition processes. The Ourense director works in Galician against many odds, including that of using actors, such as Bocas, played by Basque Karra Elejalde, who do not speak the language. Additionally, *A esmorga*'s DVD release only came after many screenings for rural audiences that have been all but ignored by the Spanish media industry, but whose cultural practices, including language, connect with the film's (somewhat) timeless atmosphere. It was in the main square of a 233-inhabitant village, Vilanova de Valdeorras, roughly one and a half miles away from O Barco de Valdeorras (Ourense), where I attended an open-air screening and Q&A with the director in August 2015, sponsored by the grassroots cultural organization O Mosteiro. In front of an audience that for the most part was likely local—by then, the film had been screened in many other small venues in the province of Ourense—Vilar discussed the tenets of the adaptation such as his reasons for filming in Galicia and in Galician. He also explained the motives for shifting the historical period: Blanco Amor's novel takes place in the nineteenth century, putting some distance between the text and the alleged facts, partly as further prevention against censorship.[29] José Somoza Medina goes as far as dating the action exactly to February 6, 1881.[30] Quite to the contrary, Vilar places the narrative during the Franco dictatorship by way of unequivocal pointers: one that stood out to me and to other viewers was the reference to a visit by the "Caudillo" to inaugurate a reservoir (Franco's compulsion for building dams is the butt of many jokes about the dictator in Spanish popular culture). The reference, in fact, can lead to a precise date for the film action, as the mentioned Velle reservoir was built in Ourense province over four years, from 1962

to 1966—in the midst of *desarrollismo*,[31] and around the time that the dictatorship celebrated "25 years of peace."[32] As we have seen, water is a recurrent symbol in the film (and the novel), albeit never dammed for profit and progress. Instead, we have free-flowing *augardente* (firewater), torrents, relentless rain, and leachate ponds. Likewise, the protagonist trio's destructive impulses oppose development: in Cibrán's words, "we kept on doing things as if we didn't realize, so that in the end nothing could be fixed. Like shutting doors behind you and tossing away the key so there'd be no running back—as if we were walking toward our own doom on purpose."[33] This line, borrowed from the novel and emphasized as a tagline in promotional materials for the film, adds a layer of meaning to the three men's experiences; the bender displays, in Lee Edelman's terms, a complete disregard for futurity that runs counter to the policy of *desarrollismo* (in which Cibrán was directly implicated through his work at the construction site of a new road in the city of Ourense).[34] The first impression of the viewers as well as the bleak mise-en-scène succinctly conveyed by the poster described at the beginning of this essay are anything but utopian: Cibrán, Bocas, and Milhomes seek, first and foremost, to undermine an ideology based exclusively on material progress, prior to finding their own space.

Seeing Galicia Queerly

As I have mentioned, Vilar introduces script pointers that the audience can link to the drastic effect of Francoist policies on Galician landscapes. He also deploys visual metaphors in order to evoke the pursuit of sexual realization, primarily by reproducing the trio's sinuous path through Ourense's streets. For these three men, neglecting their future does not correspond to a single self-destructive drive. The bender is fueled by incongruous impulses: Bocas's rapacious (and straight) sex drive conceals his need to evade homoerotic appetites and temptations; Milhomes's ability to provide food and shelter for the group shrouds his feelings for Bocas; and, last but not least, Cibrán's awareness of the impending disaster seems to do nothing but propel his flight from family and job duties. There is no shortage of visual metaphors in language to convey sexual dissidence, such as the English adjectives "queer" and "bent" or the Spanish expression *la acera de enfrente*—the other side of the street. Considering the latter could be pertinent when reading/viewing *A esmorga*, since much of it takes place in an urban setting. The simple action of walking the streets looking for erotic partners, also conveyed as "cruising," is an activity that has been considered essential for male homosexual culture in Spain prior to the introduction of commercial gay venues: "Many homosexuals insist on the innate character of knowing how to *hacer la carrera* [work the streets]."[35] One of the most celebrated Galician writers of all time, Alvaro Cunqueiro, wrote a column spurred by the listing of several places in Vigo as cruising grounds in the

FIG. 8.1 The tile in which Bocas says "We need to split" sits (probably by mere coincidence) at the intersection of Danger and Freedom Streets, in the historic district of Ourense. Photography by Darío Sánchez González (2015). See *A esmorga* (2014) by Ignacio Vilar.

popular "Spartacus Gay Guide" (1976 edition); he claimed that "traditionally, in Galicia, we have never paid much attention to homosexuals. When there was one in a small town, people laughed at him. . . . It seems that some of them do exhibit themselves in cities these days."[36]

The widely studied linkage between urban life and queer practices should be qualified by the particular setting of *A esmorga*. Most commentators on

Blanco Amor's text remind us of the fact that the Ourense in which the story takes place has few urban features: its street plan was "confined within its medieval perimeter," and the cityscape "had not densified" by the late nineteenth century.[37] While Vilar places the narrative in the 1960s, the mise-en-scène highlights Ourense's historical center. Nowadays, visitors can reproduce the trio's path in this district thanks to a series of numbered tiles affixed to walls that reproduce fragments of the novel. Drawing their locations on the map reveals that their path was anything but straight—predictably so. Vilar's portrayal of the route in the adaptation might be even more confusing for anyone unfamiliar with Ourense streets, despite the fact that there are some identifiable settings, such as Santa María Nai Church and the Praza Maior (main square). The darkness of Ourense streets and the presence of relatively hidden spots along the way often provide shelter for the three protagonists. It also happens that some of the queerest places in Vilar's film wind up in their circuit: one of them happens to be Nonó's brothel. In this venue, which also hosts small cabaret numbers, we see a performer who cross-dresses as a man, flirts with two women dressed up in burlesque attire, and flaunts his (covered) genitalia in a display of hyperbolic masculinity. Milhomes gets onstage and disrupts the act by taking the shirt off the performer, who reacts by slapping him in the face. The reverse shots to the audience reveal that the transgression implicit in uncovering the performer's breasts is not registered as such: Milhomes's mockery of hyperbolic masculine behavior flies under the radar of the amused public, much like most of his constant physical contact with Bocas. It is only the madam's suspicion that the two men are concealing a crime, and their subsequent violent reaction, that gets them expelled from the brothel. The circularity of the trio's exploits—getting to a place, wreaking havoc, and going back to the street—in addition to their venturing in and out of the city's built-up area and the denouement in an anonymous dumpster, contribute to the idea that the protagonists' path is both circumventing an ominous fate *and* spiraling down into it.

The two dimensions of this queer fugue, external and internal, spatial and psychological, are featured prominently in Vilar's film. I have already examined the first; the second is likewise conveyed through visual strategies. In the first sequence in which the three men meet, Bocas and Milhomes dance around Cibrán counterclockwise while the camera reproduces the same 360-degree movement, effectively spiraling around the group. The mood in this scene is predominantly cheerful: Bocas and Milhomes are singing, frolicking, and cracking jokes, while Cibrán makes petty excuses prior to joining the party. Later in the film, Vilar repeats a similar visual scheme in the sequence where the three men visit a distillery. Milhomes holds a circular clay pan filled with wine and spins around, this time clockwise, while the others drink from it. Bocas and Cibrán, in addition to the caretaker, will die in a fire. The camera

repeats the 360-degree movement, yet in the opposite direction to Milhomes's spinning. The visual dissonance is matched by the soundtrack: the men laugh uncontrollably, but this time their apparent joy is set in contrast to a somber piano waltz in a minor key that constitutes the leitmotif of the film's score. This sequence was selected for one of *A esmorga*'s trailers. The fact that it has no intelligible dialogue, neither in Galician nor in Spanish, could be a contributing factor for this choice, but the capacity of these images to convey the fragile homosocial dynamic of the trio, always threatened by the introduction of homosexual feelings, must also be taken into account. External pressures, as well as the threat of such feelings leading to action, eventually interrupt both "spinning" sequences.

If we go back to the landscapes, we discover that the ambiguous figure of the spiral is repeated once again, this time in an eerie overhead long shot of the three men walking around what seem to be the ruins of a *castro*,[38] where stones are arranged in the shape of spirals. As mentioned previously, Vilar displaces the time frame of the novel and gives sufficient indications of this both in the script and in the mise-en-scène—a bus can be seen in the background when the trio takes shelter from the rain beneath a bridge in town. And yet, for all the emphasis on binaries in some analyses of Blanco Amor's novel, Vilar portrays a fairly seamless relation between the past (the old ruins) and the present of Galicia. He also displays a subtle gradation between rural and urban spaces: from the forested area around Cibrán's home to the more cultured environment of Ourense's main square (where the trio first meets Socorrito), to the dirt heap where the film ends. This gradation, along with the reproduction of the drunken route and the 360-degree camera pans, signifies the three protagonists' flight as a venture with both universal and local readings. Cibrán, Bocas, and Milhomes sabotage (and ultimately fail) the tenets not just of Francoism but of a Western masculinity firmly deployed for material development in the postwar period that was involved in building new roads in Galicia and elsewhere, regardless of the perhaps irreparable damage to the environment. Some of their wanderings in older landscapes—the *castro* I have mentioned earlier but also the rivers, the dirt roads, and other rural areas—express visual tropes that speak to a local audience attuned to traditional views of Galician identity. In these spaces, the characters find a precarious balance between the push for a utopian future proposed by *desarrollismo*, which is clearly not queer, and a timeless world that might afford more room for queer practices. It was only in 1970, after all, that the LPRS included homosexual practices among those leading to the status of "social danger" based on "the changes that have happened in social structures, the alteration of customs imposed by technological progress, its repercussion on moral values . . . and the apparition of some states of danger deemed characteristic of developed countries."[39] On a similar note, Vilar

maintains (in the Vilanova Q&A)[40] that the stunning rural landscapes, despite the gray light and the rain that saturate most sequences, offer a comforting counterpoint to the bleakness of the plot.

Rallying Up the Allies

In the previous section, I described the combination of visual strategies in *A esmorga* that subtly convey queerness with those that portray an image of Galicia familiar to local audiences. The result can be best described as a *captatio benevolentiae* that does not exclude confrontation: the assemblage must remain frail and temporary. Queerness, not as a metaphor but as affection between male-identified characters that clearly exceeds the sanctioned limits of homosociality, emerges often in Vilar's film in ways that demand viewers, particularly straight ones, to complicate its relation (and theirs) to heteronormativity. In the third sequence, right after Milhomes and Bocas recruit their friend for the party, they engage in a fight that looks too much like an embrace, as seen from the perspective of a road worker to whom Cibrán is speaking. In the next sequence, at the tavern, there is a two-shot of Milhomes and Bocas tenderly kissing and caressing each other, with an insert of Cibrán's face displaying concern. This could be attributed to a homophobic reaction to his friends' behavior, but also to Cibrán being reminded of his relationship with Raxada and of the fact that he might have to rear their child alone, since his lover suffers a debilitating, potentially lethal, disease. Editing suggests a certain parallel between Milhomes and Bocas's queer physical affection and Cibrán's straight (but barely heteronormative) affair. Neither of these is easily defined as love: Bocas begs Cibrán to stay by saying, "Don't leave me with him [Milhomes], I don't know what I'll do. . . . It's no fun without him. . . . It drives me nuts, it's like a spell or something." Regarding himself and Raxada, Cibrán says: "I slept with her Saturday and Sunday, and I sure needed that, 'cause there are lots of women . . . , but Raxada, besides the flesh of her body, has a way of talking, of saying things in your ear, that sometimes they're like just breath, and you become a little boy, against her breast, as if she were your mother." Vilar front-loads this parallel while giving clear signs that neither of these paths, queer or straight, will go far.

Cibrán's straight entanglements were not quite orthodox for the public morals of Francoist Spain; it should be recalled that moral tenets of the LPRS also applied to women, such as his lover Raxada, an ex-prostitute. However, Cibrán is fundamentally split: on the one hand, the sequence with Raxada and their son at the beginning of the film shows his quasi-marital duties in a scene of relatively domestic, quiet bliss—in contrast with most of the spaces that follow. On the other hand, Milhomes and Bocas push him to be part of a queer ménage à trois, to refuse to work for the development of the state, and eventually, in

Edelman's terms, "to fuck the social order . . . and the whole network of symbolic relations."[41] His association with the other two men leads to events that end up in murder, suicide, and the killing of a police officer. Vilar still emphasizes in subtle ways the separation between Cibrán, on one side, and Milhomes and Bocas, on the other. The narrative structure facilitates this operation, but so does the marked hesitation of Cibrán when it comes to joining the others' pursuits fully. The association among the three, in fact, reveals the double-bind strategy followed by the Francoist dictatorship of adopting an essentialist *and* a constructivist understanding of homosexuality at the same time. Accordingly, "the medical discourse had to show that homosexuals were sick, on top of being immoral; both things concurrently, not one in place of the other."[42] Milhomes is the bona fide marginal character of the film, willing to steal, lie, and trick people in order to keep control of his putative lover, Bocas. Bocas attempts to brush off Milhomes's subtle advances by engaging in a straight sexual rampage that will eventually cost him his life. The duo's power to steer Cibrán away from the "right path" is manifest in two ways. First, it leads the character to state, when recalling an episode of dizziness that follows a suicide attempt, that he had reached an uncanny state of being, akin to the afterlife: "At that point, I had no idea what to do, and I felt lost. I thought about my mother, the little one, about Raxada, as if I was remembering them from the other side of death. I'd changed so much in so little time that now I was nothing like myself; I wasn't the man I wanted to be the day before when I resolved to make up with Raxada."

Second, his complicity in the events that precipitate toward the end of the film turns him into the scapegoat for any crimes that Milhomes and Bocas might have committed—including those that preceded the bender. Cibrán is eventually caught in the same double bind in which the other two men find themselves.

This situation could complicate my intention of reading *A esmorga* as a unique assemblage between queer practices and dissident political identities, for the film seems to toe a very familiar line for both straight and queer audiences: that of the partners in crime who are "villainous queers" conspiring to hide their deeds.[43] There are some ways to mitigate this connection. One is the fact that the repression of sexuality is made explicit when the characters violently reject being identified as *maricallas* ["fruit" or "queer" in Galician]; another is the physical contact that could only be perceived as sexual, such as genital fondling. If, as Didier Eribon argues,[44] the injury caused by insult is the moment of queer recognition, Milhomes seems to make clear that he is not willing to be easily called names. The web of queer suspicion in which the three characters are trapped goes beyond the incidents that prompt a specific investigation in that it has been woven by a state that sees a wide range of individuals as potentially dangerous.

Reaching a Verdict

The tragedy that unfolds at the end of *A esmorga* confirms some of the worst possibilities that the film poster portends: Cibrán, Bocas, and Milhomes end up in a literal pile of crap. Viewers are not afforded a backseat in the process that leads the protagonists there; the somber, almost chilling mood after the projection at Vilanova's town square (on an otherwise balmy summer night) could be proof of the audience's deep involvement in Cibrán's plight. In fact, Blanco Amor embeds his story as part of Auria's perennial local memory: he claims to have heard it from his uncle, writing "almost forty years after collecting such vague reports, and ninety years after the incidents themselves."[45] He then warns the reader about possible distortions of the truth in the deposition. However, the oddly silent presence of the judge makes Cibrán's story the only truthful rendition, and his likely death forecloses any attempt at ascertaining the facts. In the film, the opening and closing shots have a strong graphic match: the first is a medium shot of Cibrán escorted by a member of the Guardia Civil, looking directly into the camera (with occasional hesitations) and showing signs of a violent questioning. At the beginning of his testimony, Cibrán explains (following the book) that the written deposition is not true, partly because it is not written in the language that "we" speak,[46] and partly because "nobody saw anything." The final shot shows Cibrán panting, about to jump into a torrent, confronting the Guardia Civil agents who were following him (this time without words), but once again looking straight into the camera. It is hard, if not impossible, to escape the idea that Cibrán is pleading with the audience. Perhaps he does so to instill a dose of Brechtian estrangement prior to and after the highly emotional events of the film; or to save for us the empty seat of the judge in his case; or, perhaps, following Crenshaw's traffic allegory in her original notion of intersectionality, to have us assume the position of a bystander to the accident. The facts, however, are never clear: we are left dumbfounded with a story of political, sexual, and economic oppression that unfolds in a territory that becomes impossible to chart—even for those who are familiar with it. Cibrán's fate reads as a cautionary tale not of the contemporary "dangers" that the Francoist legislation tried to purge from its conception of modernity and development, but of the ways in which citizens became socially dangerous for reasons that exceeded the letter of the law.

In the colloquium at the end of the Vilanova screening, Vilar hinted at a connection between his film and the current situation of Galicia: "I think it [*A esmorga*] reflects a time period that, unfortunately, our forefathers had to live . . . sadly, the crisis still leads us to that kind of thing: [finding that there are] those people to whom doors are closed since birth." The director made explicit, in this and other presentations, the immediate political capital of *A esmorga* in the context of a society shaken by a persistent economic crisis

since 2008: one that threatens both to close many of the doors that opened to Galicians (and many citizens of Spain) since the end of Francoism, and to erase the cultural, linguistic, and geographic coordinates that many Galicians find meaningful—all in the name of never-ending development. And yet, Bocas's frantic exploits in Ourense's streets, Milhomes's calm and determined final plunge into oblivion, as well as Cibrán's role as the last living witness of their story show all three of them "shutting doors behind them and throwing away the keys": aggressively attacking futurity and destroying the metaphor of opportunity conveyed through the term "door." Their actions suggest a willful impulse that cancels any notion of restorative justice unless it includes a prior undoing of the structures that the Francoist regime put into place to ensure a lasting influence; any new assemblage will need to make its own space. Blanco Amor's task of spearheading contemporary Galician narrative could not happen by merely reproducing the models that were wiped out during the Civil War and the decades that followed. His success in building one of the "common spaces" for Galicians, according to Vilar,[47] came through an unexpected path and in a language that was partly new. The catastrophic spree of Cibrán, Milhomes, and Bocas, faithfully brought to the big screen by Vilar, has the potential of making room for a queer utopia, but it also points to the fact that such a place can only exist beyond the horizon of the many piles of dirt left behind by development.

Notes

1 See "'A esmorga,' segunda película en recaudación media por cine en España," *La Opinión A Coruña*, November 23, 2014, http://www.laopinioncoruna.es/sociedad/2014/11/23/esmorga-segunda-pelicula-recaudacion-media/902000.html; Lluís Bonet Mojica, "'A esmorga': Viaje sin retorno," review of *A esmorga*, by Ignacio Vilar, *La Vanguardia*, May 8, 2015, http://www.lavanguardia.com/cine/20150508/54430510391/a-esmorga-critica-de-cine.html; Jonathan Holland, review of *A esmorga*, directed by Ignacio Vilar, *Hollywood Reporter*, December 17, 2014, http://www.hollywoodreporter.com/review/a-esmorga-film-review-758303; Luis Martínez, "La lluvia por dentro," review of *A esmorga*, by Ignacio Vilar, *El Mundo*, May 8, 2015, http://www.elmundo.es/cultura/2015/05/08/554ba465e2704 e986d8b4584.html; and Antonio Weinrichter, "Crítica de 'A esmorga' (***): Noche de parranda," review of *A esmorga*, directed by Ignacio Vilar, *ABC*, May 18, 2015, http://hoycinema.abc.es/critica/20150508/abci-esmorga-critica-201505071751.html.
2 Víctor F. Freixanes and Xosé M. Soutullo, "Unha baixada aos infernos: Conversa con Ignacio Vilar, director de *A esmorga*," *Grial: Revista Galega de Cultura* 52, no. 204 (2014): 47.
3 The word "autonomous" falls short of encompassing the complexity of Galician identity, but I find it preferable to regional.
4 Miguel Anxo Fernández, "Galicia e o cine: Diversidade e identidade na procura de acomodo," *Grial: Revista Galega de Cultura* 52, no. 204 (2014): 13–27.

5 Freixanes and Soutullo, "Unha baixada aos infernos," 48.

6 Kimberle Crenshaw, "Demarginalizing the Intersection of Race and Sex: A Black Feminist Critique of Antidiscrimination Doctrine, Feminist Theory and Antiracist Politics," *University of Chicago Legal Forum* 140 (1989): 149.

7 In using "queer" in place of other descriptors, I partake in Chris Perriam's definition of the term as a departure from the gay paradigm, which he defines as "the gravitational pull of the still oddly predominant would-be mainstream, alternative-lifestyle representation of young, urban, non-immigrant, white, healthy men who have sex with men." Chris Perriam, *Spanish Queer Cinema* (Edinburgh: Edinburgh University Press, 2013), 7.

8 Gilles Deleuze and Félix Guattari, *A Thousand Plateaus: Capitalism and Schizo-phrenia*, trans. Brian Massumi (Minneapolis: University of Minnesota Press, 2005), 5.

9 In cases of ambiguity, I will include the year in references to the original book and the 2014 film.

10 "Los gallegos de la quinta provincia," *Faro de Vigo*, September 10, 2014, http://www.farodevigo.es/portada-ourense/2014/09/11/gallegos-quinta-provincia/1091659.html.

11 Victoria A. Ruiz de Ojeda, ed., *Entrevistas con Eduardo Blanco-Amor* (Gijón, Spain: Nigra, 1994), 111.

12 "Rolda de prensa A ESMORGA," *Esmorga Filme*, May 20, 2015, http://youtu.be/G35iPeAn1tM.

13 "El lugar donde coincidieron 'A esmorga' y Facebook," *La Voz de Galicia*, May 25, 2017, http://www.lavozdegalicia.es/noticia/galicia/2017/05/25/lugar-coincidieron-esmorga-facebook/0003_201705G25P8991.htm.

14 See Ruiz de Ojeda, *Entrevistas con Eduardo Blanco-Amor*, 210. In Ourense, protesters demonstrated against the preliminary text of the statute because it was deemed to be too moderate. During these demonstrations, a minute of silence was held in tribute to the writer, who had passed away in Vigo days before. See Perfecto Conde Muruais, "Normalidad en las manifestaciones contra el estatuto gallego," *El País*, December 5, 1979, http://elpais.com/diario/1979/12/05/espana/313196413_850215.html.

15 For more details on the movement's politics in Spain during these years, see Jordi Petit and Empar Pineda, "El movimiento de liberación de gays y lesbianas durante la transición (1975–1981)," in *Una discriminación universal: La homosexualidad bajo el franquismo y la transición*, ed. Javier Ugarte Pérez (Barcelona: Egales, 2008), 171–197.

16 See Ruiz de Ojeda, *Entrevistas con Eduardo Blanco-Amor*, 213, where the writer does not acknowledge the (then) recent legal change. The LPRS, despite its modifications, would be on the books until 1995, well into Spain's current democratic, constitutional period: I encourage readers to check its original list of categories at Ley de Peligrosidad y Rehabilitación Social, August 6, 1970, 12551–12553, http://www.boe.es/buscar/doc.php?id=BOE-A-1970-854.

17 Gonzalo Allegue, *Eduardo Blanco Amor: Diante dun xuíz ausente* (Gijón, Spain: Nigra, 1993).

18 Oscar Iglesias, "Blanco Amor e a censura infinita," *El País*, March 27, 2009, http://elpais.com/diario/2009/03/27/galicia/1238152704_850215.html.

19 Francisco Rodríguez Sánchez, "'A esmorga': Opresión e violencia na realidade colonial," *Nosa Terra* 3 (1985): 14.

20 Eduardo Blanco Amor, *A esmorga* (Vigo: Galaxia, 2010), 103. In the quoted passage in the text, "it" should mean sexual intimacy.

21 Some of the elements of this representation are described by Richard Dyer in *Now You See It: Studies on Lesbian and Gay Film* (New York: Routledge, 2003), 111–117. In the case of *Parranda*, Alejandro Melero Salvador illuminates them in his analysis of a film he describes as a "Spanish-style *Brokeback Mountain*" in *Placeres ocultos: Gays y lesbianas en el cine español de la transición* (Madrid: Notorious, 2010), 194. The relative obscurity of *Parranda* (a film hard to find in any current edition as of 2017), compared with Ang Lee's blockbuster status, accounts for a lack of impact that could justify my stronger interest in Vilar's work.

22 Xosé Manoel Rodríguez, "Ignacio Vilar cre que 'A esmorga' coincide co proxecto que desexaba Blanco Amor," *La Voz de Galicia*, November 4, 2014, www .lavozdegalicia.es/noticia/ourense/ourense/2014/11/14/span-langglignacio-vilar -cre-esmorga-coincide-co-proxecto-desexaba-blanco-amorspan /0003141597139103329090907.htm. I did not gain access to this document, furnished to Vilar by friends of Gonzalo Suárez, a Spanish filmmaker, writer, and screen-writer from Oviedo. However, in another letter from Suárez to Blanco Amor, the director confesses that "[filming in Asturias] was a decision that I did not take (for I never felt the need of transferring the action), but that was imposed upon me. . . . I feel regret for having disrupted things that affect you personally." Gonzalo Suárez, letter to Eduardo Blanco Amor, August 19, 1976, Eduardo Blanco Amor Papers, Biblioteca Deputación Provincial de Ourense, Ourense (Spain), Manuscript.

23 Eduardo Blanco Amor, "La parranda: Guion cinematográfico sobre la novela de mismo título ambos propiedad de su autor Eduardo Blanco-Amor," Eduardo Blanco Amor Papers, Biblioteca Deputación Provincial de Ourense, Ourense (Spain), unpublished manuscript, 3. There is perhaps a typo here. The word *ratimangos* should instead be *ratimagos*, that is, someone who is *artero, mañoso, engañador*.

24 María López Sández, "A esmorga: Espazo urbano e simbolismo especial," *Grial: Revista Galega de Cultura* 47, no. 184 (2009): 17.

25 All three main characters have several nicknames in the book and the film(s): I have decided to use those given in the 2014 film credits.

26 "Judge" is the term used in the book, but the exact role of this character is unclear.

27 Rodríguez Sánchez, "'A esmorga,'" 13.

28 "Classical heroes reflected in concave mirrors create the *esperpento*. The tragic sense of Spanish life can only be created through a thoroughly deformed aesthet-ics." Ramón Valle-Inclán, *Luces de Bohemia: Esperpento* (Madrid: Espasa-Calpe, 1974), 106. All translations are mine, unless otherwise indicated.

29 To no avail: the censors, while oblivious to any queer practices present in the novel, still demanded the removal of sections that they deemed slanderous in their portrayal of the Guardia Civil prior to the first edition in Spain in 1970. See Iglesias, "Blanco Amor e a censura infinita."

30 José Somoza Medina, "Da Auria retratada por Blanco Amor á cidade do presente," in *EBA 5.0: O universo de Eduardo Blanco Amor 50 anos despois d'A Esmorga*, ed. Xavier Paz et al. (Ourense, Spain: Difusora de Letras, Artes e Ideas, 2009), 24.

31 The *Diccionario de la Real Academia Española* defines this term as "ideology that promotes mere economic development as its ultimate goal." It is most often applied to reference the middle to late years of the Francoist period. I should add the caveat that the author always talks about the film as taking place in the 1950s.

32 Maribel Outeiriño, "La central de Velle cumple 50 años en el paisaje del Miño," *La Región*, July 19, 2016, http://www.laregion.es/articulo/ourense/central-velle-cumple-50-anhos-maridaje-minho/20160719080405636158.html.

33 English translations of the film script come from the DVD version subtitles.

34 Lee Edelman, *No Future: Queer Theory and the Death Drive* (Durham, NC: Duke University Press, 2007), 1–31.

35 Oscar Guasch, *La sociedad rosa* (Barcelona: Anagrama, 1995), 65.

36 Alvaro Cunqueiro, "Spartacus Gay Guide," in *"Los otros rostros" (1975–1981) en Sábado Gráfico (Madrid, 1956–1983)*, ed. Luis Alonso Girgado, Lorena Domínguez Mallo, and Anastasio Iglesias Blanco (Santiago de Compostela, Spain: Follas Novas, 2013), 225.

37 Somoza Medina, "Da Auria retratada," 27.

38 The word *castro* refers to a type of fortified settlement often associated with Celtic cultures in the Iberian Peninsula: remains of *castros* are a ubiquitous feature of Galician landscapes.

39 Ley de Peligrosidad y Rehabilitación Social, August 6, 1970, 12552, http://www.boe.es/buscar/doc.php?id=BOE-A-1970-854.

40 Ignacio Vilar, "A esmorga," Semana Cultural de Vilanova, August 10, 2015, Vilanova de Valdeorras (O Barco de Valdeorras), Ourense, Spain, Q&A.

41 Lee Edelman, *No Future: Queer Theory and the Death Drive* (Durham, NC: Duke University Press, 2007), 29.

42 Antoni Adam Donat and Alvar Martínez Vidal, "'Infanticidas, violadores, homosexuales y pervertidos de todas las categorías': La homosexualidad en la psiquiatría del franquismo," in *Una discriminación universal: La homosexualidad bajo el franquismo y la transición*, ed. Javier Ugarte Pérez (Barcelona: Egales, 2008), 69.

43 Arguably, the most famous cinematic rendition of this leitmotiv was Alfred Hitchcock's *Rope*. See Harry M. Benshoff and Sean Griffin, *Queer Images: A History of Gay and Lesbian Film in America* (Lanham, MD: Rowman and Littlefield, 2006), 36–37, from where I have borrowed the term "villainous queers."

44 Didier Eribon, *Reflexiones sobre la cuestión gay*, trans. Jaime Zulaika (Barcelona: Anagrama, 2001), 29–31.

45 Blanco Amor, *A esmorga*, 11.

46 This language must be Galician, but Vilar consented to dub the dialogue in Spanish, which opened the film to more markets. On the other hand, would it be possible to consider this interpellation to the judge as an inclusive *we*?

47 "A esmorga Desayuno," *Vimeo*, November 14, 2014, http://vimeo.com/111887800.

9

Gay Basque Men and the Unveiling of a Progressive Family Order in Roberto Castón's *Ander* (2009)

● ●

IBON IZURIETA

Ander explores the everyday domestic and rural routines of a family in the mountains of the Basque Country with the factual precision of a documentary. Due to the prominence of the natural surroundings and the beautiful views, the audience might be forgiven for anticipating a bucolic and idealized portrayal of rurality in the archetypal format often portrayed in Basque films with undertones of melancholic nationalism. In the film, Ander and his mother (Pilar Rodríguez) live with a strong connection to their natural environment. However, *Ander* should not be understood as an "homage to a settled rural lifestyle."[1] There is a rural space, which is more or less untouched and idyllic, but the human space is where the transformation occurs. The director, Roberto Castón, proposes a society that is decidedly not traditional and patently progressive. In *Ander*, the son of Reme (Mamen Rivera) is growing up with an absent biological father and lives in a domestic space where his education is formed by his biological mother, who is from Galicia, and two gay adopted fathers, Ander and José, who are Basque and Peruvian, respectively.[2]

Roberto Castón (1973–) assembled a diverse team that defies traditional classifications to make this film. Although Castón is a Galician from the city of

A Coruña, he is no stranger to Basque culture. In 2003 he created Zinegoak, a yearly LGBTQ film festival held in Bilbao, the largest city of the Basque Country. *Ander* was integrally financed with institutional funds from the Basque government.[3] The particular office that offered the funds is called Berdindu in Basque, which translates to "make equal," in reference to its role in supporting the community that, in Spanish, is identified by the acronym LGBTI ("Lesbianas, Gays, Bisexuales, personas Transgénero e Intersexuales").[4] That office reached out to Castón as the director of Zinegoak, a made-up name from the Basque word (from a French root) for "cinema," *zine*, combined with the word *hegoak*. Hegoak is another nonprofit association that supports the community; it is also financed by public funds but is not officially a branch of the government. Berdindu reached out to Castón with the assignment to write a script for a film with an LGBTQ-related theme to be shot in the Basque Country. Although it was not required that the film be shot in the Basque language, it had to be completed on a very small budget. This would be Castón's first film, but he was highly knowledgeable about film, having already been directing the Zinegoak film festival for many years. Castón wrote a script and it was approved. He started shooting *Ander* in 2008.

For all practical purposes, a Galician film director, who is a transplant to Bilbao, shot one of the most visually archetypal films in the history of Basque cinema. The realistic touch of rurality is so genuine that the film creates a quasi-documentary feel, with an opening focused on the mundane morning routine of Basque rural life, including tending to cows. The authenticity of the portrayal is also boosted by the use of the Bizkaian dialect,[5] instead of the standard, official Batua version, which is considered the literary, educated, and official Basque language variant that was established in 1964. Other realistic touches include depicting native speakers of the Basque language not exclusively speaking Basque, but rather code-switching back and forth between Spanish and Basque, especially when conversing with monolingual Spanish speakers. This linguistic point of view is evident in the character portrayal of Ander's mother in contrast with four other characters: her two children (Ander and Arantxa), Reme, and José. Ander's mother is a monolingual Basque speaker, but she understands Spanish. Her monolingualism has more to do with her unwillingness to communicate in Spanish in general but also, in particular, her refusal to speak with José due to her jealousy, mistrust, and fear toward an unexpected visitor from a faraway land. Ander and his sister comfortably navigate oral bilingualism between Basque and Spanish. Reme and José, for their part, communicate with each other and the other Basque characters in Spanish.

Caston's mix of languages and cultures allows the possibility that José could speak Quechua or another indigenous language as his indigenous phenotypic traits might suggest. Perhaps Reme, being Galician, could also speak Galician or Galego, showing real circumstances in the Basque Country, where various

languages come into contact. In the film, the linguistic fluidity of the protagonists will be replicated in sexual and familial fluidity. The visual experience of the film represents an archetypal, idealized rurality in the Basque Country that in the past would have been represented as an exclusively Basque-speaking community, especially in the imagination of right-wing Basque nationalism. In the visually rural context depicting stereotypical constructs of an idealized Basque purity, we have a diverse mix of languages, cultures, sexual orientations, and family units that destroy traditional archetypes. In the reshuffling of categories displaying human activity, the formation of the identity and its role requires redefinition.

The model for discussing the concept of identity adopted in this analysis is one proposed by Judith Butler in her theory of performativity. Her theory stretches further than an exclusive focus on the queer experience. It is, in fact, more about abject identities that are created as an afterthought by a signifying system that labels everything. Such a system consists of a complex, voluntary, and involuntary set of categories (concepts, feelings, ideas, and arguments) imposed on and usually reproduced by all individuals within a specific cultural context. The main character, Ander, cannot find a category of signification that allows for the existence of his sexual orientation in his close-knit community.[6] Ander is trapped in what Butler calls "the heterosexual matrix" of a signifying system that governs him.[7] He performs within the traditional category of a heterosexual identity, but since the category does not define him, he forms an abject identity that does not measure up to the norm for a heterosexual Basque man. Therefore, he must embark in an adventure of self-discovery in search of a category or an identity that defines him and away from his existence lived in abjection. *Ander* is, without a doubt, a bildungsroman: from an abject eroticism to an authentic eroticism, passing through an eroticism in rebellion between the two stages.

The model of identity adopted in this analysis insists on the arbitrary and imaginary nature of any individual "identity," including identities based on sexual orientation. Despite the imaginary nature of the concept of identity, its importance in a signifying system should not be dismissed; even though it is performed, it is still important. People will kill and die over identity, notwithstanding the fact that it is an artificial convention. Yes, identity is imaginary, but let us not dismiss it as an artificially understood falsity or void. As viewers, we can see in Ander's fluid identity that individuals struggle for what they think their identity is by causing destruction and creation.

The protagonist inhabits several identity categories or subject positions. He is a Basque man, but he does not comply with the imposed category of hypermasculinity within his community. He does not submit to the demand that he behave like a heterosexual man and marry a woman, which is what his

mother desires. He also does not adhere to the norm of discriminating against immigrants. In all of these inhabited subject positions, the most comfortable might be his identity as a Basque person—someone who was born in the mountains of Bizkaia, speaks Basque, and lives in a *baserri*, or Basque farm. In the case of Ander, he aligns with the norm of rural Basqueness in principle. No abject identity seems to be created in that dimension of Ander's self-concept. The complex subject position he does not conform to pertains to the imposed norm of the heterosexual man.

In the opening scenes, he is revealed as a bit of a loner, not fitting in with his male colleagues at his job. After his fall, in which he breaks a leg, his mother approaches a clearly uncomfortable topic. She tells him that they would not be dependent on only him if he had gotten married. His mother mentions a long-time female acquaintance of his who would have made a great wife and would have helped them with the farm, especially in situations like the one in which they find themselves after Ander's accident.

The early scenes are followed by visit by his future brother-in-law, Iñaki, who brings a Peruvian man to the *baserri* whom they hire to help with farmwork while Ander is recovering. A hypermasculine conversation about having sex, initiated by Iñaki, follows in Ander's bedroom; Ander performs very authentically in the conversation by joining in on the jokes and making references to visiting Reme. Reme, who sells sex for money in the community, ended up living there after marrying a local man, but he abandoned her and their son, leaving them in the house he owned. Although Ander performs this hypermasculine routine, the scene is shot very carefully to show that he is actually awkward and uncomfortable with his pretended "macho" identity. This is an example of his abject identity; he does not match or fulfill the normative category of hypermasculinity that surrounds him. In addition to the brother-in-law's hyperma-cho, oversexualized banter,[8] Peio (Pako Revueltas), the friend who takes Ander to the hospital after his fall, was having sex with Reme when Arantxa asked him to help her with her brother. The imposed normative category of heterosexual male does not represent Ander, but he has a hard time unlearning the imposition of the norm, even though sensitive people like Reme perceive his discomfort.

Ander, like anyone socialized to perform a normative category of heterosexuality that does not fulfill him, feels scared to resist it and rebel against it. In a hotel room, where he wants to recover his masculinity after the first sexual experience with José by having sex with Reme, he gets drunk and has a violent outburst when he realizes he is going against his own wishes by having sex with Reme. Reme had already observed this at the bachelor party and comments after the violent scene, "How afraid you men are of each other." When Ander finally breaks with the imposed category of forced heterosexuality, he is

reminded of his abject identity as soon as he dares to rebel against normative categories of identity: he and José receive the injurious insult of being called *maricones*.

The *point de non-retour* in Ander's journey of rebelling against his abject subject position of a hypermasculine man is when he and José have anal sex in the bathroom during Ander's sister's wedding (1:03:34–1:07:04). This is treated as a "true event," meaning it has unexpected, existential repercussions that break the repetitive regularity of actions and radically change the protagonist's way of life forever. Cinematographically, there is a parallel play of the camera that varies the perspective shots used until this point. The director has favored positioning the camera at medium height; the framing has been static thanks to a still camera that does not wobble even slightly. This same framing captures medium shots (waist and above) of the characters. Since the sequence in the bathroom, the camera, in its light, unstable movements, replicates the instability that is occurring in Ander's life. The camera teeters, with the most noticeable example of its instability appearing toward the end of the film when Peio shouts his abominable insult: "Vaya trío, dos maricones y una puta" (What a threesome! Two faggots and a whore!). The camera recuperates, in the last scene, almost all of its stability (1:41:10 and 1:42:39), when the central space of the kitchen around the table has recovered the serenity of the past. Ander accepts eating the lunch that José has prepared, and he reciprocates the gesture by offering red wine to José. Finally, the camera's total stability returns (between 1:54:35 and 1:57:01) when the new family dines together, and, for the first time, there is natural daylight in the kitchen—fiat lux!

The variety of camera perspectives mirrors Ander's journey through abject subjectivity to a progressive family unit that breaks traditional norms. The new family unit includes José and himself as an "out" gay couple, and Meme and her son as integral members. From the bathroom sex scene to the end of the film, Castón subtly and expertly weaves the floundering journey of Ander to his final destination: his life as a man who sexually desires José and lives with him as part of a couple. José acts as a loving partner who supports and cares for Ander. In the last scene, Ander wears a closely cropped beard and smiles in a way he has never smiled earlier in the film.

Another dimension of the model of identity adopted in this analysis is the punctual performance of identities for the purpose of dissent. If people can kill and die because of identity, identity can be harnessed as a reappropriating action for dissent. The abject subject can direct her or his experience toward fulfillment outside of the repressive work of whatever enslaving hegemonic matrix is in power. Living outside of the norm can be uncomfortable, painful, and frustrating, but it offers the freedom to imagine different models of rebellious performances of identity. At the end of the film, the injurious insult is stated: "dos maricones y una puta," because Ander asks José to live with him as a couple

and also asks Reme to live with them when her ex sells the house where she currently lives. Identity is imaginary, but the identity that lives outside of social impositions can be used positively since it is the currency that the hegemonic system of signification understands.[9] Repressive normative systems (signifying systems of subtle or apparent control that Butler has so well studied) recognize dissent and watch for insurrectionist activity. Harnessing the power of punctual identity performance for resistance is productive. Consequently, in this analysis, dissenting minority abject identities like queer, *maricón*, terrorists (to refer to all Basques), and *puta* (referring to all women) are useful in the work of disruptive political activism taken as punctual performances. In other words, dissident performative identities that avoid the pitfalls of essentialist identities are able to degrade systems of repression.

Other than Ander, José is the most important character in the film. José's character is written as a wise and tender person who is comfortable with his sexual orientation, although he is also capable of passing as a heterosexual man. He guides Ander carefully through the journey of recognizing his sexual attraction to José and along the troubled path of Ander acting out in problematic ways. José seems to be an old hat in navigating the process of sexual self-discovery, and he acts as a gentle protector of Ander's internal struggles and external reckless behavior in some of his outbursts. Reme is the other gentle presence in Ander's life who recognizes that Ander is rediscovering his sexuality thanks to José's presence in their lives. Reme and José hit it off quickly and understand what Ander is going through. They are supportive of each other and ultimately guide Ander to a happy outcome where the three of them become a family for Reme's son and live together. Reme and José live dissident lives. They are subjects of derision and cursing. Despite the repressive nature of the normative system's response to them, they rise above their abject identities. These identities do not represent who they are, since they are simply imposed on them by the rules of signification that derive from traditional, societal norms. Reme and José harness the experience of oppression to reappropriate it and create a peaceful life for themselves, defending each other from attack. José does so by beating down a drunk Peio who is about to assault Reme in one of the last scenes of the film. The dissident reappropriation of abject identities as activism in punctually performed identity is a powerful way to react to repression.

The richness of José's and Reme's psychological depth permits another angle of analysis. Thanks to these two characters, it is possible to understand a central thesis of *Epistemology of the Closet* (1990) by Eve Kosofsky Sedwick. Sedwick notes with precision: "Erotic identity, of all things, is never to be perceived or known by anyone outside of a structure of transference and countertransference."[10] Ander dramatizes this central thesis. His limited and closed social life shows that the identical reputations in his house, his work on the farm, his enjoyment with his few friends, and his work in the bike factory inevitably

FIG. 9.1 Jorgi Oriol and Dafnis Balduz. *Forasters* (2008) by Ventura Pons. Courtesy of Ventura Pons.

escape the absolutely identical repetition as much as the desirable security of those repetitions. Ander's repressed queer desire, the accident in which he breaks his leg on the farm, and the arrival of a stranger at his house will confirm the powerful, relational nature of erotic human identities. The "relational" knowledge—which is not verbalized—that José acquires in his daily approaches with Ander authorizes him to encourage himself to initiate that first, clandestine sexual encounter in the bathroom. It is also this "relational" knowledge that Reme has for Ander—which is also not verbalized—that allows her to realize that Ander's erotic orientation is toward men. It is for that reason that, rhetorically, without surprise and with much compassion, she will ask José: "Has what needed to happen already happened?"

José's character integrates another central element in the film that should be noted. Other directors who Basque by birth or by adoption, such as Montxo Armendáriz (1949–) and Imanol Uribe (1950–), have also explored the immigration of foreigners and issues of racism in their works, including a film examined in this volume that involves such a current and hot topic: immigration within the territory of Spain. I refer to *Forasters* (2008) [*Strangers*], by the Catalan director Ventura Pons (1945–). From this perspective, *Ander* should be placed in a genealogy that should also include *Las cartas de Alou* (1990) [*Letters from Alou*], by Armendáriz, on one side, and *Bwana* (1996), by Uribe, on the other. Along the same lines, one must remember the film by Manuel

Gutiérrez Aragón (1942) titled *Cosas que dejé en La Habana* (1997) [*Things I Left in Havana*].[11]

Ander is a beautifully shot film. If anyone is interested in studying the gaze of the camera, this film is a good example to contrast with the male gaze of most films. Roberto Castón wanted to shoot a completely different film to even contrast with stereotypical queer cinema. Castón, who was unhappy with an array of gay films that portrayed idealized beauty, where everyone is attractive, young, and athletic, wanted to shoot a different type of queer movie. The main character, Ander, is in his forties, is a little pudgy, and does not replicate the stereotypical beauty of a male model. Reme is also a normal woman, not an idealized supermodel. José's portrayal of a Peruvian immigrant is also very realistic. Earlier I have mentioned the documentary style of the film, with scenes expertly shot to express a visual loneliness. The stereotype of the Basques is that they are not a talkative culture, and neither is Castón's script. The director was able to express a lot with very few words. The film's scenes are eloquent and demonstrative by constructing each scene as a visual and wordless tale.[12] Short phrases abound, and many silent moments create an expressive visual portrayal with quiet characters. This passage from a French review of *Ander*, at the time of its debut, provides a very just synthesis of the film: "Talking silences, small gestures of daily life, filled with sexual desire, including secondary characters expressing a high level of humankind: [*Ander*] is a gay, rural chronicle to be discovered."[13]

Some of the secondary characters are Ander's mother and sister, both named Arantxa. The mother is a stiff, inflexible matron who runs a conservative household with a very tight grip and without any tenderness. She dictates how the seating around the kitchen table must be arranged. The father used to sit at the head of the table; following conservative tradition, Ander now sits at the head of the table after the death of his father. I have discussed how the mother refuses to recognize that her son's sexual orientation consists of an attraction to men. Ander may not have been fully aware of his sexuality for most of his life, but at least he knew he did not want to marry a woman. The price he had to pay for most of his life was that he was compelled to perform the identity of a hypermasculine heterosexual man in his close-knit community.

Gorka Bilbao Terreros has studied the conservative role of the matriarch in Basque filmography. In "Matriarchy, Motherhood, Myth and the Negotiation of (Gender) Identity in Modern Basque Cinema," he points out that the presence of the matriarch represents very restricted, obsolete, and retrograde roles that impose regressive sexual and social practices. This is true in *Ander*, even though the mother has maintained some level of romantic connection, probably purely platonic, with Evaristo throughout most of her married life. The role of the matriarch in Basque filmography is a cornerstone of the culture that

appears in other Basque films such as *80 egunean* (2010) [*For 80 Days*] by Jon Garaño (1974–) and José Mari Goenaga (1976–); *Las brujas de Zugarramurdi* (2013) [*Witching and Bitching*] by Álex de la Iglesia (1965–); and *Loreak* (2014) [*Flowers*] by Garaño and Goenaga. These films present a battle of the patriarchal order against the forces that want to break from such a norm. Eventually in this struggle, just as in *Ander*, "the cinematic presence of the traditional matriarch as the guardian of Basque tradition becomes meaningless, and as the analysis of films such as *Ander* will demonstrate, her atavistic figure will be open to revision, modernization and reappropriation."[14] Terreros correctly points to this struggle in the film when the mother ends up in the hospital after suffering a heart attack and Ander blames himself for it: "Ander and his sexuality are deconstructing a classic paradigm of masculinity while driving a fatal blow into the metaphorical heart of the reactionary and old-fashioned Basque society. That is why, when his sister arrives at the hospital, Ander only manages to say 'It was my fault.'"[15] There are several scenes between Ander and José's sexual encounter during the sister's wedding and the mother's death. In the subsequent scenes after the wedding, the mother remains alive, long enough to ensure that the sexual encounter was not the cause of her death. However, her death occurs after José puts Ander to bed and undresses him so that he can rest after the outburst with Meme during the failed sexual act. While José is undressing him, Ander grabs José's hand and places it on his shorts in the area of his crotch. José gently moves his hand out of the way to finish putting Ander to bed. Ander takes a nap and goes over to his mother's bedroom because she is not picking up the bread and the newspaper as she did all her life when the delivery car stops at the house. This is the moment when he finds his mother unconscious on her bedroom floor. At the hospital Ander takes the blame for her death and pulls away from José as if he felt that their sexual attraction was somehow responsible.

Arantxa, the daughter and Ander's sister, does not play a pivotal role. She is about to be married, and, as already discussed, it is during her wedding that Ander and José have their first sexual encounter in the bathroom of the restaurant. She moves out of the house after the wedding even though throughout the first half of the film she lived with her mother and Ander. The most important scene in which she participates is when Evaristo visits the hospital after the mother's heart attack. He opens up to Arantxa and confesses he has always been in love with her mother. She asks him why, and whether her mother also in love with him. Evaristo responds by saying that only she knew what she felt for him.

The film ends with a scene that almost identically copies the opening shots. The scene has a circular pattern in that, spatially, it ends where it started: a slow shot of the *baserri* in the dark. The film opens with that scene at five in the morning when Ander gets up, and it ends with the same shot of the *baserri* from

outside while the rain comes down. The closing scene is in the dark as well. It is New Year's Eve, and the only entertainment comes from a pocket-size transistor radio playing music. It is the same bedroom and the same house, but the feeling is completely the opposite of the opening scene. Then, there was a sense of the hard work needed to take care of the farm in addition to holding down a full-time job. The drudgery of the farm routine weighed heavily, and the sense of loneliness as Ander got up out of bed dominated. In the final scene, José is lying next to Ander, embracing him, and asks: "Are you cold?" Ander responds "no," and the scene transitions to the rain outside. The bedroom and the house no longer feel cold. These identical scenes that open and close the film have wildly different emotional charges. Ander smiles before the camera pans away to the outside of the house.

The theory of performativity applied to the creation of gendered identity that Butler proposed in *Gender Trouble: Feminism and the Subversion of Identity* (2002) and *Bodies That Matter: On the Discursive Limits of "Sex"* (2011) has been expanding. Books such as *The Psychic Life of Power: Theories in Subjection* (1997) include analyses of the constitution of the subject and, in particular, the psychological processes of the foreclosure of identity possibilities required in assenting to hegemonic categories. For example, the hypermasculine identity is the result of foreclosing, severing desired options that create melancholic echoes of the amputated possibility: less patriarchal and heterosexual options. The imposition of normative categories requires compliance with its structures; in doing so, it produces melancholic responses to the loss and identities that automatically fail to satisfy the norm, therefore creating abject subjectivities. The expansion of these theories to other areas includes a book Butler coauthored with Gayatri Spivak (1942–), *Who Sings the Nation-State?* (2007). One of Butler's latest books, *Notes toward a Performative Theory of Assembly* (2015), discusses today's political activism in relation to precarious lives.

The theory of studying identity performatively for gendered identity surely can embrace processes of the constitution of other identities such as ones that are based on nationality, culture, social groups, and linguistic communities. This proposition would hypothesize that all identities are performative but also participate in all the other processes of melancholia due to the loss of the foreclosed desired identities resulting from the experience of injurious interpellation and abjection. My proposition is in no way interested in watering down Butler's powerful work on gendered identity. It would simply follow Butler's model and propose the reappropriation of abject subjectivities to harness performative identities in order to retrieve empowering gains. The normative system that denies your right to be who you feel you are powerfully represses options for rebellion and makes the struggle against it very costly. Clearly, this reappropriation must be strategic and not fall on the essentialist construction of identity like bourgeois nationalisms. Nevertheless, as Butler herself proposes,

there is room to create a space for "stateless subjectivities" and abject subjectivities that the hegemonic system produces from positions of precarity. It is in the interest of every possible model of abject subjectivity to appropriate prejudice and to ally. Six words from the film that summarize *Ander*—"La puta y los dos maricones"—demonstrate how to promote appropriation and alliance in regard to such models of dissenting activism. *Ander*, nested in an extremely conservative rural community, shows us how progress can be achieved.

Notes

1 Barry Jordan and Rikki Morgan-Tamosunas, *Contemporary Spanish Cinema* (Manchester: Manchester University Press, 1998), 188.
2 The scene that formalizes the agreement to form this new family unit deserves detailed analysis regarding the camera perspectives used between 1:54:35 and 1:55:01. The camera shows the dramatic space of the kitchen and the area around the kitchen table where the family eats in Ander's house. The camera takes, for the first and only time, two positions that formally express a novelty in the negotiation of strengths between the two characters: the kitchen table itself disappears, and the camera captures a medium shot of Reme. Afterward, there is also a medium reaction shot of Ander. He and Reme are now standing, and the kitchen table is no longer in the frame. Ander responds to Reme with assurance, and only a small, empty space separates them. "REME.—Are you asking that we come and live with you? ANDER.—With me, no. With us." Under these cinematographic conditions, within the dialogue, the "we" appears implied with great strength, meaning "José and Ander," who are already a couple, and Reme and her son.
3 During the 1980s, "generous funding rules made film production in Euskadi particularly attractive turning the region into . . . a sort of paradise and certainly helped to ensure the return of numerous, well-established Basque directors to the region, such as Pedro Olea, Alfonso Ungría, José Antonia Zorrilla and Eloy de la Iglesia." Jordan and Morgan-Tamosunas, *Contemporary Spanish Cinema*, 186.
4 See "Berdindu," accessed July 25, 2017, www.euskadi.eus/gobierno-vasco /berdindu/.
5 Bizkaia is the Basque version of the name Vizcaya in Spanish. Bizkaia is the province where the city of Bilbao is located. Its dialect is probably the one that is the most unlike the other dialects, which are closer to the Batua standard. Native speakers of Bizkaieraz who have not been instructed in the use of Batua find the official version unfamiliar and difficult to understand. Nowadays, the programs that the Basque government instituted to increase literacy among the native speakers are making the gap less insurmountable.
6 Why did Castón give his protagonist the name Ander? A plausible hypothesis might be that other than being a man's name, the word connotes strength when it assumes the function of the only word in the title of the film. "Ander," or "Andrés," in Spanish, echoes back to the Greek etymology of the word: ἀνήρ, ἀνδρός. Among the Greek meanings of the word are "man," "husband," "warrior," and "hero." In this way, it would be possible that, in opposition to the historic Western tradition of heteronormativity, "Ander" represents a successful oxymoron outside of that custom: to be a man (ἀνήρ) and to be gay.

7 See Judith Butler, *Gender Trouble: Feminism and the Subversion of Identity* (London: Routledge, 2002), 54–55, 68.

8 Although partially the case for Ander and more precisely for Peio, with the purpose of giving a more exact meaning to the noun and adjective "hyper-macho," they could be guided by the three characteristics that Donald L. Mosher and Mark Sirkin find in "hypermasculinity": "(a) calloused sex attitudes toward women, (b) violence as manly, and (c) danger as exciting." Donald L. Mosher and Mark Sirkin, "Measuring a Macho Personality Constellation," *Journal of Research in Personality* 18, no. 2 (1984): 150.

9 In *Ander*, I have identified other aspects of queer resonance or a clear design against heteronormativity within the rural context of the Basque Country: (1) the mother has a history of a long-standing platonic connection with Evaristo (Pedro Praegi); (2) it is discussed whether Ander is possibly Evaristo's son; he denies it, but surprisingly Ander says he wishes Evaristo would have been his father; and (3) when José and Ander have sex in the bathroom, José, in opposition to Ander's mother, wears Ander's father's suit.

10 Eve Kosofsky Sedgwick, *Epistemology of the Closet* (Berkeley: University of California Press, 1990), 81. Such a structure refers to feelings, points of view, prejudices, opinions, elaborated thoughts, and the like that come and go from one individual to the other.

11 See Jordan and Morgan-Tamosunas, *Contemporary Spanish Cinema*.

12 I do not agree with Rob Stone and María del Pilar Rodríguez, for whom *Ander* presents, at the same level of importance, "male homosexuality and rural depriva-tion" of the Basque Country. Rob Stone and María del Pilar Rodríguez, "Contemporary Basque Cinema: Online, Elsewhere and Otherwise Engaged," *Bulletin of Hispanic Studies* 93 (2016): 1117.

13 "Compte rendu d'Ander," *Télérama Cinéma*, accessed July 25, 2017, http://www.telerama.fr/cinema/films/ander,383976.php.

14 Gorka Bilbao Terreros, "Matriarchy, Motherhood, Myth and the Negotiation of (Gender) Identity in Modern Basque Cinema," *Bulletin of Hispanic Studies* 94 (2017): 733.

15 Terreros, 741.

Part IV

Queer Catalonia

• •

Destroying Essential
Representations

10

The Barbarians' Inheritance

• •

Memory's Brittleness and
Tragic Lucidity in Ventura
Pons's *Amic/Amat* (1998)
and *Forasters* (2008)

JOAN RAMON RESINA

The passage of time and the decay of human things have caught the attention of many directors, but few have considered their social consequences as profoundly as Ventura Pons (1945–). Pons's works address the dangers of cultural transmission and focus on the difficulty of embodying an inheritance within an individual. This danger is personal for Pons because, among filmmakers intent on rebuilding Catalonian cinema after the death of Franco, he is the only one who has become an unequivocal referent of that cinema. His decisive achievement is constructing a meditation on the precariousness of identity and on the fragility of temporal links in a dramatic format that is accessible to all without being conventional or formulaic. In *Carícies* (1997) [*Caresses*], the decay of urban life is shot in sequential vignettes that portray a crisis in familial structures and reveal the difficulty of transmitting lifestyles and social manners that have been received. Critics of Pons's generation would probably define such manners as bourgeois, although in recent decades they have virtually

disappeared in the anomie that he studies in many of his films. Pons brings to the cinema a reflection on decadence and an inquiry into its origins. This reflection reaches metaphysical heights in *Amic/Amat* (1998) [*Beloved/Friend*], a film that grapples with the conundrum of death and the conditions of salvation in a lively debate between two professors. These two characters, united by friendship and—according to the confession of one of them—by a past erotic attraction, occupy the opposite poles of an existential dichotomy based on conflicting beliefs about the void that is opening between them. The battle, far from being "academic," will ultimately decide the triumph of either form or dissolution. It is a somewhat archaic scene, truly belonging to Apollo and Dionysus, to the angel of life and the angel of death, to Eros and Thanatos. Thus, the film goes further than Pons's modest purpose of examining the question of the possibility of a homosexual inheritance—"whether one person can 'inseminate' another intellectually."[1] The script is based on the play *Testament* by Josep Maria Benet i Jornet (1940–2020), who personally adapted his work for the big screen. That Pons would choose the campus of the Autonomous University of Barcelona, thereby infusing realism into the theme of intellectual insemination through the well-known academic setting, indicates that he knew the answer to the question of its possibility beforehand. The platonic tradition had already established the relationship between pedagogy and homosexuality many centuries ago.

In reality, the problem addressed by Pons is different. In *Amic/Amat* the pedagogical relationship transcends mere homoerotic attraction and becomes overtly sexual. Platonism fights the descent into carnal intimacy; that is, Platonism struggles against the communion of the body, which, in this case—according to the dictates of Neoplatonism—is a tomb because the professor and would-be-lover is terminally ill. The same night in which he declares his passion for his student, he also begs for euthanasia—demanding the highest proof of friendship from his doctor. As he prepares to indulge his body in one last satisfaction before its final spasm, he also fights to ensure some form of spiritual continuity. Nevertheless, this last wish demands that he resolve the problem of identity, which is also that of his individual footprint in the collective memory. In other words, he must resolve the philosophical question of paternity, of how to inseminate intellectually. The professor finds himself facing a fork in the road (sexual climax as an allegory of death or as transmission and survival of the spirit) and must make a decision just as his life is ending. If he opts for pleasure, he will not engender eternal beauty (the platonic definition of Eros) and will lose the opportunity to transmit the cultural legacy. The moral realms, which the ancients kept ideally asunder in the afterlife, are depicted communicating with and contaminating each other in secular garb, in line with Roger Caillois's (1913–1978) interpretation of the decline of providential history.[2]

In *Amic/Amat*, sexual pleasure is each character's key to freedom, while also opening a space for violence and humiliation that are apparently unforgiving. Salvation is possible, however, by means of erotic dissolution, or the surrendering of the self to a heteronomous object through homosexual Eros. The struggle for memory then becomes a fight between the ecstasy of the flesh and that of identity, opposite modalities of the same goal: to end the consciousness of separateness and finitude. The question that must be answered is if physical decay can arouse not the body of a young man to whom the image of his physical destiny is repugnant, but rather a young mind to accept an intellectual legacy. It is not an easy honor. To receive a legacy is to allow oneself to be trapped by the responsibility of providing biological continuity to a historical identity. The professor must convince the student of two things: first, to adopt values opposite to those he himself held in the past, and second, to pay the reproductive debt incurred by the professor.

Amic/Amat deals with continuity from the perspective of origin. The tradition of this particular transmission dates back to Ramon Llull (1232/33–1315/16), patriarch of the Catalan language. After eight centuries, this tradition, which is nothing less than the Catalonian conscience, languishes in a context of demographic crisis caused by the modern transvaluation of values and the intensification of egoism. The axiological rebellion of the modern subject dislocates the sense of time, arresting tradition's teleological momentum within the instantaneousness of pleasure. In the concrete case of Catalonian culture, survival of tradition coincides with its political location. Although neither the film nor Benet i Jornet's play addresses it, this political aspect is implicit in the professor's return from a long exile. In repatriating the cultural legacy before dying, he rescues it from oblivion in its own homeland. Only a breath of contemporaneity can revive the spirit of Llull, which exists exclusively in the cortex of a brain that is nearing death and in its metaphor, the hard drive of the computer that the student destroys before also breaking the floppy disk that contains the last copy of the professor's posthumous essay. But, in the student's nihilist rebellion, the latter discovers an opportunity to fulfill his own version of Pascal's wager. A book survives only if a reader absorbs it through an act of communion that is both spiritual and physical. Therefore, the professor provokes the student to destroy the last artificial copy of the text, thereby forcing him to convert the read manuscript to organic memory. The annihilation of the letter fixes the spirit in the matter of a young, evolving brain. For the purpose of resuscitating an ancient soul that he himself classifies as "an antediluvian fossil," the professor must persuade a young body to incarnate goals that transcend it, which is the classic task of pedagogy. For this reason, the last scene of the film revisits the first images, featuring the ritual of dressing oneself for a sexual encounter with sacrificial undertones of a consciousness submitting to its destiny. During the male prostitute's slow, deliberate rubbing of oil on his skin,

FIG. 10.1 Aida Oset. *Forasters* (2008) by Ventura Pons. Courtesy of Ventura Pons.

the body is eroticized by red-hot illumination that could allude to an interior private hell, or perhaps just as easily to the dawning of a re-engendered conscience.

Forasters (2008) revisits the theme of continuity, this time not from the viewpoint of a problematic awareness of the origin, but instead with a sense of the exhaustion of tradition. If the literary reference in *Amic/Amat* was Ramon Llull's *Llivre d'amic e amat*, now the reference would be *Bearn*, a novel by Llorenç Villalonga (1897–1980) about the decadence of the Majorcan aristocracy ("it is a whole world that goes down with it").[3] It is worth noting the importance of this reference, which is more subtle than the reference to Llull in the previous film. Pons has admitted to triviality in the choice of the book that Emma, the terminally ill matriarch who rules her family with an iron fist, holds in her hands. The director insists that he was simply looking for a large book for the scene in which Emma's daughter, Anna, threatens her mother and that he randomly selected the first volume of Villalonga's *Collected Works*, which contains *Bearn*, from his personal library.[4] Nonetheless, the book becomes a fitting allegory for Emma's state of mind and perfectly conveys her symbolic legacy. It really would be a happy coincidence, which is difficult to believe coming from a director who aptly replaced the title *Testament* with the Llullian *Amic/Amat* in his adaptation of Benet i Jornet's play. The reference to *Bearn* rises to apodictic necessity when Manuel hands the book to Anna and she opens it to the title page. At this moment, a close-up of *Bearn* fills the screen as a visual corollary to a subjective discovery within the character's consciousness.

FIG. 10.2 Anna Lizaran. *Forasters* (2008) by Ventura Pons. Courtesy of Ventura Pons.

Forasters begins as the heir arrives to take possession of the legacy. This establishing sequence announces the film's retrospective modality. It will later take on the value of closure when Pons finishes telling the story and the film loops back to the beginning, thereby closing the temporal parenthesis opened by the traveler's arrival in the city. Thus, his return has the character of a suspended revelation, of an impending outcome that is temporarily delayed through the intervening memory. The traveler revisits the space of a collective memory in order to make it his own. This is the sense of his purchase of the apartment that was Emma's, and her father's before her. The transfer of the apartment to this apparent outsider is a legitimate transmission, in accord with Emma's wish that it not be sold to strangers, but it will be revealed only at the end of the film through the character's anagnorisis. This manner of beginning at the end closes a cycle. By diachronic logic, the sale of the property is the premise of the narrative, and, chronologically, it takes place shortly after the first sequence. We will not know until the end, however, that it represents the last formal step in the acceptance of an inheritance that was bestowed long before. Therefore, the main theme of the film turns out to be the excavation of collective memory. It is memory and the actions associated with it that give meaning to an ordinary real estate transaction.

Forasters and *Amic/Amat* share a preoccupation with a morally and biologically exhausted society, but in *Forasters* the terms are reversed. In the earlier film, the heir resists the generative desire of the professor with a puerile nihilism when the former insists on transmitting a manuscript with their culture's

genetic code to him. In *Forasters* it is a child, Manuel, who receives the "holy" book from the hands of an ailing neighbor (again, cancer is used as a metaphor for society's internal decay). Manuel responds to the dying woman's fondness for him by identifying with her gift and going on to become a professor of Catalonian philology. Again, the heir is chosen rather than predetermined biologically, and in this case he even comes from outside of the culture to which he will be the source of continuity. The nexus that permits the relay of the identity is affection, which is the key to the exogenous subject's integrative transformation. Later, introducing himself as "Manel" to Ahmed, the new owner of the flat affirms his Catalanness, but not because his name is the Catalonian translation of "Manuel," as David J. George mistakenly proposes, believing it to be a political message; instead, "Manel" is the name's colloquial form and therefore implies familiarity.[5] By adopting this form of verbal proximity, Manuel eliminates the ambiguity surrounding his citizenship (now he is no longer an immigrant), and he also introduces Ahmed, the new "outsider," to the inner circle of an inclusive familiar sentiment. With time, Ahmed will become the new Manuel. The reflexive, autonomous *em dic* (I call myself), in contraposition to an impersonal, heteronomous *em diuen* (they call me), shows moral choice as a self-determining gesture. Manuel defines himself as an "insider" just after he guffaws, which is a sign of recognition and liberation. The burst of laughter is a Nietzschean "yes" to the eternal recurrence of that which has been lived through. Manuel's laughter echoes with an acceptance of his role in the dialectic between memory and prognostication. In the natural way that he introduces himself as "Manel," there lies a hint of irony that can only come from one who has already closed the gap between being an outsider and being an insider, a distance that Ahmed has yet to traverse. For this reason, the words Manuel uses to take leave of Ahmed, "You and I must talk," form a dialectic bridge and insinuate a pre-established link of which Ahmed is still unaware, but that will eventually break upon him.

If in *Amic/Amat* the professor returned in order to deposit his memory in a native Catalonian inheritor, in *Forasters* cultural tradition is preserved by investing it in an "outside" inheritor, in a barbarian, in the etymological sense of the word. As the youngest son of a family that immigrated from southern Spain in the 1960s, Manuel is drawn to the autochthonous family living in the same building. He returns Emma's affectionate gift of a book by turning his reading of it into a lifelong vocation. Forty years after receiving that impulse, he returns to Barcelona to take over the apartment of the disintegrating Catalonian family. The outsider of yesterday becomes the curator of the heritage of a society that renews itself through external contributors. Accepting the inheritance means taking on the responsibility for the social memory. Along with the ambiguous gift of "insider status," Manuel accepts a tragic destiny. Additionally, the decision frees him from the determinism of a nativist culture that

threatens to restrict him within a pre-tragic exceptionality. This does happen to his brother, a character who embodies all the clichés surrounding immigration and who ends up being reabsorbed by his origins.

Ventura Pons affirms the continuity of destiny between bodies that leave and enter the same scene to the rhythm of the biological cycles. Autochthony is the illusion that customs have permanence over the long term. Over time new customs continue to arise and disrupt those that are established, until they too are reduced to the status of tradition and merge seamlessly with the older customs. In this way, the civil consensus from which social identity arises is continuously re-created.

The film occurs in two different time periods that are identified by intensity of color. While the twenty-first century is shown in the full color spectrum, the sequences in sepia portray the 1960s, which is when Catalonia's relatively homogeneous population was engulfed by a migratory wave that resulted in a cultural crisis. The effect of that cultural dislocation is expressed by the tense and anxious resentment exhibited by the Catalonian family, contrasted with the dancing, shouting, and fighting of the inhabitants of the apartment above. The scenes that portray the current century show a family decomposing— illustrated by the exasperation of selfish impulses after Emma's death and the repeating of destinies as Anna in turn comes back to die in her mother's bed of forty years earlier. The unfolding of the same destiny in two separate people is represented by the simple decision to have the same actress, Anna Lizaran (1944–2013), play both characters. This transgenerational identity is resolved in a series of parallelisms that challenge the idea of historical contingency.

The South ceases to be a concrete place and becomes a metaphor for cultural dislocation. Immigration from the South inverts the historical cycle that credits the founding of Catalonia with the invasion of Roman Hispania by the northern barbarians. In *Forasters*, Pons represents, perhaps, what Giambattista Vico (1668–1744) would call a *ricorso*, or a "return." With this term, Vico referred to distinct moments in history that constitute the repetition of human events in the resurgence of nations.[6] If the meaning of the film were reduced to the politically correct message of tolerance toward immigrants, the film would lose its interest. Hence, *Forasters* does not adopt a moral tone, nor does Pons assume the role of judge of history, because he does not share the Hegelian idea that the present time encompasses the totality of consciousness. Moreover, the present seems to submit to an ahistoric pattern in the form of cyclical movement. It is sufficient to observe how the characters, who contribute to their own misery, end up adapting—for better or for worse—to the biological, sociological, and historical processes that they endure. For Vico, history does not consist only of deeds and actions but also of events and occurrences. It is not a constant and steady progression toward a fair and definitive plan. It does not move in the direction of a golden age or toward a harmonious republic. The

inevitable end of progress is a return to decadence, followed by another cycle, or *ricorso*, that begins from a new state of barbarism and amounts to a resurgence. Vico affirms, then, the existence of a historical pattern. According to this model, that which has occurred will occur again in the future with a regularity that is intrinsic to every specific culture.

It is not necessary to point out the connection between Vico's concept and the temporal structure of *Forasters*—the title of Segi Belbel's theatrical work—which Pons, following his impulse to rename *Amic/Amat*, could very well have retitled as *Bàrbars*. Perhaps it is worth noting, however, that the film's dramatic strength lies in the immanence of destiny. If, in a culture endowed with a sacred character, destiny were to reveal the presence of a metaphysical pattern, in this one salvation is not found in the surrendering of pain and fear to the transcendent sphere; instead, it is incorporated into history with the value of a nexus between an extinguished past and an uncertain future. This immanence relies on the continuity of the work of destruction and disintegration (cancer reappearing in later generations) according to a natural-historic law that is responsible for cycles and the impossibility of imagining a telos or final rescue.

Regressive repetition is not an archetype in the same way that the Catalonian philosopher Eugeni d'Ors (1881–1954) imagined the permanence of certain formal norms in the flow of time. In his theory of eons, derived from Neoplatonism, d'Ors attempted to prove the existence of invariants or "unalterables" in the course of history. He distinguished these constants from Vico's *ricorsi*, asserting that with the eons he did not claim to address the regularity or the periodicity of recurrence, but the existence of atemporal elements that help to identify the general structure of events. Neither does he allude to laws of history, but rather to predetermined categories[7] that resemble Gregor Mendel's (1822–1884) recessive traits in his theory of biological inheritance. These are traits that recur after several generations and serve as a fixed substrate or ever-present layer beneath biological modifications and variations, constituting in their ensemble something like a type or a species.[8]

It is not necessary to demonstrate that the recurrence of situations in *Forasters* does not obey the logic of the eons, although neither is it difficult to identify the kind of Catalonian family at the center of Pons's concern with cultural continuity. In both of the films examined here, the family as social nucleus is disintegrating, its components going into orbit around an identity and a sense of history that are remote but still capable of causing gravitation. What recurs, then, is not a historical law but rather a structure, a kind of metahistorical judgment that condemns a culture exhausted by an excess of conscience and introversion to re-enter into a sensual "barbarity" that is both a penance and a salvation. Vico writes: "For such peoples, like so many beasts, have fallen into the custom of each man thinking only of his own private

interests and have reached the extreme of delicacy, or better of pride, in which like wild animals they bristle and lash out at the slightest displeasure . . . they live like wild beasts in a deep solitude of spirit and will, scarcely any two being able to agree since each follows his own pleasure or caprice."[9] Dissension and civil war return these peoples to a primitive condition. "In this way," says Vico, "through long centuries of barbarism, rust will consume the misbegotten subtleties of malicious wits that have turned them into beasts made more inhuman by the barbarism of reflection than the first men had been made by the barbarism of sense."[10] In the symmetry between the events of two generations of the same family made up of "wild beasts" mired in spiritual solitude, Pons shows the underlying dynamic of a culture frayed by a proud refinement that manifests as barbarity in a dying woman's cruel lucidity and in a grandfather's awkward prejudices. When a people withers through this last civil plague, says Vico, stronger nations come to conquer it and to preserve it from outside. This is, without a doubt, the historic penalty that weighs on Catalonia, a land repeatedly occupied by foreign cultures that compete with the autochthonous one in its own territory. Then, as a result of the dialectic between seduction and repulsion, the old culture is injected with vitality, powering new cycles and eliciting rebirth: "The nations mean to dissolve themselves, and their remnants flee for safety to the wilderness, whence, like the phoenix, they rise again."[11]

It is doubtful that either Pons or Belbel was inspired by Vico, but this is an unimportant detail, since the idea of a cyclical history forms part of the modern concept of time, popularized as much by Oswald Spengler (1880–1936) and Arnold Toynbee (1889–1975) (both indebted to Vico) as by W. B. Yeats (1865–1939), James Joyce (1882–1941), T. S. Eliot (1888–1965), and, of course, Friedrich Nietzsche (1844–1900), whose theory of eternal recurrence Josep Pla (1897–1981) considered of permanent value because, he said, nothing that is truly important in history or in public life is ever really resolved.[12] Pons himself has indicated the circular structure of *Carícies*, an earlier film, observing that, after seventy minutes, the film returns to its beginning, in which the ending is inferred.[13] No matter this director's philosophical references, his preoccupation with time is undeniable, as is the combination of anguished inability to exit history and lack of faith in the vitality associated not with feelings stemming from reflection but with primary needs. Making a wager in favor of the existence of circularity is one way to escape the terror of a history submerged in perpetual transformation.

Facing history with terror and being redeemed by one's offspring are byproducts of the Christian concept of time. Pons's approach to the filmic image is never religious, but time is structured by the pursuit of redemption. When redemption is achieved, it is unmistakably secular, but for this reason it is

FIG. 10.3 Nao Albet. *Forasters* (2008) by Ventura Pons. Courtesy of Ventura Pons.

uncertain and always on the verge of being frustrated. Even so, in *Forasters*, Pons attempts to overcome the linearity of history at the point where the future opens onto a scene of vague terrors. On this path, there is no transcendence. Martin Heidegger pointed out that the historicity of the human experience closes off any possibility of transcending time.[14] There are no miraculous openings that allow the limitations of human life to be resolved in a superhuman existence or a metaphysical sphere. Neither is it possible to indefinitely expand the present time and turn it into an immature eternity (as the student is tempted to do in *Amic/Amat*). Another temptation, foretold by Mircea Eliade (1907–1986), is life's reintegration within the horizon of archetypes and of repetition, rejecting, "as meaningless and dangerous, any spontaneous gestures which might entail 'historical' consequences."[15]

Pons alludes to Catalonian society's current difficulty in carrying out this type of "spontaneous gesture."[16] For this society the future is rhetorical, a trope of modernity, itself an effect born of incorporating fashions that have triumphed elsewhere. It is not the anticipated correlate of the society's overcoming its historic fatality, which is sharply portrayed in *Forasters*. Regardless of the actual history of Catalan life—and Pons alludes to this history by setting the scene in a building dating to the end of the nineteenth century—the film represents it as gravitating toward the equilibrium of death. The fact that the filming takes place almost exclusively inside the apartment and is interspersed with a few exterior shots that serve as local markers only accentuates the sensation of

FIG. 10.4 David Selvas and Josep Maria Pou. *Amic/Amat* (1998) by Ventura Pons. Courtesy of Ventura Pons.

claustrophobia, of an intimacy poisoned by passions and fermenting silences, of a way of life that is approaching its end.

The old Catalonian work ethic, characterized by pride in hard work and austerity, finds itself exhausted by historical fatigue in the twenty-first century, and paralyzed by fear of a gesture that could bring on irreparable consequences.[17] Such dreaded consequences occur due to Anna's sexual transgression in a gesture that violates her family's conventions regarding relations between Catalonians and the "barbarians" who reside in the flat upstairs. However daring, it is no less a desperate gesture, and she is incapable of averting the fate that her mother predicts for her with a lucidity that smacks of damnation. After all, if her mother judges Anna so harshly, it is because she sees her trapped by the horizon of repetition. Ultimately, Anna's rebelliousness is as impotent as her brother's abject submission.

The drama surrounding these characters lies in the fact that, being removed from the archaic ways of life that they project on the new neighbors, they can no longer feed off of the myths of rejuvenation held sacred by premodern cultures. These cultures, to the extent that they live outside of history, can regenerate themselves ritually in the eternity of their foundational models. According to Eliade, the secret of the societies that are considered primitive lies in their periodical abolition of time and in the recovery of their virtualities at the threshold of each "new life."[18] Archaic civilizations, says Eliade, regularly

participate in repeating the cosmogony: the ultimate creative act. In *Forasters*, societal renovation is alluded to with the periodic insertion of characters who represent archaic peoples from the viewpoint of the old, exhausted culture. These newcomers are subject to certain rhythms and customs that, upon entering into conflict with the local customs, fan the embers of autochthonous passion and flare up into a new cycle.

Modernity leaves these dying people one single means of creativity, that which is sparked by a free act of self-creation. To be free, for the individual whose substance is historical, means—in essence—creating history. Moreover, history is precisely that which terrorizes a society that has forgotten how to abolish time through collective rituals of regeneration, of which the rhythmic music coming from the upstairs apartment serves as both a vestige and an example. To this end, Josep Maria Benet i Jornet has said that "the consciousness of time is felt in anguish and desolation by the characters in Belbel's works," but his commentary can equally be applied to Pons's cinematic version, which also transmits the tragic consciousness of time felt "at the precise moment of glaring lucidity, of the recognition and of the piercing acceptance of tragedy, of the acceptance of this sort of monster that time is; it can express it . . . when death, full stop, opens its mouth to devour us."[19] Now then, the flash of recognition cannot be expressed as effectively with cinematic language as with the symbolic tools that are available in theater. So, in Estel Cristià and Max Glaenzel's production of *Forasters* at Catalonia's National Theater, a series of mirrors multiplied the images of Anna and her niece Rosa, changing the gaze between the two women into a temporal abyss in which many generations of women concurrently recognize each other across a multitude of deaths and carnal seductions. Sharon Feldman describes this moment as "a simultaneous performance of many deaths, many kisses and many embraces through time."[20] Pons substituted the exchange of gazes with the sexual encounter between Rosa and Ahmed, viewed through the camera as if from the perspective of Anna, whose presence is not essential to the scene due to the flashback to what took place forty years earlier between Salva and herself. At that moment, Pons cuts to a shot of the expiatory Church of the Sacred Heart of Jesus on Tibidabo Mountain, with sweeping views of Barcelona, and it seems as if Rosa and Anna's banal transgression merges with all of those other impulses and miseries making up the beating heart of the great city.

In the stage directions in the text of the dramatic work, Belbel adds that, upon the daughter looking at her niece and encountering herself from forty years earlier at the defining moment of her life, and seeing herself from her mother's deathbed that is now hers, a sort of multiplication and unfolding is produced in which "all of her selves seem to understand the mystery that until then was hidden and impenetrable."[21] In this moment, the intensity of the gazes exchanged between three generations of living and dead produces "a brutal

FIG. 10.5 Rosa Maria Sardà and Irene Montalà. *Amic/Amat* (1998) by Ventura Pons. Courtesy of Ventura Pons.

explosion of luminosity that is absolutely blinding." Belbel ends the stage direction with the words: "As if we were present, suddenly, at the beginning of the universe."[22]

This return to the womb of the great city is nothing other than the cancellation of time and the re-establishment of society through contact with its archetypes. Eliade affirms that the tragic horizon—that is, not only individual death but also the increasing possibility of collective extinction—is the price that modernity must pay for transcending the horizon of archetypes and repetition. For him, modern man has only one way out, and it is to affirm a liberty that does not exclude God, specifically the Christian God. In other words, to literally believe in a deus ex machina that permits living historically while transcending the natural laws.

That is not Pons's (or Belbel's) solution to decadence and decay. Director and playwright do not turn to myth in order to obtain cosmic purification. Also, if a knight in shining armor does indeed appear to conquer the dragon of time, he is represented by the character of a prostitute (*Amic/Amat*) or by the youngest son of a family of raucous and violent immigrants (*Forasters*). Victory does not endure, however, and each generation must ensure its own victory. This means that the redeemer must remain trapped in the cycle that he consents to renew. The dialectics between expiration and continuity is the philosophical kernel of Pons's filmmaking. In *Forasters*, repetition is inevitable not only for the family members who hate in their predecessors what they themselves are

condemned to reproduce, but also for the "others," the outsiders from a faraway country—Andalusia in the 1960s and Morocco in current times—who, in their turn, will contribute to society's reproduction.

If the secret that is revealed at the climax is the identity of pain as a "universalizing force" (*Forasters*), Pons offers a perspective that Eliade did not consider (although Vico did). Despite the fact that his characters are historic—and from that fact stems their tragedy—they do not thereby transcend the laws of nature. They find their freedom in the affirmation of fate and the recognition of the future in the past and vice versa. Here there is no fluidity in cultural identity. On the contrary, confronted with the liquefaction of identity in contemporary society,[23] in which "hybridization" substitutes for the old "assimilation" strategies in the attitudes of the global cultural elite, Pons proposes the endurance of codes of conduct that are more tenacious than the representations of individual subjects and their racial or cultural origins. If critics then assign class or national labels to those codes of conduct, they do so at their own risk. But if we take seriously the ideas of universalization and equalizing through pain, and of rebirth through affection and care, then we should conclude that in his films, Pons addresses Catalanness metaphorically as the moment when culture becomes conscious of its tragic condition through its effort to transcend the extinction to which the inextricable dependence on the body condemns it.

Notes

1 Ventura Pons, *Els meus (i els altres)* (Barcelona: Proa, 2011), 235.
2 See Roger Caillois, "Metamorphoses of Hell," in *The Edge of Surrealism*, ed. Claudine Frank (Durham, NC: Duke University Press, 2003), 310.
3 Llorenç Villalonga, *Bearn* (Barcelona: Club Editor, 1969), 30.
4 See David George, *Sergi Belbel and Catalan Theatre: Text, Performance and Identity* (Woodbridge, UK: Tamesis, 2010), 114, no. 56.
5 See George, 103, no. 27.
6 Giambattista Vico, *Scienza Nuova*, ed. Fausto Nicolini (Milan: Riccardo Ricciardi, 2006), 633.
7 See Eugenio d'Ors, *Lo Barroco* (Madrid: Aguilar, 1964), 108.
8 See d'Ors, 112.
9 Giambattista Vico, *The New Science of Giambattista Vico*, trans. Thomas Goddard Bergin and Max Harold Fisch (Ithaca, NY: Cornell University Press, 1970), 381.
10 Vico, 381.
11 Vico, 383.
12 Josep Pla, *Notes del capvesprol*, in *Obres completes*, vol. 35 (Barcelona: Destino, 1979), 410.
13 Ventura Pons, "My Third Belbel," accessed August 5, 2012, http://www.venturapons.com/forasters/notesdirectoreng.html.
14 See Martin Heidegger, *Being and Time*, trans. John Macquarrie and Edward Robinson (New York: Harper and Collins, 1962), 63.

15 Mircea Eliade, *The Myth of the Eternal Return or, Cosmos and History*, trans. William R. Trask (Princeton, NJ: Princeton University Press, 1971), 153–154.

16 This essay was written years before the events of 2017, which contradicted the accuracy of this statement.

17 Situating the action in a formerly industrial district and in a lower-middle-class apartment, Pons revises realistically the stress on class Belbel places on the dialectic between natives and immigrants by housing both families, rather incongruously, in the same "bourgeois" building, at the same time marking the newcomers with the signs of social, cultural, and economic marginality. This schematic simplification overlooks the fact that in the mid-twentieth century, "immigrants" occupying the upper floors of upper-class buildings in Barcelona tended to be officials of the Franco regime or nouveaux riches incubated by the regime. Pons revises Belbel's historical inaccuracy by shifting the zone of contact between local and immigrant working classes to a paradigmatically working-class district.

18 Eliade, *The Myth of the Eternal Return*, 158.

19 Josep Maria Benet i Jornet, "Sergi Belbel, tot just comença," in *Forasters*, by Sergi Belbel (Barcelona: Proa, 2004), 18.

20 Sharon Feldman, *In the Eye of the Storm* (Lewisburg, PA: Bucknell University Press, 2009), 227.

21 Feldman, 226.

22 Feldman, 226.

23 Zygmunt Bauman, *Liquid Life* (Cambridge, UK: Polity, 2005), 30.

11

Intertextual Representations and Lesbian Desire in Marta Balletbò-Coll's *Sévigné (Júlia Berkowitz)* (2004)

●●●●●●●●●●●●●●●●●●●●●●

MARÍA TERESA VERA-ROJAS

Catalan filmmaker, producer, and writer Marta Balletbò-Coll[1] is the independent director of *Costa Brava (Family Album)* (1995), *"¡Cariño, he enviado los hombres a la Luna!"* (1998) [*Honey, I've Sent the Men to the Moon*], and *Sévigné (Júlia Berkowitz)* (2004), three feature films in which lesbian desire, intimacy, and women's love and relationships are the focus of her narrative. Along with Ana Simón Cerezo, Balletbò-Coll founded in Barcelona CostaBrava Films. They worked together on the scripts of Balletbò-Coll's films as well as on their novel, *Hotel Kempinsky* (1996), which was originally written in Catalan and published by El Mèdol, a Catalan independent press.[2] It is also Ana Simón Cerezo to whom Balletbò-Coll dedicated her book *Costa Brava* (1997), a romance novel based on the homonymous film that was written in English and, I would like to highlight, was published by the Naiad Press, one of the oldest and largest independent publishing houses devoted to lesbian literature in the United States.

While Balletbò-Coll's films have been lauded and have received the attention of specialists, critics, and nonmainstream audiences, scarce attention has

been paid to her novels and to the dialogic nature of her films. Together, these components offer a broader and more complex perspective regarding her creative project and the role played by intertextuality and autoreferentiality in her representation of lesbian intimacies, identity, and desire. Considering this framework, I would like to focus on the importance of intertextuality and autoreferentiality in Balletbò-Coll's cinema. They are both paramount to understanding not only the construction of a lesbian subjectivity but also the shaping of spectatorship that is produced and constantly redefined at the intersection of social bonds, shared experiences, and cultural representations.

To this end, intertextuality should be understood, following Julia Kristeva's approach to the literary word, as an *"intersection of textual surfaces."* According to her perspective, there is not a "fixed meaning" but a "dialogue among several writings" that comprise the writer, the addressee, and the cultural context. Intertextuality replaces intersubjectivity by means of the articulation of the word "with other words in the sentence, and then to look for the same functions or relationships at the articulatory level of larger sequences." Therefore, "any text is constructed as a mosaic of quotations; any text is the absorption and transformation of another."[3] In this manner, when referring to cinema, intertextuality "means that every text . . . refers to other existing texts. It is in dialogue with them in multiple ways, including structure, plots, tropes, and characters—rewriting, mimicking, rejecting and creating narratives in opposition to them. Part of how readers and viewers make sense of a text is through their recognition (conscious or not) of the familiarity of those other texts."[4]

My reading suggests that intertextuality in Balletbò-Coll's films is produced by drawing on the structures of classic comedy and drama romances through the depiction of lesbian love and everyday life. From a perspective that problematizes the violence exerted by the homonormative gaze when confronting lesbian desire, Balletbò-Coll tackles the experiences, joys, and struggles of the homoerotic relationship between women. Inseparable from the dialogic nature of her films, I would like to stress the ways in which autoreferentiality also stands out in her films through the role played by the mechanisms of the visual world on the one hand, and by playwriting, staging, and performance on the other. Theater, I argue, is the subtext that, by referring to its own means of production, underscores the fictional and performative nature of cinema. Therefore, the problematization of lesbian desire and subjectivity ensues, along with the interrogation of the heterosexual conception of lesbian representation that conflates woman-identification with desire.

According to Teresa de Lauretis, female identification with images of powerful, attractive, ego-ideal women on-screen "is not desire between women but indeed 'intra-feminine,' self-directed, narcissistic 'fascinations.'" In other words, these heterosexual and heterosexist representations seek for "woman-identification female bonding," and not for the sexualization of desire between

women, thus implying that the only "real sex" happens with men.[5] This trope of woman-identification is nourished by Adrienne Rich's "lesbian continuum," a term that seeks "to include a range—through each woman's life and throughout history—of woman-identified experience, not simply the fact that a woman has had or consciously desired genital sexual experience with another woman."[6] Rich's words represent the idea of a unifying struggle that unites all women under the same oppression, and that would defy the institution of heterosexuality and the control over the representation and identity of lesbians: "If we expand it to embrace many more forms of primary intensity between and among women, including the sharing of a rich inner life, the bonding against male tyranny, the giving and receiving of practical and political support . . . we begin to grasp the breadth of female history and psychology which have lain out of reach as a consequence of limited, mostly clinical, definitions of *lesbianism*."[7]

However, the ahistorization of lesbian experiences in Rich's manifesto has been read as the naturalization of the lesbian, making "lesbianism intelligible and seductive in normative heterosexual terms." That is, the idea of the lesbian continuum, despite becoming a source of empowerment and recognition among feminists, has been thought to desexualize lesbianism.[8] In line with this approach to lesbian identity, and despite its attempt to create new bonds with lesbian representations, the trope of woman-identification only gets to reinforce the artificial differences between hegemonic—male—and women's films, but also presupposes, as Katarzyna Paszkiewicz explains when referring to the gendering of genres, that "there is a direct correlation between images of women on-screen and the identification with these characters by women spectators."[9]

I will analyze the particularities that distinguish Balletbò-Coll's filmography to explain the ways in which her movies engage in dialogue with each other to represent lesbian desire. I argue that Balletbò-Coll creates discursive registers through her texts and films that allow her to shape new references, characters, and representations of female homoeroticism for the Spanish audience. Through these techniques, she produces the conditions of representability for a lesbian subject, thus problematizing the meaning of lesbian visibility as well as the cultural images and stereotypes that have normalized and naturalized lesbian sexuality, especially in the Spanish cultural context.[10]

I will focus particularly on her third film, *Sévigné (Júlia Berkowitz)*, in which intertextuality is nourished by the influence of the letters written by Mme de Sévigné to her daughter. Besides giving title to the film, the letters are the common thread that unfolds the relationship between Júlia and Marina: the memory of Júlia's dead daughter (Tanit) is triggered by the presence of Marina, the character played by Marta Balletbò-Coll, whose performance and apparent lousiness resemble the two main characters of her two previous films—Anna Giralt-Romaguera in *Costa Brava* and Rosa Bosch in *Honey,*

I've Sent the Men to the Moon. Moreover, by foregrounding the intertextuality between Mme de Sévigné and Júlia, Balletbò-Coll seeks to problematize the subject of the mother-daughter bond as a trope for lesbian desire. This trope, although it relegates lesbianism to presexual stages, reached a widespread consensus among feminists as the foundation of lesbianism, despite the fact that, in the conflation of woman-identification and desire, "the desire *for* another woman is subsumed to the desire to be (like) a woman."[11] Thus, in *Sévigné*, I argue, Balletbò-Coll creates an alternative representation of lesbian subjectivity and love, and, above all, constructs a different depiction of lesbian desire that intentionally seeks to find new languages and means to represent its incomprehensibility.

In Search of Marta Balletbò-Coll's Authorship: Notes on Intertextuality, Lesbian Representation, and Spanish Cinema

Hotel Kempinsky, a romantic novel written by Marta Balletbò-Coll and Ana Simón Cerezo and published originally in Catalan in 1996, portrays the love story of two women involved in the film industry who met in an airplane on their way to the Berlin International Film Festival. As the story progresses in two additional scenarios, Madrid and Barcelona, their love and relationship meet with a series of adventures and misadventures that not only confront the heterosexual stereotypes of lesbian eroticism but also offer a positive and different image of everyday life, sexuality, and intimacies of a love and sexual relationship between women. This novel does not aim at achieving literary recognition—both authors explained that it was written with the sole purpose of entertaining. What makes it interesting, however, is the fact that, in its description of *Donna K*, an underestimated film produced by Silvia Dauros, an independent Hungarian filmmaker, the narrator of *Hotel Kempinsky* represents what can be summarized as Balletbò-Coll's film project:

> The film starts and the first ten minutes cannot be worse. Blurred and with poor sound, *Donna K.* causes four North American buyers, two exhibitors, and Llauradó to leave the room . . . and all that during the first quarter of an hour of projection. However, it is quite normal that this happens in a film market.
> What is not normal is that the actresses save the film in this way: as soon as the two characters are well introduced and defined, the actresses have the audience in their pocket. Claudia and Raquel are no exception. The Hungarian director proves to have a high degree of sensibility and an exquisite sense of humor. But Silvia's tour de force is the way she takes the audience along the path of tenderness and humor, and progressively, without losing anyone, leads them to the viewing of an eroticism truly exciting but away from the typical sensual choreography of Hollywood.[12]

As it happens with Silvia Dauros throughout the novel, Marta Balletbò-Coll can also be described as a bold and tenacious independent director in the midst of the maelstrom of the film industry. She has struggled for distribution, funding, and resources, and is supported by independent and politically committed people in the media sector. Also, her movies, more than being a counterstance, offer a new perspective regarding the representation of lesbian eroticism.

As part of the so-called Joven Cine Español (Young Spanish Cinema), Balletbò-Coll also rejected labels such as feminist or women's cinema,[13] and was part of the generation of Spanish women filmmakers who sought to make commercial cinema from a gynocentric perspective.[14] This generation of women filmmakers tackled issues that "concern mainly female existence and the experience of being a woman" and deconstructed "the clichés and topics of female representation that have been naturalized by the male gaze. Thus, their cinema shapes representative models 'from within' . . . alternative models to dominant film discourses."[15] As part of the Joven Cine Español corpus, the movies that deal with lesbian representations are conceived of as a continuation of the trajectory begun by Pilar Miró with *El pájaro de la felicidad* (1993) [*The Bird of Happiness*]: "Homoerotism is presented as an extension of female solidarity and as an alternative to the conflicts present in heterosexual relations."[16] However, when confronted with Balletbò-Coll's authorship and that of other Spanish filmmakers,[17] the panorama of Spanish lesbian cinema during these decades is far from representing only an "extension of female solidarity." Indeed, I argue that, as Judith Mayne explains in reference to the films of Chantal Akerman, Ulrike Ottinger, and Midi Onodera, the very presence of Balletbò-Coll in her films, in addition to playing a part in the autoreferentiality, enhances "the articulation of lesbian authorship as a critical exploration of the very components of subjectivity—self/other relations, desire, and—where lesbianism provides the most crucial challenges to theories of the subject—the relationship between the paradigms of gender and agency, e.g., the presumed identity between activity and masculinity, passivity and femininity."[18]

Undoubtedly, Balletbò-Coll's films were considered a turning point for the representation of lesbianism in Catalan cinema in particular, and Spanish cinema in general. In her movies—as well as in her books—lesbians are depicted as professional, independent, and middle-class women. Lesbian desire is not a subtext or the appendage of a heterosexual relationship but is the axis around which the plot develops. Also, lesbian identity resists the normativity of a single conception. Her films also stand out for the recurring presence of funny and friendly characters—such as those performed by Desi del Castillo and Marta Balletbò-Coll—who embark on a passionate journey of love and happiness. These representations are inscribed to displace and interrogate the long tradition of invisibility of lesbian identities in Spanish cultural, popular, and

media representations. In this regard, Beatriz Gimeno affirms that the original reaction to this invisibility was to create an imaginary and fictitious lesbianism that sought to obviate "true" lesbianism as well as the differences, intimacies, and sexualities that threaten the heteronormative gaze.[19] Yet Balletbò-Coll's films undermine heterosexual conventions that conceive lesbian relationships as being seen either by the erotic and reifying male gaze, or by the weepy and displaced female eye. This distance from melodrama and tragic endings is also reinforced by Balletbò-Coll's detachment from mainstream stereotypes of lesbian identity in film and popular culture—such as the dehumanized evil/masculine or dead lesbian stereotype and the chic lesbian trope[20]—and by her understanding of lesbian desire through a lens that joins tenderness, humor, and eroticism.

Her opera prima, *Costa Brava*, is indeed a fine example of this innovative and changing gaze on lesbianism in Spanish cinema. This film is a lesbian romantic comedy, written and performed in English, set in the city of Barcelona and the Costa Brava. A low-budget production shot within the span of fourteen days, it was first released in Barcelona through independent means and networks in a short period of time. The film reached national and international circulation mainly in LGBTQ festivals, and received national and international awards.[21] *Costa Brava* stands out not only for being the first film directed by a woman filmmaker that explicitly addresses lesbian identity in Spanish cinema, but also for creating a lesbian subject that is portrayed in relation to the international context fostered by the development of Barcelona as a modern—although predominantly white—city. Therefore, it tackles the invisibility of lesbian identity in Spanish cinema by means of a matrix of cultural, social, and economic conditions produced within the context of the global world.[22]

In an interview conducted by María Camí-Vela in 2005, Balletbò-Coll explained that the main reason for making her movie in English was for commercial purposes, a decision that engages with those of the other women filmmakers of the Joven Cine Español. However, as Camí-Vela explained in a later text, there might also have been cultural reasons for not shooting in Spanish or Catalan: the film would not have had the same meaning, since one of the components that distinguishes *Costa Brava* is the fact that "the constitution of the lesbian family created by her leading characters . . . goes without the local ties and in favor of a mobile and global culture. It is perhaps, for this reason, that the space that better symbolizes love between them is not the local and iconic city of Barcelona, full of cultural and national references, but the universal nature: the sea of the Costa Brava, unlimited space, without horizons or borders."[23]

Not surprisingly, it is on a tour to the Costa Brava organized by Anna Giralt-Romaguera that Anna and Monserrat Ehrzman-Rosas get to know each other for the first time. As an openly lesbian Barcelona-based playwright and actress,

Anna works as a tour guide to make ends meet. This triggers the relationship between Anna and Montserrat, a bisexual, semicloseted lesbian of Jewish American origins who is teaching engineering at the university in Barcelona. Anna, despite her doubts about her own sexuality, moves in with Montserrat, and they begin a new life as a couple. When Montserrat is dismissed from her job and gets a research position in a U.S.-based company, Anna, who is still struggling because of the lack of public funding to stage her monologue, *Love Thy Neighbor*, finally receives the acceptance letter from San Francisco's Another Stage, "The Oldest US International Lesbian/Gay Theater Touring Company," and is able to move to San Francisco with Montserrat to start a new life together.

As will happen with Marina in *Sévigné*, Anna's personality in *Costa Brava* is marked not only by the mix of her clumsy and straightforward openly lesbian attitude, but also by her relation to the ins and outs of the world of theater, which lead us to a metatextuality shaped by the intention to perform nonnormative sexual desire and to construct a perspective on lesbianism that is bonded to performance.[24] Indeed, Anna's monologue has paramount importance in the film. On the one hand, Montserrat's attraction to Anna, as well as her thoughts regarding her sexuality, is mediated by her reading of Anna's monologue script. On the other hand, theater works as a critical subtext against the conventions of normative families vis-à-vis lesbian women: in *Love Thy Neighbor*—which Anna rehearses and videotapes on the rooftop of an apartment building with Gaudi's Sagrada Familia in the background—the main character of the monologue, a housewife, apparently a straight woman, wife, and mother of two children, despite her gossipy and suspicious comments about her lesbian neighbor, ends up having sex and falling in love with her.

As Monserrat's attraction to Anna grows, she interrogates herself regarding her sexuality. As Montserrat explains, she has been in two previous relationships, one with a woman and the other with a man, and she finds the need to understand whether she is a lesbian or not. However, as Montserrat finds herself compelled to speak the "truth of sex,"[25] Anna's approach to her own sexual identity resists the normativity with which power controls the subject and positions lesbianism not as a fixed and ontological attribute but as a flexible and performative construction resistant to normalization.[26] This fact aids in problematizing the naturalization of images and stereotypes about lesbians portrayed by the media and, at the same time, emphasizes the discursive nature of images and cultural representations. In addition, this denaturalization of the cinema apparatus, explains Barbara Zecchi, is stressed in this film by the anthropomorphization of framing and music that provides the camera with a "ludic subjectivity," which is expressed through its voyeuristic performance when spying Anna and Montserrat from a distance on their first kiss, as well as through the extradiegetic uses of music, which is subjectively interrupted to highlight changes in the characters' moods.[27]

In *Costa Brava*, lesbian subjectivity is portrayed through the intimacies of looks, everyday life, and complicities. There are no explicit sexual relations; the film instead offers a complex and uncoded eroticism, hidden from the heterosexual gaze. However, despite this innovative approach, *Costa Brava* has also been criticized for leaning toward the naturalization of lesbian sexuality, particularly through its depiction of the lesbian family formed by Anna and Montserrat. Indeed, this film represents different stages in the relationship between Anna and Montserrat that transform their attraction and erotic encounters into their everyday life as a lesbian family. It is a relationship that begins in the outdoors—the Costa Brava coast and the university, for instance—and moves to the interior of the household, where we are invited to share the intimacies of their everyday life: the decoration of their home, the nuisances of laundry, the joys of birthday celebrations, and the sharing of a common life project that transcends national borders. Although this representation of the lesbian family subverts the stereotypes about lesbian relationships, Yeon-Soo Kim explains that in *Costa Brava* "emotional ties" are portrayed "as a necessary familial condition," and the lesbian family acceptance "does not grow in opposition to heterosexuality but rather as the only possible healthy social unit on-screen in which two individuals care for each other, share the pain of separation and reconfirm their mutual love through that experience." As portrayed here, lesbianism ends up being normalized.[28] Moreover, in this film, lesbian desire seems to be detached from lesbian sexuality, meaning that lesbian identity "is viewed as part of a whole alliance of women in general," as well as an expression of Rich's "lesbian continuum" and its emphasis on "female bonding." This is why Kim argues that "the film's primary focus on normalizing lesbianism is not presented in a combative mode but rather through an emotional communication among women that leads to a tender physical union."[29]

This idea of women's empowerment and alliance, more than the representation of lesbian desire or lesbian love, gives shape to Balletbò-Coll's second film, *Honey, I've Sent the Men to the Moon*. Also shot in English, the film was produced, directed, and written by Balletbò-Coll in collaboration with Ana Simón Cerezo. *Honey* is a science fiction comedy that mocks the standard parameters of that genre to imagine a future without men thanks to the uses of science and technology. After a decrease in the consumption of sanitary napkins, Rosa Bosch, performed by Balletbò-Coll, takes the position of general manager of Wondernapking and, along with her two best friends, assumes the responsibility of saving the company. In developing her strategy for achieving this, she recalls a newspaper report in which it was explained that men were the cause of women's stress and discrimination, and, consequently, the cause of the loss of women's menstruation and the decline in the consumption of sanitary napkins. Thus, by a divine act, she finds the "McGuffin Effect" report written by Nettie Zuloaga (Desi del Castillo), a scientist working at the

sanitary napkin company, who explains that when male hormones were contaminated with "gamma alpha plus radiation," men underwent a "gamma transposition," which means that they would disappear quickly. The story goes on, and Rosa, along with her friends, makes men disappear from the Earth by adding the gamma alpha plus radiation emitter to a mix of toothpaste. And so, men are sent to the moon and stay there for three months, which is precisely the time that Rosa Bosch needs to attain the profits that would save the company.

In this film, Balletbò-Coll deals with female empowerment and sorority, and rewrites the role of women in science fiction: women in *Honey* aren't machines, experiments, or aliens to be defeated. Instead, they are "real" women in charge of their own survival and success, appearing not as superstylized heroes but as scientists, executives, detectives, politicians, women's rights activists, and even mafia cartel leaders.

Although lesbianism is not the main topic of this film, lesbian desire is explored through the insinuations, hints, and progressive closeness between Nettie and one of the feminist protesters. This stereotypification of sexuality and women's relationships, in addition to laughing at the stereotypes linked to feminists and to the vindication of women's rights, opens up a space for another way—anchored in 1980s feminist thought, although splashed with winks to the lesbian punk subculture—to understand the importance of women's alliance. Thus, despite its lack of awareness regarding women's differences and its depiction of womanhood as white, middle-class, and Caucasian, the film ingeniously places the values of a community of women as a source of empowerment at the forefront.

Sévigné (Júlia Berkowitz): Rewriting Love and Lesbian Desire in Spanish Cinema

> JÚLIA.—A veure, tu deixes que cadascú interpreti el que va passar entre
> mare i filla. Però tu realment què creus que va haver-hi?
> MARINA.—Amor.[30]
>
> *Sévigné (Júlia Berkowitz)*

Sévigné (Júlia Berkowitz), Balletbò-Coll's third full-length film,[31] is a romance drama in which desire and female homoeroticism are displayed in a network of intertextual references that not only emphasize the discursive nature of sexual identities but also problematize the scope of visibility and representation of lesbian subjectivity beyond the limits of the male gaze. Shot mainly in Catalan, but also in Spanish and English, *Sévigné* breaks away from the comedy genre of Balletbò-Coll's previous film. By means of its intertextual and autoreferential strategies—which are epitomized by the dedication of the film to the

memory of Pilar Miró—*Sévigné* seeks to defy fixity in the images' connotation by producing a more complex and less rigid meaning of lesbian representations and desire. Thus, it constructs a spectatorship that "is able to reinvent itself more than just to confirm its social identities or usual positioning" in front of the characters and images on the screen.[32]

This film narrates the love story of Júlia Berkowitz (Anna Azcona) and Marina Ferrer-Amat (Marta Balletbò-Coll). The first is a former actress who stopped performing after the sudden death of her daughter, Tanit, and who returned to theater to become the most prestigious director of the Catalan theatrical scene. As for Marina, she is a playwright aspiring to stage her play while working as an Audio Video Interleave editor for a TV cooking show.

Sévigné begins with an extradiegetic introduction by Gerardo (Josep Maria Pou), the "son of a bitch" theater critic and, according to him, the person who is responsible for the staging of *El manual del noble art de la seducció per la molt illustrada Madame de Sévigné* (The manual of the noble art of seduction by the very enlightened Madame de Sévigné) and, implicitly, for the relationship between Marina and Júlia.

However, this apparent omniscience and control over the narrative is problematized by means of the power offered to the spectator when Gerardo is in front of the Public Theater, where the play is about to begin. He directly addresses the audience by saying:

> This is the most important public theater in Barcelona. And, by the way, very good plays are staged here in Catalonia, eh? Really, great. And I am the son of a bitch critic, you know. In just over an hour and a half will premiere a show here in this theater. The truth is that I did not intend to stay here, I thought to stay at home or at the newspaper office for reasons that now do not come to mind, but I could not concentrate. I was restless, so I decided to come here. You know, I have had something to do with tonight's premiere. Perhaps you would like to know how this story about a mother, Mme de Sévigné, and her daughter, Mme de Grignan has come this far . . . No, no, but only if you are interested, if you are curious. As for me, well, it would really do me good to talk about it.

Gerardo's direct address to the spectator seeks the interplay between audience and performers, such as that fostered by theater. It subtly interrupts the illusion of narrative cinema as a spectacle to be looked at, as well as the narcissistic identification with female characters on-screen who typify some tendencies of lesbian cinema. Thus, in its distance from the voyeuristic and narcissistic gaze, the film demands a more conscious and critical view of the theatricality behind the spectacle—both on-screen and onstage—that is about to start. But, more important, it allows for the creation of a lesbian subject position that is not fixed but open to new experiences and loci of enunciation. Also, the

critic's direct address to the audience works as a cathartic experience that, instead of giving him the epistemic power over the story, exposes him to the judgment of the spectator; put simply, we become the critics, and he becomes the subject to be criticized.

The story Gerardo tells—which ends up being the plot of the film—is mediated from the very beginning by its mechanism of production, that is, by "the visual" as a technology: "We are going to approach only for a moment to this other world of the visual, of the image. The filmmaker is Marina Ferrer-Amat, the author of this play on Mme de Sévigné." This "world of the visual" is presented as the world of Marina in a blend of moving and still images along with those of the TV program that continue along with Marina's voice-over: "Working on TV is selling the soul. No, for me the important thing is to make *Sévigné*, but nobody produces it, and it's not that I haven't tried."

Although Marina is presented through images and as someone who is producing images, her voice is separated from her body in an autobiographical manner that attempts to summarize her past and present in a few seconds: it is as if her consciousness is speaking to the images of a lost and wandering Marina, whose life is immobilized in front of the movements and progress of the subway. Yet, at the same time, this voice-over speaks of her as an author who is seeking to resignify the meaning of the image—and her representation as an image—in order to position herself as an author not only of *Sévigné* but also of the film. It is by means of the voice-over that Marina reflects about her life, her love for Júlia, and her discontentment with her job, and articulates the experiences that shape her subjectivity. At the same time, Marina's character and unstoppable pursuit of the production of her play resemble those of Anna in *Costa Brava*. It could be said that they represent the zenith of a project that finds its primary expression in the articulation of desire and female homoerotism as an inseparable part of the theater and motion picture worlds.

Despite her pessimistic position after having her play rejected seven times at the Public Theater, Marina sends it to Ignasi Besauri (Eduard Farelo), the theater programmer, who hands the script to Júlia. It is at that point that the voice of Gerardo appears once more to introduce us to Júlia—who is also in a relationship with Gerardo and in the middle of an affair with Ignasi—through still images as a visual character in a film. We later see her at her daughter's grave, with Barcelona's landscape in the background, and then reading Marina's script at home while looking obliquely at the picture of her daughter.

Marina and Júlia have their first in-person encounter right after the mechanisms of visual representation are shown and are consciously incorporated into the dialogic referentiality to the world of theater. That is, the image on-screen is projected as an artifice and as a product, thus making a mechanism of autoreferentiality that, by denaturalizing women and lesbian representation on-screen,

would allow the spectators to have an unconventional approach to Marina and Júlia's lesbian relationship.

In a subsequent scene, Júlia and Gerardo are having dinner at the same restaurant where Marina is having dinner with her friends from the TV show. Marina holds a camera and is recording her friends, and Júlia is visible in the background. At the same time, Júlia stares at Marina's table silently; when Gerardo asks her about it, she tells him that she was looking at a woman who reminded her of Tanit. In this scene, both women look at each other, which not only problematizes the idea of the look as a male possession but also creates an erotism of the look that is produced to convey a woman's desire for another woman. The female gaze as a central event lines up in dialogue with de Lauretis, who has asserted, "The construction and appropriation of femininity in Western erotic ethos has also had the effect of securing the heterosexual social contract by which all sexualities, all bodies, and all 'others' are bonded to an ideal/ideological hierarchy of males."[33]

Their looks, however, are different in that they position the spectator at two different starting points regarding the representation of lesbian desire. On the one hand, Marina refuses to conflate lesbian desire with the identification of woman as the origin of lesbian sexuality; on the other, Júlia turns to the mother-daughter bond as a continuity of female friendship and intimacy. In this manner, Marina's camera—in an autoreferential gesture to Balletbò-Coll's camera and authorship—turns Júlia into an image, yet not an image to be consumed narcissistically, but rather a diffused image that is marginal to the foreground, slippery, and resistant to the normativity of the male gaze. As for Júlia, when she stares at Marina, she turns her into the object of her desire, a desire that brings her back to her daughter and to memories of possession and loss related to the daughter's death. It is this drive toward another woman that triggers their desire and becomes the impulse behind their actions: their awareness and need for alterity shape their subjectivity and structure their sexuality.

Right after this moment and the exchange of looks, Marina approaches the couple's table to express her admiration to Gerardo as a critic, and to Júlia as an actress and director. When she addresses Júlia, she does so with sexual hints that openly express her sexuality, bringing up the topic of sex. She announces that "it is the problem of the intellectual that by definition he is a disaster in bed" in order to position herself as an intellectual and bring out her power of seduction through that characteristic instead of her sexual performance. Yet Marina speaks to Júlia mostly with admiration, expressing her knowledge about Júlia's theatrical work and trajectory. Days later, when Júlia must meet the author of the play to let her know she was not going to produce it, she finds out that the woman in the restaurant was the author of the play. After she starts speaking with Marina, Júlia becomes hesitant and asks Marina to be part of

the theater workshop on a new piece she is producing. At the workshop, Júlia sits at the back to watch Marina's lecture while looking at her in a relaxed, pleasant way. It is during this workshop that Júlia decides to produce the play and even commits to work hand in hand with Marina to adapt it to create a more appealing and effective script—despite Gerardo's opposition and the hesitations of Pol (Manel Bartomeus), the Public Theater director.

Júlia's interest in Marina increases as they begin to work together, first during a couple of trips to Júlia's place at the Montseny, and then in a final expedition to Grignan in Provence, France, where Mme de Sévigné and her daughter lived. Throughout these journeys, the two women also begin to explore their own lives and reconsider the meaning of their past and present relationships, as well as reconfigure their subjectivity through the sexual tensions of their desire for each other. Thus, unlike in Balletbò-Coll's previous films, in *Sévigné* sexuality is not simply placed at the core of the main characters' subjectivity, thus suggesting that "sexuality is the place from which the subject (re) elaborates the image of the self and of the erotic body in the encounter with the male or female other, and (re)elaborates its own corporeal knowledge, its own understanding, its ways of relating and acting in the world."[34] Sexuality is also portrayed as the "common-place" of lesbian existence: "It is the place in which an erotic 'crossing of the body' of the other [woman] and of one's own takes place, with a consequent, and often surprising, 'change in perception with regard to heterosexual schemata.'"[35]

In *Sévigné*, this crossing of the body of the other woman is represented not by means of sexual encounters or by way of the objectification of the female body, but through haptic qualities that are closely bound up with the material dimension of the subject. Thus, the woman's body is not limited to Júlia's body in her conscious sensuality, but also is highlighted by a camera that sees through the confidence of a body that is convinced of her power to attract the male and female gaze. In *Sévigné*, the emphasis on tactile sensitivity allows for the representation of lesbian desire through the embraces between Júlia and Marina. This seeks to translate the emotions between Mme de Sévigné and Mme de Grignan to the audience. Moreover, lesbian desire is expressed through stressing the touching and interweaving hands, as when Júlia touches the palm and the back of Marina's hand with her fingertips. Julia tickles Marina's hand—such a gesture also tickles the audience's imagination.

As the story progresses, Marina becomes not only the alterity that triggers Júlia's sexual desire and makes her face her fears and weakness, but also Júlia's confessor and the figure who allows her to heal the wounds from the loss of her daughter and find the meaning of such grief in the absence of her mother, also named Tanit. As for Marina, the script brings with it six years of writing that she shared with Joanne (Leslie Charles), her ex-girlfriend, whom Marina re-encounters at the same restaurant where she first saw Júlia. It is the script of

her play that confronts Marina regarding her solitude and discomfort with her job, but it is also the object that keeps her tied down to a past love. Rewriting it also means she revisits memories of Joanna as well as the possibility of a new beginning with Júlia. These tensions are articulated in a scene at Marina's apartment, where Júlia tries to persuade her to continue with the editing and production of the play after Marina decides to take it back, in part convinced by her ex-girlfriend's indignation at the several amendments made to the script. In the midst of their argument, Júlia appropriates Mme de Sévigné's words, thus not only embodying her character but also translating to herself Mme de Sévigné's despair and thoughts about death. At this juncture, when Júlia and Mme de Sévigné mirror each other, Marina realizes that she is in love with Júlia:

> JÚLIA.—It is this feeling of not being able to do what you want, what you need. In life, everything is okay, or so it seems, but do you know that I can't remember the last time I had a dream, nor what it was about? There is something that Madame de Sévigné told her daughter that summarizes it all: "Embarked upon life without my consent."
>
> MARINA (IN VOICE-OVER).—And now I'm saying yes to changes I rejected hours ago, and using her "embarked" as the main theme of the play. I have fallen madly in love with Berkowitz.

As the film's title suggests, intertextual relations are set up with Mme de Sévigné and her intimate and dependent relationship with her daughter, Mme de Grignan. The importance of the reference to Mme de Sévigné's ambiguous relationship with her daughter becomes evident in the connection to Júlia's personal story and the way the script interrogates her about her own feelings, her grief, and the meaning of her relationship with her daughter, as well as with her mother, Tanit, which is the bond Júlia longs for and has projected onto the loss of her daughter. This is made explicit when, on their trip to Grignan, Júlia and Marina stop to visit Júlia's mother to hand her a photo album. It is there that Júlia tells her mother she is going to break up with Gerardo. It is also there that Marina, with the "Salve Regina" as the soundtrack to her speech, articulates the origin of Júlia's longing:

> MARINA.—Yes, Tanit was like a mother for you, and that is what you are missing for seven years, that mother's love, not your daughter . . .
>
> MARINA.—So, this process of covering up the pain of not having had a mother and when you stop covering it, then you will be able to sleep, cry, and begin to live.

At this point of unveiling, however, Júlia distances herself from the mother-daughter bond that has kept her a prisoner of her desire, and the film allows us

to question the lasting trope that has found the origins of lesbian desire in the "identification with the mother," as de Lauretis explains:

> As the two terms *desire* and *identification with the mother* slide into each other, the masculine (lesbian) connotation of *desire* is assimilated to the feminine (narcissistic) connotation of *identification*; and both the lesbian and the narcissistic connotations, which are socially disparaged or disapproved, become muted under the strong positive connotations of a *maternal* feminine identification. Whether that maternal identification is Oedipal or pre-Oedipal, reconstructed or primary, does not alter the operation of the metaphor a great deal. Thus to make desire for, as well as identification with, the mother a *sine qua non* condition of feminism continues to blur the already fraught distinction between heterosexual feminism and lesbian feminism, to say nothing of the far more consequential differences between lesbian sexuality or subjectivity and heterosexual female sexuality or subjectivity.[36]

In this manner, not only does Júlia mirror her life in Mme de Sévigné's, but also this self-reflexivity aims at problematizing the definition of lesbian love, homoeroticism, and desire. It is not surprising, therefore, that as Marina and Júlia's desire increases, so does Júlia's need for understanding Mme de Sévigné's love for her daughter. In addition, Marina's refusal to label Mme de Sévigné's love is also related to her rejection of labeling her love for Júlia. Her arguments are also addressed to Júlia, who, in searching for the meaning of her love for her daughter, is also looking to identify her attraction to Marina and to find ways to cope with her pain. It is then that Júlia is finally able to speak out her truth to Marina: "I do not care what Mme de Sévigné felt about her daughter. What I want to know is what I felt for mine."

Once Júlia is finally able to dream, her sexuality is depicted in images of her passionately kissing Ignasi or of her in Marina's apartment trying to kiss her and get physically closer to her—images that intend to confront her with her grief and her feelings about her daughter, particularly when, at the end of the dream, we hear Marina's voice-over saying: "You are sleeping in the car and I am not your daughter. Wake up!" Along with Marina's interpellation to distinguish Júlia's sexual desire from her mother-daughter bond, Júlia's crying at the room in Grignan means the end of her mourning for her daughter. In this manner, through her tears and their long embrace, the love between Júlia and Marina distances itself from the bond of motherhood to finally open another way for understanding lesbian subjectivity, detaching itself from the idea of Adrianne Rich's lesbian continuum and the mother-daughter bond.

However, I would like to stress that, although there is not an explicit sexual encounter between Marina and Júlia, in this movie lesbianism needs to be understood as a "sexual practice, as well as a particular structuration of desire,"

which, according to de Lauretis, means that "whatever other affective or social ties may be involved in a lesbian relationship . . . the term *lesbian* refers to a sexual relation, for better or for worse, and however broadly one may wish to define *sexual*. I use this term in its psychoanalytic acceptation to include centrally . . . the conscious presence of desire in one woman for another. It is that desire, rather than woman-identification or even the sexual act itself . . . that specifies lesbian sexuality."[37]

This approach to lesbianism as "the conscious presence of desire in one woman for another," which refers to "sexual relation . . . beyond any performed or fantasized physical sexual act," shapes the relationship between Júlia and Marina in *Sévigné* and defies the conception that has portrayed the lesbian in a single manner.[38] Yet, what makes this movie exceptional is not only that sexual desire for another woman is positioned at the core of lesbian identity but also the fact that love is represented in a subversive way, not because it is associated with homoerotic desire, but because its success and its continuity are detached from their romantic and monogamous heteronormative version. Indeed, right before the film reaches its end, and after their long kiss and embrace, when Júlia has accepted to perform Mme de Sévigné in Marina's play, we see Júlia backstage, getting ready to perform, and we hear Marina's voice-over: "Everything in my life works now perfectly. My only problem is that I do not know what I have done so that, suddenly, everything works. Things have been fixed by themselves or by a *diva ex machina*. . . . And I have matured so much that I do not care how long it may last with Júlia. At a certain age, when you start a relationship and it is not an open one, this means that nothing has been learned from life. . . . But I have yet to mature more; otherwise, why do I blame myself so much for her comeback? I love you, Berkowitz."

Corresponding to the circularity of love-hate-love in the relationship between Mme de Sévigné and Mme de Grignan, this movie ends by returning to the place where it started: the Public Theater. There, while having doubts about entering to watch the play, Gerardo encounters Núria Frutchman d'Abadal (Carme Elias), an art critic with whom he was having an affair and who unexpectedly gives him airplane tickets to go with her to New York. After she leaves, he addresses the audience of the film one last time and reveals his theory about love: "I have a theory about love. If what is intended is a stable relationship, it is never advisable for it to be with anybody whom one loves madly. One cannot demand to be loved with the same intensity. It is absurd, it is naive. It is better to be with someone with solid and irreconcilable differences. Núria Frutchman d'Abadal, for example. . . . Thank you very much for listening to me. I needed it."

By these means, the film achieves a circular effect and detaches the spectator from the illusion of reality of the film to restore its critical place vis-à-vis the representation of female homoeroticism and lesbian desire. Thus, it is

theater, the bond that leads Júlia and Marina to meet each other; more important, it is the rewriting of the play that frames their sexual desire and allows their relationship to unfold. In other words, their subjectivity is problematized through their desire for the other woman, which, along with the rewriting of the play, defines the process that allows them to explore not only their relation to their past and present but also their sexual desire.

Notes

1 Born in the city of L'Hospitalet de Llobregat (1960), in the province of Barcelona, Catalunya, filmmaker Marta Balletbò-Coll studied chemistry sciences at the Universitat de Barcelona. She later went to the United States to pursue an MFA in film screenwriting/directing at Columbia University. Before releasing her feature films, she also worked as a journalist. She was the screenwriter of TV comedy series *Amor, salut i . . . feina!* (1986) and *Una parella al vostre gust* (1995), but she is mostly known for being the writer and director of two short films, *Harlequin Exterminador* (1991) and *Intrepidíssima* (1992; winner of the "Audience Award" for Best Short at the San Francisco International Lesbian and Gay Film Festival in 1993), the TV documentary *Caminos de Sefarad* (1995), the latter produced by CostaBrava, an independent film production company founded by Marta Balletbò-Coll along with Ana Simón Cerezo, who was also the producer of her three full-length films: *Costa Brava*, released in 1995, followed in 1998 by *Honey, I've Sent the Men to the Moon* and, her third and last film to date, *Sévigné (Júlia Berkowitz)*, released in 2004. She is currently a high school physics and chemistry teacher. For more information, see Magí Crusells, *Directores de cine en Cataluña: De la A la Z* (Barcelona: Universitat de Barcelona, 2008); and the following links: http://ciencies007.wixsite.com/martaballetbofilms; http://catalanfilms.cat/es/empresas/costabrava-films; and www.imdb.com/name/nm0050815/?ref_=nmawd_awd_nm.

2 There is also a Spanish translation of *Hotel Kempinsky* made by Montserrat Triviño and published in 2002 by Egales, the most prestigious Spanish LGBTQ press. Marta Balletbò-Coll and Ana Simón Cerezo, *Hotel Kempinsky*, trans. Montserrat Triviño (Barcelona: Egales, 2002).

3 Julia Kristeva, "Word, Dialogue and Novel," in *The Kristeva Reader*, ed. Toril Moi (New York: Columbia University Press, 1986), 36–37 (emphasis in the original).

4 Liz Millward, Janice G. Dodd, and Irene Fubara-Manuel, *Killing Off the Lesbians: A Symbolic Annihilation on Film and Television* (Jefferson, NC: McFarland, 2017), 17.

5 Teresa de Lauretis, *The Practice of Love: Lesbian Sexuality and Perverse Desire* (Bloomington: Indiana University Press, 1994), 120.

6 Adrienne Rich, "Compulsory Heterosexuality and Lesbian Existence," in *Blood, Bread, and Poetry: Selected Prose, 1979–1985* (New York: Norton, 1994), 51.

7 Rich, 51–52 (emphasis in the original).

8 Kathleen Martindale, *Un/Popular Culture: Lesbian Writing after the Sex Wars* (Albany: State University of New York Press, 1997), 4.

9 Katarzyna Paszkiewicz, *Rehacer los géneros: Mujeres cineastas dentro y fuera de Hollywood* (Barcelona: Icaria, 2017), 44. All translations are mine, unless otherwise indicated.

10 See Meri Torras i Francès, "Pensar la in/visibilitat: Papers de treball," *Lectora: Revista de Dones i Textualitat* 17 (2011): 139–152.

11 Judith Mayne, "A Parallax View of Lesbian Authorship," in *Inside/Out: Lesbian Theories, Gay Theories*, ed. Diana Fuss (New York: Routledge, 1991), 181.

12 Balletbò-Coll and Cerezo, *Hotel Kempinsky*, 56.

13 See María Camí-Vela, *Mujeres detrás de la cámara: Entrevistas con cineastas españolas, 1990–2004* (Madrid: Ocho y Medio, 2005).

14 See Barbara Zecchi, *Desenfocadas: Cineastas españolas y discursos de género* (Barcelona: Icaria, 2014), 125.

15 Zecchi, 125.

16 Zecchi, 130.

17 According to Chris Perriam, Marta Balletbò-Coll is one of the forerunners and a long-established name of what he defines as a "New Lesbian Spanish Cinema," which achieved vitality and visibility through the work of filmmakers such as Laura Cancho, Chus Gutiérrez, Mariel Maciá, Rut Suso and María Pavón, Inés París and Daniela Fejerman, and Blanca Salazar, who were in charge of moving lesbian film in Spain "so far on from what it had been in Spain until the 1990s." Chris Perriam, *Spanish Queer Cinema* (Edinburgh: Edinburgh University Press, 2013), 6.

18 Mayne, "A Parallax View of Lesbian Authorship," 177.

19 See Beatriz Gimeno, *Historia y análisis político del lesbianismo: La liberación de una generación* (Barcelona: Gedisa, 2005), 294–295. Furthermore, as Alberto Mira explains, during the eighties, "lesbian invisibility was one of the clichés of gay studies. Lesbian invisibility was understood as the lack of a tradition of representation of the lesbian *qua* lesbian. Although it was easy to find homoerotic trends fixed in practices such as the 'Boston marriages,' 'the lesbian' in history was always a matter of interpretation, as in *Carmilla*, even a matter of forced reading, of a will to exist. This invisibility in history (invisibility that, it is worth mentioning, only depends on the terms in which we speak of desire) is translated into an invisibility in literature and later in the creations of popular art, including cinema and television. This does not mean that there are not homoerotic trends in the relationships between women in the texts, on the contrary, it is just that heterosexism resists labeling them as lesbian except in very specific conditions and especially when such labels diminish the power of the women involved and tinge the representation with negativity." Alberto Mira, "¿Gay, queer, gender . . . ? Paradigmas críticos. El ejemplo de representación lésbica en las nuevas series," in *Nuevas subjetividades/Sexualidades literarias*, ed. María Teresa Vera-Rojas (Barcelona: Egales, 2012), 44.

20 Millward, Dodd, and Fubara-Manuel, *Killing Off the Lesbians*, 6–7.

21 *Costa Brava* was released in 1995 and was the winner of the Los Angeles Gay and Lesbian Film Festival Award for Best Picture. It was also awarded the "Audience Award" for Best Feature at the San Francisco International Lesbian and Gay Film Festival in 1995, the "Special Award" by the Sant Jordi Awards, and the less credited Yoga Awards in 1996 for "Worst Spanish Director."

22 See Elena Oroz, *"I'm not, but . . . I am, but . . .* Identitats lèsbiques en trànsit als films de Marta Balletbò-Coll," in *Identitats en conflicte en el cinema català*, ed. Ana Rodríguez Granell (Barcelona: Universitat Oberta de Catalunya, 2017), 63–79. It is worth mentioning that, as Chris Perriam points out, this decade was particularly important for LGBTQ rights in Spain, as well as for the cultural

advancement of LGBTQ cinema: "The 1990s were years of rising recognition for lesbian and gay, and New Queer, cinema worldwide, and Spain by the end of the decade had joined in; furthermore, 1998 was the year in which the Catalan government passed the first of a series of regional government laws in Spain on civil union, marking a substantial increase in the intensity and visibility of discourses—verbal and visual or performed—around LGBTQ identities." Perriam, *Spanish Queer Cinema*, 1.

23 María Camí-Vela, "Cineastas españolas que filmaron en inglés: ¿Estrategia comercial o expresión multicultural?," in *Estudios culturales y de los medios de comunicación*, ed. María Pilar Rodríguez Pérez (Bilbao: Universidad de Deusto, 2009), 57.

24 Susan Martin-Márquez has also found an intertextual dialogue between *Costa Brava* and Pedro Almodóvar's *La ley del deseo* (1987) [*Law of Desire*], particularly with respect to their humorous position on the representation of sex, the relationship with characters unsure of their sexual identity, the influence of technology in the development of both Anna and Montserrat's and Pablo and Antonio's relationships, and the image of a normalized homosexuality in democratic Spain, among other subjects. See Susan Martin-Márquez, *Feminist Discourse and Spanish Cinema: Sight Unseen* (Oxford: Oxford University Press, 1999).

25 See Michel Foucault, *The History of Sexuality. Volume 1: An Introduction*, trans. Robert Hurley (New York: Vintage Books, 1990).

26 In this respect, I follow Judith Butler in her refusal to define what lesbian identity means, to rather explore the means by which these identity categories can subvert the very regulatory regimes that try to define them: "If it is already true that 'lesbians' and 'gay men' have been traditionally designated as impossible identities, errors of classification, unnatural disasters within juridico-medical discourses, or, what perhaps amounts to the same, the very paradigm of what calls to be classified, regulated, and controlled, then perhaps these sites of disruption, error, confusion, and trouble can be the very rallying points for a certain resistance to classification and to identity as such." Judith Butler, "Imitation and Gender Insubordination," in *Inside/Out: Lesbian Theories, Gay Theories*, ed. Diana Fuss (New York: Routledge, 1991), 16.

27 See Zecchi, *Desenfocadas*, 180.

28 See Yeon-Soo Kim, "A Lesbian Family Album: Family Album as a Portable Home and 'Homelessness' in Marta Balletbò-Coll's *Costa Brava (Family Album)*," in *The Family Album: Histories, Subjectivities and Immigration in Contemporary Spanish Culture* (Lewisburg, PA: Bucknell University Press, 2005), 136.

29 Kim, 145.

30 JÚLIA.—Let's see, you let everyone construe what happened between mother and daughter, but what do you think really happened? MARINA.—Love.

31 Also a renowned film, *Sévigné* received awards for Best Catalan Film, Best Catalan Film Actor (Josep Maria Pou), and Best Catalan Film Actress (Anna Azcona) from Premis Butaca de Teatre i Cinema de Catalunya in 2005. It also received the "Audience Award" for Best Film at the Paris International Lesbian and Feminist Film Festival in 2006. In addition, Josep Maria Pou won Best Actor category in the Barcelona Film Awards of 2005 for his performance in *Sévigné*.

32 Paszkiewicz, *Rehacer los géneros*, 44.

33 Teresa de Lauretis, "Sexual Indifference and Lesbian Representation," in *Figures of Resistance: Essays in Feminist Theory*, ed. Patricia White (Champaign: University of Illinois Press, 2007), 52.

34 Teresa de Lauretis, "The Intractability of Desire," in *Figures of Resistance: Essays in Feminist Theory*, ed. Patricia White (Champaign: University of Illinois Press, 2007), 233.

35 Liana Borghi, "Apertura del Convegno," in *Da desiderio a Desiderio. Donne, sessualità, progettualità lesbica*, proceedings of the Fifth National Lesbian Conference, Impruneta, December 5–7, 1987 (Florence: L'Amandorla 1987), 9; quoted in de Lauretis, "The Intractability of Desire," 233.

36 de Lauretis, *The Practice of Love*, 190 (emphasis in the original).

37 de Lauretis, 284 (emphasis in the original).

38 Noemí Acedo Alonso, "Re/presentacions del desig lèsbic a *Sévigné (Júlia Berkowitz)*, de Marta Balletbò-Coll," in *Accions i reinvencions cultures lèsbiques a la Catalunya del tombant de segle XX–XXI*, ed. Meri Torras i Francès (Barcelona: Universitat Oberta de Catalunya, 2011), 171.

12

"Com si fóssim la pesta"

• •

Francoism and the Politics of
Immunity in Agustí Villaronga's
Pa negre (2010)

WILLIAM VIESTENZ

In the aftermath of the Nationalist triumph in the Spanish Civil War, the Francoist propaganda often represented governmental opposition and nonconformist identities through the lens of biopolitical degeneration, with the liberalization of the state during the Second Republic particularly symbolized as a type of cancerous growth. As Michael Richards writes, cities such as Bilbao and Barcelona, both homes to cultures inconsistent with Francoism's Castilianization of the state, were represented as primary entry points for disease vectors: "Degeneration and social chaos, explained ethnologically, was due to an influx of strains inimical to Spain through the industrial cities of the coast: of this taint in her bloodstream Spain must cleanse herself."[1] Francoism, in its construction of an ideal imagined community aligned with the tenets of *nacionalcatolicismo*, deemed Marxists, homosexuals, regional nationalists, Jews, and others as "tumors," "plagues," and "infections" to be extirpated from the state's regenerated, reunified body.

At the same time that the regime pathologized its opposition, Francoist ideology envisioned the structure of the state in organicist terms, which implied

conceptualizing the Spanish nation as a totalized whole with interlocking, mutually dependent parts.[2] In this fashion, the Spanish body politic mirrored the biological functioning of the human body, each entity a closed, organic system equal only to itself and vulnerable to degeneration. The rearticulation of Spain as a unitary whole was one of the first ideas emphasized in a public *bando* issued in 1939 shortly after Nationalist forces began their occupation of Barcelona: "The triumph of Caudillo Franco's arms" allows that Catalans "reintegrate fully, definitively, and irrevocably to the greatness and unity of the Patria."[3] Francoism's political organicism took its cue from the approach's popularity in developmental biology over the first half of the twentieth century. Organicism, whether applied to a biological organism or a political body, emphasizes that an entity can be understood only through a focus on its wholeness, teleological directedness toward fulfilling a certain mission or end goal (hence the aforementioned irrevocability of Catalonia's reassimilation into the patria), and the top-down regulation of the system's individual parts.[4] In the wake of its bloody civil war, Spain was organized both spatially and temporally under the idea of verticalism, which came together through the workings of "history, divine providence, self-sufficiency and the need to rebuild the state."[5] Francoism thus viewed the cleansing of the state's impurities and threatening pathogens as a necessary step in reconsecrating national territory, which came to be populated with sacred sites and symbols that reminded of both the Nationalist victory and the re-engagement of Spain's providential mission to serve as the most formidable remaining bastion of the Catholic faith in the Western world.

Taken together, the ideologies of national degeneration and political organicism embody a pathological idea of political power concerned primarily with the work of exclusion and territorial closure. The nation, having lost sight of its essential character and telos through the incursion of liberalism and other corruptive elements, succumbs to diseases, and only a formidable, top-down hierarchy of power can extirpate this illness from the body politic. The state's body, formerly opened up to, and colonized by, antagonistic strains of being and thought, seals its periphery to become a self-sufficient, recolonized whole. The state's borders function as clearly articulated and monitored lines of territoriality, with sovereignty serving as a tool for exiling or eliminating the pathogens that would threaten moral and physical degeneration to the polity's vulnerable and weak citizenry.

A pathological paradigm radically discourages coexistence with the elements of society that threaten the integrity of the nation. Indeed, toward the end of the Civil War, a 1938 column in *ABC* quotes Franco rejecting mediation with opposed Republican leaders to bring the conflict to a halt, as such an approach serves "the Reds and undercover enemies of Spain," permitting "that criminals and their victims live together; peace for today and war for tomorrow."[6] Evil,

under this approach, can only be defused by pushing it away from the state's borders, and forces inimical to the reproduction of the ideal forms of Spanish life are to be resisted and given no quarter.

. The intellectual foundation for Francoism's deployment of metaphors of illness to conceive of the Spanish nation extends into the nineteenth century. Alfredo Sosa-Velasco details how, in the concluding decades of the nineteenth century and first half of the twentieth, the writings of Santiago Ramón y Cajal (1879–1930), Pío Baroja (1872–1956), Gregorio Marañón (1887–1960), and Antonio Vallejo Nágera (1889–1960) construct racial, sexual, and pathological discourses around the notion of national regeneration. National configurations that went against the Castilian-centric vision of the state were often termed "pathological" in favor of a homogeneous Spanish nationalism free of regional particularisms.[7] Moreover, medical-scientific visions of a restored body politic often were steeped in heteronormativity and misogyny. The Nobel laureate Ramón y Cajal, for example, envisions a "puramente masculina" community, composed of scientific investigators, in which a "virile archetype, proposed by Amparo Moreno Sardà, molds the behavior of the men and women of the nation."[8]

In this essay, I will investigate the ways in which Agustí Villaronga's film *Pa negre* (2010) [*Black Bread*] engages with the gendered and nationalistic overtones of Francoism's pathological rendering of the Spanish political body. Through his depiction of the aftereffects of queer violence in a rural Catalan mountain village during *los años de hambre*, I will assert that Villaronga challenges the idea that the paradigmatic nature of the dictatorship was primarily pathological, despite the regime's ideological exhortations to the contrary. Instead, Villaronga, through his filmic adaptation of Emili Teixidor's novels *Pa negre*, *Sic transit Gloria Swanson*, and *Retrat d'un assassí d'ocells*, paints a picture of a postwar nation that engages with otherness, dissent, and the reinstitution of community through an immunologic paradigm.

The Italian theorist Roberto Esposito puts forth that political power mimics the biological body, but not simply in its absolute rejection of the pathological and reinforcement of external borders. Rather, the state assimilates into itself what it pathologizes in order to confer immunity onto the national body politic, effectively introducing into the folds of life what is understood to be the germ of death. In other words: evil must be thwarted, but not by keeping it at a distance from one's borders; rather, it is included within them. The dialectical figure that thus emerges is that of exclusionary inclusion or exclusion by inclusion. The body defeats a poison not by expelling it outside the organism but by making it somehow part of the body.[9]

In *Pa negre*, Villaronga shows that Francoism relied on the deployment of three forms of power: the sovereign authority to inflict death, the necropolitical

ability to merely expose certain lives to death within the spaces of the living, and the biopower necessary for disciplining and molding populations. Necropower, in particular, is essential for a politics of immunity, as it keeps pathologized life immanent to the social within spaces of "internal exclusion": a contagious form of life visible to the community but nonthreatening due to its weakened state. Conceptually, this model of necropolitical introjection resembles how weakened, but living, bacterial organisms can innocuously enter into biological systems as vaccines for the purposes of self-protection.

Over the course of *Pa negre*, Andreu, the film's child protagonist, undergoes a protracted process of immunization, as he eventually becomes "Andrés" after assimilating into a conservative, bourgeois family unit, but only having first come into contact with leftist deviance and homicidal criminality in the form of his father, tuberculosis, and queer sexuality in the institutionalized patient played by Lázaro Mur, and with nonhegemonic cultural identity in the shape of his Catalanness, the last rebuffed symbolically through a rejection of the mother at the end of the film. Andreu's assumption of Francoism's dominant gender, cultural, and other normative roles is a process simultaneous with the desubjectification of other marks of identity, as if his bildungsroman-esque formation consisted in exposure to, and containment of, a series of pathological contagions, which the state's repressive apparatuses and ideological discourses aid in suppressing.[10]

I will conclude that *Pa negre*, the first Catalan-language feature to earn a Goya Award for Best Picture, brings to light the biopolitical operations of Francoism to call the spectator's attention to policies in contemporary Spain in which LGBTQ identities are folded back into the processes of life through legal protections and rights. At the same time, Villaronga also gestures toward what Jasbir Puar and others call "queer necropolitics," or how, as some Spanish queer subjects are "folded (back) into life," other queernesses are left "implicitly or explicitly targeted for death."[11] In this respect, I will discuss recent legislation to address shortcomings in the 2006 Ley de Identidad de Género as an example.

I will begin by offering a brief summary of the theoretical overlap between the Francoist vision of a purified state and Michel Foucault's notion of biopower, which primarily aims to excise the political propagation of death in order to maximize the production and individuation of life—similar to Francoism's Manichaean elimination of the degenerative in order to produce a reconsecrated national community. I will next outline how *Pa negre*'s immunologic conception of Francoist Spain mirrors theoretical revisions to Foucault's concept of biopower. This will then lead to a focus on the "necropolitical" in the film and attention to the procedures by which society, in Villaronga's vision of postwar Spain, becomes "healthy" through exposure to that which it deems contaminating and hostile to its reproduction. The film shows that the traces

of contamination remain immanent to the inner workings of society through the physical inclusion of the contagious within the same social space as those who are regenerated, but also through the sublimation of exclusionary violence. More precisely, the transformation of Marcel Saurí into Pitorliua re-enacts the Girardian model of scapegoating in which the castigation and subsequent mythologization of a persecuted victim resolve social crises and reinstitute the sexual and class taboos that codify social life.

Michel Foucault outlines the processes by which the West, toward the turn of the eighteenth century, moved to a modern model of power based on the political administration and manipulation of life. As the human body becomes an object of knowledge through advancements in medicine, psychology, and science, the West witnesses a transition from the early-modern emphasis on sovereign power to biopower. Biopower marks a point at which "the ancient right to *take* life or *let* live was replaced by a power to *foster* life or *disallow* it to the point of death."[12] The state's political mandate thus shifts from the sovereign right to make die and let live to being focused on the surveillance, manipulation, and disciplining of populations. Bodies, instead of being taken hold of by the sovereign and exposed to death, are instead seized, opened up, and operated on by a biopower that generates particular forms of life in order to then regulate and discipline them.[13]

Subsequent thinkers, most notably the Italian theorist Giorgio Agamben and the Cameroonian scholar Achille Mbembe, assert that biopower's efforts to completely eradicate the presence of death from the everyday management of life are an alibi that shields from view the latent presence of sovereign power in the modern state and its ability to define whether or not certain modes of existence are disposable. In contrast with Foucault, Agamben asserts that lives included within a biopolitical order may be deemed worthy of continued existence, but each person nevertheless retains the virtual potential to be stripped of political qualifications and reduced to bare life: "Bare life is no longer confined to a particular place or a definite category. It now dwells in the biological body of every living being."[14] Authority, in other words, retains the ability to suspend the political life of a particular class of individuals and place them in a relationship of abandonment to the state, essentially diminishing their degree of humanity in a graduated way.

Mbembe, in his widely cited article "Necropolitics," similarly asserts that the biopolitical management and disciplining of life assimilates into the internal dynamics of the state the right to create boundaries, assert logics of exclusion and inclusion, and determine friendship and enmity. Mbembe proposes a tripartite division of power to describe political units in which sovereignty, biopower, and necropower—the right to create zones of bodies vulnerable to death—interface with one another to produce territories that are internally splintered and composed of bodies that are granted differing degrees of

humanization and access to the political. Mbembe argues that "the most accomplished form of necropower is the contemporary colonial occupation of Palestine,"[15] where one sees a logic of spatial fragmentation and isolation of Israeli settlements from the rest of the territory. The internal splintering of domestic territory yields increased outbreaks of violence due to the exponential augmentation of zones of contact and friction. Sovereignty and biopower come to promiscuously coexist, as land is annexed and cleared with earthmovers at the same time that techniques of surveillance inscribe the bodies of enemy populations into networks of monitoring. While Foucault argues that in late modernity power is only "over life, throughout its unfolding," with death as its limit,[16] Mbembe counters that modernity features a number of territories containing overlapping geographies where life is either maximized, eliminated altogether, or necropolitically left vulnerable to the power of death, transforming the latter inhabitants into the "living dead,"[17] whose humanity is either diminished or outright suspended.

Through its ideological projection of a pathological paradigm, Francoism purports to exhibit a form of Foucauldian biopower by establishing a strict spatial and ontological division between life and death—an attempt to eradicate the latter in order to maximize the former. The elimination of pathological strains inimical to the essential character of the Spanish state permits those bodies deemed redeemable and worth living to be individuated in particular ways, safeguarded from the possibility of infection and corruption.[18] The vitality of the state, in this respect, can only flourish once the pathological elements that threaten the unfolding of life are expelled from the polity and all signs of death are resignified as sources of vitality. Even while keeping the threat of ills such as Marxist infection present in propaganda and official rhetoric, the regime paradoxically attempted to reframe the material vestiges of death from the war as spaces of life and regeneration. Richards notes that the "physical ruins of the war were turned into purified shrines, 'symbols of life and not of death, of fidelity, not of abandonment,' and many of them were 'adopted' by Franco, father of the nation."[19] Death, like the sovereign border of the nation, is represented in propaganda as the ideological limit of Francoism's version of autocratic power. Individuals punished by the state, under this understanding, are not killed or disposed of as evidence of the sovereign right to "make die," but rather are dispatched on the grounds of ensuring that the "healthy" body politic flourishes. Death, in other words, is an ancillary concern of the state secondary to the propagation of life-forms that materialize the ideological tenets of *nacionalcatolicismo*.

In her sophisticated analysis of *Pa negre*, Erin K. Hogan notes that the film routinely demonstrates Foucault's concept of biopower, most explicitly in its "exposure of exclusionary practices, the regulation of the body, and the interdiction of abjection and contagion."[20] Hogan emphasizes the overlap between

the film's portrayal of repressed homoerotic desire and Francoist Spain's techniques of individuation, which mandated a well-demarcated line between "male/female, heterosexual, homosexual."[21] The film, in this regard, reflects how the regime established clear thresholds between both gendered difference and sexual orientation and concomitantly founded an array of carceral institutional frameworks to produce Spanish bodies that accorded with the ideological principles of Francoism through discipline and the installation of power.

The outset of Pa negre references the mobilization of biopower, after Andreu witnesses the murder of Dionís Seguí and his son, Culet. Unbeknownst to the child at the time, his father, Farriol, carries out the attack in order to cover up his and Seguí's forced castration of another man, Marcel, who had been involved in an affair with a brother of the wealthy Manubens family. After reporting the incident, a Guardia Civil officer informs Andreu as he leaves the forest to report to the police station the following day to give testimony. The exchange, unlike the beginning scenes of the film prior to this point, transpires in Castilian Spanish and emphasizes the filing of paperwork, as the Guardia Civil officer notes: "Paperwork, you know, now everything is a sea of paperwork." The murder must be inscribed in official documentation, brought under the registered control of the law, and subjected to centralized surveillance by authorities. Society, as Foucault reminds, must be defended (and administered). The exchange signals the beginning of Andreu's self-folding into the Castilianizing machinery of Francoist society, as the guard demands a testimonial accounting of fact in a linguistic register in which the child does not "identify" or "feel comfortable"—a kind of police officer interpellation resembling the Althusserian "hey you, there."[22] The next day, Andreu's accounting of the event transpires in Catalan, and at a later point the same Guardia Civil agent switches to Catalan when the child fails to understand a question.

The two scenes emphasize together how the biopolitical seizure of the human body exerts a power that divides the self into two forms of life, one biological and the other political.[23] These two registers can be disarticulated: in Pa negre, the adolescent, prepolitical child experiences reality in ways that are inexpressible through official channels, whether due to the untranslatability of affective experience into language or through the disenfranchisement of his native register, Catalan, in favor of the imposed, but legally sanctioned, Castilian. Dean Allbritton convincingly argues that the linguistic code-switching both in this scene and at a later moment in Andreu's classroom "underscores the persistent indoctrination and encompassing propaganda employed by the Francoist regime."[24] I would extend this observation to argue that Villaronga reveals how Francoism's necropolitical division of national territory into vanquished and victorious zones required splintering the bodies of the defeated ontologically. For Andreu, the seeds of queer desire and nonnormative linguistic identity must be repressed and made proper to one's internal bare life in order for

the political subject to be folded into the institutions charged with the propagation of Spanish citizenship. In the same way that the film's sanatorium is set apart spatially from Andreu's village and composed of beings whose weakened state allows for easy control, the boy's marks of latent pathology must be circumscribed and preserved within the subconscious through the sublimation of desire, a displacement that immunizes his future political existence from his repressed bare life.[25]

Villaronga's film, while certainly highlighting Francoist uses of biopower, also shows that the political generation of qualified life-forms is inseparable from the "exclusive inclusion" of pathologized life. In this respect, my analysis would challenge Hogan's assertion that *Pa negre* emphasizes the absolute "interdiction of abjection and contagion." Villaronga's representation of Francoist institutional authority stresses the inseparability of three forms of power: the sovereign right to "make die"; necropower, where lives are made disposable, deemed contagious, but not killed; and the biopower that regulates politically eligible life. This triptych of authority describes the separate trajectories of Andreu's nuclear family by the conclusion of *Pa negre*. On the one hand, Farriol is executed under the sovereign jurisdiction of the state, an act of power that his wife describes as gratuitous and therefore extraneous to the safeguarding of the body politic: "Does this death serve any purpose? Does it serve any purpose to not let him be buried as God intended?" The audience may or may not agree, knowing of Farriol's complicity in the murders at the behest of the Manubens, but reference to the gratuitousness of the castigatory violence insinuates the state's general possession of a sovereign mandate to "make die." Florència, decrying that she was not executed at her husband's side, next describes her own existence in necropolitical terms: biologically alive, but placed in subhuman conditions akin to a loaf of "black bread, red sugar . . . bread without soul nor virtue, dead." Her flesh, like the materiality of the bread, lacks spiritual vitality and occupies an ontological threshold between life and death.

As regards biopower, Andreu submits ultimately to a process of individuation that transforms him into "Andrés Manubens" after the death of his biological father, a form of both sexual and cultural repatriation that suppresses his queer desire and his primary ethnosymbolic marks of linguistic identity. Villaronga gestures toward these three distinct forms of power through the film's mise-en-scène: Farriol's relation to the right of sovereign exception is referenced as Andreu passes by two men subjected to the garrote just prior to his own father's death; Florència, while admonishing the mayor for diminishing her status to the living dead, is surrounded by baskets of stale black bread, an object past the point of utility and expendable; Andreu, while walking to meet his mother at the end of the film, passes a boy being "disciplined and punished," instructed by a priest to keep his face to the wall to redress some form of deviant behavior.

The film reveals how the logic of political inclusion is only legible in the presence of contagious subjectivities vulnerable to death, either gratuitously "made to die" or necropolitically left alive as the "living dead." The tuberculosis hospital near Andreu's home, for example, is a zone of bacterial pathology included within the social but in a quarantined form. By including that which threatens bodily materiality alongside the paths that lead through the forest from home to work, and home to school, the clinic exists to help define the normative meaning of "healthy" through negation. Health, from this optic, is not a preexisting condition that degenerates into illness but is an active vital force that is generated as a response to the containment and neutralization of the germs of death. Illness, by the same token, cannot be thwarted completely, as it must remain present in order for life to continue deriving meaning from its contradictory opposite. The tuberculosis sanatorium is thus a marker of illness that is "internally excluded"; it is separate enough to avoid contagion with the healthy but near enough to the social to serve an advisory function, not dissimilar from the ringing of bells that signal the administering of last rites just prior to execution in other scenes.

Quirze attempts to deflect Andreu's peripheral contact with the patients by ascribing their affliction to excessive and nonconformist sexual behavior. As Hogan trenchantly notes, "Andreu's subconscious, influenced by his cousin's words, makes a connection between the patient and Piorliua on the basis of their sexual orientation when it recreates the assault scene with a show that substitutes the consumptive adolescent for Pitorliua."[26] The circumscription of contagion splinters the social into both necro- and biopolitical zones and also is the motor for asserting the sexual and epidemiological standards that define normative marks of identity, including the expression of heterosexual desire. Gema Pérez-Sánchez emphasizes Francoism's keen attention to "criminalizing and containing homosexuality,"[27] conceived as an underlying threat to the sexualization of the homosocial groupings of virile masculinity lionized in Fascist discourse. Pérez-Sánchez further notes the importance in Fascist ideology that enemies be both external (Jews, Marxists) and internal, as the latter demonstrate the potential corruptibility of the nation's citizens.[28] In order to function as a credible threat, homosexuality and the marks of minority cultures like Catalan had to be "contained" and not eliminated altogether, as if they were weakened bacterial cultures in a vaccine. In Pa negre, the containment of queer desire transpires in multiple ways, such as the process of repression and sublimation of Andreu's sexuality as he becomes "Andrés." As I will discuss later, queer violence is also "contained," yet kept visible within the social in a distorted way, through the creation of myth in response to collective scapegoating.

In general, Pa negre shows how, under a paradigm of immunologic power, community defines itself negatively, that a "healthy" body politic has no

positive meaning on its own merits but merely signifies the absence of disease and vice. This logic of immunologic power extends to the containment, attenuation, and "inclusive exclusion" of Catalan culture in the film, a dynamic that the opening scenes introduce, but that is emphasized later in an educational setting. Josep Benet catalogs the extensive efforts of the regime to prohibit and discourage the Catalan language, particularly in educational settings. Catalan was prohibited in "la vida oficial i pública de Catalunya," including in all public and private schools, where all books, pamphlets, and notebooks written in the language were removed.[29] The minimization of Catalan culture extended especially to social domains where biopower most adheres: hospitals and clinics, judicial administration and prisons, and so on. The government linked the public expression of the language to the disaggregation of the national body politic, as if it were a kind of antisystemic microbe. In 1939, Alfonso Iniesta, a Francoist education minister, described the use of Catalan in Barcelona's schools and intellectual centers as part of a sinister effort to "cultivate the desire for separation," while the Francoist publication *Solidaridad Nacional* declared the use of Catalan in either a monolingual or bilingual curriculum a "war on the Spanish language, on the Spanish spirit, on everything, in the end, that smells of Spain."[30]

In *Pa negre*, Catalan culture, in spite of being a taboo prohibition, nevertheless remains extraofficially present within carceral spaces such as the police barracks and the classroom. However, this visibility serves only to emphasize its denigration and subservience to authoritarian control and surveillance. In a classroom scene, the camera accompanies Andreu's professor in a tracking shot during a dictation exercise, as students are made to repeat "Victory is never neutral nor undeserved. It is necessary to keep away from the defeated as one would keep away from the plague." Amago quite astutely observes that the camera pans both to a photograph of Franco on the wall behind the instructor and to a sketch of the interior anatomy of the hand; "taken together, these images represent a visual pun denoting the Spain of the dictator and the *Falange* (phalanges!)."[31] In addition, I would argue that the two images together symbolize the instructor's pedagogical merging of the domains of political ideology and medical discourse, which when combined with his focus on *la peste* winnows the connection further to medical epidemiology. In a later scene, Andreu remarks on the effort to pathologize the Catalan losing side, noting to his father that "they always talk about the winners and losers and they point at us like we're the plague."

According to an immunizing logic, a system absorbs the pathological in order to affirm its negation. The pathological is excluded from the domain of the healthy through the very act of its being included, which makes it unsurprising that the schoolteacher interrupts the dictation exercise to field questions and give answers in Catalan, keeping present within the classroom—a primary

space in which Falangist ideology is transmitted—a mark of identity belonging to the pathologized defeated. In this respect, I would expand on Allbritton's reasoning for Villaronga's nearly universal inclusion of Catalan in the film, which shows "Franco's cultural repression while also hinting at the potential for resistance and the instinct to survive at all costs."[32]

I would add that the preponderance of Catalan is partly historical realism, given the isolation of the remote mountain village and thus lower frequency of Castilian speakers. Secondly, the code-switching in the classroom and barracks—where deviation from *la lengua del imperio* is taboo—necropoliticizes Catalans by attaching illness to their ethnocultural symbolism. That which is most threatening to the Francoist vision of the nation—in this scene, Catalanness, but later in the film, queer sexuality vis-à-vis hetero-nationalist virility— is kept closed in an attenuated form. Necropolitically, the defeated are "inclusively excluded" as a type of "living dead," and the energy dedicated to their dehumanization and control is one of the primary impulses that constitute community. Andreu is offered the possibility of either repression of nonconformist traits and behaviors, or continued vulnerability to death in the form of political pathologization. The film thus echoes Esposito's contention that "immunity constitutes or reconstitutes community precisely by negating it."[33] In *Pa negre*, the production of zones of biopower, where life is managed and generated, requires the coextensive presence of a dehumanizing, necropolitical force.

That the instructor is able to break taboo and reintroduce Catalan to the classroom is a sign of his own immunization from the shared rules that govern the rest of the community, similar to how the Guardia Civil agent can switch back and forth between Catalan and Castilian in the barracks earlier in the film. As Esposito writes, "Those who are immune owe nothing to anyone . . . what counts in defining the concept is exemption from the obligation of the *munus*, be it personal, fiscal, or civil."[34] Through an etymological focus on the Latin *munus*, meaning responsibility or debt, Esposito defines community as those who are related by each being beholden to an obligation to sacrifice what is proper. The condition of immunity would imply a freedom from the universal demands that weigh down the rest of the body politic, mimicking sovereign power, which operates along a threshold space within and beyond the law. In the same fashion that he who is immune exists as the negation of he who is ill, the sovereign, as Jacques Derrida emphasizes, is the antipode of the dehumanized beast, as "both share the very singular position of being outlaws . . . the beast ignorant of right and the sovereign having the right to suspend right."[35] In *Pa negre*, the schoolteacher retains the right to suspend the prohibitions governing social taboos, not only linguistic but also sexual in nature, as evidenced by his unseemly relationship with Andreu's minor cousin, Núria.

In Andreu's classroom, being marked by the stain of defeat overlaps with a metaphor of illness, *la peste*, which then is grafted onto Catalan cultural identity. In her famous treatise on illness, Susan Sontag warns against thinking of illness metaphorically, and *Pa negre* shows how metaphoric illness—such as tuberculosis, which figuratively "invades" and "consumes" the body—can undergo a second transmutation when discursively extended to various forms of difference.[36] The instructor's taboo relationship with Núria, an example of immunologic exception from social obligation, simultaneously strips away the humanity of the girl to convert her into an inanimate, passive object to be seized and acted upon. As she explains to Andreu, the teacher "gave me coins . . . he said that I'm like a tree or a stone because I don't demand anything." Both the metaphors of illness (*la peste*) and of the objective, nonhuman world (*arbre, pedra*) work in tandem to expose the internal separation within the human of a bare life, exposed to the sovereign exception to the law, and a political life vulnerable to the investment of institutional biopower. In the same way that the representative of sovereign power possesses an immunity allowing for the breaking of taboo, the defeated are reduced to a bestial state that is overdetermined by restrictive barriers and prohibitions.

The dichotomous relationship between Andreu and Saurí is instructive in revealing how the latent presence within the social of the "living dead" influences other subjects with nonconformist traits to submit to the disciplinary regulation of Francoist social engineering. Importantly, Saurí becomes visible to Andreu not through material presence but through the Pitorliua myth. Saurí, bestialized due to his sexual difference with a tool precisely meant for porcine castration, is reabsorbed into the fabric of the living as Pitorliua, which aligns him with other mythologies of the monstrous that in all likelihood have their roots in concrete moments of historical violence.

René Girard argues that collective violence is a "mechanism" that creates myth in order to distort the horrific historical reality of scapegoating persecution.[37] Scapegoating is a process by which a culture mired in a crisis of mimetic violence restores its unity through redirecting "unanimous violence . . . against the single victim, the victim finally selected by the entire community."[38] The "single victim" is a blameless, liminal figure onto whom a host of evil characteristics adhere. Girard emphasizes that scapegoating is the first stage of myth; "then comes the second stage when he [the victim] is made sacred by the community's reconciliation."[39] The process of sacralization distorts the narrative of persecution that preceded the act of scapegoating, altering the concrete historical identity of the victim and often attaching positive qualities to him or her for being the root cause of society's reunification.

In Andreu's re-creation of the event, Saurí's persecution, though motivated by the Manubens family, becomes a mob attack, insinuating that a Girardian

victimary mechanism is at work.[40] Earlier in the film, Villaronga indeed ges-
tures toward mimetic rivalry in reference to the love triangle between Farriol,
Florència, and the town's mayor. The castration and eventual death of Saurí
symbolize an outbreak of violence that serves as an outlet for the accrued ten-
sion of this and a host of other rivalries threatening the town's social fabric.
Though he is banished materially from the social, Saurí's victimization births
a myth that helps conceal the violent historical reality of its origin, but this very
act of concealment is also a cipher that motivates Andreu to imaginatively
reconstruct the recent past.

As Eva Bru-Domínguez asserts, the experience "renders homosexuality vis-
ible, performative and embodied."[41] Isabel Alvarez Sancho further argues that
Andreu's envisioning of the castration is a "psychic projection" of a phantom
rather than an autonomous ghostly apparition, meaning that Saurí's reappear-
ance is not the presence of the unresolved past in the present but the phantas-
matic consequences of the intergenerational "transmission of secrets."[42] While
largely agreeing with these nuanced interpretations, I would submit further
that Saurí's re-emergence as a scapegoated victim affirms a connection between
the visible containment of contagion and social reunification.

Scapegoated victimization, once distorted onto a mythological plane, com-
municates the dangers of uncontrolled mimetic rivalry, which Girard himself
often calls "the mimetic *contagion* of collective murder."[43] Beyond mimetic
rivalry, the mythologization of liminal figures like Saurí is also a mechanism
for keeping alive banished forms of pathological life that putatively threaten
the healthy tissue of the body politic, though in a phantasmatic way. Saurí's
phantasmatic presence, so well described by Alvarez Sancho, is a form of
necropolitical life within the collective imaginary that emerges as a vestige of
sovereign exclusionary violence. In *Pa negre*, monstrosity is not strictly an object
of "denial and suppression,"[44] but is weakened, quarantined, and folded into
the tissues of the living for the purposes of political immunization.

In this essay, I have argued that *Pa negre* disrupts the notion that the Fran-
coist dictatorship operated according to a pathological paradigm. *Pa negre* ref-
erences the inseparability of three distinct, yet interrelated, forms of authority,
and especially shows the importance of necropolitical power in the unfolding
of a politics based on immunization. In the film's representation of early Fran-
coism, necropolitical life merges with metaphors of illness and pathology in an
effort to reunify and regenerate the body politic through contained exposure
to that which is believed to threaten the social system. Necropolitical forms of
life, including regional nationalisms, queer sexualities, and leftist political ori-
entations, are contained and intentionally kept present rather than universally
eliminated, even after sovereign banishment in the case of scapegoating. This
"excluded inclusion" allows for community and, by extension, understandings
of health and vitality, to be constituted through the negation of that which

is deemed to be contagious and threatening to the tissue of the state. Approaching *Pa negre* through the concept of immunity contributes nuance to scholarship that predominantly has tied the film to the absolute purging of the contagious and monstrous, a modus operandi more characteristic of a pathological paradigm.

Allbritton has noted that *Pa negre* speaks in a constructive way to the contemporary moment of its production, expressing "a very specific set of critiques of contemporary Spanish society that indicts the beliefs, practices, and events of the allegedly peaceful and democratic present."[45] For Allbritton, Villaronga highlights how the psychologically damaging effects of the dictatorship persist into the future and demand redefining futurity as a concept inclusive of ill, traumatized, and psychotic subjectivities. For the purposes of this essay, my concluding thoughts concern the way the film shines a light on the relevance of necropower to the way one understands Spain's global standing at the forefront of LGBTQ rights. A piece of legislation that helped contribute to this perception was the 2006 Ley de Identidad de Género, which, when put into practice the following year, allowed, among other measures, transgendered people to alter their name and gender on official documents without sex reassignment surgery or judicial approval. The measure was described in the press as the biopolitical inclusion of gender nonconformist subjects into the social processes that "foster life": "a specific piece of legislation that grants coverage and juridical security to the necessities of these people."[46] The law, passed four years before *Pa negre*'s release, was only recently revised to correct grievous shortcomings in 2017. The reform disallowed the previous obligation that transgender persons undergo a process in which "they are obligated to declare themselves sick in order to have access to the name change," and undergo years of treatments to "adjust their physical characteristics to correspond to the requested sex."[47] In addition, the reform extended the rights stipulated in previous legislation to minors.

Recent scholarship on the notion of queer necropolitics, as first described by Jasbir Puar and later investigated in greater depth in *Queer Necropolitics* (2014),[48] a volume edited by Jin Haritaworn, Adi Kuntsman, and Silvia Posocco, pushes for analysis of how measures such as the one described here not only foster life but also leave spaces for the simultaneous co-presence of death. Or, as Puar writes, how does the advancement of liberal gay politics give life to some, but "entail deferred death or dying for others"?[49] In my interpretation of *Pa negre*, Villaronga is calling the spectator's attention to similar questions by reproducing the complex myriad ways in which power invests the biological body. The original wording of the Ley de Identidad de Género necropoliticizes certain queer bodies by making submission to a process of pathologization (*declararse enfermos*), a prerequisite for the conferral of rights. In addition, the law exempts the bodies of children from access to rights altogether. In the

context of the liberalization of the Spanish democratic state, *Pa negre* is valuable not only in recalibrating the way one thinks about the historical machinations of Francoist ideology, but also in showing how the management and reproduction of life by political regimes in the present century concomitantly produce zones of abandonment and pathologized confinement. Humanity, like the splintered social space in *Pa negre*, becomes a set of populations with varying degrees of disposability.

Notes

1 Michael Richards, *A Time of Silence: Civil War and the Culture of Repression in Franco's Spain, 1936–1945* (Cambridge: Cambridge University Press, 1998), 62.
2 Organicist rhetoric had its roots in turn-of-the-century Spanish regenerationism, and later became "an important component of the belief-system of Francoist military officers and ministers ... the country's 'organic-purity'—moral, religious, biological—had to be guarded." Richards, 18.
3 Cited in Josep Benet, *L'intent franquista de genocidi cultural contra Catalunya* (Barcelona: Publicacions de l'Abadia de Montserrat, 1995), 265. All translations are mine, unless otherwise indicated.
4 See Donna Haraway, *Crystals, Fabrics, and Fields* (New Haven, CT: Yale University Press, 1976), 34.
5 Richards, *A Time of Silence*, 71.
6 Cited in Fernando Díaz-Plaja, *La España política del siglo XX en fotografías y documentos* (Barcelona: Plaza & Janes, 1972), 451.
7 See Alfredo Sosa-Velasco, *Médicos escritores en España, 1885–1955* (Woodbridge, UK: Tamesis, 2010), 184.
8 Sosa-Velasco, 41.
9 See Roberto Esposito, *Immunitas: The Protection and Negation of Life*, trans. Zakiya Hanafi (Cambridge, UK: Polity, 2011), 8.
10 Thomas Deveny has argued that *Pa negre* is a *Bildungsfilm* that traces Andreu's transition from childhood to the monstrous. See Thomas Deveny, "*Pa Negre (Pan negro)*: Bildungsroman/bildungsfilm de memoria histórica," *La Nueva Literatura Hispánica* 16 (2012): 397–416.
11 Jasbir Puar, *Terrorist Assemblages: Homonationalism in Queer Times* (Durham, NC: Duke University Press, 2007), 34–35.
12 Michel Foucault, *The History of Sexuality. Volume 1: An Introduction*, trans. Robert Hurley (New York: Vintage Books, 1990), 138 (emphasis in original).
13 Similar to Foucault, Roberto Esposito identifies the passage from the eighteenth to the nineteenth century as a critical moment when the concept of immunity evolves from being considered a passive, natural occurrence to an artificially acquired condition. This transformation affects how the immunologic is used metaphorically in nonbiological domains such as politics and law. Esposito emphasizes that the transformation coincides with Kris Jenner's development of the measles vaccine, the bacterial experiments of Louis Pasteur and Robert Koch, and the emergence of the field of medical bacteriology. See Esposito, *Immunitas*, 7.
14 Giorgio Agamben, *Homo Sacer: Sovereign Power and Bare Life*, trans. Daniel Heller-Roazen (Palo Alto, CA: Stanford University Press, 1998), 140.

15 Achille Mbembe, "Necropolitics," *Public Culture* 15, no. 1 (2003): 27.

16 Foucault, *The History of Sexuality*, 138.

17 Mbembe, "Necropolitics," 40.

18 Josep Benet documents how in postwar, Fascist-occupied, Barcelona, propaganda appeared throughout the city, touting the ability of officially sanctioned organizations to biopolitically generate forms of life resistant to pathology and suitable for the ideological mission of the nation. The Organización Juvenil, for example, allows for one's daughter to become "healthy, a lover of beauty" (Benet, *L'intent*, 278). The Organización Juvenil Femenina, meanwhile, "will give to girls and adolescents from ages 7 to 17 a National-Syndicalist formation, which will bring to life José Antonio's doctrine" (278).

19 Richards, *A Time of Silence*, 73.

20 Erin K. Hogan, "Queering Post-war Childhood: *Pa negre* (Agustí Villaronga, Spain 2010)," *Hispanic Research Journal* 17, no. 1 (2016): 10.

21 Hogan, 10.

22 Louis Althusser, in asserting the ways in which ideology "recruits subjects among the individuals," compares the interpellative "hey you" to the "commonplace everyday police (or other) hailing." Louis Althusser, *Lenin and Philosophy and Other Essays*, trans. Ben Brewster (New York: Monthly Review Press, 2001), 118.

23 In *Homo Sacer*, Agamben refers to these distinct forms of life as *zoe* and *bios*. The politicization of biological life (zoe) into an array of qualified forms of existence (bios) is for Agamben "the decisive event of modernity." Agamben, *Homo Sacer*, 4.

24 Dean Allbritton, "Recovering Childhood: Virulence, Ghosts, and *Black Bread*," *Bulletin of Hispanic Studies* 91, no. 6 (2014): 629.

25 Though my focus is on *Pa negre*, Alberto Mira notes that one of the primary ways that queer desire was sublimated during Francoism was by concealing it within "the rhetoric of friendship." Alberto Mira, *De Sodoma a Chueca: Una historia cultural de la homosexualidad en España en el siglo XX* (Barcelona: Egales, 2007), 329. Mira references the plot of Blai Bonet's *El mar* as an example, though importantly in Villaronga's filmic representation "the homoerotic aspects insinuated in the text were brought to the forefront" (329).

26 Hogan, "Queering Post-war Childhood," 12.

27 Gema Pérez-Sánchez, *Queer Transitions in Contemporary Spanish Culture* (Albany: State University of New York Press, 2007), 12.

28 Pérez-Sánchez, 12.

29 Benet, *L'intent*, 383.

30 Cited in Benet, 381.

31 Samuel Amago, *Spanish Cinema in the Global Context: Film on Film* (New York: Routledge, 2013), 99.

32 Allbritton, "Recovering Childhood," 623.

33 Esposito, *Immunitas*, 9.

34 Esposito, 5.

35 Jacques Derrida, *The Beast and the Sovereign I*, trans. Geoffrey Bennington (Chicago: University of Chicago Press, 2009), 32.

36 See Susan Sontag, *Illness as Metaphor* (New York: Farrar, Straus and Giroux, 1978).

37 See René Girard, *The Scapegoat*, trans. Yvonne Freccero (Baltimore: Johns Hopkins University Press, 1986), 49–50.

38 René Girard, *I See Satan Fall Like Lightning*, trans. James G. Williams (New York: Orbis, 2008), 30.

39 Girard, *The Scapegoat*, 50.
40 Marsha Kinder has detailed Girardian scapegoating in Villaronga's feature debut, *Tras el cristal* (1986), in a comparison of the film with Ricardo Franco's *Pascual Duarte* (1976). In both films, there is a reliance on "the kind of double substitution (both for violence and eroticism) that Girard claims is typical of the 'purifying ritual'—the choice of an outsider (carefully chosen by category) to stand in for the communal scapegoat." Marsha Kinder, *Blood Cinema: The Reconstruction of National Identity in Spain* (Berkeley: University of California Press, 1993), 192.
41 Eva Bru-Domínguez, "Repressed Memories and Desires: The Monstrous Other in Agustí Villaronga's *Pa negre*," *Bulletin of Hispanic Studies* 93, no. 9 (2016): 1017.
42 Isabel Alvarez Sancho, "*Pa negre* y los otros fantasmas de la posmemoria: El 'phantom' y los intertextos con *La plaça del diamant, El espíritu de la colmena* y *El laberinto del fauno*," *MLN* 131 no. 2 (2016): 522.
43 Girard, *The Scapegoat*, 135 (emphasis added).
44 Bru-Domínguez, "Repressed Memories and Desires," 1021.
45 Allbritton, "Recovering Childhood," 634.
46 "Entra en vigor la Ley de Identidad de Género," *El País*, March 17, 2007, http://elpais.com/sociedad/2007/03/17/actualidad/1174086001_850215.html.
47 "Congreso avala sin el apoyo del PP que las personas trans cambien su sexo legal sin declararse enfermas," *El Diario*, November 30, 2017, http://www.eldiario.es/sociedad/Congreso-reforma-considerar-personas-enfermas_0_712528886.html.
48 See Jin Haritaworn, Adi Kuntsman, and Silvia Posocco, "Introduction," in *Queer Necropolitics*, ed. Jin Haritaworn, Adi Kuntsman, and Silvia Posocco (New York: Routledge, 2014), 1–29.
49 Puar, *Terrorist Assemblages*, 36.

Part V

Burning Counterpoints
with Religiosity

13

Bound and Cut

• • • • • • • • • • • • • • • • • • •

João Pedro Rodrigues's
O ornitólogo (2016)

KELLY MOORE

João Pedro Rodrigues's *O ornitólogo* [*The Ornithologist*], released in 2016, shrouds metaphors of filmmaking in a mystical quest for transcendence. On the level of story, it retells the life of Anthony of Padua (1195–1231), patron saint of Lisbon. Oscillating between hagiography and nature documentary, Catholic imaginary and Shinto animism, the tale unfolds via a series of encounters between an ornithologist and a cast of extravagant characters: he escapes from sadistic Chinese pilgrims, has sex with a young Jesus, is urinated on by *caretos* during their carnivalesque rituals, and is even killed and resurrected by Latin-speaking Amazon huntresses. As provocative as the adventure proves, it is on the level of film assembly—and its relationship to the plot—where questions are raised about the erotic nature of filmmaking and spectatorship. Using the violent grammar of cinema—the severed continuity of montage—the film constructs a narrative of religious eroticism culminating in Saint Anthony's ecstasy. The holy man, however, begins his journey not as Anthony of Padua, but rather as Fernando, the ornithologist. The spectator apprehends his transformation into the saint through the subtle replacement of the actor with shots of the director himself—seen from the perspective of the very birds Fernando sets out to study—until the twin identities violently merge both on the level

of narration and on that of cinematic editing, via a bloody match cut through the saint's severed throat. Discontinuities between images (i.e., the gaps between photograms and the scenes that must be spliced together) and identities (i.e., the split nature of the protagonist) are reassembled and collapsed into a transcendent continuity. The film reads, as this essay will show, as an enactment of a sacred collapse of discontinuity in the sense that its final unity is an assembled film in and of itself, but, moreover, as a merging between spectator and film, a union that is the product of erotic violence. Fernando's transformation will serve as a meditation on the affinities between mystical ecstasy, achieved through abjection, and the erotic violence constitutive of cinema and its consumption.

Saint Anthony was an important symbol for the Salazar regime (1933–1974) in Portugal. As the patron of lost things, travelers, animals, and even counter-revolutionaries, he remains an icon in Lisbon; the saint is often depicted supporting the baby Jesus on his left arm. Saint Anthony, in canonical legend, was born Fernando Martim de Bulhões e Taveira Azevedo and joined the Franciscan order in Coimbra before traveling to Morocco and eventually Padua, Italy.[1] The director recalls, "I was interested in telling myths from popular Portuguese history, those stories we all share, and in some way invent my films based on them."[2] Indeed, Rodrigues furnishes the film with popular lore: there is an eroticized encounter with a young man named Jesus, the famous sermon to the fish, and the resurrection of a dead man, all episodes attributed to the life of Anthony of Padua. Fernando's journey and his eventual rebirth as Saint Anthony, however, are far from canonical.

Over the course of the film, Fernando becomes António. In the opening sequence, Fernando is an ornithologist studying a dwindling population of black storks. The only clues to his mundane life come in the form of cryptic text messages from Sergio, his husband, urging him to remember his medication, presumably antiretroviral drugs.[3] After a kayaking accident, Fernando leaves his worldly concerns behind and embarks on a surreal adventure that concludes when he reaches the afterlife—in this case Padua, Italy—in his new form. As Fernando, portrayed by the French actor Paul Hamy, gets closer to becoming António, shots of this actor are interposed with those of Rodrigues—the director himself—also portraying the hero, a trade that spotlights the hero's dual and fluctuating identity. At first, only the birds Fernando studies perceive this switch (e.g., in the opening sequence when Fernando is tracking a black stork). Here, the action is shaped by the birds' glances and gazes. As the camera shows us the researcher's binocular perspective, a narrowed field of vision revealing a bird (0:04:10), the bird suddenly turns to look back at him (0:05:00). The following sequence repeats this movement, illustrating human's and fowl's dramatically differing fields of vision: Fernando's limited and technologically aided; the bird's expansive, divine. From the bird's point of view,

FIG. 13.1 Paul Hamy. *O ornitólogo* (2016) by João Pedro Rodrigues. Courtesy of Blackmaria.

Fernando is more than he first appears. Almost imperceptibly, a brief shot replaces Paul Hamy with Rodrigues in the kayak (0:14:59). It is not until the film's halfway point that the transformation is easily perceived by not only the birds but also the spectator: The camera lingers on the main character caught in an owl's gaze (0:56:40–0:56:47). There is a blurred and discolored image of a man in the water, a shot in which Hamy has been replaced by Rodrigues, thereby allowing the spectator to fully apprehend the hero's split identity. When António finally reaches ecstasy and his transformation is complete, he will eclipse Fernando; Rodrigues will totally supplant Hamy. The transition from ornithologist to saint—from the beginning to the end of the film—is fitting given that Rodrigues himself has stated that before becoming a filmmaker, his dream was to be an ornithologist.[4] The birds allow us to see the manner in which Paul Hamy, the actor, and João Pedro Rodrigues, the director, are edited into one and the same, and by the same token, fragmented into distinct parts. There is a further uncanniness to the fusion between protagonist and director: Rodrigues dubbed all Paul Hamy's lines with his own voice. These splits, however, never mean that the main character is entirely the one identity or the other. His fragmentation is only finally resolved (or perhaps resorbed) in the film's conclusion when Fernando becomes Santo António.

In the director's own assessment, film possesses a sublime, transcendental power, above all in the correspondences between self and place: "Cinema is a point of view about the world. And in some way, it is the mode I found to *sublimate* this relationship that I have with the world, making it personal and also mysterious."[5] For Rodrigues, the spiritual element of film lies in its ability to transform our relationship between ourselves and the place in which we dwell. This is an act of *sublimation*, a change in state, an apt description for what happens to the ornithologist who transcends his worldly self to become one with something divine.[6] But, what are the contours of this divinity? *O ornitólogo* is an iconoclastic consecration that wrests the saint from the Estado novo imaginary, not to mention the Catholic tradition. Here, Saint Anthony is a gay man who makes love to Jesus, and in this story, paganism and Shintoism are as present as Catholicism. Institutional dogmas of God and sainthood are never invoked; instead, Fernando's ecstasy becomes an allegory for the very experiences of filmmaking and film watching. In what ways does the film prime the viewer for this shift in state, a sublimation of the character's relationship to the world? And, how is this transcendence linked to film on the level of its assembly?

In *O ornitólogo*, a cinematic chuckle—and perhaps also a flashing up of a "now of recognizability"—is entwined in the names of two pilgrims. After losing consciousness during a kayaking accident, Fernando washes up on a riverbank and is revived by two sadistic Chinese women, pilgrims who have strayed from the Way of Saint James. They drug and restrain him. We first see the

sadistic pair making their way through the forest, lost (0:16:50). The women resemble monks in their travelers' clothes, robed, respectively, in pink and blue, reminiscent of depictions of the Virgin Mary with the baby Jesus.[7] They call themselves Lin and Fei, a detail that demands close reading. The words *lin* and *fei* are possibly Mandarin for "forest" and "fragrance of flowers and plants," appropriate given the film's setting.

For Walter Benjamin, "The name is the object of mimesis" (V, Q° 24), and between names there can exist a "non-sensuous similarity" that is a similarity "not only between the spoken and the signified but also between the written and the signified, and equally between the spoken and the written."[8] Names can have correspondences with their signified in the sense of onomatopoeia but also in the magical residues of correspondences that may not be immediately graspable, correspondences that have been lost to time.[9] Names, thus, contain latent, rediscoverable knowledges. In his exploration of dialectical images in Benjamin's thought, Michael W. Jennings shows the dialectical image can be the product of reading names. In Jennings's view, the dialectical image is the product of an enlightened mystical reading: "The past and present moment 'flash up' into a constellation thereby coming to legibility . . . formed from the perception of the 'nonsensuous similarity' that links one name with another. Dialectical images are bursts of recognition."[10] Jennings suggests adding reading to the forms of experience privileged by Benjamin (i.e., the child, the insane, the intoxicated).[11]

In *O ornitólogo*, Rodrigues gifts the attentive spectator with such a moment of intoxicating recognition, one that unlocks the connections between the story and its form. Fei and Lin are names with special correspondences. What warrants observation is the dialectical relationship of these sounds: *fēilín* (achieved through parataxis) results in a Sinicized version of an English loanword—colloquial Cantonese and Mandarin for "roll of film."[12] While this may be a film pun, the joke reveals an important interpenetration of meanings that parallel the interpenetration of the film's images. When we meet these women and learn their names, they are lost in the forest. Lin has an injury and wears a leg brace. She stumbles into a bush and cuts her knee (00:17:44). As Fei approaches, she offers a blood-stained fingertip for her lover to suck. Fei accepts and leans down to lick the wound itself (00:18:20–00:19:07). Immediately, the paronomasia of their names is related to eroticized violence and abjection.

Through their abject eroticism, Fei and Lin are enacting the erotic carnages of filmmaking and spectatorship. Their union, as sexual partners who take pleasure in erotic acts involving blood loss and vampirism, results in the word "film." The image of Fei sucking Lin's wound recalls Georges Bataille's "fundamental connection between religious ecstasy and eroticism."[13] For Bataille (1897–1962), sacrament and erotic activity are imbued with a violent nature because of their ability to collapse the separate—discontinuous—nature of

beings and, like sacredness, reveal the continuity between people. Eroticism, for Bataille, is violence; it explains the erotic and violent nature of religious iconography. Fei and Lin's scandalous abjection and devouring show them to be subjects—like those for whom the eating of Christ's body entails a sublime jouissance[14]—who can dissolve into each other as does Fei's blood in Lin's mouth.

When Fernando revives and meets his rescuers, at first he cannot distinguish between the two women, mixing up their names. This reads as an amusing comment about filmmaking, finding the right cuts and assemblages of different montages: the right parataxis and the appropriate syncope. It is only in the collision of their names, their juxtaposition and montage, that we are able to understand their allegorical purpose in deciphering the film. Montage, according to Sergei Eisenstein, is a force of collision and conflict, the synthesis of dialectical elements: "From the superimposition of two elements of the same dimension always arises a new, higher dimension."[15] For Eisenstein, double exposure and superimposition suggest the conceptual transcendence of ideograms. From the collision, from the conflict, arises a concept.[16] The theoretical underpinnings of the film are now recognizable. What is innovative here, however, is the deliberate eroticization of this collision. Thus, once the ideograms Fei and Lin are juxtaposed and we can see their erotic dissolution into each other, we can read the concept that arises: the erotic violence of the cinematic image. This suggests Fei and Lin's metaphoric role/roll in the film to be a comment on the very act of filmmaking and the dual role of the cut, that which works on the level of edits and transitions as well as the interstitial frame line between photograms. Between two cuts—and between each image flitting by—is an erotic and violent exchange that enables the sacred collapse of the discontinuous.

Once Fei and Lin reveal Fernando's journey as inextricably linked to the notion of film, other associations can be untangled. At several points in the film, water currents are explicitly linked to transitions between shots. Water is a crucial element to the film's plot; the action takes place alongside a river, in the canyons of a region known as Trás-os-montes, or "beyond the mountains."[17] Moments into the film, Fernando disappears into the rapids after overturning his kayak. The water blends into the appearance of pilgrims in the woods, and currents ripple into wind through trees as the images are superimposed onto one another (0:16:25–0:16:38).[18] The accident and the filmic transition that accompanies it signal the beginning of Fernando's spiritual journey, and the movement from the terrestrial to the celestial. The use of such a technique prepares the spectator for a shift in the protagonist's relationship to his surroundings. Superimposition, particularly in early photography and cinema, was used to produce spectral images of ghosts and was thought to provide access to the spirit world.[19] What is more, fluid images—or images of water—invoke a

spiritual element, "a more than human perception" through what Gilles Deleuze has called "liquid perception."[20] Abandoning traditional continuity editing signals the film's departure from earthly, solid perceptions to a spiritual, "liquid perception" characteristic of a departure from secular terrain. In *O ornitólogo*, these spectral transitions aid the spectator in suspending his or her expectation of terrestrial space and time logic and perceiving what is beyond the frame, to sense *the beyond* in general.

What the flowing water also achieves, beyond priming the spectator for the otherworldly, is to link the idea of film to that of a moving river. As we have seen, water is explicitly related to transitions between shots. The river itself becomes an allegory of photo frames coursing past on a film reel. Shortly after the kayak disappears into the rapids, two pilgrims make their way to the edge of the river. The liquid flow morphs into a slideshow montage of the photographs they have taken of their trip along the Way of Saint James (0:21:47–0:23:36). Their travel photographs tell the story of their journey, their progress through terrestrial space, and the time that has passed during their trek. The fluid motion of the river, from which the slideshow emerges, enacts the passage of time for the spectator through montage. At first, the film lingers on each photograph before increasing the speed at which the photos pass by. Momentarily, the equitable distribution of filmic time among frames is disrupted and the temporal meter of the film seems to quicken.[21] This rupture in traditional film time highlights the spectator's subjugation to the rhythm of the images coursing by, not unlike being fixed—bound in place—in the middle of a river, at the mercy of its flow. The images floating past will change the spectator, by virtue of experiencing the film even as he or she remains physically fixed in the flow of images on a screen.[22]

Effectively, the river and the montage sequence reinforce the river's connection to the apparatus of cinema.

From here on, geographic location will have no bearing on either Fernando's or the pilgrims' journeys. The scenery assists us with this transition as it positions the protagonist, along with the spectator, within vertical space. The canyon walls rise above Fernando, emphasized by the camera's insistence on pulling our gaze skyward. Vertical space is associated with the mythical realm, as opposed to the secular nature of horizontal space.[23] Fernando began the film kayaking down a river, and the pilgrims hiking down a path, each traversing horizontal secular space, only to abandon geographic destinations and embark on a spiritual journey. These transitions, the superimposition and the slideshow, signal the moment, for Fernando and the pilgrims, respectively, when their journeys are no longer tied to a logic of space and time. Later in the film, a double-exposure technique overlays images of Fernando's adventure (1:23:13–1:23:40). As he sleeps in an abandoned monastery, his image (that of Fernando alternating with that of António) is superimposed with elements of

his journey, both already passed and yet to come: sculptures of saints, the shepherd Jesus, the dove that sees Fernando's multiple selves, and the fish to which he will preach. The flowing river is superimposed over the entire montage. If the earlier slideshow of the pilgrims' journey linked flowing water to film, the logic on which this was predicated has now shifted. The equivalence between time passing and space traversed has been dismantled; the water's flow suggests not the montage-like passage of time but another kind of time wherein multiple temporalities coexist.[24] Film as flowing water now suggests the qualitatively changing whole of time, and the qualitative transformation of Fernando.

The river, as well as Fei and Lin, help us think about film and the splicing together of images. Other moments reveal a philosophy of filmic transcendence unfolding alongside the film. After rescuing Fernando, Fei and Lin tie him up and go to sleep in their tent. They leave the scientist as bait for the *tengu* demon—a Shinto god—and whisper their plans to castrate him in the morning (00:39:55), a violent desire that mimics film's syncope or that which is lost between frames. Indeed, loss and repetition pervade the film. In the wake of a strange ritual, Fernando finds his lost gear. Someone has burned out his eyes on his identification card and removed the image of his fingerprint, a sign of his dissolution, a discontinuity becoming continuous (0:52:13). Eventually, Fernando deliberately sheds his identity. He burns off his fingerprints, while discarding his worldly possessions, including his phone, his identification, and his pills, tossing everything into the river (1:31:02). This fragmentation and reassembly are crucial to Fernando's eventual spiritual ecstasy and transformation into António; it is the revelation of "continuity through the death of a discontinuous being."[25] Just as Fernando's worldly losses make space for a new synthesis, a new totality, their partial reacquisition allows for his eventual transformation into Saint Anthony. In turn, what is omitted (cut) and assembled (spliced together) allows for the spectator's consumption and sublime devouring of the film as product.

The violence to which the odd pair subject Fernando also acts as commentary on film. In addition to the sacred violence that makes film possible, the collapse of the discontinuous images of which it is composed, Fei and Lin's actions suggest an erotic union with the spectator, a union predicated on erotic bondage. After rescuing Fernando, the pilgrims capture him—like the film captures a spectator—suggesting the violence of the camera, its ideological and suturing work, but also the spectator's subjugation and stillness before the moving image. After the Chinese pilgrims drug and restrain Fernando, the image of his awakening, while tied to a tree, is evocative of Guido Reni's paintings of Saint Sebastian (0:34:57), suggestively penetrated by arrows, which have helped consecrate this particular saint as a homoerotic icon.[26] As Fernando struggles in his bonds, he is clearly, if not fully, aroused. The technique used to tie him

FIG. 13.2 Fernando (Paul Hamy) escaping from his bonds. *O ornitólogo* (2016) by João Pedro Rodrigues. Courtesy of Blackmaria.

up is reminiscent of Hojōjutsu, a binding technique traditional to Japanese martial arts that restrains a captive *without any knots*.[27] The Hojōjutsu beautifully analogizes film's "narrative elision of the image flow" described by Stephen Heath.[28] The rope's aesthetic uninterruption presents the illusion of a seamlessness, a freedom from rupture, a continuity (an invisible editing), an aestheticizing that belies the violence of its purpose: restraint, confinement, capture. The Alfred Hitchcock film most lauded for its invisible editing, after all, is titled *Rope* (1948). The movie spectator, like Fernando, is ensnared by the film's knotless suture, Heath's "surgical tying of the lips of a wound,"[29] which ropes the spectator into the action, a mechanism made possible by the cinematic cut that harnesses the productivity of omission. Heath cautions us to heed the political problem of film, the erasure of its mechanical artifice, and the manipulation of image and desire—making subject—through suture: "In its process, its framings, its cuts, its intermittences the film ceaselessly poses an absence, a lack, which ceaselessly bound up in and into the relation of the subject, is, as it were, ceaselessly recaptured *for* the film."[30] The rope's emphasis on ceaselessness is an emphasis on continuity, on unification. What is more, Hojōjutsu, historically a torture and military technique, was repurposed for aesthetic use by twentieth-century Kabuki theater, an early configuration of *kinbaku*, a kind of erotic rope bondage. In addition to paralleling the spectator's continuity with the film, this eroticized violence triggers Fernando's spiritual awakening. The bound state of the spectator allegorized in Fernando's bonds is not merely a process of subjectification; Fernando's predicament is explicitly erotic and explicitly violent. *O ornitólogo* asks the spectator to consider his or her relationship with film through a logic of bondage and domination, submission to force, and the resulting sacred union. The audience, we might say, is sutured in precisely through the process of an erotic violence (the cuts), which place us in communion—in continuity—with the movie.

Acts of sacred violence hurl the film reel, and Fernando along with it, to their respective destinations: a finished film and the afterlife. After escaping from the pilgrims, Fernando encounters a group of *caretos*, masked men enacting a pagan and distinctly Portuguese ritual.[31] Later, he meets a deaf and mute shepherd pointedly named Jesus—eroticizing the appearance of the baby Jesus to Saint Anthony. The amorous encounter ends tragically when Fernando accidentally kills Jesus. This violence, like Fernando's role in it, has a utility: it is key to his dissolution of self. In the final sequence, António—in the form of Rodrigues—resurrects a dead boy wearing a *careto* costume and a *tengu* mask. Removing the mask, he finds the face of Jesus, the young man whom he killed (1:42:45). This, it turns out, is Jesus's twin brother, Tomé. Perhaps the film's most overtly abject moment occurs as António raises Tomé's shirt to reveal an injury in his side, identical to the wound Jesus received from Fernando and a clear reference to the Spear of Destiny (1:41:10). In the book of John, we find:

"Instead, one of the soldiers pierced Jesus' side with a spear, bringing a sudden flow of blood and water" (19:34). The blood and water symbolize Jesus's dual nature, both celestial and terrestrial, a baptism and an atonement. Water, I have argued, speaks to the perception of the film as spiritual, while blood is related to the erotic abjection performed in the filmic cut. In the film's most squeamish image, António penetrates the vagina-like opening of the wound with his fingers, assuming the role of Doubting Thomas who probed Jesus's spear wound after doubting the veracity of the resurrection (1:41:10–1:42:10). Moreover, this image recalls Heath's "lips of the wound" allegorizing the filmic suture. This confrontation with the abject is key to Fernando's final transition to António: the revulsion caused by abjection triggers his desire to transcend the body's boundaries.[32] Julia Kristeva's abject appears, with its echoes of the sublime, an important modality for Christian mysticism: "The Christian mystic's familiarity with abjection is a fount of infinite jouissance. One may stress the masochistic economy of that jouissance only if one points out at once that the Christian mystic, far from using it to the benefit of a symbolic or institutional power, displaces it indefinitely . . . within a discourse where the subject is resorbed . . . into communication with the Other and with others."[33]

It is precisely this resorption into communication with the Other that the film employs as a strategy to represent the possibility of a mystical continuity, and therefore, posits as the power of film itself. We are bound, sutured, in the creation of continuity between spectator and image, like a mystic seeks continuity with the Other. As Georges Bataille writes, "Indeed, mystical experience reveals an absence of any object. Objects are identified with discontinuity, whereas mystical experience, as far as our strength allows us to break off our own discontinuity, confers on us a sense of continuity."[34] Indeed, the nauseating image of penetrating the wound undoes the subject/object, inside/outside opposition, enabling a transcendence into a greater whole. In the penultimate scene, the violent filmic cut is finally enacted for the spectator. The resurrected Tomé realizes that António was responsible for his brother's murder. Tomé cuts António's throat (1:47:17). The shot of António's bleeding neck is interpolated with the image of Paul Hamy as Fernando (1:47:17–1:47:43). The initial reaction to the cut is shock, but as the blood flows more heavily from the wound, Fernando and António raise their eyes up in ecstasy, suggesting a divine union with their split halves, with the spectator, with a greater whole, or, as this essay contends, with the film itself. The slitting of the throat renders the cinematic splicing of images together, a match cut—a dialectical collision of two ideas whose unity, rendered through violence, becomes transcendent. Death undoes the discontinuity between them, and a new Fernando, finally Santo António, reaches the afterlife.

The film closes with Santo António walking down a busy street on the outskirts of Padua, Italy. António, transformed, is perhaps experiencing a future

FIG. 13.3 *Caretos wearing tengu masks. O ornitólogo (2016) by João Pedro Rodrigues. Courtesy of Blackmaria.*

(a death) free from HIV. The Chinese women call out to him: "Hello António! Hello António! Finally you have found your path!" (1:48:30–1:48:31). As he wanders down the street holding hands with Tomé—still dressed as a *careto*—António Variações's "Pick-up Song" plays:

> You are free and I am free / and there is a night to be spent / why wouldn't we spend it together / why don't we embark / on an adventure of the senses . . . come, because love / isn't time / Nor is it time / that makes it / Come, because love / is the moment / where I give myself / and you give yourself / You who looks for company / and I who look for whomever is willing / to be the recipient of this energy. / To be a body of pleasure . . . / And I am better than nothing. (1:48:50–1:53:00)

Variações provides the only lyrics in the soundtrack, that of a hookup ballad, or divine erotic union. The change the birds divined from the beginning has reached its conclusion: Fernando has become António. This shift has unfolded in tandem with the passage of the film; he switches from a terrestrial time and space logic to a celestial journey where he inhabits multiple temporalities and multiple selves. The discontinuities of his identity are smoothed over into a continuous whole through loss and reformation. The abject eroticism of the splicing together of images—revealed in the pilgrims' names—is fully enacted in the final match cut that allows Fernando to fully become António. The cut acts as a sacrificial guillotine that holds the audience in thrall. Rodrigues does not merely depict achieving mystical union in *O ornitólogo*; the film *is* that mystical union.

Notes

1 Juan Carmona Muela, *Iconografía de los santos* (Tres Cantos, Spain: Akal, 2015), 34–37.
2 Aisha Rahim, "Interview with João Pedro Rodrigues," *Metropolis* 41 (August 21, 2016), http://www.cinemametropolis.com/index.php/pt/revistas/2015/k2-categories/sport/ item/1525-o-ornitologo-joao-pedro-rodrigues-em-entrevista. All translations are mine, unless otherwise indicated.
3 Sergio is the protagonist of an earlier João Pedro Rodrigues film, *O Fantasma* (2000) [*Phantom*]. While this is surely not the same Sergio, who turns into a dog at the end of that story, I believe the use of this name evokes the Rodrigues canon.
4 Christopher Heron, "A Voyage in Space and Time: João Pedro Rodrigues Interview (*The Ornithologist*)," *The Seventh Art*, October 15, 2016, theseventhart.org/joao -pedro-rodrigues-interview-the-ornithologist/.
5 Heron (emphasis added).
6 I use the word "sublimation" in the sense of a metaphoric change of state and am not engaging with the psychoanalytical perspective.

7 Especially present in depictions of lactating Virgins, for example, *Madonna del Latte* (1324–1325) by Ambrosio Lorenzetti or Lorenzo Monaco's *Madonna of Humility* (1418). See Ambrogio Lorenzetti, *Madonna del latte*, 1324–1325, Palazzo Arcivescovile, Siena, and Lorenzo Monaco, *Madonna of Humility*, tempera and gold on panel, 1418, Thorvaldsens Museum. The Virgins are dressed in blue, the baby Jesus in pink. The references to religious artwork in the film are intentional. Rodrigues has explained how his education in biblical stories was based on religious paintings: "I'm a very rational person who's not religious at all. But I'm very attracted to the idea of how religion is told. What made religion interesting for me was art. I learned about the stories of Christ and the saints through paintings, which is natural when you consider that the story of Western painting begins almost purely with depictions of religious stories and characters." Robert Koehler, "Super-ornithologist: João Pedro Rodrigues' Birdman," *Cinema Scope* 69 (2017), http://cinema-scope.com/features/super-ornithologist-joao-pedro-rodrigues-birdman/.

8 Walter Benjamin, *Reflections*, trans. Edmund Jephcott (New York: Random House, 2007), 335.

9 Benjamin, 334.

10 Michael W. Jennings, *Dialectical Images: Walter Benjamin's Theory of Literary Criticism* (Ithaca, NY: Cornell University Press, 1987), 119.

11 According to Jennings, Benjamin's language theory and the "flashing up" of a dialectical image appear in the reading of names in an anecdote included in *The Arcades Project*:

> There is Place du Maroc in Belleville: that desolate heap of stones with its rows of tenements became for me . . . not only Moroccan desert but also, and at the same time a monument of colonial imperialism; the topographic vision was intertwined there with allegorical meaning in this square, . . . , street names are like intoxicating substances that make our perceptions more stratified and richer in space. . . . One could call the energy by which they transport us into such a state their *vertu évocatrice*, their evocative power—but that is saying too little; for what is decisive here is not the association but the interpenetration of images. (P1a,2)

Walter Benjamin, *The Arcades Project*, trans. Howard Eiland and Kevin McLaughlin (Cambridge, MA: Harvard University Press, 1999), 518. A history of colonial imperialism can flash up and intoxicate a reader with a vision. With this passage, Jennings suggests that the "density and complexity of realms of experience" can be "entwined in names."

12 The word *fēilín* (菲林) is out of use in Mandarin and has since been replaced by *jiāo juǎn* (胶卷). In Cantonese, however, *fēilín* is commonly used especially in cities like Macao whose history is deeply intertwined with Portuguese colonialism and serves as the setting of Rodrigues's *A última vez que vi macau* (2012). The pilgrims, however, are speaking Mandarin.

13 Georges Bataille, *The Tears of Eros*, trans. Peter Connor (San Francisco: City Lights, 1990), 206.

14 For Julia Kristeva, abjection—"edged with the sublime"—results from a breakdown in meaning between self and other, manifested in human reactions like horror and disgust. Julia Kristeva, *Powers of Horror: An Essay on Abjection*, trans. Leon S. Roudiez (New York: Columbia University Press, 2010), 11. Kristeva concludes that Christianity "identified abjection as a fantasy of devouring" (119).

As Virginia Burrus notes, "For ancient Christians, the abjection of the flesh went hand-in-hand with the exaltation of divinity." Virginia Burrus, *Saving Shame: Martyrs, Saints, and Other Abject Subjects* (Philadelphia: University of Pennsylvania Press, 2007), 47. The consumption of the flesh of the savior by the faithful in the communion ritual "results in their virtual identification (I in you and you in me), it also results in a mutual and ongoing transformation of identity. Flesh as food traverses bodily boundaries and brings us again to the threshold of the boundary-dissolving abject" (Kristeva, 50). For Kristeva jouissance emanates from the mystic's familiarity with abjection (127). This "jubilant self-abjection" can be seen in Francisco de Assis's kissing the leper, Angela of Foligno drinking the water that was used to clean a leper's sore, and Catherine of Siena drinking a cup of pus. Cristina Mazzoni, *Saintly Hysteria: Neurosis, Mysticism, and Gender in European Culture* (Ithaca, NY: Cornell University Press, 1996), 87.

15 Sergei Eisenstein, *Film Form*, trans. Jay Leyda (San Diego: Harcourt, 1949), 49.

16 Eisenstein, 37.

17 Trás-os-montes is where António Reis and Margarida Cordeiro made *Trás-os-montes* (1973) a film which Haden Guest calls "a lyrical search for the very 'soul' of Portuguese culture and history in the myths and peasant folklore embodied in Portugal's remote far-north region." Haden Guest, "The School of Reis: The Films and Legacy of António Reis and Margarida Cordeiro," Harvard Film Archive, accessed December 21, 2017, http://hcl.harvard.edu/hfa/films/2012aprjun/reis.htm. In fact, Margarida Cordeiro helped Rodrigues find locations to shoot *O ornitólogo*. Rahim, "Interview to João Pedro Rodrigues." The ethnographic flavor of *Trás-os-montes* is gone, however, and in Rodrigues's work the landscape takes center stage.

18 Before World War II, directors like Abel Gance invented the superimposition of images, a layering spooky effect, which according to Gilles Deleuze created "an effect of all these superimpressions in the soul, on the constitution of a rhythm of added and subtracted values, which presents to the soul the idea of a whole as the feeling of measurelessness and immensity." Gilles Deleuze, *Cinema 1: The Movement-Image*, trans. Hugh Tomlinson and Barbara Habberjam (Minneapolis: University of Minnesota Press, 1986), 48.

19 Simone Natale, "A Short History of Superimposition: From Spirit Photography to Early Cinema," *Early Popular Visual Culture* 10, no. 2 (2012): 126. In André Bazin's essay "The Life and Death of Superimposition," he posits, "Superimposition on the screen signals: 'Attention: unreal world, imaginary characters.'" See André Bazin, "The Life and Death of Superimposition (1946)," trans. Bert Cardullo, *Film-Philosophy* 6, no. 1 (2002), https://www.euppublishing.com/doi/full/10.3366/film.2002.0001.

20 Deleuze, *Cinema 1*, 80. These kinds of effects harken back to the pre–World II French films responsible for inventing "the cinema of the sublime" 48). Images of water were harnessed to extract forms of movement that expressed the "open whole as the immensity of future and past" (46). Liquid was imbued with another state of perception than solids, a perception "which passed through or under the frame" (80) and, as opposed to solid terrestrial perception linked to the earth, contained a "clairvoyant function" associated with liquid (79).

21 In *The Emergence of Cinematic Time*, Mary Anne Doane has shown film to be uniquely modern in its relationship to time and contingency. In cinema, "time is a series of equivalent and equidistant instants, subjected to no hierarchy

whatsoever." Mary Ann Doane, *The Emergence of Cinematic Time: Modernity, Contingency, the Archive* (Cambridge, MA: Harvard University Press, 2002), 179. In the instance of the slideshow, however, a kind of temporal hierarchy is reinstituted, and the film momentarily appears (if perhaps not in a technical sense) to do away with cinema's traditional rhythm of consistent frames per second.

22 Movement, from a Bergsonian perspective, is *transformation* rather than mere translation. See Ronald Bogue, *Deleuze on Cinema* (New York: Routledge, 2003), 24; Henri Bergson, *Œuvres*, ed. André Robinet (Paris: Presses Universitaires de France, 1959), 521.

23 Yi-Fu Tuan, "Space and Place: Humanistic Perspective," in *Philosophy in Geography*, ed. Stephen Gale and Gunnar Olsson (Berlin: Springer Verlag, 2013), 395.

24 The distance between these two scenes that use the river as film analogy enacts the switch from the movement-image to the time-image described by Deleuze. See Gilles Deleuze, *Cinema 2: The Time-Image*, trans. Hugh Tomlinson and Robert Galeta (Minneapolis: University of Minnesota Press, 1989).

25 Georges Bataille, *Erotism: Death and Sensuality*, trans. Mary Dalwood (San Francisco: City Lights, 1986), 22.

26 Susan Sontag connects Saint Sebastian to the photograph of the *Hundred Cuts* Georges Bataille kept on his desk and featured in *The Tears of Eros*. See Susan Sontag, *Regarding the Pain of Others* (London: Penguin Books, 2004), 98; Bataille, *The Tears of Eros*, 204.

27 This image has echoes of Yukio Mishima's *Confessions of a Mask* (1949), which tells the story of a young man coming to terms with his homosexuality. Mishima's first masturbation to ejaculation was inspired by a painting of Saint Sebastian. See Yukio Mishima, *Confesiones de una máscara*, trans. Rumi Sato (Madrid: Alianza, 2015), 48. In fact, much of the film recalls paintings, both religious and secular. The promotional poster artwork, an image of Fernando immediately after freeing himself from bondage (0:38:33), recalls Jean Bernard Restout's depiction of the god Morpheus, *Sleep* (1771). See Jean Bernard Restout, *Sleep*, oil on canvas, 1771, Cleveland Museum of Art.

28 Stephen Heath, "On Screen, in Frame: Film and Ideology," *Quarterly Review of Film Studies* 1, no. 3 (1976): 261.

29 Heath, 261.

30 Heath, 261.

31 The *caretos* are masked young men associated with winter solstice festivals. *Os caretos* participate in a traditional coming-of-age ceremony in which only young, single men can participate. They wear costumes decorated with red, green, and yellow wool fringe. The festival is a carnivalesque ritual, a space where everything is permitted. "*Caretos* transpose the dark side of human beings into reality through a symbolic performance, therefore achieving the liberation of the more mischievous and diabolic side of the human soul; it is a way of purging it or purifying the community for the new year." Carlos Carneiro, "Caretos," *Portugal num Mapa*, accessed May 22, 2017, http://www.portugalnummapa.com/caretos/. The overall effect of the *careto* costume is that of a bird with feathers.

32 Mazzoni, *Saintly Hysteria*, 86.

33 Kristeva, *Powers of Horror*, 127.

34 Bataille, *Erotism*, 23.

14

Queering Lisbon in Paulo Rocha's *A raíz do coração* (2000)

•••••••••••••••••••

Santo António Festivities, Politics, and Drag Queens

RUI TRINDADE OLIVEIRA

A raíz do coração [*The Heart's Root*] is, as indicated in its opening credits, a "dramatic fantasy" centered around the tragic love story between Sílvia (who used to be Sílvio), a young transgender woman, and Vicente, a member of a far-right militia who patrols Lisbon at night. Nevertheless, the central character is the city of Lisbon. A futuristic Portuguese capital during the Santos Populares (Popular Saints) festivities serves as a background. The film is a visually vibrant allegory that looks at Lisbon as a modern metropolis but also as an ancient city clinging to old traditions. Strangely, though, the film cannot be found in digital format at all. At the time I am writing this, even in Portugal the film has only been distributed on VHS and was never distributed on DVD. Unfortunately, this is the case for most of the films by this director, Paulo Rocha, in addition to many older Portuguese films in general. In 2014, none of Rocha's films had been distributed on DVD.[1]

Portuguese cinema has always found great difficulty in entering international markets and adapting to an increasingly globalized world. Even

becoming a transnational cinema and joining the "international art films" or "world cinema" categories has been a rare occurrence, as pointed out by João Maria Mendes.² Mendes suggests two main reasons for the stagnation of Portuguese cinema and why it is still confined to a categorization of national cinema incapable of crossing its national borders: its financial dependence on state subsidies and public funds, with residual financing from international production companies; and its weak diffusion and circulation in international film markets.³ These difficulties have inevitably affected and limited the production of Portuguese genre cinema—and queer cinema is no exception.

The Portuguese film industry has always been a fragile one, at least after the golden age of the more successful musical comedies of the 1930s and 1940s ended. This national cinema was officially backed by António de Oliveira Salazar's fascist regime (1933–1974), as it was, with few exceptions, an anodyne cinema with a main purpose: to provide a way of escapism to Portuguese audiences. This meant that other genres or cinema movements, which failed to comply with the principles and ideology of the regime, would not find funding or even be produced at all. Nevertheless, and after a decade of stagnation, a new cinema movement known as Cinema Novo (New Cinema), influenced by the French Nouvelle Vague, developed in the early 1960s and allowed fresh blood and new ideas to revolutionize Portuguese cinema. This movement accompanied the explosion of film as an artistic medium across the world. Peter Cowie notes that during the 1960s, film was seen as "a medium that knew no artistic limitation."⁴ Paulo Rocha, thirty-seven years before making *A raíz do coração*, was one of the filmmakers responsible for this new movement in Portugal.

It is difficult to speak about queer cinema in the Portuguese context, as there are so few films dealing with the subject, scattered across four decades after the fall of Salazar's dictatorship. João Ferreira (artistic director of Queer Lisboa— International Queer Film Festival) points out that Portuguese queer cinema as an independent production industry is still a fragile one and adds that it is "difficult to write about an aesthetic and narrative coherence within those films that deal with homosexual or transsexual themes in Portugal."⁵ Therefore, it is probably more correct to speak about Portuguese queer films than a Portuguese queer cinema per se. When thinking about these films, Portuguese gay director João Pedro Rodrigues is the name that comes to mind, as he can be considered the filmmaker who bravely delved into the queer subjectivities in Portuguese cinema with a controversial art film that ended up winning several international awards and acquiring cult status. I am referring to his first fiction feature, *O fantasma* (2000) [*Phantom*], which Antônio M. da Silva analyzes in his article "The Portuguese Queer Screen: Gender Possibilities in João Pedro Rodrigues' Cinematic Production," regarding the construction of queer subjectivities and how these characters relate to the urban space they inhabit (in this case also the city of Lisbon).⁶ Not as revolutionary as

João Pedro Rodrigues's *O fantasma*, *A raíz do coração* (which premiered the same year), from straight director Paulo Rocha, nevertheless can be considered as one of the most surprising films of his filmography and one of the most kitschy films to have been produced in Portugal. The film engages with queer characters and their roles within tradition, politics, and family in Portuguese society. These themes are explored through a transgressive fantasy set in Lisbon in 2010, during the election campaign for a new mayor. The aim of this essay is to examine how Rocha explores the city of Lisbon, how he situates his characters (queer and nonqueer) in a city that is experiencing constant change, and how he uses them to reflect on the idiosyncrasies of a nation—a nation that has made an abrupt transition from dictatorship to democracy and that is still at odds with its oppressive past, while at the same time looking to the future with high expectations. Before analyzing this urban fable of recent Portuguese cinema, it is important to contextualize Rocha's cinematic output.

Paulo Rocha: From Black-and-White Neorealism to Colorful Urban Fables

In 1962, while studying for his film directing degree at the Institut des hautes études cinematographiques in Paris, Paulo Rocha started as a trainee assistant director to one of the most relevant names of the French Nouvelle Vague, Jean Renoir, in the film *Le Caporal épinglé* (1962) [*The Vanishing Corporal*].[7] When he returned to Portugal, Rocha worked as assistant director to Manoel de Oliveira, before directing his own first feature film.[8] Rocha would then become one of the most relevant Portuguese directors to arise from the Cinema Novo movement in Portugal in the 1960s, along with other names of this movement, such as António Reis, Fernando Lopes, and João César Monteiro. In fact, his debut feature film, *Os verdes anos* (1963) [*The Green Years*], is a seminal work in the history of Portuguese cinema. Considered by some critics and film historians the film that initiated this new Portuguese cinema movement, it became a main reference for future generations. The film was produced by Produções Cunha Telles, which also produced Rocha's second feature, *Mudar de vida* (1966) [*Change One's Life*].[9] In its subject matter and focus, *Os verdes anos* can be said to reveal the influence of Italian neorealism. The main characters belong to the working class: Júlio, an aspiring shoemaker who has moved from the rural countryside to Lisbon, and Ilda, a housemaid working for a bourgeois family in the capital—who in due course fall in love with each other. It was the film's new formal aspects (filmmaking language and mise-en-scène) that caught the attention of international critics, as it moved away from the old and conventional cinema promoted by Salazar's "Estado Novo."

Through the trajectories of Júlio and Ilda, Rocha explores the growing migratory movement of rural workers from the countryside to Lisbon in search of a

better life, and reflects on the social struggle of working-class communities in the capital in the 1960s. Supported by a melancholic soundtrack that is dominated by the music of the iconic Carlos Paredes (the musician who made the Portuguese guitar popular), the film is embedded with strong lyricism that is highlighted by the inspired cinematography by Luc Mirot. The way Rocha shoots the Portuguese capital—a city undergoing an accentuated urban expansion—from the new city blocks of the Estado Novo to the "ancient city," contributes to this lyricism. Formally, sometimes Lisbon is shown in very closed shots, as if to accentuate the claustrophobic feeling of an "enclosed city" where the characters are trapped. As critic and academic João Bénard da Costa has argued, "A vision of Portugal, or Lisbon, as a claustrophobic space, with no way out, where everything thwarts and agonizes itself (in a slow death) is shown for the first time in Rocha's film."[10] In *A raíz do coração* Rocha again explores Lisbon's urban spaces, as I will analyze later in this chapter. In *Os verdes anos*, the director makes use of this mechanism to convey that Lisbon, along with the rest of the country, was suffocating under the authoritarian regime of Salazar. In the dialogue between the characters, one can also identify a subtext of subtle criticism against the regime, which Rocha skillfully uses to avoid the censor's cut.

Rocha's next film, *Mudar de vida* (1963) [*Change One's Life*], is also a portrait of the working class's struggle to survive, this time focused on a fishing community at Furadouro Beach in the north of Portugal. Narratively and aesthetically, the film is embedded with the neorealist style that was a trademark of Rocha's cinema at that time, blended with a documentary style that depicts the fishing community's everyday activity. The film also serves to document the disappearing traditional labor techniques and the religious traditions deeply rooted in the coastal communities of northern Portugal.

In the 1980s, Paulo Rocha's cinema would become less narrative and more focused on exploring formal innovations, thus proving itself to be an antinaturalistic cinema as shown in *A ilha dos amores* (1982) [*The Island of Love*], Rocha's love letter to the Japanese cinema of Kenji Mizoguchi and Yasujirô Ozu. This increasing stylization, with a turn toward a more exuberant and operatic mise-en-scène, would reach its peak with his films of the late 1990s and early years of the first decade of the 2000s. *A raíz do coração* is one of the most representative of this new aesthetic period.

Lisbon: A New Modernized City

The portrayal of how deep social and economic changes affect the way of life and the struggles of specific working classes or social groups in Portugal has been present in most of Paulo Rocha's filmography, including *A raíz do coração*. When the film premiered in 2000, there was an ongoing debate in the

public sphere and in Parliament regarding the inclusion of same-sex couples in the nonmarital partnership tax status. The bill regulating this issue and allowing this inclusion would be approved in 2001.[11] In 2000, the country was also undergoing intense economic growth and still enjoying a very positive response from within Europe while also experiencing a surge in world tourism thanks to Expo '98. The world's fair, set in the capital, was the largest cultural event to have happened in Portugal since democracy had been restored. Besides its relevant economic impact, Expo '98 also changed the face of Lisbon.[12] The entire area at the eastern end of the city's waterfront was rebuilt for the event. When it was finished, the new urban district was named Parque das Nações (Park of Nations), which today is one of the largest urban redevelopment projects in Europe. The event also required improved public transport and new infrastructure across the capital, including a new bridge over the Tagus River—the Vasco da Gama Bridge, at that time the longest in Europe.

With a more modern, even futuristic facade, Lisbon also became a more open and welcoming city to the global tourist, as a metropolis it was with urban spaces similar to those in other European capitals. Despite being aesthetically far from Rocha's 1960s neorealist films, *A raíz do coração* still shares with *Os verdes anos* the detail and importance given to the spaces and the characters within those spaces. In *A raíz do coração*, Rocha clearly prioritizes the mise-en-scène over the script, as he did in *Os verdes anos*. In fact, Rocha overtly admitted this in an interview, regarding the latter: "The same story can be told in two ways: a good way or a bad way, and still be the same story. The fact that I overvalue the mise-en-scène is therefore a question of war against mental and moral laziness. . . . In *Os verdes anos* I tried to fight against this [laziness]. What interested me the most was the relation between the decor and the character, the way the cinematographic 'matter' was treated."[13]

In *A raíz do coração*, the way the city is framed from within its most iconic open sites, the way Rocha shoots the interiors of Dona Ju's Photo Française (a photography studio) or Catão's apartment, and the way the characters are displayed within those sets are all testimony to Rocha's formal preoccupation with the relation of the set to the characters, and ultimately the composition of every shot. Nevertheless, and attesting to his experimental penchant for mixing aesthetics, the director also uses a different aesthetic language that contrasts with this rigorous mise-en-scène. In a scene in which Sílvia decides to pick up her video camera and go out to the streets of Lisbon to film the residents celebrating the Santo António (Saint Anthony) festivities, Rocha makes use of this new technology to bring back, for a brief moment, the documentary language he had used so effectively in *Mudar de vida*, showing us the people of Lisbon (nonactors) engaging in these traditional festivities. The relevance of video as a revolutionary technology is also highlighted when one of the characters uses it as a privileged medium for her blackmailing business. At

the time of the film's release, video technology was a new experimental medium being explored in Portuguese cinema, and that year another relevant contemporary director, Pedro Costa, used it to shoot his film *No quarto da Vanda* (2000) [*In Vanda's Room*] in its entirety.

Aesthetically, *A raíz do coração* is closer to Rocha's previous film, *O rio do ouro* (1998) [*River of Gold*], which was an homage to the Douro River region in the north of Portugal, or to *Vanitas* (2004) [*Vanity*], in which he shoots the city of Porto and the world of fashion design. In these three films, the color palette is rich and varied, exploring all the possibilities given by either a wild countryside landscape of one of the largest rivers in Portugal (*O rio do ouro*), the kaleidoscopic range of colors of the fashion design world established in Porto (*Vanitas*), or the bursting of colors of Lisbon's popular summer festivities in *A raíz do coração*. With the latter, Rocha returns to Lisbon, the city he filmed in *Os verdes anos*, as the central character. This time, however, he pays homage to the capital by shooting it as a modern city facing the future, while at the same time preserving its old traditions and romantic charm.

The main characters move around a city celebrating the Santo António festivities, the popular saint who is the patron of newlywed couples and of the city of Lisbon.[14] During these festivities, which take place during the month of June, many iconic sites of the capital are bathed in light and color, especially its central and traditional *bairros* (neighborhoods). There, almost every street is festively decorated, and small courtyards become hubs of traditional Portuguese music where all can dance, eat, and drink. At the same time, Rocha portrays a city inundated with political demonstrations and protests occurring during the campaign for the new mayor. The main urban conflict in the film happens precisely between the supporters of far-right candidate Catão (played by Luís Miguel Cintra) and the protesters against his campaign, a colorful group of drag queens. *A raíz do coração* was initially thought of as a musical. However, due to budgetary constraints, it ended up becoming a "dramatic fantasy" containing only a couple of musical moments, with lyrics by Regina Guimarães and music by Portuguese author-composer José Mário Branco (who also composed the soundtrack for *O rio do ouro*). Although infrequent, these musical moments provide the lyrics and melodies that are present during the whole film, as these define the stereotypical antagonistic groups (the drag queens and the far-right militia). Even when there is no music, the characters find themselves humming or just saying the lyrics.

The urban spaces of Lisbon are fully exploited by Rocha: both the sites of historic and ancient Lisbon, and the new architectural landmarks built during the recent economic boom and Expo '98. Relevant scenes are set in iconic tourist sites, such as the Elevador de Santa Justa (Santa Justa Elevator/Lift), the little squares centered around fountains from Príncipe Real area that overlook the city, the quayside of the Tagus River, the Castelo de São Jorge on one of

Lisbon's hilltops, or the Praça do Comércio/Terreiro do Paço. At some of these sites, the Santo António festivities mix with the political rallies and campaigning from Catão, the candidate for the fictitious right-wing party, the Popular National Front. The new area of Parque das Nações and the Vasco da Gama Bridge also features in scenes in which Catão is holding a private party for his supporters and the night militia he secretly controls. Contrasting with the way Rocha filmed the capital in *Os verdes anos* (a claustrophobic and enclosed city), here he frames Lisbon as a spacious and free city, with its monumental open spaces that are full of potential and where everyone is welcome. The action is set in the year 2010 (ten years in the future from when the film was released), which helps the viewer think of the Portuguese capital as a modern city projected into the future. Rocha shoots Lisbon as a seductive and colorful lover, whose magic and appeal seduce not only the creatures of the night (symbolically represented by the drag queens) but mostly Catão, who is trying to become the mayor of this alluring city at whatever the cost so that he can purge it from the "undesirables" and bring it to the "purity" of old times. These open spaces are presented as spaces for celebration and collective partying (especially during these festivities), where the people can indulge in dancing and drinking.

At the same time, these open spaces are also presented as spaces for demonstrations and social protest, where citizens can express their social and political concerns in total freedom without fear of being attacked or arrested, despite the oppressive forces that lurk in the shadows. Rocha ultimately shows us a new Lisbon, a noisy city that is no longer silenced by the dictatorial regime of Salazar (as he presents it in *Os verdes anos*), but also a Lisbon susceptible to falling into the wrong hands again, especially if its people are not aware of what is happening in the streets or do not consciously exercise the right to vote.[15] In those cases, even far-right candidates such as Catão can attempt to bring back an authoritarian regime.

Although, as mentioned previously, the action takes place during the Santo António festivities in Lisbon, most of the spaces shown are even more "queered" than the already colorful reality of these events thanks to the drag queens inhabiting them. In the beginning of the film, a giant transparent white veil falls over a demonstration of Catão's supporters and ends up covering all of Elevador de Santa Justa. Looking at the night sky while the veil falls over them, one of the campaigners comments: "It is the end of the world." In fact, this action that we witness at the start of the film is the work of the main oppositional force to Catão's overwhelming political campaign: the group of drag queens who symbolize love, desire, freedom of speech, and democracy. Apparently, this minority group will be the only one that will oppose and fight the far-right shadow that threatens to fall over Lisbon. They are the queer force that has set itself to protect the capital from that antidemocratic threat.

Queers and Crows: Queer as a Liberating and Democratic Force

A raíz do coração is, above all, a satire about power and politics that conveys how love can rescue and redeem someone from the corrupting power of far-right politics. Catão is a corrupt politician, an unscrupulous and dangerous man who will certainly bring darkness to Lisbon. His appearance, with a gray goatee and smart suit, evokes a devilish figure, a sort of modern Mephistopheles willing to do anything to become the mayor of Lisbon. While advocating moral values and the preservation of old traditions, he consumes drugs, hires prostitutes, and harbors a secret desire toward a young transgender woman (Sílvia), whom he constantly sexually harasses. To appeal to the more conservative sector of Lisbon voters, he shamelessly uses the religious festivities of Santo António and related iconography as part of his political campaign. In one scene, Catão is shooting a public speech for a TV broadcast on family values and keeping Portuguese traditions, dressed as the patron saint of the city and surrounded by brides of Santo António. When a couple of drag queens invade the set and disrupt the shooting, they are swiftly removed from the site by Catão's security forces.

Throughout the film, the aforementioned group of drag queens, dressed in white as provocative and exuberant brides of Santo António, continually try to boycott Catão's rallies and strongly protest against his events. For this, but mostly because they are "queers," they are persecuted in the streets, and humiliated and beaten up by "Os corvos" (The Crows), the militia force secretly commanded by Catão.[16] Although they are not an official police squad, they stand as the equivalent to the repressive force that was at the service of Salazar's dictatorship, known as the International Police and Defense of the State (PIDE). Just as the real PIDE would repress any form of political protest against the regime, "Os corvos" repress the drag queens' protests against Catão. In addition, they persecute the drag queens at night, even when no political events are in question. They are a force of oppression over other minorities as well as the "lower end of society," as they call it, including black people, drug addicts, and prostitutes. As their motto, expressed in the song they sing when patrolling the streets, explicitly states: "Beating up the whores, beating up the negro, beating up the poor.... Destroy the drug addicts, the shameless ones and the other bastards."

"Os corvos" represent intolerance and social prejudice. As film critic João Vaz Silva has pointed out: "The predominance of mistreated minorities in a film where there are few women is noticeable. Highlighted are the transvestites."[17] In the opening sequence, we are inside a cabaret watching a show in which a black transvestite (also played by actor Luís Miguel Cintra), dressed in white as a bride of Santo António, is performing and singing an ominous song.

Onstage, next to her are two performers dressed as *corvos* (crows). She tries to push them away, but they continue attacking and harassing her until she cannot fight them anymore and ends up overpowered—probably killed—at the end of the show. What is enacted in the show eventually happens at the end of the film when one of the drag queens, the black Luna, is killed by one of the "corvos." She is killed because she is a queer, potentially transgender person (it is never revealed), and therefore subverts gender normativity. The fact that she is also a black person is certainly no coincidence. Gender and racial prejudice go hand in hand in this urban fable, conveying to us that discriminating against LGBTQ individuals is as reprehensible as discrimination based on race. At one point in one of the film's musical moments, Sílvia (Joana Bárcia), the white transgender protagonist, sings, with some irony, a melancholic song about loneliness and prejudice: "I want to be black, my body is a big black hole. . . . I'm white. I'm a slave of whiteness, but inside I'm dark. . . . What seems is not, and what is does not show in the heart of the little boy." She is metaphorically referring to her gender identity, but I argue that the fact she uses the color of her skin as a metaphor is intentional. Again, the two forms of prejudice are referred to as if they were one and the same.

"Os corvos" are portrayed as a group of petty, hateful, frustrated white men who live to serve Catão and cleanse the city of the "trash" in society. They function as a collective and do not show distinctive identities—except for Vicente Corvo. With all of them dressed the same in dark overalls, it is difficult to tell them apart. This contrast with the drag queens' colorful wigs and exuberant wedding dresses—each one uses a distinctive wig and dress—highlights the significant gap between what the two groups represent. The diversity exhibited by the drag queens speaks directly to nonnormativity and plurality, as opposed to the uniformity of the "corvos."

While persecuting the drag queens, at the same time some of the "corvos," like their boss Catão, flirt with a couple of the queer characters. Luca, one of the "corvos," ends up murdering the drag queen Luna after being rejected by her. "Os corvos" are also a metaphor for male chauvinism, misogyny, machismo, and homophobia, reflecting attitudes in which women or female figures are regarded as mere objects of desire. This idea is also expressed in one of the lines spoken by the black transvestite during her satirical monologue at the cabaret show, in the film's opening scene: "Where in this room can I find a virile man who will want me, fuck me and rip out my heart's root?" This expression evokes an act of passion and desire associated with violence. In the film, most acts of desire from the men—"Os corvos" or Catão—toward the transgender individuals are also accompanied by acts of violence (and vice versa) against their objects of desire, in a kind of attraction and repulsion that eventually destroys the object of desire. "Transphobia" is therefore another word to add to the negative adjectives associated with the "corvos" in the film. The expression "to rip

out the heart's root" is traditionally associated with misogyny and male pos-
session over women, as well as a form of domestic violence that persisted in Por-
tuguese society for generations. Rocha took the expression from a traditional
tale from the Trás-os-Montes region in the north of Portugal, which appears
at the beginning of the film just before the main credits: "May the crows eat
her eyes and her heart's root." Therefore, the title of the film refers to this expres-
sion that defines the relationships between the film's men and the female
transgender characters.

Sílvia, Catão, Ju, and Vicente: Desire and Politics

Catão is emotionally and sexually obsessed with Sílvia. He paid for her gender
reassignment surgery when she was only fourteen years old and her name was
Sílvio. This act feeds Catão's view of her as his property. In one scene, when
they are inside his car and after consuming cocaine, he gropes Sílvia's breasts
and says: "These titties are mine. I made them." She plays along, but she is not
happy with the road their relationship has taken and is constantly avoiding him.
It may have started with love, but now their relationship is one of dependence
and gratitude (from Sílvia toward Catão) and of obsession and possession (from
Catão toward Sílvia). Things are changing, as Sílvia wants to free herself from
Catão's grasp and starts to push him away and avoid him. In her view, power
and politics are taking over their relationship. At one point, Catão asks Sílvia
who owns her ass and her heart, to which she replies: "It was Catão." The fact
that she answers him using the past tense reveals she is no longer the little boy
he seduced many years ago, and that she wants to move on.

Before the surgery, Sílvia used to live under the protection of Dona Ju (Isa-
bel Ruth), and she now seeks her support again. Ju is her godmother and intro-
duced her to Catão. She is the owner of the Photo Française, which also serves
as a cover-up for her sex business, which is patronized by the city's most power-
ful figures and politicians. On that account, Ju circulates within the corridors
of power and also plays a dangerous game by using incriminating photographs
and videos of those same politicians (including Catão) as they were using her
services. Blackmail is therefore her main source of income. Dona Ju is also part
of the "love square" that is at the center of the narrative. She engages in a court-
ship game with the young "corvo" Vicente (Melvil Poupaud), sent by his supe-
riors to spy on her activities and obtain any information that can help Catão
and his campaign. However, Vicente inevitably falls in love with Sílvia, who is
also Catão's object of desire. Here Catão and Ju represent the political past of
the country grounded on materialism and possession, which are values associ-
ated with the privileged upper class during the Estado Novo. Because they are
older, both Catão and Ju had close connections with the nation's dictatorship
past. Catão's father, also a politician, had once been a feared member of the

regime, and Ju's late lover was one of Salazar's ministers, who treated her as if she were part of high society and left her all she had. These "corners" of the relationship overlap with those of the contrasting relationship of the other two figures: Sílvia and Vicente. Both are young and from a lower class, with no possibility of a stable life, and they are not free as they both live under the domain (financial or ideological) of more powerful figures, such as Catão or Ju.

A love story ending in tragedy because of a crime of passion is commonplace in the cinema of Paulo Rocha. As with Júlio and Ilda in *Os verdes anos* or António and Carolina in *O rio do ouro*, despite their mutual feelings, Sílvia and Vicente's love is interrupted by death. Unaware of their relationship, the drag queens end up killing Vicente as retaliation for Luna's death. What Sílvia sings at the beginning of the film, again, becomes reality: "She will find her love on the other side of death." As if Vicente could only be redeemed for his bad actions in the militia by death, that event serves as a wake-up call for Sílvia. In grief, Sylvia decides to end Catão's thirst for power and his political career by using one of the videos from Ju's business in which Catão is seen having sex, with her screening it at his main rally in Praça do Comércio. After all, she still hoped that, despite his bad actions, he could be a good man, if only he could be removed from the corrupting power of politics.

After being jeered at by his campaign supporters during the rally, Catão returns home and finds Sílvia waiting for him. By abandoning her innocent and naive side—represented in the film as she was as a young boy—and by playing by his rules, Sílvia is able to redeem Catão and get him back to her as an ordinary man, freed from the corruption of power. Joining the real Santo António in the skies (actress Joana Bárcia now looking like a young boy—Sílvio before the surgery), the little boy says to Santo António that he only wanted to be like everyone else, to which the saint replies: "But you're not. If you can't resist temptation, cut the evil by the root. Kill the cause of your doom." This line functions as a metaphor for her gender reassignment surgery, but it also serves to convey that power and politics are toxic and, unless exterminated, can kill the love and the good inside each one of us.

As Kathleen Gomes argues, despite being a work of insubordination when compared with Rocha's previous films, in *A raíz do coração* one still "recognizes the tension and discipline of a tragedy taken to its utmost consequences and haunted by the emotional extremism that confers a winged quality to the characters, such as happens in *O rio do ouro*."[18] The blood-soaked narrative outline of Rocha's previous tragic love stories is softened here by the musical fantasy element, and even Vicente's death is nothing more than a choreographed oppressive dance by the drag queens who surround him until he collapses on the ground. Nevertheless, and as Gomes points out, the film again focuses on "the story of a redemption—this time happening in a fable-like Lisbon—only possible through love (and after death)."[19]

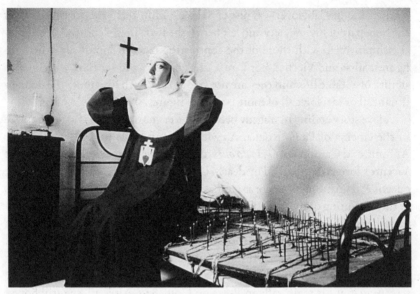

FIG. 14.1 Marisa Paredes. *Entre tinieblas* (1983) by Pedro Almodóvar. Courtesy of El Deseo, S.A.

Regarding how Portugal's historic past is represented in Portuguese cinema, Iván Villarmea Alvarez has stated: "The Portuguese society of today is heir of all its previous forms—the authoritarian society of the Estado Novo, the militant society of the Revolução dos Cravos . . . the consumerist society of the Third Republic. . . . In parallel, Portuguese cinema reflects the imaginary of these societies, in which there are always continuities from the past and influences from abroad."[20] With this transgressive and corrosive urban fable and by using fantasy and allegory (in the tradition of the Portuguese satire of Gil Vicente), Rocha brings to the twenty-first century his social and political reflections on a Portuguese society that is in constant flux. Trying to move forward after decades of "Salazarism," but without ignoring its historic past and religious traditions, the way of being and thinking of the Portuguese people is still being shaped. Looking at Lisbon, almost forty years after his seminal film *Os verdes anos*, Rocha approaches concerns of race and gender discrimination and relates them to the dangers of nationalist political parties and the corrupting power of politics in general, in a society that cannot and does not want to return to the oppressive times of a relatively recent past.

Notes

1 Cunha, Paulo. "Paulo Rocha, o eterno aprendiz." *A Cuarta Parede*, February 27, 2014, http://www.acuartaparede.com/paulo-rocha/?lang=es.

2 João Maria Mendes, "Objectos únicos e diferentes: Por uma nova cultura organizacional do cinema português contemporâneo," in *Novas & Velhas Tendências no Cinema Português Contemporâneo*, ed. João Maria Mendes (Amadora, Portugal: Escola Superior de Teatro e Cinema), 2013. 62.

3 Mendes, 60, 65, 82.

4 Peter Cowie, *Revolution! The Explosion of World Cinema in the 60s* (London: Faber, 2004), xi.

5 João Ferreira, "The Politics of Desire in Portuguese Cinema," in *Cinema e Cultura Queer | Queer Film and Culture*, ed. João Ferreira and António Fernando Cascais (Lisbon: Queer Lisboa, 2014), 106.

6 Antônio M. da Silva, "The Portuguese Queer Screen: Gender Possibilities in João Pedro Rodrigues' Cinematic Production," *Rupkatha Journal on Interdisciplinary Studies in Humanities*, special issue on LGBT and Queer Studies 7, no. 1 (2014): 69–78.

7 At the end credits of *A raíz do coração*, Rocha dedicates the film to Jean Renoir and Federico Fellini, two of his main influences.

8 Paulo Rocha was assistant director to Manoel de Oliveira in two of his films: *Acto da primavera* (1963) [*Rite of Spring*] and the short film *A caça* (1964) [*The Hunt*].

9 The producer António da Cunha Telles was involved with some directors of the Nouvelle Vague, such as Pierre Kast, through the financing of French-Portuguese coproductions shot in Portugal. Kast's *Vacances portugaises* (1963) [*Portuguese Vacation*] was one such film.

10 João Bénard da Costa, "Especial Paulo Rocha: *Os verdes anos*," trans. Francisco Algarín Navarro, *Lumière*, accessed January 15, 2018, http://www.elumiere.net /especiales/rocha/index.php.

11 The bill recognizing same-sex couples in the nonmarital partnership tax status was published as Lei 7/2001, on May 11, 2001. The same-sex marriage bill, published as Lei 9/2010, would come out on May 31, 2010, making Portugal the sixth country in Europe, and the eighth country in the world, to officially recognize same-sex marriages.

12 Expo '98 was held between May 22 and September 30, 1998. With the theme "The Oceans, a Heritage for the Future," the mega cultural event also served to commemorate officially 500 years of Portuguese discoveries and brought 11 million visitors to Lisbon in four months.

13 Paulo Rocha, quoted in Paulo Cunha, Rui Silva, and Samuel Silva, "Paulo Rocha," *En[Q]uadramento do Cineclube de Guimarães* 3 (2014): 11.

14 This religious tradition is deeply rooted in Portuguese culture. Every city and village in the country has a patron saint, and every year festivities are held to celebrate and honor that patron. Between May and September, these festivities are held all over the country. The Santos Populares festivities in Lisbon and Porto are some of the largest in Portugal. Every year in Lisbon, engaged couples apply to get married and be blessed by Santo António during these festivities. The brides of Santo António are one of the symbols of these celebrations.

15 The number of nonparticipant voters and the abstention rate in Portuguese elections (for either local or general elections) have been increasing at least since 1980. In 2001, the abstention rate for local elections was 39.9 percent. In the last general elections for the Portuguese government, this rate rose to a record high of 44.1 percent, meaning that slightly less than 56 percent of the voting population went to the polls to elect a new government. Data from *PORDATA: Base de*

Dados Portugal Contemporâneo, accessed January 28, 2018, https://www.pordata .pt/Homepage.aspx.

16 These birds are one of the symbols of the city of Lisbon.

17 João Vaz Silva, "*A raíz do Coração* de Paulo Rocha," *Apokalipse: Centro de Estudos Cinematográficos* 29 (2001), accessed January 9, 2014, http://www.cecine.com/2014 /01/09/a-raiz-do-coracao-de-paulo-rocha/.

18 Kathleen Gomes, "A Cidade a Seus Pés," *Ípsilon (Jornal Público)*, January 25, 2001, http://www.publico.pt/2001/01/12/jornal/a-cidade-a-seus-pes-153520.

19 Gomes.

20 Iván Villarmea Alvarez, "Mudar de perspetiva: A dimensão transnacional do cinema português contemporâneo," *Aniki: Portuguese Journal of the Moving Image* 3, no. 1 (2016): 109.

15

Entre tinieblas (1983)

••••••••••••••••••••••

Pedro Almodóvar, a Reformer of Catholicism?

ANDRÉS LEMA-HINCAPIÉ

A Francoist Spain is a Catholic Spain. This affirmation, so continuously repeated, always demands new detailed analysis. What forms does Catholicism take in Franco's Spain? Responding to this question will enable us to understand the elements of Almodóvar's religious irreverence and, in particular, that against which Almodóvar directs his critical thought in *Entre tinieblas* (1983) [*Dark Habits*]—especially in the context of the Madrid Scene.

Less Destructive Than Reformative

In 1953, the *Inter Sanctam Sedem et Hispaniam Sollemnes Conventiones*, or Concordat, was signed. It was a sort of religious-political treaty whose most important signatories were Pope Pius XII (1876–1958) and Francisco Franco (1892–1975), in their respective roles as representative of the pontificate and Spanish chief of state. Knowing specific central points of this Concordat allows the identification of certain fundamental forms of Spanish Catholicism as lived by Almodóvar, which also live on in a reactive way through the artists of the Madrid Scene and beyond.[1] Article I of the Concordat, for example, establishes that "the Apostolic Roman Catholic Church will continue to be the sole religion

of the Spanish State and will enjoy the rights and prerogatives due to it under Divine and Canon Law."[2] After the release of the film *Volver* (2006) [*To Return*], Almodóvar gave an interview in 2009 to the German periodical *Die Zeit*. In this interview, never published in Spanish, more than anticlericalism he made explicit a certain antidogmatism in relation to certain practices of Catholicism. Catholicism, he suggests, can display a profound disconnection with people's daily lives" "Why doesn't the pope simply go out and wander sometime, out of the Vatican, and observe what a family is these days? Clearly, it's completely demented not to recognize the way in which millions and millions of human beings live! My families are more real than the pope's families, because mine don't live according to predetermined dogmas. . . . And I experience this as an enormous freedom of film, to make acceptable, in a gentle way, this vision of human beings upon the world."[3]

I will demonstrate later that, in the 1983 film, Almodóvar will not be so radical. The five nuns in *Dark Habits* share one of the most flamboyant flags of the Madrid Scene in their struggle against the Catholicism dominant in Spain, which is, along with Francoist militarism, one of the most effective sources for the promotion of ultraconservatism. In his prologue to *Patty Diphusa y otros textos*—probably written in 1998—Almodóvar characterizes this countercultural flag as "the impudence of then."[4] Having said that, there is impudence in the nuns, but it is rather moderate, and never reaches the exuberance of scandal. The severity and simplicity of their habits are not all that characterize the moral simplicity of the five nuns' psyches. In their mannerisms, even in the film's loveliest moment of extravagance—Yolanda (Cristina Sánchez Pascual) singing, accompanied by the five nuns—there is gestural, choreographic, and wardrobe simplicity for the five Humble Redeemers. Yolanda, in contrast, already reverberates with other Almodóvar characters, in that she anticipates them with her bodily stylization, her clothing, and her conscious sensuality. To limit myself in listing these foreshadowed characters, I will mention only Tina Quintero (Carmen Maura) in *La ley del deseo* (1987) [*Law of Desire*], Becky del Páramo (Marisa Paredes) in *Tacones lejanos* (1991) [*High Heels*], Huma Rojo (Marisa Paredes) in *Todo sobre mi madre* (1999) [*All About My Mother*], and Zahara (Gael García Bernal) in *La mala educación* (2004) [*Bad Education*].

With all this, the Madrid Scene and Almodóvar's films put into question something stated with total clarity in the first section of Article II of the 1953 Concordat: on the one hand, the unity and moral perfection of the Catholic Church, and, on the other, the spiritual power of that church—here "spiritual power" signifies dominion over people's consciences or, in more contemporary terms, over their psychic lives.[5] In the words of the Concordat: "The Spanish State recognizes the Catholic Church as the character of a perfect society and guarantees it the free and clear exercise of its spiritual power and jurisdiction, along with the free and public exercise of its worship."[6] By way of its

transcendent investiture, the Catholic Church is the institution with the right to attribute or not attribute sinfulness to the words, works, and omissions of all Spaniards. On this topic, in *Patty Diphusa y otros textos*, Almodóvar avoids any ambiguity: "For all that [Juan Pablo II] intends to make sin stylish, I will not sin, because sin has totally vanished from my life."[7] According to Catholic moral theology, to tempt the believer and to persuade him to sin, evil assumes three modes: the world (or the pleasures of the profane life), the devil (or the Prince and Conjurer of Darkness, who since Adam and Eve covets the spiritual ruin of humankind), and the flesh (or the enjoyment of bodily pleasures).[8] In contrast, Almodóvar's five nuns serenely navigate the profane world because no temptation accosts them from that source; the devil is not a character because he never bears mention and no supernatural conjuring lies in wait for them; the flesh is neither silenced nor repressed because its desires are felt moderately, but never drastically condemned or guiltily indulged. As to the body in the convent, Almodóvar shows that each nun enjoys her body in a different way. For example, Sor Estiércol (Marisa Paredes) understands the mortification of flesh not as purification and punishment for sinful thoughts and desires. Instead, she understands martyrdom more as a pleasant show for an audience and an effective way to earn money for the convent. In this way, Sor Estiércol accompanies and happily assists the Mother Superior (Julieta Serrano). Trying to console the Mother Superior about the convent's bankruptcy, Sor Estiércol proposes, with almost ecstatic excitement, the following source of funds: "Don't worry any more about money, Mother! . . . We could put on a circus. Yes! A nun circus! Something unique. With the tiger and Sor Perdida, and . . . Sor Rata doesn't know how to do anything. It's fine, I could even crucify myself in the middle of the Rastro . . . for the sins of the people, and for my own, obviously" (1:00:03–1:01:02).

It is advisable not to fall into the trap of considering *Dark Habits* as an audiovisual document similar in tone and objectives to other, more incendiary documents against ecclesiastical Catholicism. I think here, as an example, of *La Religieuse* (1796), a paradigmatic novel by Denis Diderot (1713–1784). As the anonymous author of a small "Notice" in my edition asserts, Diderot's novel may be "before all else an enraged pamphlet against convents."[9] I would add that *La Religieuse* would have been written according to the spirit of a French elaboration of a markedly anticlerical intent, springing from the free thought (*la libre pensée*) of the Age of Enlightenment. *Dark Habits* is not absolutely anticlerical, though it can be understood as a film that defends free thought alongside the Catholic Church. The pamphlet-like character of Diderot's novel, devoid of humor and joy, denounces practices of mortification of the flesh and humiliating lesbianism.[10] The anonymous author continues: Diderot's novel describes "a particular corner of Hell where women who suffer the condemnation of luxury and neurosis are heaped."[11]

In *La Religieuse*, lesbianism is more explicit than in *Dark Habits*. By means of the first- person narrator, Diderot describes the physical intimacy of gestures: "The Mother Superior embraced me about the waist. She thought I had the loveliest waistline. The Mother Superior pressed me against her and made me sit upon her knees. While she lifted my head with her hands . . . she praised my eyes, my mouth, my lips, and the color of my skin. I held my silence, without responding, and I lowered my eyes, delivering myself to these caresses as if I were an idiot."[12]

In contrast, Almodóvar's anticlerical, antireligious position in his 1983 film carries no charge of bitter insult or caustic, destructive critique against Catholicism. Almodóvar is not Diderot—he may come to resemble the author more in other films, like *Bad Education*. There is a critique here, but instead of repudiating the true faith or practice of Catholicism, the critique in *Dark Habits* serves more to deepen certain Catholic virtues, albeit along oblique, unexpected, and subtle paths. Differently from later films, in *Dark Habits* Almodóvar is less of an apostate heretic and more of a reforming heretic within Catholicism itself. Recall here the scene in which the dissolution of the convent is imposed. In certain and forceful words, the Mother Superior speaks against the new Mother General (Berta Riaza): "Indeed, these are difficult times, but I've never been scared of struggle. I've written to the Pope and I've decided to fund my own order." Nuria Vidal, with an excellent critical nose, assures us that the poster for *Dark Habits*—a nun's veil over a tiger's face— "suggests the mystery and surrealism underlying this film that is more mystical than it seems."[13]

Roads Not Taken

In terms of the audiovisual construction of convent life in *Dark Habits*, Almodóvar does not settle for those solutions that traditional culture allows the character of the nun; the film does not stoop to the sexual treatment of the nuns, which would make it so *Dark Habits* might be categorized as "nunsploitation"; it does not seek to be edifying propaganda for an eventual religious vocation; it evades the genre of musical or light comedy that might satisfy a typical Spanish family on a Sunday afternoon; and it does not attempt to identify as a lesbian film per se.[14] I will move to summarily examine these four possible options that Almodóvar did not use.

In the first place: What would be the precedent works about nuns that Almodóvar could have seen, and that might echo in *Dark Habits*? Without the possibility of consulting with the director himself, the answer to this question can only emerge through conjecture and estimation. I hazard the speculation that he knew of nunsploitation or convent pornography, in which certain audiences enjoy images and sounds of nuns' bodies suffering confinement,

sadomasochism, and sexual tyranny. In relation to the viewer, this subgenre of pornography takes advantage of one way of living human sexuality: *hiero-philia*. It consists of excitement, enjoyment, and orgasm through interaction with thoughts, images, objects, places, and possibly smells linked with the universe of Catholic religion. I cannot access information about which nun-sploitation films may have circulated at that time in Spain, due to the censor-ship that held sway during and after Francoism. It must suffice to speculate that these sorts of films could have been seen by Spaniards, because they were directed, produced, distributed, and seen in Poland, Italy, Germany, Mexico, and Japan. It would not be easy to deny the plausibility of an affirmation that Almodóvar saw in its time a famous film that explored themes of eroticism in connection with a young nun: *Viridiana* (1961), from Spanish director Luis Buñuel (1900–1983).[15]

In any case, I now think about Castilian versions of the *Lettres Portugaises traduites en français* (1669). This work circulated through the centuries in Spanish-speaking countries under the title *Cartas portuguesas*, *Cartas de amor de la monja portuguesa*, or *Cartas de la monja portuguesa*, and in English-speaking countries under the title *Letters of a Portuguese Nun*. In the same breath, it is worth remembering the Swiss-German film *Die Liebesbriefe einer portugiesischen Nonne* (1977) [*Love Letters of a Portuguese*], by the Spanish director Jesús Franco (1930–2013). The small book attributed to Sor Mariana Alcoforado (1640–1723), which includes five famous amorous missives, was adapted for the screen under the guidance of the Swiss writer Erwin C. Diet-rich (1930–2018). Jesús Franco would bet on soft-porn eroticism, lesbian and heterosexual, from the original literary work, thanks to a soundtrack full of moans of pain and pleasure accompanied by an extradiegetic organ off-screen, along with completely nude images of the lead actress, the German-Portuguese Susan Hemingway.

Did Almodóvar read the book or see the film adaptation? I do not know. Regardless, there are suggestive similarities between the letters—now attrib-uted to Gabriel Joseph de Lavergne, Comte de Guilleragues (1628–1685)—of the Portuguese nun Mariana de Alcoforado, and the Mother Superior in Almodóvar's film. Just as Mariana was seduced and abandoned, and felt a deep love for her seducer, the Marquis de Chamilly, the Mother Superior in *Dark Habits* is seduced and abandoned by Yolanda, and the first woman's love for the second is intense and painful. There is another similarity that partly sug-gests the thematic and formal parentage of the 1983 film in the 1669 epistolary collection. I refer to the obscuring of authorship under a pseudonym. The French writer Guilleragues preferred to hide his name and use the real name of a nun who had been compromised by a heartrending amorous experience: Mariana de Alçoforado. After writing, in letter format, the story the Marquis de Chamilly had confided in him, perhaps Guilleragues had wished to protect

himself with this act of literary transvestism against all imputation for attributing such improper thoughts to the character of a rigorously moral Catholic woman.[16]

A clear indication that Almodóvar did not want to make a nunsploitation film emerges in the sequence that takes place in church, when Sor Rata de Callejón (Chus Lampreave) reads aloud a passage that proves edifying for herself and her companions in the order: "The Danger of Kisses." In the silence of the sacred enclosure, Chus Lampreave's voice pours out the words with mischief and a hint of sensuality: "There are as many kinds of kisses as kinds of love; the paternal kiss on the forehead, the kiss on the eyes full of peace, the amusing kiss on the nose, the friendly kiss on the cheek. All of these are somewhat anodyne, but they could be taken as tempting invitations to more perfidious ones.... And, finally, there is the kiss on the lips. A kiss means nothing.... But if that kiss has filled you with delight, bear in mind that it has moved him even more strongly and awoken all the strength of his desire. Don't give even a single kiss ... unless you already wear a wedding ring."

In the second place, *Dark Habits* is not a film about nuns created with the explicit intention of promoting, among Spain's female audience, a religious vocation. These movies, which were aired in Francoist Spain, idealized the values of women who had entered the cloistered life. Nuns were depicted as superwomen who, even through doubt, difficulty, and ethical imperfection, always succeeded in embodying exemplary lives—worthy of admiration and imitation. Up until now, I have not read any document that allows me to know if, before 1983, Almodóvar saw and studied such films in detail:[17] *Cradle Song* (1933), an adaptation of the work of theater by the same name by the Spanish writer María de la O Lejárraga (1874–1974);[18] *The Song of Bernadette* (1943); *The Bells of St. Mary's* (1945); *Come to the Stable* (1949); *Heaven Knows, Mr. Allison* (1957); *The Nun's Story* (1959); *Conspiracy of Hearts* (1960); *Lilies of the Field* (1963); *The Trouble with Angels* (1966); *Two Mules for Sister Sara* (1970); and *The Runner Stumbles* (1979).

I feel obligated to connect certain elements of the plot of *Les Anges du péché* (1943) [*Angels of Sin*], by the French director Robert Bresson (1901–1999), with *Dark Habits*. The religious order that Bresson presents also serves to rehabilitate delinquent women. Sor Anne-Marie (Renée Faure) embraces the order, leaving behind the comforts of her wealthy family. In the convent, she expresses a special interest in the rehabilitation of one of the young criminals, Thérèse (Jany Holt). Thérèse is unjustly accused of having participated in a robbery, and she refuses any consolation from Sor Anne-Marie, who visits her in prison. After two years in the penitentiary, Thérèse is liberated and quickly obtains a gun: she kills her lover, the true thief and direct cause of the two years Thérèse spent in prison. Thérèse, now an assassin, returns to the convent of Dominican nuns seeking refuge, pretending a wish to enter the Dominican Order of

Bethany. For Yolanda as well, the convent of the Humble Redeemers in *Dark Habits* appears as a convenient place to hide from the police, who are searching for her, blaming her as a suspect in the death of her junkie boyfriend.[19] Sor Anne-Marie, like Almodóvar's Mother Superior, develops a strong mystical, delirious—perhaps repressed lesbian?—emotional need for Thérèse. Anne-Marie, also like the Mother Superior, publicly criticizes her superiors in the order for their hypocrisy. Punished for not completing penitence, Anne-Marie will abandon the convent and the order for a short time. In her turn, the Mother Superior in *Dark Habits* also decides to abandon the order and the convent, perhaps forever, with the goal of traveling to the Philippines and founding a new religious order there.[20]

There is a third film genre—that of musicals and light comedies—that also sheds light on this film. These musicals and comedies combine soft parody with the goal of causing spectators to feel warmth for a simple life and happiness for the women consecrated to God in convents. It is possible that some of the titles I will mention could have been familiar to Almodóvar. The genre, at the beginning of the 1990s, had a momentary rebirth thanks to two movies starring Whoopi Goldberg: *Sister Act* (1992) and *Sister Act 2* (1993). In the musical number performed in honor of the Mother Superior, prepared by four of Almodóvar's five nuns and with Yolanda's starring turn, it would not be unreasonable to retrospectively glimpse anticipations of those two films. Three U.S. feature films and one television series from the 1960s bear mentioning here. Under the Spanish title *La monja voladora*, this television series from the 1960s earned the affection of families in Colombia, Spain, and Mexico—where it was dubbed in Spanish. Its original title was *The Flying Nun* (airing from 1967 to 1970), with Sally Field in the leading role of Sister Bertrille. Although it was about a superheroine in clumsy flight—thanks to her headwear of cornettes—*The Flying Nun* proposed to its audiences a character with superpowers, full of friendliness and kindness, opposite to the stereotypical characteristics of cloistered priests and nuns: severity, bitterness, bad temper, and lack of people skills. In the joyous lightness of Sor Perdida (Carmen Maura), the person in charge of the vegetable garden, the hens, and the rabbits in the convent, I sense a supernatural ability as well that relates her to Sister Bertrille: just as Bertrille experiences a natural ease with the supernatural gift of flight, Perdida shows a natural, if astonishing, talent in her tender relationship with Niño, her pet tiger.

The three full-length films are, in chronological order, the U.S. films *The Sound of Music* (1965) and *The Singing Nun* (1966) and the Spanish film *Sor Citroën* (1967). What conjectures can link these three films with *Dark Habits*? Even if Sor Víbora (Lina Canalejas) is a nun, not a novice like Maria (Julie Andrews) in *The Sound of Music*, both women finally decide to choose a heterosexual partnership over the Church. No doubt Sor Víbora's choice is more radical, not just because she will need to leave behind her habit to be able to

marry, but also because her future husband is no layman—like Captain Georg von Trapp (Christopher Plummer)—but rather a priest, who was her chaplain, her confessor, and her sewing companion.

In the case of *The Singing Nun*, the lightly biographical plot—following Sister Ann, as portrayed by Debbie Reynolds (1932–2016)—resonates less than the accounts of the life of the Belgian nun that inspired the film. The movie seeks to be a biopic about the life and music of the Dominican nun Sister Luc-Gabrielle—also known as Sœur Sourire, and whose real name was Jeanne-Paule Marie "Jeannine" Deckers (1933–1985). It is worth mentioning here a personal anecdote: the songs of this nun and three of her companions in the order, who were skilled guitarists and singers, were released in Colombia, my country. My mother, María Ofelia Hincapié Ramírez, purchased a vinyl record as a gift for me featuring the songs of Sor Sonrisa. "Dominique," the song that would carry Sor Sonrisa to stardom, could well have captured Almodóvar's attention in the early years of the 1960s. According to the British periodical *The Guardian*, "The song, 'Dominique'—inspired by the 13th-century saint who founded her order—sold millions of copies worldwide, and Deckers remains the only Belgian to have had a US No 1."[21] In 2009, continues *The Guardian*, *Soeur Sourire* [*Sister Smile*], by the Belgian director Stijn Coninx (1957), is a film that depicts Deckers's life. The whole story of this life, especially its monstrous, amorous end, was unknown to me until very recently. This story, very Almodovarian to be sure, includes the questions of faith that overtook Deckers during her time studying in Leuven, out of the convent; the encounter with her future partner, the young Annie Pécher (1944–1985); founding with Pécher a rehabilitation center for autistic children; the Belgian Treasury that pursued Deckers for unpaid taxes related to her musical successes; the ruin of the rehabilitation center and the financial ruin of the two lovers; and, at last, the two women's final decision to commit suicide together on March 29, 1985, by taking barbiturates and alcohol.

In 1967, a Spanish movie about nuns received widespread acclaim. I speak now of *Sor Citroën*, by the director Pedro Lazaga (1918–1979) and, in the leading role, Gracita Morales as Sister Tomasa Carrasco. The movie is a comedy of errors, gags everywhere, the ingenuity to maintain a convent dedicated to the care of orphans, the counterpoint between a provincial nun and the daily public life of Madrid, simple solutions to narrative conflicts, and travel to reach better sources of alms for the convent. *Dark Habits*, however, distances itself from Lazaga's film project: Almodóvar does not simplify the conflicts of his five nuns, nor does he resolve them within his film's plot;[22] among other elements, he avoids gestural and discursive impudence in his depiction of each sister; he opts for a contained, theatrical mise-en-scène instead of filming exteriors or indeed nearly any locations outside the convent; he does not dilute his focus with secondary characters; and he insists on using a soundtrack that

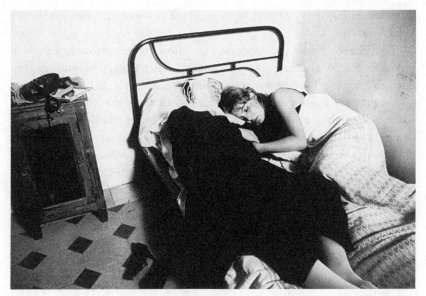

FIG. 15.1 Julieta Serrano and Cecilia Roth. *Entre tinieblas* (1983) by Pedro Almodóvar. Courtesy of El Deseo, S.A.

combines songs sung within the film and songs from outside. Having pointed out these contrasts, I should also note that Sor Citroën and her companions in the convent share with the Sisters of Humble Redemption the trait of an iron will to complete necessary moral work. In the first case, there are orphan girls who will always need care, in the face of a disinterested bureaucratic state. In the second case, there are women worthy of assistance who suffer the misfortunes of drugs and prostitution, also in the face of an absent state.

Cinematographic Language

From the abstract generality of the film's first shot, exterior and panoramic, which depicts a city in full speed and motion, cars in traffic, and varied light—any city without distinct individuals (0:01:56)—Almodóvar's film draws to a close with another fixed shot. Each shot has a significant value (1:32:15–1:35:47). Having said so, the initial shot does not follow any earlier shot, as the last one will. This long final shot follows a medium interior shot of a room. The room was originally Virginia's cell, and later that of Yolanda. It is there that the Mother Superior earlier felt love for Virginia, and now she feels love for another woman. Thus, a medium shot situates us within the concrete history of the convent. In the final shot, two women join in an embrace: the Mother Superior in loss, Sor Estiércol in consolation—and certainly in mutual care and a kind of love.[23] From this medium shot, the camera zooms out, distancing spectators

from the moment of intimacy between these two women, allowing them a certain privacy.

The final fixed panoramic shot does not allow the viewer to assign any subjective or human point of view: the camera position perfectly captures a symmetrical framing. The elements of this framing demonstrate balanced harmony, in the mode of a church niche: there are two curtains; the window homogeneously contains two distant bodies; the space of the walls of the building around the window presents a precise and startlingly equal area; and there is balance in the nocturnal shadows cast horizontally by those walls. It is possible to identify the romantic aesthetic of the shot with the element of the palm tree, which projects its shadow on the wall thanks to possible moonlight. At last, in the final take, the nonhuman or objective point of view of the camera for the panoramic shot is no longer situated as a high-angle shot or as a nearly zenithal shot.[24] This new point of view is now in a shot situated along a parallel line with the two nuns. Is it possible that, at last, the way God looks at his five nuns has changed? At any rate, now the eternal, timeless gaze of the camera (with no signs of movement) drives the humanization of the scene. Earlier, in the first shot, the focal distance and high angle impeded this humanity. If this interpretation is plausible, God, if not the Mother Superior, understands, accepts, and respectfully but not invasively accompanies his two simultaneously weak and strong female creatures.

Similar to the way the first and last shots offer interpretive clues for the whole film, the narrative arc of *Dark Habits* is framed by two highly significant and enigmatic melodies. Whereas the "Valse crépusculaire" by Miklos Rozsa (1907–1995) accompanies the fixed shot of a large city where the morning comes and Yolanda slowly walks, the bolero "Encadenados" accompanies the final embrace of the two nuns experiencing consolation: Sor Estiércol offering, the Mother Superior receiving. Rozsa's music may express Yolanda's mood and that of a city receiving the light of dawn. Even if the night before was not entirely happy, dawn holds a certain joy of the night and an agreeable *spleen*. The light of day will arrive for Yolanda with the aggressive rudeness of her lover, followed by his death. In the bolero "Encadenados," whose point of view is represented in the overdubbed song, and who calls out to receive the message?

It should not be forgotten that "Encadenados" was already intradiegetic during minutes 0:31:55–0:34:02. Its repetition in the film could imply that it holds interpretive clues of great value. The bolero sequence in the Mother Superior's cell establishes the coordinates of connection between Yolanda and the nun. For Yolanda, the mischievous game—not primarily erotic—of singing the song while looking at the nun reveals the liking and comradeship that can arise between people who appreciate the same kind of music; for the Mother Superior, singing and gazing at Yolanda without blinking awakens the hope of a new requited lesbian love—the Mother Superior captures Yolanda with her gaze,

in a long reverse shot where the spectators will also take Yolanda's point of view. Here, the Mother Superior yearns to seduce and be seduced. Seduction is the affective tonality of this sequence: for the nun, at play here is the agonized duel of her lesbian love.[25] She will be defeated in this duel and, upon losing to Yolanda later, she will live out this agony. Sor Víbora will embrace the hurting woman (1:32:03). It is impossible to know if this open ending is an augury for a seduction and lesbian love between Sor Víbora and the Mother Superior. In any case, the plastic force of the two sequences, with the bolero amorously reinstalled in the love triangle, thus links (or, in Spanish, *encadena*, in reference to the song's title) the spectators to the moment frozen in a final, forceful fixed shot. It is pleasant to imagine there might be an open erotic connection between the two nuns. Even so, by finishing the film here, the plot joins, against all voyeurism, in the intimate secret of these women, respecting them.

Without documentary evidence, I propose that, in the final sequence, Sor Estiércol is the one dedicating this bolero to the Mother Superior, not Mother Superior dedicating it to Yolanda. "Encadenados" describes an amorous relationship that has existed for some time and predicts it will endure. I leave the Spanish for its sounds, and follow with a rough translation: "Nos hemos hecho tanto, tanto daño, / que amor entre nosotros es martirio; / jamás quiso llegar el desengaño, / ni el olvido ni el delirio, / seguiremos siempre igual" (We have done each other so much, so much harm, / that love between us is martyrdom; / I never wanted to come to disillusion, /nor forgetfulness nor delirium, / we will be forever the same). These last words operate like the last frozen frame: the love of the two nuns will remain "forever the same."

By reason of its formal characteristics, the final shot of the film is related to another shot (0:56:31–0:57:01). There the spectator confirms that between the Mother Superior and Yolanda there has arisen an insurmountable distance of affection and eroticism. The first will declare her love for the second; Yolanda will not return this love. As in the last shot of the film, the camera will be outside, capturing not one but two windows, and though the Mother Superior appears through the right window, in the left window the spectator contemplates Yolanda. The shot is daylit, without zoom, except at the strong beginning of the take, with some violence in the montage of points of view. The montage is violent because there is no soft transition or fade. It also is explicitly arranged: from the Mother Superior's cell, there is a medium shot on Yolanda's face, which is replaced by a long exterior shot, where importance shifts to the architecture of the facade—severe, without embellishment or shadows. And even if Yolanda will repay the Mother Superior's love with indifference, without knowing it, that same Yolanda, as a catalyst, will revive the Mother Superior's faith in projects to save the convent.

Finally, I transcribe these words from the Mother Superior, in which she justifies to Yolanda why one of the walls of her nun's cell is papered with photos

of actresses, that is to say, of women who publicly sin: "[These women] are some of the great sinners of the century. . . . In imperfect creatures is where God finds all his greatness. . . . When I look at some of these women, I feel enormous gratitude toward them, because it's thanks to them that God keeps dying and being resuscitated every day." With these words, Almodóvar establishes the theological paradox of the human need for sin and the sinners: only if they exist, as a necessary condition, can an absolutely good God be incarnated, who will die, be reborn, and redeem man. Only then can this be logically possible and, at the same time, humanly comprehensible.[26] Thus, Almodóvar embraces with combative seriousness a fascinating paradox that, amid the darkness of concepts, resides at the very heart of Christianity. A God who is limitlessly good necessitates a sinful man who will obstinately lose the connection with his God and Creator. In other words, a good Creator requires for its existence a human creature that might turn out to be evil.

Compared with earlier comedies and musicals, there is something unusual, while at the same time fundamental, in *Dark Habits*: in the score and soundtrack, popular music predominates, replacing the sacred music of chants and melodies. I suppose that Almodóvar lends an artistic hand to ensure the supportive cohesion of the nuns. He dilutes the importance of the usual votive rites of Catholicism—like prayer, confession, the Eucharist. Faced with a hostile world, there might be one possible exit for the five nuns: art postpones, for them, the tragedy that lies in wait. By resorting to specific arts, the terrible tragedy of a failing community project can be temporarily wished away: singing and dancing for the Mother Superior, writing for Sor Rata de Callejón, sewing for Sor Víbora, cooking for Sor Estiércol, and cultivating life for Sor Perdida. It is as though, with the art his five nuns create, Almodóvar is expressing—with tacit certainty—this imperative against an evil that is more human than transcendent: *not today, Satan!*

Almodóvar's Solution, 1983

In its complex relationship with Catholicism, Almodóvar's work does not fall into cynicism, nor does it reveal blind faith. *Dark Habits* contains parody, recrimination, rancor, and sarcasm, but Catholicism is not presented by way of fundamental attacks founded in a cynical, justified bitterness or an impoverished faith, unthinking and childish. These attacks are explicit and structural in two other Almodóvar films: *Law of Desire* and *Bad Education*.

In *À la Voltaire, à la Diderot*, and possibly *à la Luther*, Almodóvar directs his attacks at Catholic reactions to Francoism, at the same time rescuing certain humanizing elements of this same Catholicism: charity, community life in solidarity, the hope of redemption of those at the margins of society, especially women who sell their bodies to survive and fall into the trap of drugs.

Even so, a vital distinction: the letters attributed to Mariana Alcoforado possess a significant absence. The epistolary voice of a Portuguese nun never places the necessary strength in God to survive romantic indifference. Voltaire and Diderot might applaud this decision. In the place of the Catholic God—who does not appear in these epistles—Mariana reaches out for a reason to try to reclaim her serenity, after being seduced by the Marquis de Chamilly. The five letters written by Alcoforado record a surprising asepsis to Catholic divinity. It is as though the pain of frustrated love, for the cloistered lover, had nothing to do with God. The exacerbated rationality of this document from the middle of the seventeenth century does not harmonize, in this respect, with Almodóvar's film about religion. Compared with the rationality of the Lusitanian nun, the nuns in *Dark Habits* pray in community and solitude. At the same time—as I showed earlier—they make sure that in the convent theirs is a subtle god: in lighting, in frames, in high-angle shots, in scenic design and in costumes. Theirs may be, in my judgment, a patient, silent God, who understands and subtly accompanies his five creatures in habits—and in him, the reason that these five nuns might be aware that sin does not distance the sinner from God, but rather one way that sinners draw nearer to one another, and convoke, at the same time, the presence of God himself.

It is certain that *Dark Habits* reveals that, in a convent of women, the desired "perfection" of the Concordat of 1953 is no more than an ideal: the Mother Superior thinks, fantasizes, and lives a guiltless lesbianism; she sells and consumes drugs like cocaine and heroin; she lies, to save Sor Estiércol from prison; and she does not hesitate to resort to extortion of the marquesa (Mary Carrillo). For their part, Sor Víbora and the priest decide to break, in the middle of the sacrament of confession, the sacrament of the celibate priesthood, as a consequence of their long practice of designing and creating dresses for the Virgin. This practice has turned an act of religious devotion into an exercise of high fashion so that the image of the Virgin might serve as a frozen catwalk model. What an abomination of Francoism, and what a humanization of Catholicism, to depict a priest-tailor who enjoys sewing in the company of the nun he loves! In opposition to the hegemonic rules of Franco and "his" Church, Almodóvar proposes more than a radical revolution within the Catholic Church. In the case of Sor Víbora and her priest lover, the division of domestic labor along the lines of sex or gender has been abolished, on one side, and on the other side, the romantic link between a nun and a priest might suggest a revision of Catholicism from certain positions more aligned with reformed churches: it is possible to keep believing in evangelical messages, while genuinely living the love of partnership and, at the same time, inhabiting the sacrament of priesthood as fully as the sacrament of marriage. In this sense, Almodóvar does not feel that these two sacraments must exclude one another. They would do better to be integrated and lived joyfully.

Although *Dark Habits* asserts the failure of the spiritual power of the traditional Catholic Church in people's intimate lives, especially in instances of their sexuality or their own modes of practicing religiosity, the film also portrays a group of women sincerely dedicated to the most startling gestures of solidarity with other socially excluded women. These women, on the one hand, experience a profound mysticism in the humanity of need, and they verbalize this mysticism using formulas and images drawn from the traditions of Catholic Christianity; on the other hand, guilt does not consume them when they practice "original," decidedly not "saintly," methods to realize their humanitarian mysticism. Article XXIX of the Concordat of 1953 established: "The State will ensure that the institutions and services that form public opinion, in particular radio and television channels, give a proper position to the exposition and defense of the true religion by designated priests and religious, in agreement with the respective Ordinary."[27] State censorship, according to religious criteria, has also failed, as Sor Rata de Callejón succeeds in becoming a renowned author of melodramatic novels. The plots of her novels are not spiritually edifying, as the lines she reads aloud in church claim to be, whose literal meaning catalogs the sinfulness of different human kisses.[28] All the same, Sor Rata's novels are the living, direct testimony of excluded women. In those novels their stories find voice, audience, and recognition.

Almodóvar's nuns in *Dark Habits* are not Francoist nuns. They distinguish themselves patently from the conformity desired by the Concordat of 1953 between the tyrannical Francoist state and the Catholic Church. Note this example of conformity: on October 19 of the same year, the *Boletín Oficial del Estado* opened with the following seven words of preamble to the Concordat, which was being published for all Spanish citizens to see for the first time: "In the name of the Holy Trinity."[29] In opposition to that phrasing, and if the police embody one of the clearest manifestations of the forces of the state in strong league with the Church, this short dialogue from *Dark Habits* could not be more explicit:

YOLANDA.
—Are you going to call the police?

MOTHER SUPERIOR.
—I don't like the police.

Some critics of *Dark Habits* committed the error of falling into one of two extremes expressed in a popular saying: "Ni tanto que queme al santo, ni tampoco que no lo alumbre,"[30] which translates approximately to "Neither burn the saint nor illuminate him." Alberto Mira suggests that, in *Dark Habits*, Almodóvar "attempts at convening the conditions of life in a religious context"

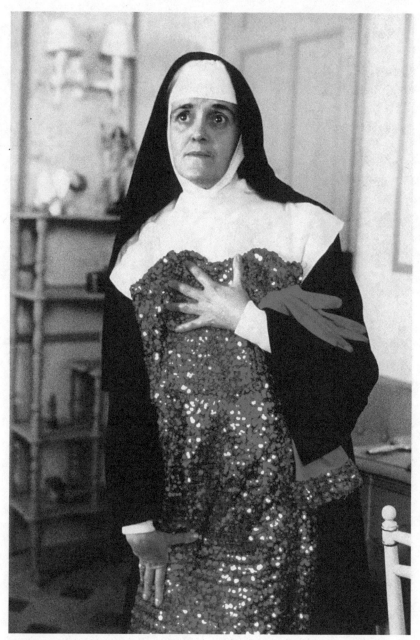

FIG. 15.2 Chus Lampreave. *Entre tinieblas* (1983) by Pedro Almodóvar. Courtesy of El Deseo, S.A.

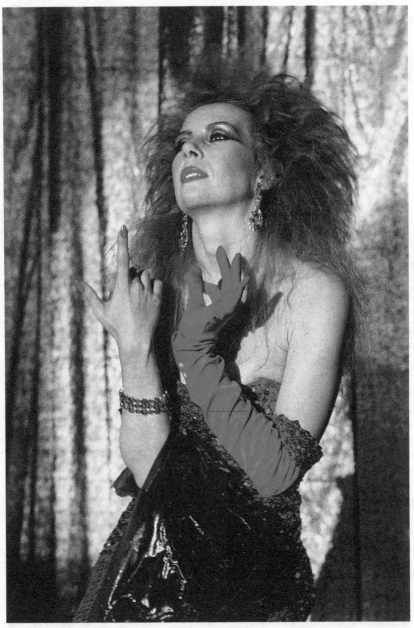

FIG. 15.3 Cristina Sánchez Pascual. *Entre tinieblas* (1983) by Pedro Almodóvar. Courtesy of El Deseo, S.A.

that comes from his childhood years at a religious school in Cáceres (Spain).[31] To this same critic, in *Bad Education*, "we find his most sustained and detailed treatment of this period, implicitly contradicting his off-screen insistence that religion was never traumatic for him, that he was not attempting to settle accounts through this film."[32] In my judgment, in contrast, both movies, though they may contradict each other, justly represent Almodóvar's complex thoughts about the Church as an institution. In Almodóvar's own words about the judges of the Cannes Film Festival, the 1983 film never stood a chance because to them it was "too scandalous."[33] In the Venice Film Festival, Almodóvar continues, *Dark Habits* was also overlooked. "In Venice, some members of the committee thought that the film was great, they love it; but there was another faction that was horrified by it, they found it anti-Catholic and blasphemous."[34] The film aired during the festival, but it did not officially compete for any prize.

Neither can I fully agree with two Italian critics of the same era: according to Gwynne Edwards, the film critic of the Venetian newspaper *Il Gazzettino*, the film was indeed scandalous, whereas the Roman newspaper *Corriere della Sera* "saw Almodóvar as a true heir of the acclaimed Italian filmmaker Pier Paolo Pasolini and applauded his attack on the repressive nature of formal religion."[35]

The trouble is that I am not convinced, along with Almodóvar's assertion in dialogue with Anna Llauradó in 1983, that God is gone from the convent in *Dark Habits*. God continues to exist, even without grandiloquent protagonism: God persists perhaps in the least evident way, as in a few nearly zenithal shots of an objective point of view, of individual prayers, in the sacrament of confession, in the barely attended Eucharist offered by the convent's priest (Manuel Zarzo, 1932–), or in the recognition of the spiritual authority of the Pope, for a few examples. Almodóvar interprets his own 1983 film as the apology of Christianity without God: "The mother superior in my story is a very mystical being, pious, but her piety is not directed towards God but towards delinquency. Piety, in fact, is the language between human beings and God but in this case God has disappeared and she substitutes him for delinquents. . . . Julieta's attitude in the film is absolutely Christian in the sense of protecting the helpless . . . which is the highest act of love and piety that one can achieve."[36]

Last Words

In the Catholic religion Almodóvar espouses, there is neither fear of God nor horror before the possibility of a universe without God. In his prologue to works by Voltaire and Diderot, the Argentine critic, translator, and writer José Bianco (1908–1986) recalls that André Gide (1869–1951) discovered in Voltaire a certain "Annexation to Catholicism."[37] Two films, *The Law of Desire* and *Bad Education*, would be for Almodóvar what those stories, pamphlets, and dialogues

were for Voltaire. Almodóvar could sign his works; Voltaire gave his to the press under obscuring pseudonyms. To Almodóvar's tranquility, the Franco regime had already lost dominance: for the film director, *Dark Habits* was an occasion to defend a Catholicism that was distinct from the Catholicism that Franco wished to impose on Spain.

It is very suggestive that Almodóvar situates the title of his film *Dark Habits* in the first seconds of the work. First the title, then the principal credits of the film, appear and disappear over the middle of the frame and as part of the establishing shot of a chiaroscuro high-angle panorama of the city—possibly from God's point of view. This open shot, without humans, is existentially merciless: there are only gray buildings that imply overcrowding and high-velocity cars. This shot reveals a city receiving the arrival of morning (0:01:57). This sequence of freeze-frames of the city is prolonged by the narrative zoom of the next two scenes: first, Yolanda crosses a bridge and enters a nondescript building (0:01:58–0:02:27); then, she meets her boyfriend in an apartment the two seem to share (0:02:29–0:05:05). What will take place in this profane domestic space—the death of Yolanda's anonymous junkie boyfriend and her terrified panic—and then the whole city covered with the luminous day, led me to this thought: darkness lives in the very heart of this luminous city, and it is expressed in the life of a couple without solidarity and without affection.

The original title in Spanish, *Entre tinieblas*, literally "between darkness" or "within darkness," is disorienting, enigmatic. The translation to English plays with the double meaning of the word "habit" (nun's vestments and someone's repeated behavior) and the triple meaning of "dark" (black, mysterious, and lugubrious or sad). The five nuns do not live in a diluted interior world of intolerance, lack of mercy, and unsolidarity. They, simply, and even when suffering difficulties within, live surrounded by (within, *entre*) this intolerance, this absence of affection for which one suffers—which is the etymological meaning of *misericordia*, the Spanish word for "mercy"—and the atomization of individuals or groups.

Within this shining darkness of Madrid—the oxymoron is not unwarranted—there lives a group of five admirable women. Their moral fortitude springs from this fact: they will not see their misfortunes as the fault of destiny—be they divine, be they social, be they economic. Following Aristotle's terminology, the nuns are united by an intentional friendship, not an accidental one.[38] Fiction informs: according to the "business" card that Sor Estiércol and the Mother Superior give to Yolanda, the convent is located in the neighborhood called "Madrid's Star," more precisely on "Number 5 Flying Fish Street." The website Madrid Destino and David Losa assure us in turn that "the convent from *Dark Habits* (*Entre tinieblas*, 1983) was in the middle of Calle Hortaleza," and that the film takes place in "Convent of Santa María Magdalena. Almost all the action of *Dark Habits* takes place here, known vulgarly as

the Convent of the Very Fucked, and now the site of the UGT (Unión General de Trabajadores) Syndicate, at 88 calle Hortaleza."[39]

The five nuns and the Bengal tiger Niño live "within darkness," but their very life is a successful struggle against the darkness of failed human relationships.[40] It is not their convent that is "within darkness." It is the city and its many inhabitants that live badly, to Almodóvar, in other darknesses: the lack of compassion for others and the lack of consolation that can be found in the big city. In this sense, *Dark Habits* consecrates Almodóvar as a humanist trying to morally reform Catholicism. From *¿Qué he hecho yo para merecer esto?* (1984) [*What Have I Done to Deserve This?*] to *Julieta* (2016), the Almodóvar of 1983 has not appeared again. In dialogue with Maria M. Delgado, Almodóvar confessed: "The Catholic religion provides an enormous quantity not only of rites, but of hope, which in many instances does not have to do with God directly, but there are so many customs that I remember, in La Mancha, related to religion. . . . These rites or these ceremonies seemed admirable to me. . . . I believe that this cult and this idolatry can be enormously helpful to many people" (1:01:49–1:06:27).[41]

Entre tinieblas is not an ode either to suffering or to the lushness of the sacred. The film is a recognition of a respectful and serene lesbian love. But, much more than that, it is an admiring testimony to the expansive solidarity that arises among five women, who are united, *by some Catholic rituals*, to help themselves, each other, and other women who have suffered the blows of impious life.

Notes

I want to express here my sincere gratitude to my former student and poet Leslie Beach. She deserves thousands of heartfelt thanks. These pages started taking shape in Stanford. In 2015, Professor Joan Ramon Resina invited me to teach a course titled "The Cinema of Pedro Almodóvar" at Stanford University. He and my Colombian friend Martha Lucía Moreno read early versions of my essay. I am in debt to them for their meaningful remarks on "*Entre tinieblas* (1983): Pedro Almodóvar, a Reformer of Catholicism?"

1 Conservative groups reacted against blasphemous content in the visual arts and music of the Madrid Scene. As an example, it should suffice to remember that, upon the occasion of one of the episodes of the television program *La Edad de Oro* (1983–1985), its director and interviewer Paloma Chamorro suffered legal action for having offended the religion of the state. Acclaimed for giving massive visibility to Spanish artists of the Madrid Scene, *La Edad de Oro* shocked in many ways, including Chamorro's relaxed appearance in punk attire. One episode of *La Edad de Oro*, aired October 16, 1984, was considered excessively disrespectful of crucial Catholic iconography—the crucifix. Almost ten years later, Chamorro would be exonerated by the state of these charges brought against her. See Marina Segarra and Audiovisual Communication Students of the EPSG (Universitat

Politècnica de València), *La Nueva Ola en Madrid*, Parte 1, March 26, 2015, http://www.youtube.com/watch?v=qBi01qvuik4.

2 Santa Sede, *Inter Sanctam Sedem et Hispaniam Sollemnes Conventiones: Concordato entre la Santa Sede y España*, accessed March 1, 2015, http://www.vatican.va/ roman_curia/secretariat_ state/archivio/documents/rc_seg-st_19530827 _concordato-spagna_sp.html.

3 Katja Nicodemus, "Pedro Almodóvar: 'Eine Art Gott,'" *Die Zeit Online*, October 2, 2009, www.zeit.de/2009/33/Interview-Almodovar.

4 Pedro Almodóvar, "Prólogo," in *Patty Diphusa y otros textos* (Barcelona: Anagrama, 2011), 11.

5 To avoid any biological or supernatural implications of the terms "psychic life" or "consciousness," I prefer an expression I coined: "individuals' interior landscapes."

6 Santa Sede, *Inter Sanctam Sedem*.

7 Pedro Almodóvar, "Autoentrevista 1984," in *Patty Diphusa y otros textos* (Barcelona: Anagrama, 2011), 150.

8 The joie de vivre of the nuns in *Dark Habits* renders them immune to the usual melancholy of convent life, which is imagined as a common mood within Catholic cloisters and which contributes to Satan's visit. See Roger Bartra, *Cultura y melancolía: Las enfermedades del alma en la España del Siglo de Oro* (Barcelona: Anagrama, 2001), 125–126, 139, 142.

9 Denis Diderot, *La Religieuse* (Paris: Gründ, n.d.), 12.

10 *Dark Habits*, in turn, respects the sexual intimacy of its nuns: lesbianism (Mother Superior, Sor Estiércol, Virginia), heterosexualism (Sor Víbora), and the bland indifference of Sor Perdida and Sor Rata de Callejón toward their own sexual preferences and those of their companions in the cloister. Neither is there on-screen evidence that Yolanda is lesbian. On-screen evidence suggests, instead, that she comes from a heterosexual relationship: the viewer knows that her boyfriend recently died. For these reasons I cannot agree with Alberto Mira, for whom *Dark Habits* is a film "centered on lesbian emotions that viewers curiously tend to ignore." Alberto Mira, *Miradas insumisas: Gays y lesbianas en el cine* (Barcelona: Egales, 2008), 401.

11 Diderot, *La Religieuse*, 13.

12 Diderot, 232–233.

13 Nuria Vidal, *El cine de Pedro Almodóvar* (Barcelona: Destino, 1988), 340.

14 Lack of space prohibits a discussion of three other paths that Almodóvar did not follow, which the history of film offered him. First, *Dark Habits* could have been an enigmatic story of terror and Satanism within the enclosed space of a convent. Second, Spanish spectators who were part of the Madrid Scene would have delighted in a fictional audiovisual denunciation—understandably, after all the Francoist years—and a treatise, against female monastic life. Finally, many spectators, young and old, who were part of the Madrid Scene would have appreciated a lesbian film that exploited *claustrophilia* as much as *hierophilia*. By avoiding this threefold trap, and because the Mother Superior's lesbian desire is treated with respect and without emphasis, this variation on the theme of queer love is normalized and easily gains the sympathy of spectators.

15 There are explicit references to Buñuel's works in various Almodóvar films, of which I will simply mention two. First, in one sequence of *Carne trémula* (1997) [*Live Flesh*], there are apparent references to a "film within a film" of *Ensayo de un crimen* (1955) [*The Criminal Life of Archibaldo de la Cruz*]. See Peter W. Evans,

"Acts of Violence in Almodóvar," in *All about Almodóvar: A Passion for Cinema*, ed. Brad Epps and Despina Kakoudaki (Minneapolis: University of Minnesota Press, 2009), 106. Second, in *Bad Education*, "The positioning of the priests seated at a long table with Father Manolo in the center recalls Da Vinci's *The Last Supper*, and perhaps Buñuel's musical/visual parody of the same in *Viridiana*." Kathleen M. Vernon, "Queer Sound: Musical Otherness in Three Films by Almodóvar," in *All about Almodóvar: A Passion for Cinema*, ed. Brad Epps and Despina Kakoudaki (Minneapolis: University of Minnesota Press, 2009), 68.

16 In turn, in *Dark Habits* a literary pseudonym is also used to conceal the works' true authorship. That Sor Rata de Callejón does not sign her novels confirms two common sites of censorship: the ecclesiastical institution that concedes or does not concede the *nihil obstat* for the imprimatur, and the bureaucratic institution of the military and tyrannical governments like those of, among many others, Franco.

17 I choose these in place of others because they have been positively received by critics. I have consulted the Internet Movie Database and Rotten Tomatoes to ascertain which prizes certain of these films have won. Furthermore, and justified by my knowledge of Almodóvar's life and cinematography, I mention movies whose themes I believe would have interested him.

18 Two decades later, in 1953, the Mexican director Fernando de Fuentes (1894–1958) made a version of this same work. The poster for this movie still exists, and it leads me to believe that it may have circulated in theaters in Spain. De Fuentes was known for two classics of Mexican film: *El Compadre Mendoza* (1933) [*Godfather Mendoza*] and *¡Vámonos con Pancho Villa!* (1936) [*Let's Go with Pancho Villa*].

19 The Concordat of 1953, in part 3 of Article XXII, declares: "3. Except in an emergency, the public authorities may not enter the buildings cited above in the exercise of their duties without the consent of the proper Church authorities." Santa Sede, *Inter Sanctam Sedem*. Almost without knowing it, for his convent Almodóvar will re-create the near-total inviolability that would descend upon "canonically established religious houses" (number 2 of the same article).

20 There are two more films that have already been mentioned by critics in works on Almodóvar and that may well have resonated significantly when Almodóvar planned, created, and filmed *Dark Habits*. I refer to *La hermana San Sulpicio* (1951), by the Spanish director Luis Lucía (1914–1984), and *Marcelino, pan y vino* (1954) [*The Miracle of Marcelino*], by the Austro-Hungarian director László Vajda Weisz (1906–1965). Respectively, and imagining that Almodóvar's attention would certainly have been attracted by some aspects of those films, Paul Julian Smith notes that "the first [film is] a discreet account of female sexuality and spirituality, and the second [film is] an unselfconsciously homoerotic tale of a small boy raised by a community of monks and rapt to heaven by a naked Christ." Paul Julian Smith, *Desire Unlimited: The Cinema of Pedro Almodóvar* (London: Verso, 2014), 39.

21 "New Film Tells Tragic Story of Belgium's Singing Nun: Biopic Recalls Life of Jeannine Deckers, Who Once Beat the Beatles to Top of US Charts," *The Guardian*, April 29, 2009, http://www.theguardian.com/world/2009/apr/28/singing-nun-jeannine-deckers.

22 In *Sor Citroën*, there are three central conflicts relating to filiality, family, and ecclesiastical hierarchy: Sister Tomasa's suffering at having left her old engineer father behind; two orphan children, boy and girl, who do not wish to be separated to live in different orphanages; and punishing Sor Citroen for insubordination by

moving her to Bilbao. In *Dark Habits*, the main conflicts overflow the familiar and the domestic, and no precisely religious conflict arises. Almodóvar's nuns live out conflicts of love, finances, and ecclesiastical hierarchy.

23 I advance, without fully unfurling, the following hypothesis: if we carefully study the link between Sor Estiércol and the Mother Superior, it is probable that sufficient evidence exists to suggest the first's lesbian love for the second. Thus it is that Sor Estiércol confesses to Yolanda: "[Mother Superior] redeemed me. I owe her everything. I'm capable of doing anything to defend her."

24 For possible camera angles of an all-seeing God, there are short general shots, large general shots, nearly zenithal shots, soft high-angle shots, appearing at 0:03:54, 0:07:13, 0:14:02, 0:16:10, 0:24:26, and 0:57:43, for example.

25 Jean Baudrillard, *De la Séduction* (Paris: Galilée, 1979), 144.

26 In harmony with what Almodóvar proposes theologically in *Dark Habits*, on April 3, 2015, an article ran in *The Guardian* with the title "Christianity, When Properly Understood, Is a Religion of Losers," by Giles Fraser. I am grateful to my friend and colleague Martha Lucía Moreno Fajardo for this pertinent reference. See Giles Fraser, "Christianity, When Properly Understood, Is a Religion of Losers," *The Guardian*, April 3, 2015, http://www.theguardian.com/commentis-free/belief/ 2015/apr/03/.christianity-when-properly-understood-religion-losers

27 Santa Sede, *Inter Sanctam Sedem*.

28 Perhaps in the character of Sor Rata de Callejón Almodóvar wanted to recall the prolific work of romance novelists. Think of Corín Tellado (1927–2009), or, also, of the photo novels that Almodóvar frequently read and even published. Almodóvar, under the pseudonym Patty Diphusa, published the photo novel *Toda tuya* (1982).

29 Quoted in Juan G. Bedoya, "El Concordato que nadie quiere festejar," *El País*, August 31, 2013, elpais.com/diario/2003/08/31/sociedad/1062280801_850215.html.

30 To maintain the religious atmosphere of this essay, the Spanish original keeps this verse in Spanish, and the translator chooses a literal translation. My colleague Devin Jenkins suggests two English sayings that bear similar meanings: "Neither feast nor famine" (anonymous) and "Everything in moderation, including moderation" (attributed to Oscar Wilde).

31 Alberto Mira, "A Life, Imagined and Otherwise: The Limits and Uses of Autobiography in Amoldóvar's Films," in *A Companion to Pedro Almodóvar*, ed. Martin D'Lugo and Kathleen M. Vernon (Malden, MA: Wiley-Blackwell, 2013), 98.

32 Mira, 99.

33 Anna Llauradó, "Interview with Pedro Almodóvar: *Dark Habits*," in *Pedro Almodóvar: Interviews*, ed. Paola Willoquet-Maricondi (Jackson: University Press of Mississippi, 2004), 18.

34 Llauradó, 18.

35 Gwynne Edwards, *Almodóvar: Labyrinths of Passion* (London: Peter Owen, 2001), 31.

36 Llauradó, "Interview," 19–20.

37 José Bianco, "Estudio preliminar to Voltaire and Diderot," in *Obras escogidas*, ed. José Bianco, vol. 33 of *Clásicos Jackson* (Buenos Aires: W. M. Jackson, 1949), xvi.

38 The Art of Improvement, "Aristotle's Timeless Advice on What Real Friendship Is and Why It Matters," accessed January 10, 2017, http://youtu.be/Fi8kSA8OxqY.

39 Madrid Destino Cultura Turismo y Negocio, "Un paseo por el Madrid de Almodóvar," accessed November 12, 2016, www.esmadrid.com/madrid-de

-almodovar; David Losa, "Los escenarios de película de Pedro Almodóvar por España," *Huffingtonpost España*, February 16, 2016, http://www.huffingtonpost. es/2016/02/16/ escenariosalmodovarespa_n_9181584.html.

40 Reflecting on the inclusion of a Bengal tiger into the plot would require development and planning that exceeds the scope of this essay. I will limit myself to launch this provisional interpretation: for the nuns, Niño might incarnate serene domestication in the midst of the terrible reality in which they live. For the spectator, a tiger happily roaming around a half-ruined convent introduces a cheerfully surreal element. This surreal tiger distances these five nuns from thoughts traditionally assigned to monastic life: severity, sadness, bitterness, daily disputes, and self-absorption, among other negatively valued thoughts.

41 Maria M. Delgado, "Pedro Almodóvar in Conversation," London: British Film Institute, September 15, 2016, https://www.youtube.com/watch?v=GUdm BSKMbdY.

Acknowledgments

Much like the work of bringing a film to life, the editing of a critical anthology depends on the support of a countless legion, among them friends, colleagues, students, translators, and publishing house staff members, in addition to those charged with cinema direction, production, distribution, and exhibition. The Argentine writer Jorge Luis Borges once said that when uttering the humblest word in a language, that same word summoned a countless number of human beings who, for centuries, had been repeating or had even thought to have coined that word. We would like to expand Borges's statement to all human activities. Understood this way, there should always exist an implicit and invisible debt of gratitude that lurks below our words and actions.

The editors thank, first of all, the thirteen contributors. Their scholarship and patience encouraged us throughout the long and difficult process of putting together *Indiscreet Fantasies: Iberian Queer Cinema*. We hope our thirteen colleagues, upon having this book in their hands, will finally be able to experience the words of Thomas à Kempis, *In omnibus requiem quaesivi, et nusquam inveni nisi in angulo cum libro* (In everything I have sought peace and have not found it, except in a quiet corner with a book). We likewise thank our copyeditors and translators for their extraordinary help: *muchas gracias* to Diana de Armas Wilson, Leslie Beach, Joe Cahn, Michael J. Carr, Stacy Crum Duran, Diane Dansereau, Brittany Frysinger, Meredith Jeffers, Cheryl Kaas, Dakota Leonard, Jenna Reynolds, Keith Robbins, Annie Robinson, Caitlyn Scharmerand, and Jeff Schweinfest.

Moltes gràcies, especially, to two of our Catalan friends: filmmaker Ventura Pons and Professor Joan Ramon Resina. Ventura gave us permission to include within this volume beautiful photograms, or stills, of two of his feature-length films, *Amic/Amat* (1998) [*Beloved/Friend*] and *Forasters* (2008) [*Strangers*]. Joan Ramon, since the time we met him in Ithaca, New York, almost twenty

years ago, has served as a mentor, a colleague, a model of scholarship, and, of course, a dear friend.

We would also like to offer a few words of thanks for the other illustrations we now have the good fortune to present to the reader. First, Professor Maria M. Delgado, Director of Research at the Royal Central School of Speech and Drama, led us on the right path to get in touch with Emmanuelle Depaix. Emmanuelle's support allowed us to embellish our work with several stills from Pedro Almodóvar's lovely film *Entre tinieblas* (1983) [*Dark Habits*]. The already mythical El Deseo, S.A., his production company, granted us the privilege to reproduce those graphic materials with Bucknell University Press. Second, the photograms in Kelly Moore's essay on João Pedro Rodrigues's *O ornitólogo* (2016) are there courtesy of Blackmaria, an important audiovisual company located in Lisbon. As for the image included in his own essay, we say *moitas grazas* to Darío Sánchez González. In 2015, Darío, currently an Assistant Professor of Spanish, Gender, Women and Sexuality Studies at Gustavus Adolphus College, took the photograph featured in his essay.

Our final words of gratitude go to Bucknell University Press and Rutgers University Press, in particular Professors Isabel Cuñado and Jason McCloskey, the Series Editors of *Campos Ibéricos: Bucknell Series in Iberian Studies*. A warm *gracias* as well to Professor Greg Clingham, former Editor in Chief of Bucknell University Press; to Suzanne E. Guiod, the new Director; to Amy McCready, Interim Director; to Pamelia Dailey, Managing Editor; to Alissa Zarro, Production Editor at Rutgers University Press; to Greg Hyman, Production Editor at Westchester Publishing Services; and to Susan Ecklund. We will not stop admiring the eagle eyes of editors Susan and Greg.

We could not have imagined that a regular academic event in Walla Walla, Washington, would become a printed artifact. That is to say, in the spring of 2007, Andrés taught an advanced undergraduate seminar at Whitman College, titled "Unexpected Lives: Spanish Queer Cinema"; this course then became the starting point of our critical endeavor. The keen emotion of those undergraduate students has continued to inspire us for more than a decade. We believe that their eagerness to learn about queer issues through the lens of Iberian cinema will, in turn, inspire future scholars and spectators. At the same time, in the United States and abroad, readers of this collective anthology will find *Indiscreet Fantasies: Iberian Queer Cinema* to be a friendly companion that enhances their critical film viewing.

Filmography

A esmorga. Directed by Ignacio Vilar, 2014.
Amic/Amat. Directed by Ventura Pons, 1998.
Ander. Directed by Roberto Castón, 2009.
A raíz do coração. Directed by Paulo Rocha, 2000.
Castillos de cartón. Directed by Salvador García Ruiz, 2009.
El diputado. Directed by Eloy de la Iglesia, 1978.
Entre tinieblas. Directed by Pedro Almodóvar, 1983.
Forasters. Directed by Ventura Pons, 2008.
Krámpack. Directed by Cesc Gay, 2002.
La residencia. Directed by Narciso Ibáñez Serrador, 1969.
Mi querida señorita. Directed by Jaime de Armiñán, 1971.
O ornitólogo. Directed by João Pedro Rodrigues, 2016.
Pa negre. Directed by Agustí Villaronga, 2010.
Sévigné (Júlia Berkowitz). Directed by Marta Balletbò-Coll, 2004.
Spinnin'. Directed by Eusebio Pastrana, 2007.
Torremolinos 73. Directed by Pablo Berger, 2003.

Bibliography

Aaron, Michele. "Introduction." In *New Queer Cinema: A Critical Reader*, edited by Michele Aaron, 3–14. New Brunswick, NJ: Rutgers University Press, 2004.

Acedo Alonso, Noemí. "Re/presentacions del desig lèsbic a *Sévigné (Júlia Berkowitz)*, de Marta Balletbò-Coll." In *Accions i reinvencions cultures lèsbiques a la Catalunya del tombant de segle XX–XXI*, edited by Meri Torras i Francès, 165–172. Barcelona: Universitat Oberta de Catalunya, 2011.

Acevedo-Muñoz, Ernesto R. "The Body and Spain: Pedro Almodóvar's *All about My Mother*." *Quarterly Review of Film and Video* 21 (2004): 25–38.

Adam Donat, Antoni, and Alvar Martínez Vidal. "'Infanticidas, violadores, homosexuales y pervertidos de todas las categorías.' La homosexualidad en la psiquiatría del franquismo." In *Una discriminación universal: La homosexualidad bajo el franquismo y la transición*, edited by Javier Ugarte Pérez, 109–138. Barcelona: Egales, 2008.

"*A esmorga* Desayuno." *Vimeo*, November 14, 2014. http://vimeo.com/111887800.

"'A esmorga,' segunda película en recaudación media por cine en España." *La Opinión A Coruña*, November 23, 2014. http://www.laopinioncoruna.es/sociedad/2014/11/23/esmorga-segunda-pelicula-recaudacion-media/902000.html.

Agamben, Giorgio. *Homo Sacer: Sovereign Power and Bare Life*. Translated by Daniel Heller-Roazen. Palo Alto, CA: Stanford University Press, 1998.

Aguilar, Carlos. "Fantasía española: Negra sangre caliente." In *Cine fantástico y de terror español 1900–1983*, edited by Carlos Aguilar, 11–47. Donostia: Donostia Kultura, 1999.

Alcaforado, Mariana. *Cartas de la monja portuguesa*. Translated by Enrique Badosa. Barcelona: Acantilado, 2008.

Aliaga, Juan Vicente, and José Miguel Cortés. *Identidad y diferencia: Sobre la cultura gay en España*. Barcelona: Egales, 1997.

Allbritton, Dean. "Recovering Childhood: Virulence, Ghosts, and *Black Bread*." *Bulletin of Hispanic Studies* 91, no. 6 (2014): 619–636.

Allegue, Gonzalo. *Eduardo Blanco Amor: Diante dun xuíz ausente*. Gijón, Spain: Nigra, 1993.

Almela Boix, Margarita. "Reflexiones sobre los estereotipos de maldad y bondad femeninas: Apuntes sobre la historia de una infamia." In *Malas*, edited by

Margarita Almela Boix, María Magdalena García Lorenzo, and Helena Guzmán García, 63–110. Madrid: Universidad Nacional de Educación a Distancia, 2015.

Almodóvar, Pedro. "Autoentrevista 1984." In *Patty Diphusa y otros textos*, 143–151. Barcelona: Anagrama, 2011.

——, dir. *Entre tinieblas*. Madrid: Tesauro, 1983.

——. *Hablé con ella*. Madrid: El Deseo, 2002.

——. *Julieta*. Madrid: El Deseo, 2016.

——. *La piel que habito*. Madrid: El Deseo, 2011.

——. *Patty Diphusa y otros textos*. Barcelona: Anagrama, 2011.

——. "Prólogo." In *Patty Diphusa y otros textos*, 7–11. Barcelona: Anagrama, 2011.

——. *Todo sobre mi madre*. Madrid: El Deseo, 1999.

"Almodóvar hubiera querido dirigir a López Vázquez en *Mi querida señorita*." *La información: Cine*, November 3, 2009. http://www.lainformacion.com/arte -cultura-y- espectaculos/cine/almodovar-hubiera-querido-dirigir-a-lopez-vazquez -en-mi-querida- senorita_oGXGmzhsgoHwx9RfrIsaY6/.

Althusser, Louis. *Lenin and Philosophy and Other Essays*. Translated by Ben Brewster. New York: Monthly Review Press, 2001.

Alvarez Sancho, Isabel. "*Pa negre* y los otros fantasmas de la posmemoria: El 'phantom' y los intertextos con *La plaça del diamant*, *El espíritu de la colmena* y *El laberinto del fauno*." *MLN* 131, no. 2 (2016): 517–535.

Amago, Samuel. *Spanish Cinema in the Global Context: Film on Film*. New York: Routledge, 2013.

Aranoa, Fernando León de, dir. *Los lunes al sol*. Pozuelo de Alarcón, Spain: Sogepaq, 2002.

Armiñán, Jaime de, dir. *Mi querida señorita*. Madrid: El Imán, 1971.

Arredondo, Luis. "*Torremolinos 73*: Un afortunado collage." *Butaca Ancha*, January 20, 2014. http://butacaancha.com/torremolinos-73-un-afortunado-collage.

The Art of Improvement. "Aristotle's Timeless Advice on What Real Friendship Is and Why It Matters." Accessed January 10, 2017. http://youtu.be/F18kSA8 OxqY.

Asión Suñer, Ana. "La Tercera Vía del cine español: Relecturas del periodo tardofran-quista." *Revista de la Asociación Aragonesa de Críticos de Arte* 26 (2014): 1–13.

Azaña, Manuel. Letter to Eduardo Blanco Amor. August 12, 1939. Eduardo Blanco Amor Papers, Biblioteca Deputación Provincial de Ourense, Ourense (Spain). Manuscript.

Badosa, Enrique. "Las 'Cartas portuguesas.'" In *Cartas de la monja portuguesa*, by Mariana Alcaforado, 7–16. Barcelona: Acantilado, 2008.

Ballesteros, Isolina. *Cine (ins)urgente: Textos fílmicos y contextos culturales de la España postfranquista*. Madrid: Fundamentos, 2001.

——. "El despertar homosexual del cine español: Identidad y política en transición (Eloy de la Iglesia, Pedro Olea, Imanol Uribe y Pedro Almodóvar)." In *Cine (ins) urgente: Texto fílmicos y contextos culturales de la España posfranquista*, 91–128. Madrid: Fundamentos, 2001.

Balletbò-Coll, Marta, dir. *Costa Brava*. Tallahassee, FL: The Naiad, 1997.

——. *Costa Brava (Family Album)*. Barcelona: CostaBrava, 1995.

——, dir. *Sévigné (Júlia Berkowitz)*. Barcelona: CostaBrava, 2004.

Balletbò-Coll, Marta, and Ana Simón Cerezo, dirs. *Honey, I've Sent the Men to the Moon*. Barcelona: CostaBrava, 1998.

——. *Hotel Kempinsky*. Translated by Montserrat Triviño. Barcelona: Egales, 2002.

Baptista, Tiago. "Na minha cidade não acontece nada: Lisboa no cinema (anos vinte–cinema novo)." *Ler História* 48 (2005): 167–184.

Barthes, Roland. *La cámara lúcida: Nota sobre la fotografía.* Translated by Joaquim Sala- Sanahuja. Barcelona: Paidós, 1990.

Bartra, Roger. *Cultura y melancolía: Las enfermedades del alma en la España del Siglo de Oro.* Barcelona: Anagrama, 2001.

Bataille, Georges. *Erotism: Death and Sensuality.* Translated by Mary Dalwood. San Francisco: City Lights, 1986.

———. *The Tears of Eros.* Translated by Peter Connor. San Francisco: City Lights, 1990.

Baudrillard, Jean. *De la Séduction.* Paris: Galilée, 1979.

Bauman, Zygmunt. *Liquid Life.* Cambridge, UK: Polity, 2005.

Bazin, André. "The Life and Death of Superimposition (1946)." Translated by Bert Cardullo. *Film-Philosophy* 6, no. 1 (2002). https://www.euppublishing.com/doi /full/10.3366/ film.2002.0001.

Bedoya, Juan G. "El Concordato que nadie quiere festejar." *El País*, August 31, 2013. elpais.com/diario/2003/08/31/sociedad/1062280801_850215.html.

Benet, Josep. *L'intent franquista de genocidi cultural contra Catalunya.* Barcelona: Publicacions de l'Abadia de Montserrat, 1995.

Benet, Vicente J. *El cine español: Una historia cultural.* Barcelona: Paidós, 2012.

Benet i Jornet, Josep Maria. "Sergi Belbel, tot just comença." In *Forasters*, by Sergi Belbel, 7–20. Barcelona: Proa, 2004.

Benjamin, Walter. *The Arcades Project.* Translated by Howard Eiland and Kevin McLaughlin. Cambridge, MA: Harvard University Press, 1999.

———. *Reflections.* Translated by Edmund Jephcott. New York: Random House, 2007.

Benshoff, Harry M. *Monsters in the Closet: Homosexuality and the Horror Film.* Manchester: Manchester University Press, 1997.

Benshoff, Harry M., and Sean Griffin. *Queer Cinema: The Film Reader.* New York: Routledge, 2004.

———. *Queer Images: A History of Gay and Lesbian Film in America.* Lanham, MD: Rowman and Littlefield, 2006.

Bentley, Bernard P. E. *A Companion to Spanish Cinema.* Woodbridge, UK: Tamesis, 2008.

"Berdindu." Accessed July 25, 2017. www.euskadi.eus/gobierno-vasco/berdindu/.

Berger, Pablo, dir. *Torremolinos 73.* Madrid: Telespan, 2002.

Bergson, Henri. *Œuvres.* Edited by André Robinet. Paris: Presses Universitaires de France, 1959.

Berzosa, Alberto. *Homoherejías fílmicas: Cine homosexual subversivo en España en los años setenta y ochenta.* Madrid: Traficantes de Sueños, 2014.

Bianco, José. "Estudio preliminar to Voltaire and Diderot." In *Obras escogidas*, edited by José Bianco, ix–xxxv. Vol. 33 of *Clásicos Jackson*. Buenos Aires: W. M. Jackson, 1949.

Bilbao Terreros, Gorka. "Matriarchy, Motherhood, Myth and the Negotiation of (Gender) Identity in Modern Basque Cinema." *Bulletin of Hispanic Studies* 94, no. 7 (2017): 731–745.

Blanco Amor, Eduardo. *A esmorga.* Vigo: Galaxia, 2010.

———. "La parranda: Guion cinematográfico sobre la novela de mismo título ambos propiedad de su autor Eduardo Blanco-Amor." Eduardo Blanco Amor Papers, Biblioteca Deputación Provincial de Ourense, Ourense (Spain). Unpublished manuscript.

Blázquez Carmona, Feliciano. *La traición de los clérigos en la España de Franco: Crónica de una intolerancia, 1936–1975.* Madrid: Trotta, 1991.

Bogue, Ronald. *Deleuze on Cinema.* New York: Routledge, 2003.

Bollaín, Icíar, dir. *Te doy mis ojos.* Madrid: La Iguana, 2003.

Bonet Mojica, Lluís. "'A esmorga': Viaje sin retorno." Review of *A esmorga*, by Ignacio Vilar. *La Vanguardia*, May 8, 2015. http://www.lavanguardia.com/cine/20150508 /54430510391/a-esmorga-critica-de-cine.html.

Borau, José Luis. *Diccionario del cine español.* Madrid: Alianza, 1998.

Borges, Jorge Luis, Adolfo Bioy Casares, and Silvina Ocampo, eds. *Antología poética argentina.* Buenos Aires: Sudamericana, 1941.

Borghi, Liana. "Apertura del Convegno." In *Da desiderio a Desiderio. Donne, sessualità, progettualità lesbica.* Proceedings of the Fifth National Lesbian Conference. Impruneta, December 5–7, 1987. Florence: L'Amandorla 1987. Quoted in Teresa de Lauretis, "The Intractability of Desire." In *Figures of Resistance: Essays in Feminist Theory*, ed. Patricia White, 217–234. Champaign: University of Illinois Press, 2007.

Boschi, Elena. "Sexuality and the Nation: Urban Popular Music and Queer Identities in *Krámpack.*" *Quaderns* 9 (2014): 87–95.

Bru-Domínguez, Eva. "Repressed Memories and Desires: The Monstrous Other in Agustí Villaronga's *Pa negre.*" *Bulletin of Hispanic Studies* 93, no. 9 (2016): 1009–1022.

Burrus, Virginia. *Saving Shame: Martyrs, Saints, and Other Abject Subjects.* Philadelphia: University of Pennsylvania Press, 2007.

Butler, Judith. *Bodies That Matter: On the Discursive Limits of "Sex."* London: Routledge, 2011.

———. "Gendering the Body: Beauvoir's Philosophical Contribution." In *Women, Knowledge, and Reality: Explorations in Feminist Philosophy*, edited by Ann Garry and Marilyn Pearsall. 253–262. Boston: Unwin Hyman, 1989.

———. *Gender Trouble: Feminism and the Subversion of Identity.* London: Routledge, 2002.

———. "Imitation and Gender Insubordination." In *Inside/Out: Lesbian Theories, Gay Theories*, edited by Diana Fuss, 13–31. New York: Routledge, 1991.

———. *Notes toward a Performative Theory of Assembly.* Cambridge, MA: Harvard University Press, 2015.

———. *The Psychic Life of Power: Theories in Subjection.* Palo Alto, CA: Stanford University Press, 1997.

Butler, Judith, and Gayatri Spivak. *Who Sings the Nation-State? Language, Politics, Belonging.* New York: Seagull, 2011.

"Cada año más mujeres al volante." Dirección General de Tráfico. Accessed December 3, 2017. http://revista.dgt.es/es/noticias/nacional/2017/03MARZO/0307 -Dia-Mujer.shtml# WiR2JLQ-fUI.

Caillois, Roger. "Metamorphoses of Hell." In *The Edge of Surrealism*, edited by Claudine Frank, 298–311. Durham, NC: Duke University Press, 2003.

Camí-Vela, María. "Cineastas españolas que filmaron en inglés: ¿Estrategia comercial o expresión multicultural?" In *Estudios culturales y de los medios de comunicación*, edited by María Pilar Rodríguez Pérez, 53–70. Bilbao: Universidad de Deusto, 2009.

———. *Mujeres detrás de la cámara: Entrevistas con cineastas españolas, 1990–2004.* Madrid: Ocho y Medio, 2005.

Caparrós Lera, José María. *Historia del cine español.* Madrid: T&B Editores, 2007.

Carmona Muela, Juan. *Iconografía de los santos*. Tres Cantos, Spain: Akal, 2015.

Carneiro, Carlos. "Caretos." *Portugal num Mapa*. Accessed May 22, 2017. http://www. portugalnummapa.com/caretos/.

Carreño, José María. Review of *Mi querida señorita*. *Fotogramas* 54 (1972): 35–40.

Carreño, José María, and Fernando Méndez-Leite. "Ocupadísimo, Jaime de Armiñán: Entre el cine y T.V.E." *Fotogramas* 55 (1972): 16–17.

Cascais, António Fernando, and João Ferreira, eds. *Cinema e cultura queer*. Lisbon: Associação Cultural Janela Indiscreta, 2014.

Castón, Roberto, dir. *Ander*. Bilbao: Berdindu, 2009.

Chanan, Michael. "The Economic Condition of Cinema in Latin America." In *New Latin American Cinema*, edited by Michael T. Martin, vol. 1, 185–200. Detroit: Wayne State University Press, 1997.

Charleston, Jim, dir. "Teliko." *X-Files*. Season 4, episode 3. October 18, 1996.

Chomsky, Noam. *Media Control: The Spectacular Achievements of Propaganda*. New York: Seven Stories, 2002.

"Compte rendu d'*Ander*." *Télérama Cinéma*. Accessed July 25, 2017. http://www .telerama.fr/ cinema/films/ander,383976.php.

Conde Muruais, Perfecto. "Normalidad en las manifestaciones contra el estatuto gallego." *El País*, December 5, 1979. http://elpais.com/diario/1979/12/05/espana /313196413_ 850215.html.

"Congreso avala sin el apoyo del PP que las personas trans cambien su sexo legal sin declararse enfermas." *El Diario*, November 30, 2017. http://www.eldiario.es /sociedad/Congreso- reforma-considerar-personas-enfermas_0_712528886.html.

Connell, R. W. *Gender*. Cambridge, UK: Polity, 2002.

Córdoba, David, Javier Sáez, and Paco Vidarte, eds. *Teoría Queer: Políticas bolleras, maricas, trans, mestizas*. Barcelona: Egales, 2005.

Cowie, Peter. *Revolution! The Explosion of World Cinema in the 60s*. London: Faber, 2004.

Crenshaw, Kimberle. "Demarginalizing the Intersection of Race and Sex: A Black Feminist Critique of Antidiscrimination Doctrine, Feminist Theory and Antiracist Politics." *University of Chicago Legal Forum* 140 (1989): 139–167.

Crusells, Magí. *Directores de cine en Cataluña: De la A la Z*. Barcelona: Universitat de Barcelona, 2008.

Cunha, Paulo, Rui Silva, and Samuel Silva, eds. "Paulo Rocha." *En[Q]uadramento do Cineclube de Guimarães* 3 (2014): 1–36.

———. "Paulo Rocha, o eterno aprendiz." *A Cuarta Parede*, February 27, 2014. http:// www. acuartaparede.com/paulo-rocha/?lang=es.

Cunqueiro, Alvaro. "Spartacus Gay Guide." In *"Los otros rostros" (1975–1981) en Sábado Gráfico (Madrid, 1956–1983)*, edited by Luis Alonso Girgado, Lorena Domínguez Mallo, and Anastasio Iglesias Blanco, 223–225. Santiago de Compostela, Spain: Follas Novas, 2013.

da Costa, João Bénard. "Especial Paulo Rocha: *Os verdes anos*." Translated by Francisco Algarín Navarro. *Lumière*. Accessed January 28, 2018. http://www .elumiere.net/especiales/rocha/index.php.

Davies, Ann. "Spanish Gothic Cinema: The Hidden Continuities of a Hidden Genre." In *Global Genres, Local Films: The Transnational Dimension of Spanish Cinema*, edited by Elena Oliete-Aldea, Beatriz Oria, and Juan A. Tarancón, 115–126. London: Bloomsbury, 2016.

de Lauretis, Teresa. "The Intractability of Desire." In *Figures of Resistance: Essays in Feminist Theory*, edited by Patricia White, 217–234. Champaign: University of Illinois Press, 2007.

———. *The Practice of Love: Lesbian Sexuality and Perverse Desire*. Bloomington: Indiana University Press, 1994.

———. "Sexual Indifference and Lesbian Representation." *Figures of Resistance: Essays in Feminist Theory*, edited by Patricia White, 48–71. Champaign: University of Illinois Press, 2007.

Deleuze, Gilles. *Cinema 1: The Movement-Image*. Translated by Hugh Tomlinson and Barbara Habberjam. Minneapolis: University of Minnesota Press, 1986.

———. *Cinema 2: The Time-Image*. Translated by Hugh Tomlinson and Robert Galeta. Minneapolis: University of Minnesota Press, 1989.

Deleuze, Gilles, and Félix Guattari. *A Thousand Plateaus: Capitalism and Schizophrenia*. Translated by Brian Massumi. Minneapolis: University of Minnesota Press, 2005.

Deleyto, Celestino. "Aquellas pequeñas cosas: Una entrevista con Cesc Gay y Tomás Aragay." *Hispanic Research Journal* 9, no. 4 (2008): 354–368.

Delgado, Maria M. "Pedro Almodóvar in Conversation." London: British Film Institute. September 15, 2016. https://www.youtube.com/watch?v=GUdm BSKMbdY.

Denver Film Society. "Denver Film Festival 2018." Accessed September 29, 2018. https://secure.denverfilm.org/festival/film/results.aspx?FID=100().

Dercksen, Daniel. "Spanish Writer-Director Pedro Almodóvar Talks about *Julieta*, His Most Severe Film to Date." *Writing Studio*, November 3, 2016. http://writing studio.co.za/ spanish-writer-director-pedro-almodovar-talks-about-julieta-his-most -severe-film-to- date/.

Derrida, Jacques. *The Beast and the Sovereign I*. Translated by Geoffrey Bennington. Chicago: University of Chicago Press, 2009.

Deveny, Thomas. "*Pa Negre (Pan negro)*: Bildungsroman/bildungsfilm de memoria histórica." *La Nueva Literatura Hispánica* 16 (2012): 397–416.

Díaz-Plaja, Fernando. *La España política del siglo XX en fotografías y documentos*. Barcelona: Plaza & Janes, 1972.

Diderot, Denis. *La Religieuse*. Paris: Gründ, n.d.

D'Lugo, Marvin. *Guide to the Cinema of Spain*. Westport, CT: Greenwood, 1997.

Doane, Mary Ann. *The Emergence of Cinematic Time: Modernity, Contingency, the Archive*. Cambridge, MA: Harvard University Press, 2002.

d'Ors, Eugenio. *Lo Barroco*. Madrid: Aguilar, 1964.

Driver, Susan. "Girls Looking at Girls Looking for Girls: The Visual Pleasures and Social Empowerment of Queer Teen Romance Flicks." In *Youth Culture in Global Cinema*, edited by Timothy Shary and Alexandra Seibel, 241–255. Austin: University of Texas Press, 2007.

Durrell, Lawrence. *Quinx: Or, the Ripper's Tale*. Vol. 5. London: Faber and Faber, 1985.

Dyer, Richard. *The Culture of Queers*. New York: Routledge, 2002.

———. *Now You See It: Studies on Lesbian and Gay Film*. New York: Routledge, 2003.

Eco, Umberto. *De los espejos y otros ensayos*. Translated by Cárdenas Moyano. Barcelona: Debolsillo, 2012.

Edelman, Lee. *No Future: Queer Theory and the Death Drive*. Durham, NC: Duke University Press, 2007.

Edwards, Gwynne. *Almodóvar: Labyrinths of Passion*. London: Peter Owen, 2001.

———. "Sexual Ambiguity in Jaime Armiñán's *Mi querida señorita* (1972)." *Tesserae* 2 (1996): 39–54.

"8 de marzo: Ser mujer en los 50, en los 80 y ahora." Accessed December 3, 2017. http://www.eslang.es/politica/8-de-marzo-ser-mujer-en-los-50-en-los-80-y-ahora_20160308-lr.html.

Eisenstein, Sergei. *Film Form*. Translated by Jay Leyda. San Diego: Harcourt, 1949.

Eliade, Mircea. *The Myth of the Eternal Return or, Cosmos and History*. Translated by William R. Trask. Princeton, NJ: Princeton University Press, 1971.

"El lugar donde coincidieron 'A esmorga' y Facebook." *La Voz de Galicia*, May 25, 2017. http://www.lavozdegalicia.es/noticia/galicia/2017/05/25/lugar-coincidieron-esmorga-facebook/0003_201705G25P8991.htm.

"Entra en vigor la Ley de Identidad de Género." *El País*, March 17, 2007. http://elpais.com/sociedad/2007/03/17/actualidad/1174086001_850215.html.

"Entrevista a Use Pastrana." June 20, 2007. http://www.alejandro-tous.es/entrevistause.

Eribon, Didier. *Reflexiones sobre la cuestión gay*. Translated by Jaime Zulaika. Barcelona: Anagrama, 2001.

Erikson, Erik H. *Identity: Youth and Crisis*. New York: W. W. Norton Company, 1968.

Esposito, Roberto. *Immunitas: The Protection and Negation of Life*. Translated by Zakiya Hanafi. Cambridge, UK: Polity, 2011.

Evans, Peter W. "Acts of Violence in Almodóvar." In *All about Almodóvar: A Passion for Cinema*, edited by Brad Epps and Despina Kakoudaki, 101–117. Minneapolis: University of Minnesota Press, 2009.

Faulkner, Sally. *A History of Spanish Film: Cinema and Society 1910–2010*. London: Bloomsbury, 2013.

Feldman, Sharon. *In the Eye of the Storm*. Lewisburg, PA: Bucknell University Press, 2009.

Fernández, Miguel Anxo. "Galicia e o cine: Diversidade e identidad na procura de acomodo." *Grial: Revista Galega de Cultura* 52, no. 204 (2014): 13–27.

Ferreira, João. "The Politics of Desire in Portuguese Cinema." In *Cinema e Cultura Queer | Queer Film and Culture*, edited by João Ferreira and António Fernando Cascais, 106–135. Lisbon: Queer Lisboa, 2014.

Foucault, Michel. *The History of Sexuality. Volume 1: An Introduction*. Translated by Robert Hurley. New York: Vintage Books, 1990.

———. "Of Other Spaces: Utopias and Heterotopias" (1967). Translated by Jay Miskowiec. Accessed February 13, 2017. http://web.mit.edu/allanmc/www/foucault1.pdf.

———. *Surveiller et punir: Naissance de la prison*. Paris: Gallimard, 1975.

Fouz-Hernández, Santiago. "Boys Will Be Men: Teen Masculinities in Recent Spanish Cinema." In *Youth Culture in Global Cinema*, edited by Timothy Shary and Alexandra Seibel, 222–237. Austin: University of Texas Press, 2007.

———. "Caresses: The Male Body in the Films of Ventura Pons." In *Mysterious Skin: Male Bodies in Contemporary Cinema*, edited by Santiago Fouz-Hernández, 143–157. London: Tauris, 2009.

———. "Identity without Limits: Queer Debates and Representation in Contemporary Spain." *Journal of Iberian and Latin American Studies* 10, no. 1 (2004): 63–82.

———. "Queer in Spain: Identity without Limits." In *Queer in Europe: Contemporary Case Studies*, edited by Lisa Downing and Robert Gillett, 189–202. New York: Routledge, 2016.

———. "School Is Out: The British 'Coming Out' Films of the 1990s." In *Queer Cinema in Europe*, edited by Robin Griffiths, 145–164. Bristol: Intellect, 2008.

Fouz-Hernández, Santiago, and Alfredo Martínez-Expósito. *Live Flesh: The Male Body in Contemporary Spanish Cinema*. London: Tauris, 2008.

Franco, Jesús. *Die Liebesbriefe einer portugiesischen Nonne*. Zurich: Ascot, 1977.

Fraser, Giles. "Christianity, When Properly Understood, Is a Religion of Losers." *The Guardian*, April 3, 2015. http://www.theguardian.com/commentisfree/belief/2015 /apr/03/christianity-when-properly-understood-religion-losers.

Freixanes, Víctor F., and Xosé M. Soutullo. "Unha baixada aos infernos: Conversa con Ignacio Vilar, director de *A esmorga*." *Grial: Revista Galega de Cultura* 52, no. 204 (2014): 47–53.

Fuentes, Miguel Angel. "Elementos generales sobre sexualidad humana." *Catholic.net*. Accessed December 9, 2017. http://es.catholic.net/op/articulos/20325/cat/320/es -correcto-el-cambio-de-sexo.html.

Galeano, Eduardo. *Open Veins of Latin America: Five Centuries of the Pillage of a Continent*. Translated by Cedric Belfrage. New York: Monthly Review Press, 1997.

Garaño, Jon, and Jose Mari Goenaga, dirs. *80 egunean*. Bilbao: Irusoin, 2010.

———. *Loreak*. Bilbao: Euskal Irrati Telebista, 2014.

García Figer, Antonio. *Medina*. Madrid: Sección Femenina, 1945.

Garrido Pizarroso, Sergio. "No puedo imaginarme *Mi querida señorita* sin López Vázquez." *Aisge*, April 16, 2013. http://www.aisge.es/coloquio-sobre-mi-querida -senorita.

Gatica, Lucho. "Encadenados." July 27, 2018. http://www.youtube.com/watch?v =L5sft2vK1O8.

Gay, Cesc, dir. *Krámpack*. London: Messidor Films. 2000.

George, David. *Sergi Belbel and Catalan Theatre: Text, Performance and Identity*. Woodbridge, UK: Tamesis, 2010.

Gimeno, Beatriz. *Historia y análisis político del lesbianismo: La liberación de una generación*. Barcelona: Gedisa, 2005.

Girard, René. *I See Satan Fall Like Lightning*. Translated by James G. Williams. New York: Orbis, 2008.

———. *The Scapegoat*. Translated by Yvonne Freccero. Baltimore, MD: Johns Hopkins University Press, 1986.

Giroux, Henry A. "Teenage Sexuality, Body Politics, and the Pedagogy of Display." In *Youth Culture: Identity in a Postmodern World*, edited by Jonathan Epstein, 24–55. Oxford: Blackwell, 1998.

Gomes, Kathleen. "A Cidade a Seus Pés." *Ípsilon* (*Jornal Público*), January 25, 2001. http://www.publico.pt/2001/01/12/jornal/a-cidade-a-seus-pes-153520.

Grandes, Almudena. *Castillos de cartón*. Barcelona: Tusquets, 2004.

Griffiths, Robin, "Introduction: Contesting Borders—Mapping a European Queer Cinema." In *Queer Cinema in Europe*, edited by Robin Griffiths, 14–19. Bristol: Intellect, 2008.

Guasch, Oscar. *La sociedad rosa*. Barcelona: Anagrama, 1995.

Guasch, Oscar, and Olga Viñuales. "Introducción: Sociedad, sexualidad y teoría social: La sexualidad en perspectiva sociológica." In *Sexualidades: Diversidad y control social*, edited by Oscar Guasch and Olga Viñuales, 9–18. Cerdanyola del Vallès, Spain: Bellaterra, 2003.

Gubern, Román, José Enrique Monterde, Julio Pérez Perucha, Esteve Riambau, and Casimiro Torreiro. *Historia del cine español*. Madrid: Cátedra, 2017.

———. "Introduction." In *Un extraño entre nosotros: Las aventuras y utopías de José Luis Borau*, edited by Hilario J. Rodríguez, 9–14. Madrid: Notorious, 2008.

———. *Proyector de luna: La generación del 27 y el cine*. Barcelona: Anagrama, 1999.

Guest, Haden. "The School of Reis: The Films and Legacy of António Reis and Margarida Cordeiro." Harvard Film Archive. Accessed December 21, 2017. http://hcl.harvard.edu/hfa/films/2012aprjun/reis.html.

Gutiérrez Albilla, Julián Daniel. "Reframing *My Dearest Señorita* (1971): Queer Embodiment and Subjectivity through the Poetics of Cinema." *Studies in Spanish and Latin American Cinemas* 12, no. 1 (2015): 27–42.

———. *Queering Buñuel: Sexual Dissidence and Psychoanalysis in His Mexican and Spanish Cinema*. New York: Tauris Academic Studies, 2008.

Gutiérrez Aragón, Manuel, dir. *Cosas que dejé en La Habana*. Madrid: Tornasol, 1997.

Haggerty, George E. *Queer Gothic*. Champaign: University of Illinois Press, 2006.

Hall, Donald E. "Graphic Sexuality and the Erasure of a Polymorphous Perversity." In *RePresenting Bisexualities: Subjects and Cultures of Fluid Desire*, edited by Donald E. Hall and Maria Pramaggiore, 99–123. New York: New York University Press, 1996.

Halperin, David M. *One Hundred Years of Homosexuality and Other Essays*. New York: Routledge, 1990.

———. *Saint Foucault: Towards a Gay Hagiography*. Oxford: Oxford University Press, 1995.

Haraway, Donna. *Crystals, Fabrics, and Fields*. New Haven, CT: Yale University Press, 1976.

Hardcastle, Anne, Roberta Morosini, and Kendall Tarte, eds. *Coming of Age on Film: Stories of Transformation in World Cinema*. Newcastle upon Tyne: Cambridge Scholars, 2009.

Haritaworn, Jin, Adi Kuntsman, and Silvia Posocco. "Introduction." In *Queer Necropolitics*, edited by Jin Haritaworn, Adi Kuntsman and Silvia Posocco, 1–29. New York: Routledge, 2014.

Heath, Stephen. "Male Feminism." In *Men in Feminism*, edited by Alice Jardine and Paul Smith, 1–32. New York: Routledge, 1987.

———. "On Screen, in Frame: Film and Ideology." *Quarterly Review of Film Studies* 1, no. 3 (1976): 251–265.

Heidegger, Martin. *Being and Time*. Translated by John Macquarrie and Edward Robinson. New York: Harper and Collins, 1962.

Hemmings, Clare. *Bisexual Spaces: A Geography of Sexuality and Gender*. New York: Routledge, 2002.

Hens, Antonio, dir. *Clandestinos*. Madrid: Galiardo, 2013.

Heron, Christopher. "A Voyage in Space and Time: João Pedro Rodrigues Interview (*The Ornithologist*)." *The Seventh Art*, October 15, 2016. theseventhart.org/joao-pedro-rodrigues-interview-the-ornithologist/.

Hitchcock, Alfred, dir. *Rope*. Hollywood: Transatlantic Pictures, 1948.

Hogan, Erin K. "Queering Post-war Childhood: *Pa negre* (Agustí Villaronga, Spain 2010)." *Hispanic Research Journal* 17, no. 1 (2016): 1–18.

Holland, Jonathan. Review of *A esmorga*, by Ignacio Vilar. *Hollywood Reporter*, December 17, 2014. http://www.hollywoodreporter.com/review/a-esmorga-film-review-758303.

Hontanilla, Ana. "Hermafroditismo y anomalía cultural en *Mi querida señorita*." *Letras Hispanas* 3, no. 1 (2006): 113–122.

Hughes, William, and Andrew Smith. "Introduction: Queering the Gothic." In
 Queering the Gothic, edited by William Hughes and Andrew Smith, 1–10.
 Manchester: Manchester University Press, 2009.
Ibáñez Serrador, Narciso, dir. *Historias para no dormir*. Madrid: Radio y Televisión
 Española, 1964.
———. *La Residencia*. Madrid: José Frade Producciones Cinematográficas, 1970.
Iglesia, Alex de la, dir. *Las brujas de Zugarramurdi*. Madrid: Enrique Cerezo, 2013.
Iglesia, Eloy de la, dir. *Diputado*. London: Figaro, 1978.
———. *El pico*. London: Opalo, 1983.
———. *Los novios búlgaros*. London: Altube, 2003.
———. *Los placeres ocultos*. London: Alborada, 2003.
Iglesias, Oscar. "Blanco Amor e a censura infinita." *El País*, March 27, 2009. http://
 elpais.com/diario/2009/03/27/galicia/1238152704_850215.html.
Jacobs, Helmut C. *El sueño de la razón: El Capricho 43 de Goya en el arte visual, la
 literatura y la música*. Frankfurt: Iberoamericana Vervuert, 2011.
Jennings, Michael W. *Dialectical Images: Walter Benjamin's Theory of Literary
 Criticism*. Ithaca, NY: Cornell University Press, 1987.
Jerez-Farrán, Carlos. "Una lectura 'perversa' del *Ensayo de un crimen: La vida criminal
 de Archibaldo de la Cruz* de Luis Buñuel." *Chasqui* 43, no. 2 (2014): 179–191.
Johnston, Lynda, and Robyn Longhurst. *Space, Place, and Sex: Geographies of
 Sexualities*. Lanham, MD: Rowman and Littlefield, 2010.
Jordan, Barry, and Rikki Morgan-Tamosunas. *Contemporary Spanish Cinema*.
 Manchester: Manchester University Press, 1998.
Kentlyn, Sue. "The Radically Subversive Space of the Queer Home: 'Safety House' and
 'Neighborhood Watch.'" *Australian Geographer* 39, no. 3 (2008): 327–337.
Keown, Dominic. "The Catalan Body Politic as Aired in *La teta i la lluna*." In
 Burning Darkness: A Half Century of Spanish Cinema, edited by Joan Ramon
 Resina and Andrés Lema-Hincapié, 161–172. Albany: State University of New York
 Press, 1996.
Kim, Yeon-Soo. "A Lesbian Family Album: Family Album as a Portable Home and
 'Homelessness' in Marta Balletbò-Coll's *Costa Brava (Family Album)*." In *The
 Family Album: Histories, Subjectivities and Immigration in Contemporary Spanish
 Culture*. 132–147. Lewisburg, PA: Bucknell University Press, 2005.
Kinder, Marsha. *Blood Cinema: The Reconstruction of National Identity in Spain*.
 Berkeley: University of California Press, 1993.
———. "Reinventing the Motherland: Almodóvar's Brain-Dead Trilogy." *Film
 Quarterly* 58 (2004): 9–25.
Koehler, Robert. "Super-ornithologist: João Pedro Rodrigues' Birdman." *Cinema
 Scope* 69 (2017). Accessed March 12, 2018. http://cinema-scope.com/features
 /super-ornithologist-joao-pedro-rodrigues-birdman/.
Kowalsky, Daniel. "Rated S: Soft-Core Pornography and the Spanish Transition
 to Democracy, 1977–1982." In *Spanish Popular Cinema*, edited by Antonio
 Lázaro-Reboll and Andrew Willis, 188–218. Manchester: Manchester Univer-
 sity Press, 2004.
Kristeva, Julia. *Powers of Horror: An Essay on Abjection*. Translated by Leon S.
 Roudiez. New York: Columbia University Press, 2010.
———. "Word, Dialogue and Novel." In *The Kristeva Reader*, edited by Toril Moi,
 34–61. New York: Columbia University Press, 1986.

Lacan, Jacques. "El estadio del espejo como formador de la función del yo [*je*] tal como se nos revela en la experiencia psicoanalítica." In *Escritos 1*, translated by Tomás Segovia and Armando Suárez, 99–105. Madrid: Siglo XXI, 2009.

Lacuesta, Isaki, dir. *Murieron por encima de sus posibilidades*. Barcelona: Alicorn, 2014.

Lamos, Colleen. "The Ethics of Queer Theory." In *Critical Ethics: Text, Theory and Responsibility*, edited by Dominic Rainsford and Tim Woods, 141–151. Basingstoke: Macmillan, 1999.

Lazaga, Pedro, dir. *Sor Citröen*. Madrid: Pedro Masó, 1967. http://gloria.tv/video /W8Ni8wViRpKK4dEx96yLmGk9V.

Lázaro-Reboll, Antonio. "Screening 'Chicho': The Horror Ventures of Narciso Ibáñez Serrador." In *Spanish Popular Cinema*, edited by Antonio Lázaro-Reboll and Andrew Willis, 152–168. Manchester: Manchester University Press, 2004.

———. *Spanish Horror Film*. Edinburgh: Edinburgh University Press, 2012.

"Lee el emotivo homenaje de Pedro Almodóvar a Chus Lampreave." *Noticias de Cine*, April 5, 2016. http://www.ecartelera.com/noticias/30116/este-es-homenaje -almodovar-chus-lampreave/.

Lema-Hincapié, Andrés, and Debra A. Castillo. "Introduction." In *Despite All Adversities: Spanish-American Queer Cinema*, edited by Andrés Lema-Hincapié and Debra A. Castillo, 1–15. Albany: State University of New York Press, 2015.

Ley de Peligrosidad y Rehabilitación Social. August 6, 1970, 12551–12557. http://www .boe.es/buscar/doc.php?id=BOE-A-1970-854.

Llauradó, Anna. "Interview with Pedro Almodóvar: *Dark Habits*." In *Pedro Almodóvar: Interviews*, edited by Paola Willoquet-Maricondi, 17–25. Jackson: University Press of Mississippi, 2004.

López Sández, María. "A esmorga: Espazo urbano e simbolismo espacial." *Grial: Revista Galega de Cultura* 47, no. 184 (2009): 16–27.

Lorenz, Ralph D. *Spinning Flight: Dynamics of Frisbees, Boomerangs, Samaras, and Skipping Stones*. New York: Springer, 2006.

Lorenzetti, Ambrogio. *Madonna del latte*. Palazzo Arcivescovile. Siena, ca. 1320–1325.

Losa, David. "Los escenarios de película de Pedro Almodóvar por España." *Huffingtonpost España*, February 16, 2016. http://www.huffingtonpost.es/2016/02/16 /escenariosalmodovarespa_n_9181584.html.

"Los gallegos de la quinta provincia." *Faro de Vigo*, September 10, 2014. http:// www.faro devigo.es/ portada-ourense/2014/09/11/gallegos-quinta-provincia /1091659.html.

Löwith, Karl. *Meaning in History*. Chicago: University of Chicago Press, 1949.

Lubbock, Tom. "Goya, Francisco de: The Dog (c1820)." *Independent*, July 10, 2008. http://www.independent.co.uk/arts-entertainment/art/great-works/goya-francisco -de-the-dog-c1820-864391.html.

Luque Carreras, José A. *El cine negro español*. Madrid: T&B Editores, 2015.

Madrid Destino Cultura Turismo y Negocio. "Un paseo por el Madrid de Almodóvar." Accessed November 12, 2016. www.esmadrid.com/madrid-de -almodovar.

Martí, Octavi. "La crítica francesa aclama *Torremolinos 73*, de Pablo Berger." *El País*, June 24, 2005. http://elpais.com/diario/2005/06/24/cine/1119564016_850215 .html.

Martindale, Kathleen. *Un/Popular Culture: Lesbian Writing after the Sex Wars*. Albany: State University of New York Press, 1997.

Martínez, Josefina. "Tal como éramos . . . El cine de la Transición política española." *Historia Social* 54 (2006): 73–92.

Martínez, Luis. "La lluvia por dentro." Review of *A esmorga*, by Ignacio Vilar. *El Mundo*, May 8, 2015. http://www.elmundo.es/cultura/2015/05/08/554ba465e 2704e986d8b4584.html.

Martínez-Expósito, Alfredo. *Los escribas furiosos: Configuraciones homoeróticas en la narrative española*. New Orleans: University Press of the South, 1998.

Martínez-Lázaro, Emilio, dir. *Ocho apellidos vascos*. Universal City, CA: Universal, 2014.

Martin-Márquez, Susan. *Feminist Discourse and Spanish Cinema: Sight Unseen*. Oxford: Oxford University Press, 1999.

———. "Pedro Almodóvar's Maternal Transplants: From *Matador* to *All about My Mother*." *Bulletin of Hispanic Studies* 81 (2004): 497–509.

Matellano, Víctor. *Spanish Horror*. Madrid: Ayuntamiento de Talamanca de Jarama, 2009.

Mayne, Judith. "A Parallax View of Lesbian Authorship." In *Inside/Out: Lesbian Theories, Gay Theories*, edited by Diana Fuss, 173–184. New York: Routledge, 1991.

Mazzoni, Cristina. *Saintly Hysteria: Neurosis, Mysticism, and Gender in European Culture*. Ithaca, NY: Cornell University Press, 1996.

Mbembe, Achille. "Necropolitics." *Public Culture* 15, no. 1 (2003): 11–40.

Melero Salvador, Alejandro. *Placeres ocultos: Gays y lesbianas en el cine español de la transición*. Madrid: Notorious, 2010.

———. *Violetas de España: Gays y lesbianas en el cine de Franco*. Madrid: Notorious, 2017.

Mendes, João Maria. "Objectos únicos e diferentes: Por uma nova cultura organizacional do cinema português contemporâneo." In *Novas & Velhas Tendências no Cinema Português Contemporâneo*, edited by João Maria Mendes. 52–88. Amadora, Portugal: Escola Superior de Teatro e Cinema, 2013.

Millward, Liz, Janice G. Dodd, and Irene Fubara-Manuel. *Killing Off the Lesbians: A Symbolic Annihilation on Film and Television*. Jefferson, NC: McFarland, 2017.

"Mi querida señorita." *El cine en que vivimos*. Accessed December 3, 2017. www .elcineenquevivimos.es/index.php?movie=2115.html.

"Mi querida señorita." *Filmaffinity*. Accessed November 13, 2017. http://www.film affinity.com/es/reviews/1/257805. html.

"Mi querida señorita (Jaime de Armiñán, 1971)." *Cine progre y subvencionado*, September 28, 2012. http://cineprogre.blogspot.com/2012/09/mi-querida-senorita -jaime-de-arminan.html.

Mira, Alberto. *The A to Z of Spanish Cinema*. Lanham, MD: Scarecrow Press, 2010.

———. *De Sodoma a Chueca: Una historia cultural de la homosexualidad en España en el siglo XX*. Barcelona: Egales, 2007.

———. "¿Gay, queer, gender . . . ? Paradigmas críticos: El ejemplo de representación lésbica en las nuevas series." In *Nuevas subjetividades/Sexualidades literarias*, edited by María Teresa Vera-Rojas, 41–52. Barcelona: Egales, 2012.

———. "A Life, Imagined and Otherwise: The Limits and Uses of Autobiography in Amoldóvar's Films." In *A Companion to Pedro Almodóvar*, edited by Martin D'Lugo and Kathleen M. Vernon, 88–104. Malden, MA: Wiley-Blackwell, 2013.

———. *Miradas insumisas: Gays y lesbianas en el cine*. Barcelona: Egales, 2008.

Mishima, Yukio. *Confesiones de una máscara*. Translated by Rumi Sato. Madrid: Alianza, 2015.

Monaco, Lorenzo. *Madonna of Humility*. Tempera and gold on panel. 1418. Thorvald-sens Museum.

Montxo, Armendáriz, dir. *Las cartas de Alou*. Madrid: Elías Querejeta, 1990.

Moretti, Franco. *The Way of the World: The Bildungsroman in European Culture*. Translated by Albert Sbragia. New York: Verso, 2000.

Mosher, Donald L., and Mark Sirkin. "Measuring a Macho Personality Constella-tion." *Journal of Research in Personality* 18, no. 2 (1984): 150–63.

Natale, Simone. "A Short History of Superimposition: From Spirit Photography to Early Cinema." *Early Popular Visual Culture* 10, no. 2 (2012): 125–145.

Neumeyer, David. "Film Theory and Music Theory: On the Intersection of Two Traditions." In *Music in the Mirror: Reflections on the History of Music Theory and Literature for the 21st Century*, edited by Andreas Giger and Thomas J. Mathiesen, 275–294. Lincoln: University of Nebraska Press, 2002.

"New Film Tells Tragic Story of Belgium's Singing Nun: Biopic Recalls Life of Jeannine Deckers, Who Once Beat the Beatles to Top of US Charts." *The Guardian*, April 29, 2009. http://www.theguardian.com/world/2009/apr/28/singing-nun-jeannine-deckers.

Nicodemus, Katja. "Pedro Almodóvar: 'Eine Art Gott.'" *Die Zeit Online*, October 2, 2009. www.zeit.de/2009/33/Interview-Almodovar.

NIV Bible. London: Hodder and Stoughton, 2000.

O'Donnell, Thomas Joseph. *Medicine and Christian Morality*. Barcelona: Alba, 1998.

"Office of LGBT Outreach and Services." December 24, 2011. http://oregonstate.edu/lgbtqqia/.

Oroz, Elena. *"I'm not, but . . . I am, but . . .* Identitats lèsbiques en trànsit als films de Marta Balletbò-Coll." In *Identitats en conflicte en el cinema català*, edited by Ana Rodríguez Granell, 63–79. Barcelona: Universitat Oberta de Catalunya, 2017.

Outeiriño, Maribel. "La central de Velle cumple 50 años en el paisaje del Miño." *La Región*, July 19, 2016. http://www.laregion.es/articulo/ourense/central-velle-cumple-50-anhos-maridaje-minho/20160719080405636158.html.

Palencia, Leandro. *El cine queer en 33 películas*. Madrid: Popular, 2011.

Palmer, Paulina. *The Queer Uncanny: New Perspectives on the Gothic*. Cardiff: University of Wales Press, 2012.

Pastrana, Eusebio, dir. *Spinnin'*. Madrid: Big Bean & The Human Bean Band/Mundo-free, 2007.

Paszkiewicz, Katarzyna. *Rehacer los géneros: Mujeres cineastas dentro y fuera de Hollywood*. Barcelona: Icaria, 2017.

Pérez, Jorge. "Who's Your Daddy? Queer Masculinities and Parenthood in Recent Spanish Cinema." In *The Dynamics of Masculinity in Contemporary Spanish Culture*, edited by Lorraine Ryan and Ana Corbalán, 99–112. New York: Routledge, 2017.

Pérez-Sánchez, Gema. *Queer Transitions in Contemporary Spanish Culture*. Albany: State University of New York Press, 2007.

Perriam, Chris. *Spanish Queer Cinema*. Edinburgh: Edinburgh University Press, 2013.

Perriam, Chris, and Darren Waldron. *French and Spanish Queer Film: Audiences, Communities, and Cultural Exchange*. Edinburgh: Edinburgh University Press, 2016.

Petit, Jordi, and Empar Pineda. "El movimiento de liberación de gays y lesbianas durante la transición (1975–1981)." In *Una discriminación universal: La homosexu-alidad bajo el franquismo y la transición*, edited by Javier Ugarte Pérez, 171–197. Barcelona: Egales, 2008.

Pla, Josep. *Notes del capvesprol*. In *Obres completes*. Vol. 35. Barcelona: Destino, 1979.

Podolsky, Robin. "Sacrificing Queers and Other 'Proletarian' Artifacts." *Radical America* 25, no. 1 (1991): 53–60.

Pohl, Burkhard. "'Hemos cambiado tanto': El tardofranquismo en el cine español." Translated by Alistair Ross. In *Cine, nación y nacionalidades en España*, edited by Nancy Berthier, Jean-Claude Seguin, Fernando Lara, and Alistair Ross, 217–231. Madrid: Casa de Velásquez, 2007.

Pons, Ventura, dir. *Amic/Amat*. Barcelona: Els Films de la Rambla, 1998.

———. *Els meus (i els altres)*. Barcelona: Proa, 2011.

———. *Forasters*. Barcelona: Els Films de la Rambla, 2008.

———. "My Third Belbel." Accessed August 5, 2012. http://www.venturapons.com /forasters/notesdirectoreng.html.

PORDATA: Base de Dados Portugal Contemporâneo. Accessed January 28, 2018. https://www.pordata.pt/Homepage.aspx.

Pramaggiore, Maria. "Straddling the Screen: Bisexual Spectatorship and Contemporary Narrative Film." In *RePresenting Bisexualities: Subjects and Cultures of Fluid Desire*, edited by Donald E. Hall and Maria Pramaggiore, 272–297. New York: New York University Press, 1996.

Prout, Ryan. "*El Diputado / Confessions of a Congressman*." In *The Cinema of Spain and Portugal*, edited by Alberto Mira, 159–167. New York: Wallflower, 2005.

Puar, Jasbir. *Terrorist Assemblages: Homonationalism in Queer Times*. Durham, NC: Duke University Press, 2007.

Rahim, Aisha. "Interview with João Pedro Rodrigues." *Metropolis* 41 (August 21, 2016). http://www.cinemametropolis.com/index.php/pt/revistas/2015/k2 -categories/sport/ item/1525-o-ornitologo-joao-pedro-rodrigues-em-entrevista.

Rancière, Jacques. *Dissensus: On Politics and Aesthetics*. Translated by Steve Corcoran. New York: Continuum, 2010.

Reis, António, and Margarida Cordeiro. *Trás-os-montes*. Lisbon: Centro Português de Cinema, 1976.

Resina, Joan Ramon, and Andrés Lema-Hincapié, eds. *Burning Darkness: A Half Century of Spanish Cinema*. Albany: State University of New York Press, 2008.

Restout, Jean Bernard. *Sleep*. Oil on canvas. 1771. Cleveland Museum of Art.

Rich, Adrienne. "Compulsory Heterosexuality and Lesbian Existence." In *Blood, Bread, and Poetry: Selected Prose, 1979–1985*, 23–75. New York: Norton, 1994.

Richards, Michael. *A Time of Silence: Civil War and the Culture of Repression in Franco's Spain, 1936–1945*. Cambridge: Cambridge University Press, 1998.

Rocha, Carolina, and Georgia Seminet. "Introduction." In *Representing History, Class, and Gender in Spain and Latin America*, 1–29. Basingstoke: Palgrave Macmillan, 2012.

Rodowick, David Norman. *The Crisis of Political Modernism: Criticism and Ideology in Contemporary Film Theory*. Urbana: University of Illinois Press, 1988.

Rodrigues, João Pedro, dir. *A última vez que vi Macau*. Paris: Epicentre Films, 2012.

———. *O Fantasma*. Lisbon: Rosa Filmes, 2000.

———. *O ornitólogo*. West Orange, NJ: Black Maria, 2000.

Rodríguez, Hilario J. "Made in Spain: *Torremolinos 73*." *Ikusgaiak: Cuadernos de Cinematografía* 7 (2005): 184–188.

Rodríguez, Xosé Manoel. "Ignacio Vilar cre que 'A esmorga' coincide co proxecto que desexaba Blanco Amor." *La Voz de Galicia*, November 4, 2014. https://www

.lavozdegalicia.es/noticia/ourense/ourense/2014/11/14/span-langglignacio-vilar-cre
-esmorga-coincide-co-proxecto-desexaba-blanco-amorspan/0003141597139103329
0907.htm.

Rodríguez Sánchez, Francisco. "'A esmorga': Opresión e violencia na realidade
colonial." *Nosa Terra* 3 (1985): 13–16.

Rogers, Kara. *The Reproductive System*. Chicago: Britannica, 2011.

"Rolda de prensa A ESMORGA." *Esmorga Filme*, May 20, 2015. http://youtu.be
/G35iPeAn1tM.

Romo, Leticia I. "Intersexualidad: La irregularidad entrópica del sistema en *Mi
querida señorita, Cola de lagartija* y *En el nombre del nombre*." *Latin Americanist*
55, no. 1 (2011): 109–129.

Ruiz de Ojeda, Victoria A., ed. *Entrevistas con Eduardo Blanco-Amor*. Gijón, Spain:
Nigra, 1994.

Sánchez Vidal, Agustín. *Borau*. Zaragoza: Caja de Ahorros de la Inmaculada, 1990.

San Miguel, Helio. "The New Ethos of Gay Culture and the Limits of Normaliza-
tion." In *(Re)viewing Creative, Critical and Commercial Practices in Contemporary
Spanish Cinema*, edited by Duncan Wheeler and Fernando Canet, 79–92. Bristol:
Intellect, 2014.

Santa Sede. *Inter Sanctam Sedem et Hispaniam Sollemnes Conventiones: Concordato
entre la Santa Sede y España*. Accessed March 1, 2015. http://www.vatican.va/roman
curia/secretariat state/archivio/documents/rc_seg-st_19530827_concordato
-spagna_ sp.html.

Schlegel, Nicholas G. *Sex, Sadism, Spain, and Cinema: The Spanish Horror Film*.
Lanham, MD: Rowman and Littlefield, 2015.

Schwartz, Ronald. *Great Spanish Films since 1950*. Lanham, MD: Scarecrow Press, 2008.

———. *Spanish Film Directors (1950–1985): 21 Profiles*. Lanham, MD: Scarecrow
Press, 1986.

Sedgwick, Eve Kosofsky. *Epistemology of the Closet*. Berkeley: University of California
Press, 1990.

———. *Tendencies*. Durham, NC: Duke University Press, 1993.

Segarra, Marina, and Audiovisual Communication Students of the EPSG (Universitat
Politècnica de València). *La Nueva Ola en Madrid*. Parte 1. March 26, 2015. http://
www.youtube.com/watch?v=qBio1qvuik4.

Seguin, Jean-Claude. "El espacio-cuerpo en el cine de Pedro Almodóvar o la modifi-
cación." In *Almodóvar: El cine como passion*, edited by Francisco A. Zurian
Hernández and Carmen Vázquez Varela, 229–242. Toledo: Universidad de
Castilla–La Mancha, 2005.

———. *Pedro Almodóvar o la deriva de los cuerpos*. Murcia, Spain: Tres Fronteras, 2009.

Shary, Timothy. *Generation Multiplex: The Image of Youth in Contemporary American
Cinema*. Austin: University of Texas Press, 2002.

———. "Teen Films: The Cinematic Image of Youth." In *Film Genre Reader III*,
edited by Barry Keith Grant, 490–515. Austin: University of Texas Press, 2003.

Shaw, Debra, ed. *Contemporary Latin American Cinema: Breaking into the Global
Market*. Lanham, MD: Rowman and Littlefield, 2007.

Shelp, Earl E. "Introduction." In *Sexuality and Medicine*, xxi–xxxii. Dordrecht:
Reidel, 1987.

Silva, Antônio M. da. "The Portuguese Queer Screen: Gender Possibilities in João
Pedro Rodrigues' Cinematic Production." *Rupkatha Journal on Interdisciplinary*

Studies in Humanities. Special issue on LGBT and Queer Studies 7, no. 1 (2014): 69–78.

Silva, João Vaz. *"A raíz do Coração* de Paulo Rocha." *Apokalipse: Centro de Estudos Cinematográficos* 29 (2001). Accessed January 9, 2014. http://www.cecine.com /2014/01/09/a-raiz-do-coracao-de-paulo-rocha/.

"Síndrome de Insensibilidad Androgénica." December 15, 2017. http://www.orpha.net /data/patho/Pro/es/Sindrome-Insensibilidad-Androgenica.pdf.

Smith, Paul Julian. *Desire Unlimited: The Cinema of Pedro Almodóvar.* London: Verso, 2014.

———. "Eloy de la Iglesia's Cinema of Transition." In *Modes of Representation in Spanish Cinema,* edited by Jenaro Talens and Santos Zunzunegui, 216–254. Minneapolis: University of Minnesota Press, 1998.

———. *"Torremolinos 73." Sight and Sound,* July 2005. http://old.bfi.org.uk/ sightand-sound/review/2400.

Somoza Medina, José. "Da Auria retratada por Blanco Amor á cidade do presente." In *EBA 5.0: O universo de Eduardo Blanco Amor 50 anos despois d'A Esmorga,* edited by Xavier Paz, Benito Losada, Xosé Lois Vázquez, and Concellería de Cultura do Concello de Ourense, 21–35. Ourense, Spain: Difusora de Letras, Artes e Ideas, 2009.

Sontag, Susan. *Illness as Metaphor.* New York: Farrar, Straus and Giroux, 1978.

———. *Regarding the Pain of Others.* London: Penguin Books, 2004.

Sosa-Velasco, Alfredo. *Médicos escritores en España, 1885–1955.* Woodbridge, UK: Tamesis, 2010.

"Spinnin." *Urban Dictionary.* Accessed September 21, 2017. http://www.urbandiction ary.com.

"Spinning." *Dictionary.com.* Accessed September 20, 2017. http://www.dictionary .com.

"Spinning." *Urban Dictionary.* Accessed September 21, 2017. www.urbandiction-ary.com.

Stam, Robert. "Hitchcock and Buñuel: Desire and the Law." *Studies in the Literary Imagination* 16, no. 1 (1983): 7–27.

Stone, Rob, and María del Pilar Rodríguez. "Contemporary Basque Cinema: Online, Elsewhere and Otherwise Engaged." *Bulletin of Hispanic Studies* 93 (2016): 1103–1122.

Suárez, Gonzalo. Letter to Eduardo Blanco Amor, August 19, 1976. Eduardo Blanco Amor Papers, Biblioteca Deputación Provincial de Ourense, Ourense (Spain). Manuscript.

———, dir. *Parranda.* Beverly Hills, CA: Lotus, 1977.

Sullivan, Nikki. *A Critical Introduction to Queer Theory.* New York: New York University Press, 2003.

Terreros, Gorka Bilbao. "Matriarchy, Motherhood, Myth and the Negotiation of (Gender) Identity in Modern Basque Cinema." *Bulletin of Hispanic Studies* 94 (2017): 731–746.

Tesson, Eugène. "Moral Reflections." In *Medical Experimentation on Man,* edited by Dom Peter Flood, 101–115. Cork: Mercier, 1955.

Torras i Francès, Meri. "Pensar la in/visibilitat: Papers de treball." *Lectora: Revista de Dones i Textualitat* 17 (2011): 139–152.

Torres, Sara. "Entrevista." In *Cine fantástico y de terror español 1900–1983,* edited by Carlos Aguilar, 223–256. Donostia: Donostia Kultura.

Townshend, Dale. "'Love in a Convent': Or, Gothic and the Perverse Father of Queer Enjoyment." In *Queering the Gothic*, edited by William Hughes and Andrew Smith, 11–35. Manchester: Manchester University Press, 2009.

Triana-Toribio, Núria. *Spanish National Cinema*. New York: Routledge, 2003.

Trujillo Barbadillo, Gracia. "Desde los márgenes: Prácticas y representaciones de los grupos *queer* en el Estado español." In *El eje del mal es heterosexual: Figuraciones, movimientos y practices feministas queer*, edited by Grupo de Trabajo Queer, 29–44. Madrid: Traficantes de Sueños, 2005.

———. "Sujetos y miradas inapropables/adas: El discurso queer." In *Lesbianas: Discursos y Representaciones*, edited by Raquel Platero Méndez, 107–119. Santa Cruz de Tenerife, Spain: Melusina, 2008.

Tuan, Yi-Fu. "Space and Place: Humanistic Perspective." In *Philosophy in Geography*, edited by Stephen Gale and Gunnar Olsson, 387–427. Berlin: Springer Verlag, 2013.

Uribe, Imanol, dir. *Bwana*. Madrid: Aurum, 1996.

Valle-Inclán, Ramón. *Luces de Bohemia: Esperpento*. Madrid: Espasa-Calpe, 1974.

Variações, António. "Canção de Engate." Accessed January 28, 2018. http://www .youtube.com/watch?v= bzhLamrxacE.

Vega, Verónica, Pablo de Vedia, and Denise Roitman. "Narcisismo e identificación en la fase del espejo: Una articulación entre Freud y Lacan." Buenos Aires: Universidad de Buenos Aires. Accessed November 27, 2017. http://www.psi.uba.ar/academica /carrerasdegrado/psicologia/sitios_catedras/obligatorias/055_adolescencia1 /material/archivo/narcisismo_identificacion.pdf.

Vernon, Kathleen M. "Queer Sound: Musical Otherness in Three Films by Almodóvar." In *All about Almodóvar: A Passion for Cinema*, edited by Brad Epps and Despina Kakoudaki. 51–70. Minneapolis: University of Minnesota Press, 2009.

Vico, Giambattista. *Ciencia nueva*. Translated by J. M. Bermudo and Assumpta Camps. 2 vols. Barcelona: Orbis, 1985.

———. *The New Science of Giambattista Vico*. Translated by Thomas Goddard Bergin and Max Harold Fisch. Ithaca, NY: Cornell University Press, 1970.

———. *Scienza Nuova. Opere*. Edited by Fausto Nicolini. Milan: Riccardo Ricciardi, 2006.

Vidal, Belén. "Memories of Underdevelopment: *Torremolinos 73*, Cinephilia, and Filiation at the Margins of Europe." In *Cinema at the Periphery*, edited by Dina Iordanova, David Martin-Jones, and Belén Vidal, 211–231. Detroit: Wayne State University Press, 2010.

Vidal, Nuria. *El cine de Pedro Almodóvar*. Barcelona: Destino, 1988.

Vilar, Ignacio, dir. *A esmorga*. Pontevedra: Vía Láctea, 2014.

———. "A esmorga." Semana Cultural de Vilanova, August 10, 2015, Vilanova de Valdeorras (O Barco de Valdeorras), Ourense, Spain. Q&A.

Villalonga, Llorenç. *Bearn*. Barcelona: Club Editor, 1969.

Villarmea Alvarez, Iván. "Mudar de perspetiva: A dimensão transnacional do cinema português contemporâneo." *Aniki: Portuguese Journal of the Moving Image* 3, no. 1 (2016): 101–120.

Villaronga, Agustí, dir. *El mar*. Barcelona: Picture This!, 2000.

———. *Pa negre*. Barcelona: Cameo, 2011.

Vosburg, Nancy, and Jacky Collins, eds. *Lesbian Realities/Lesbian Fictions in Contemporary Spain*. Lewisburg, PA: Bucknell University Press, 2011.

Warner, Michael. "Introduction." In *Fear of a Queer Planet: Queer Politics and Social Theory*, edited by Michael Warner, vii–xxxi. Minneapolis: University of Minnesota Press, 1994.

Weinrichter, Antonio. "Crítica de 'A esmorga' (***): Noche de parranda." Review of *A esmorga*, directed by Ignacio Vilar. *ABC*, May 18, 2015. http://hoycinema.abc.es /critica/20150508/abci-esmorga-critica-201505071751.html.

Yourcenar, Marguerite. *Con los ojos abiertos: Entrevistas con Matthieu Galey*. Translated by Elena Berni. Buenos Aires: Emecé, 1982.

Zecchi, Barbara. *Desenfocadas: Cineastas españolas y discursos de género*. Barcelona: Icaria, 2014.

Notes on Contributors

JENNIFER BRADY (PhD, University of Colorado Boulder) is associate professor of Hispanic studies at the University of Minnesota Duluth, where she teaches courses in Spanish language and in cinema, cultural, and literary studies. She also serves as the managing editor of *Hispania*, the scholarly journal of the American Association of Teachers of Spanish and Portuguese (AATSP). Her research is focused on repetition, neurosis, gender, and illness as related to identity and agency in contemporary filmic and literary works from Spain. She has published on masculinities, maternity, the body, and life writing. In these areas, she has coedited the anthology *Collapse, Catastrophe, and Rediscovery: Spain's Cultural Panorama in the Twenty First Century* (2014) and has published articles and book chapters on the following topics: contemporary Spanish authors José Javier Abasolo, Juan José Millás, and Rosa Montero; and Catalonian and Spanish cinema. Although her main area of research is twentieth-century and twenty-first-century literature and film from Spain, she has published on other topics as well, including studies on early modern, seventeenth-century, and nineteenth-century literary works from Spain.

ANA CORBALÁN is professor of Spanish at the University of Alabama. She received her PhD from the University of North Carolina at Chapel Hill in 2006. She has published extensively on twentieth-century and twenty-first-century Spanish literature, culture, film, gender studies, memory, migrations, cultural studies, and transatlantic studies. She is the author of *El cuerpo transgresor en la narrativa española contemporánea* (2009) and *Memorias fragmentadas: Mirada transatlántica a la resistencia femenina contra las dictaduras* (2016). She has also coedited five volumes: *Toward a Multicultural Configuration of Spain: Local Cities, Global Spaces* (2014); *Hacia una redefinición del feminismo en el siglo XXI* (2015); *The Dynamics of Masculinity in Contemporary Spanish*

Culture (2017); *European Cinema: Crisis Narratives and Narratives in Crisis* (2018); and *Todos a movilizarse: Protesta y activismo social en la España del siglo XXI* (2019). Currently, she is working on a new book project on migrant narratives.

ANN DAVIES is chair of Spanish Studies at the University of Stirling and has published widely on contemporary Spanish cinema, with a particular emphasis on the Gothic and horror. She has also published extensively on the work of the director Guillermo del Toro. She is the author of *Contemporary Spanish Gothic* (2016); *Penélope Cruz* (2014); *Spanish Spaces: Landscape, Space and Place in Contemporary Spanish Culture* (2012); *Daniel Calparsoro* (2009); and *Carmen on Film: A Cultural History*, with Phil Powrie, Chris Perriam, and Bruce Babington (2007). She is also the editor of *Spain on Screen: Developments in Contemporary Spanish Cinema* (2011); *The Transnational Fantasies of Guillermo del Toro*, coedited with Dolores Tierney and Deborah Shaw (2014); *Carmen: From Silent Film to MTV*, coedited with Chris Perriam (2005); and *The Trouble with Men: Exploring Masculinities in European and Hollywood Cinema*, coedited with Phil Powrie and Bruce Babington (2004). She is currently writing a book on landscape, space, and place in Spanish horror and Gothic film and TV.

CONXITA DOMÈNECH (PhD in Spanish literature, University of Colorado Boulder) is an associate professor of Iberian cultures and literatures in the Department of Modern and Classical Languages at the University of Wyoming, where she teaches and does research in early modern Spanish literature and Peninsular cinema. She also serves as the assistant managing editor of *Hispania*, the scholarly journal of the American Association of Teachers of Spanish and Portuguese (AATSP). Her current research is on a seventeenth-century bilingual Catalan-Spanish play entitled *La famosa comedia del marqués de los Vélez*. Professor Domènech has published three books: *La Guerra dels Segadors en comedias y en panfletos ibéricos: Una historia contada a dos voces (1640–1652)* (2016); *Letras hispánicas en la gran pantalla: De la literatura al cine* (with Andrés Lema-Hincapié, 2017); and *Saberes con sabor: Culturas hispánicas a través de la cocina* (with Lema-Hincapié, 2020). She has coedited three collective volumes with Professor Lema-Hincapié, *Pedro Calderón de la Barca's* La vida es sueño: *Philosophical Crossroads* (2014); *Ventura Pons: Una mirada excepcional desde el cine catalán* (2015); and *El Segundo* Quijote *(1615): Nuevas interpretaciones cuatro siglos después* (2018). Professor Domènech has also published more than thirty scholarly book chapters and articles in peer-reviewed journals such as *Hispanic Review, Romance Quarterly, Revista Canadiense de Estudios Hispánicos, Bulletin of Hispanic Studies, Catalan Review, Hispanófila, Bulletin of the Comediantes, Cervantes, Ometeca, Neophilologus, Caplletra*, and *Signos Literarios*.

IBON IZURIETA is an associate dean of the College of Letters, Arts and Sciences and a professor of Spanish in the Metropolitan State University of Denver. He researches post-Franco narrative, written in the Basque language; Basque film; and Peninsular Spanish narrative and film since 1975. Among his most recent publications are the book *Collapse, Catastrophe and Reconstruction: Spain's Cultural Panorama in the XXI Century* and the book chapters "Identidades performativas como espacios de activismo político en el cine de Ventura Pons," in *Ventura Pons: Una mirada excepcional desde el cine catalán*; '"Sara izeneko gizona' (Un espía llamado Sara): ¿Novela juvenil?," included in a volume on Basque writer Bernardo Atxaga that will be published by Anthropos and will be entitled *El mundo está en todas partes: La creación literaria de Bernardo Atxaga*. Additionally, he has written "Exile and Psychosis in Joseba Sarrionandia's *Lagun Izoztua*," in *Shifting Subjectivities in Contemporary Fiction and Film from Spain* (2018). Dr. Izurieta Otazua earned his PhD in Spanish and his master's degrees in Spanish and comparative literature at the University of Iowa.

MEREDITH LYN JEFFERS earned her PhD from the Department of Spanish and Portuguese at the University of Colorado Boulder in 2013. She is currently associate professor of Spanish at Metropolitan State University of Denver, specializing in twentieth-century and twenty-first-century Peninsular culture, literature, and film. She also serves as production assistant for the managing editor of *Hispania*, the scholarly journal of the American Association of Teachers of Spanish and Portuguese (AATSP). Her current research examines new pedagogical approaches for incorporating cinema into culture courses. Dr. Jeffers's most recent publications include the coedited anthology *Shifting Subjectivities in Contemporary Fiction and Film from Spain*, in addition to an article on recent Spanish cinema: "Representing (Dis)ability and Inability in *Yo, También* and *El truco del manco*," in *Discovering (Dis)abilities: Critical and Artistic Perspectives on Alternative-ableness in Spanish-Speaking and US Chicano/Latino Contexts* (2019).

ANDRÉS LEMA-HINCAPIÉ is an associate professor of Ibero-American literatures and cultures at the University of Colorado Denver. He holds two PhDs, one in German philosophy from the Université d'Ottawa and the other in Romance studies from Cornell University. With Joan Ramon Resina, Lema-Hincapié coedited *Burning Darkness: A Half Century of Spanish Cinema* (2008). Lema-Hincapié and Debra A. Castillo's edition of the collective volume *Despite All Adversities: Spanish-American Queer Cinema* was published in 2015. Lema-Hincapié wrote with Conxita Domènech, *Letras hispánicas en la gran pantalla* (2017). Domènech and Lema-Hincapié are also the editors of the following scholarly volumes: *Calderón de la Barca's* La vida es sueño: *Philosophical Crossroads* (2014); *El Segundo* Quijote *(1615): Nuevas interpretaciones cuatro siglos*

después (2015); and *Ventura Pons: Una mirada excepcional desde el cine catalán* (2015). With Conrado Zuluaga Osorio, Andrés is the co-founder/codirector of The García Márquez Project at the University of Colorado Denver. In 2015, Andrés was a visiting associate professor at Stanford University, where he taught an upper-division seminar on the cinema of Spanish filmmaker Pedro Almodóvar. Finally, Jeff Schweinfest and Andrés cofounded and will codirect the first International Queer Biennial Arts and Academic Conference (Denver, June 9–11, 2021).

NINA L. MOLINARO is associate professor of Spanish at the University of Colorado Boulder. She has published *Foucault, Feminism, and Power: Reading Esther Tusquets* (1991) and *Policing Gender and Alicia Giménez Bartlett's Crime Fiction* (2015). Together with Inmaculada Pertusa-Seva, she has coedited *Esther Tusquets: Scholarly Correspondences* (2014), and, with Nancy Vosburg, she has co-edited *Spanish and Latin American Women's Crime Fiction in the New Millennium: From* Noir *to* Gris (2017). Her most recent monograph, *The Art of Time: Levinas, Ethics, and the Contemporary Peninsular Novel* (2019), is from Bucknell University Press. Her areas of scholarly expertise include postwar Peninsular literature and culture, Hispanic women's literature, Hispanic crime fiction, and Peninsular film.

KELLY MOORE is a PhD candidate in the Department of Romance Studies at Cornell University. She studied Latin American politics and Spanish literature for her bachelor's degree before completing a Fulbright English Teaching Assistantship in Madrid. She has a master's degree in Spanish linguistics and literatures from the University of Wyoming, where she assisted with the conference "Don Quixote in the American West" (2015). Her research interests are in contemporary Iberian film and literature. She currently is working on her dissertation, which explores anticlerical violence and theorizes transfers of sacrality she contends occurred during Spain's revolutionary moment.

RUI TRINDADE OLIVEIRA is a PhD researcher at Northumbria University, currently writing his dissertation on the industrial contexts and cultural specificity of Southern European horror cinema, specifically Italian and Spanish horror. He is concluding his PhD degree under the supervision of Dr. Johnny Walker. He holds a BA in film studies from the University of Beira Interior, Portugal, as well as a BA in biology and an MA in forensic sciences, from the University of Aveiro and from the University of Porto, Portugal, respectively. He has spoken about his research at various academic events and conferences.

JOAN RAMON RESINA is professor in the Departments of Comparative Literature and Iberian and Latin American Cultures at Stanford University, where he

specializes in the European novel, cultural theory, Spanish and Catalan literature and film, and urban culture. He earned a PhD in comparative literature at the University of California, Berkeley, and a doctorate in English philology at the University of Barcelona. He has held visiting positions at several European and American universities. His single-authored books include *La búsqueda del Grial* (1988); *Un sueño de piedra: Ensayos sobre la literatura del modernismo europeo* (1990); *Los usos del clásico* (1991); *El cadáver en la cocina: La novela policiaca en la cultura del desencanto* (1997); *El postnacionalisme en el mapa global* (2005), *Barcelona's Vocation of Modernity: Rise and Decline of an Urban Image* (2008; Catalan translation, 2008; Portuguese translation, 2013); *Del Hispanismo a los Estudios Ibéricos: Una propuesta federativa para el ámbito cultural* (2009); *Josep Pla: The World Seen in the Form of Articles* (2017); and *The Ghost in the Constitution: Historical Memory and Denial in Spanish Society* (2017). He has edited eleven collections of essays and more than 175 critical essays in refereed journals and collective volumes. Between 1998 and 2004, he was chief editor of the journal of cultural theory *Diacritics*; currently he is a member of the editorial boards of various U.S. and European journals. He contributes regularly to the Catalan press. Among other awards, he has received the Fulbright Scholarship, the Alexander von Humboldt Fellowship, the Donald Andrews Whittier Fellowship at the Stanford Humanities Center, the Serra d'Or Award for literary criticism, and twice a fellowship in the Käte Hamburger Internationales Kolleg Morphomata in Cologne.

DARÍO SÁNCHEZ GONZÁLEZ is assistant professor of Spanish and gender, women and sexuality studies at Gustavus Adolphus College. Born in Asturias, Spain, since 2008 he has lived in the United States, where he completed his doctoral degree in Spanish literature at Rutgers University–New Brunswick in 2014. His fields of specialization are queer studies and contemporary film and narrative from Spain and the Latin American Southern Cone. He has presented at numerous conferences, including CineLit in Portland, Oregon (2011, 2015) and the MLA International Symposium in Düsseldorf (2016). His publications include articles on filmmakers such as Josefina Molina, Cecilia Bartolomé, and Ventura Pons. His ongoing lines of research are the negotiation of national identities and dissident sexualities within the Spanish state, as well as the representation of queer masculinities in Spanish-speaking countries that have suffered systematic state-sponsored violence. At present, he is preparing an article about the BDSM-themed Argentine film *A Year without Love* (Anahí Berneri, 2005); he is also taking his archival research on Galician author Eduardo Blanco Amor (addressed in this volume) in a new direction, more focused on Blanco Amor's Latin American connections, particularly with Chilean critic Hernán Díaz Arrieta (aka Alone). Darío lives between Minneapolis and Asturias.

LENA TAHMASSIAN is assistant professor of Spanish at the University of South Carolina. She earned her doctorate from the Department of Iberian and Latin American Cultures at Stanford University. She specializes in cultural studies of contemporary Spain, particularly through the lens of cinema and visual media, music, and social movements from 1975 to the present moment. With a particular focus on Spain's regional cultures, especially the Catalan and Basque traditions, she has published articles on Iberian cinema as well as Spanish democracy. Professor Tahmassian is currently working on a book project examining the dimensions of countercultural critique in Spain's urban centers and peripheries during the Transition and beyond.

MARÍA TERESA VERA-ROJAS is lecturer of Hispanic philology at the Universitat de Lleida. She is a research member of ADHUC–Research Center for Theory, Gender, and Sexuality at the Universitat de Barcelona, and the editor of the *452°F: Revista de Teoría de la Literatura y Literatura Comparada*. She holds a PhD in cultural and gender studies from the Universitat de Barcelona and a PhD in Hispanic studies from the University of Houston. Her interdisciplinary research focuses on gender and sexuality studies, queer theory, postcolonial feminism, and cultural and literary studies, with a particular interest on contemporary Hispanic Caribbean, Venezuelan, and Spanish literature and culture, as well as early twentieth-century Hispanic culture, literature, and feminism in the United States. She has published several journal articles, book chapters, and encyclopedia entries on these subjects. In addition, she is the editor of the book *Nuevas Subjetividades/Sexualidades Literarias* (2012) and the author of *"Se conoce que usted es 'Moderna'": Lecturas de la mujer moderna en la colonia hispana de Nueva York (1920–1940)* (2018).

WILLIAM VIESTENZ is associate professor of Spanish in the Department of Spanish and Portuguese Studies at the University of Minnesota, Twin Cities, where he holds a joint appointment in the Institute for Global Studies. He graduated from Stanford University with a PhD in Iberian and Latin American cultures in 2011. He is presently the editor of the *Catalan Review*, where previously he held the position of managing editor. He has served as the Vice President of the North American Catalan Society since 2015. Professor Viestenz specializes in modern Iberian literature and culture, with an emphasis on the intersection of Catalan studies, the environmental humanities, and political theory. He is the author of *By the Grace of God: Franco's Spain and the Sacred Roots of Political Imagination* (2014) and has coedited *The New Ruralism: An Epistemology of Transformed Space* (2013); *Ethics of Life: Contemporary Iberian Debates* (2016); and *A Polemical Companion to Ethics of Life: Contemporary Iberian Debates*. He has published multiple articles in specialized journals and contributed to a number of edited volumes.

Index

violence (cont.)
coercive, 100; collective, 13, 199; domestic,
232; drama, 36; erotic, 208, 212, 216;
eroticized, 14, 211, 216; exclusionary, 192,
200; forms of, 4; heterosexual, 32;
historical, 199; lesbian, 27; mimetic, 199;
political, 100; queer, 190, 196; reciprocal,
99; sacred, 214, 216; state sponsored, 287;
unanimous, 199
Virgin (Mary), the / Virgins, 211, 220n7, 249
Viridiana, 242, 257n15
Volver, 238

Willem, Linda M., 2
Wise, Robert, 28
woman / women, 2, 7, 8, 10, 11, 15, 171, 23,
25, 27, 29–33, 42, 44, 47, 53–60, 62–64,
66n19, 73, 75, 79, 81, 82, 107–115, 116n1,
118n25, 125, 129, 131, 140, 143, 145, 149,
158, 161, 164, 165, 168, 176, 178–180, 183,
185n19, 190, 210–212, 219, 223, 230–232,
239, 241–250, 254, 255, 262, 268, 286, 287
women's cinema, 170, 172
women's literature, 286
women's studies, 2

X-Files, The, 5, 17n5, 269

Yeats, W. B., 161
Yourcenar, Marguerite, 6, 17n10, 282

Zarzo, Manuel, 253
Zecchi, Barbara, 174, 185nn14–16, 186n27,
282
zine, 139
Zinegoak, 65n3, 139